THE SHOCK OF THE NEW

ALSO BY ROBERT HUGHES

The Art of Australia (1966)
Heaven and Hell in Western Art (1969)
The Fatal Shore (1987)
Lucian Freud (1988)
Frank Auerbach (1990)
Nothing If Not Critical (1990)

THE SHOCK OF THE NEW

SECOND EDITION

ROBERT HUGHES

McGRAW-HILL, INC.

New York St. Louis San Francisco Auckland Bogotá Caracas Hamburg Lisbon London
Madrid Mexico Milan Montreal New Delhi Paris San Juan São Paulo Singapore Sydney
Tokyo Toronto

TO VICTORIA, WITH LOVE

1 2 3 4 5 6 7 8 9 0 KGP KGP 9 5 4 3 2 1 0

ISBN 0-07-031127-7

Grateful acknowledgement is made to the following for permission to reprint from previously published material:

Faber and Faber Ltd.: Excerpt from "MCMXIV" by Philip Larkin. Reprinted by permission of Faber and Faber Ltd. from *The Whitsun Weddings* by Philip Larkin.

Editions Gallimard: Excerpts from *Oeuvres de Gérard de Nerval de la Bibliothèque de la Pléiade,* © Editions Gallimard 1952 and 1956. Excerpts from *Oeuvres poétiques de Guillaume Apollinaire de la Bibliothèque de la Pléiade,* © Editions Gallimard 1957.

Harcourt Brace Jovanovich, Inc., and Faber and Faber Ltd.: Excerpt from "East Coker" by T. S. Eliot is reprinted from *Four Quartets* by permission of Harcourt Brace Jovanovich, Inc., and Faber and Faber Ltd.; copyright 1943 by T. S. Eliot; copyright renewed 1971 by Esme Valerie Eliot.

John Murray (Publishers) Ltd. and Houghton Mifflin Company: Excerpt from "Planters Vision" by John Betjeman, from *Collected Poems* by John Betjeman. Reprinted by permission of John Murray (Publishers) Ltd., and Houghton Mifflin Company.

Punch and Rothco Cartoons, Inc.: Six lines of poetry from an issue of *Punch* published in the 1930s. Copyright Punch.

Random House, Inc., and Faber and Faber Ltd.: Excerpt from "Epitaph on a Tyrant" by W. H. Auden. Copyright 1940 by W. H. Auden. Copyright renewed 1968 by W. H. Auden. From *W. H. Auden: Collected Poems,* edited by Edward Mendelson. Reprinted by permission of Random House, Inc., and Faber and Faber Ltd.

Peter Newbolt: Excerpt from "Vitaï Lampada" by Sir Henry Newbolt. Reprinted by permission.

McGraw-Hill edition published by arrangement with Random House, Inc.

Library of Congress Catalog Card Number: 90-61591.

CONTENTS

INTRODUCTION

This book grew out of a television series I wrote and narrated for the BBC. From the first take to the last, *The Shock of the New* ate up three years of research, writing, and filming; and having addressed the camera from places as remote from one another, geographically and spiritually, as the Japanese bridge of Monet's lily-pond in Giverny, the crematorium at Dachau, a roof in Brasília, the edge of the Grand Canyon, and the ruins of the Marquis de Sade's *château*, I find – adding up the air tickets – that I covered more than a quarter of a million miles doing it. The soul, some Arabs believe, can only travel at the pace of a trotting camel. They are right.

From the start, the producers, directors, and I agreed that *The Shock of the New* should be, as Kenneth Clark put it more than ten years ago in his subtitle to *Civilisation*, "a personal view" of the art of our century. Eight hours sounds like a lot of air time, and it is; but it is totally inadequate to the task of doing a formal history of modern art on television, with every artist who did anything significant given his or her just place and explication. There are no footnotes on the Box. Instead, we decided to do eight essays about eight separate subjects that seemed important to an understanding of modernism. We would start with a programme about the blossoming of a sense of modernity in European culture – roughly from 1880 to 1914 – in which the myth of the Future was born in the atmosphere of millenarian optimism that surrounded the high machine age, as the nineteenth century clicked over into the twentieth century. We would finish with a film that tried to describe how art gradually lost that sense of newness and possibility, as the idea of the *avant-garde* petered out in the institutionalized culture of late modernism. In between, we would have six programmes dealing with six subjects – visual essays on the relationship of painting, and to a lesser degree sculpture and architecture, to some of the great cultural issues of the last hundred years. How has art created images of dissent, propaganda, and political coercion? How has it defined the world of pleasure, of sensuous communion with worldly delights? How has it tried to bring about Utopia? What has been its relation to the irrational and the unconscious? How has it dealt with the great inherited themes of Romanticism, the sense of the world as a theatre of despair or religious exaltation? And what changes were forced on art by the example and pressure of mass media, which displaced painting and sculpture from their old centrality as public

speech? Obviously, these are only some of the themes of modern art. Equally obviously, neither eight chapters nor eight programmes can cover them fully. But to tackle themes rather than a formal, sequential history seemed the best way to present at least some of this vast subject in so limited a frame, and to give a fairly wide panorama of the relations of art to ideas and to life in the modernist century.

So I did not try to get everyone in, and there is a long roster of artists whose work is not discussed (and often not even mentioned) in *The Shock of the New*. Little attention has been paid to sculpture, beyond the work of Brancusi, Picasso, and some of the Constructivists: no Rodin, Rosso, or Moore, no Gonzales, Calder, Anthony Caro, Louise Nevelson, or David Smith. In painting, artists as diverse and important as Vuillard, Hans Hofmann, and Balthus are left out. I can only plead, in modest self-defence, that their omission was not the result of ignorance but of the insuperable difficulty of fitting them into the narrative frame. In any case, it seemed better to look at a few artists quite closely than to try for a generalized and speckly *tour d'horizon*; and if that is advisable with the written word, it is an iron law of television.

The eight chapters of this book follow the eight programmes of the series quite closely in theme and general structure, and though they are much longer than the scripts – about five times as long – all the same I decided to use the extra space to flesh out the discussion rather than to introduce more characters. Television does not lend itself to abstract argument or lengthy categorization. If the making of the series had one repeated phrase that still echoes in my head, it was not heard on the soundtrack; the inexorable voice of Lorna Pegram, the producer, muttering: "It's a clever argument, Bob dear, but what are we supposed to be *looking at?*"

What the Box can do is show things, and tell. The inaccurate image on the screen is not the real painting, and does not substitute for the real experience of art – any more than a reproduction on the printed page, an image inaccurately reassembled in terms of printer's dots rather than electronic lines, can do so. No matter; we are used to the conventions of print reproduction of works of art, and the same will happen with television as more arts programming is done. Besides, the great virtue of TV is its power to communicate enthusiasm, and that is why I like it. I am not a philosopher, but a journalist who has had the good luck never to be bored by his subject. *"Je resous de m'informer du pourquoi,"* Baudelaire wrote after seeing *Tannhäuser* in 1860, *"et de transformer ma volupté en connaissance"*: "I set out to discover the why of it, and to transform my pleasure into knowledge." Pleasure is the root of all critical appreciation of art, and there is nothing like a long, steady project to make one discover (and with luck, convey) what it was in the siren voices of our century that caught me as a boy – when I first read Roger Shattuck's translations of Apollinaire, hidden from the Jesuits in the wrapper of a Latin grammar – and has never let me go.

NOTE TO 1991 EDITION

Books have their fate, and this one has been lucky enough to last more than ten years – certainly a good deal longer than the television series on which it was based. In the

meantime, I have to confess, the enthusiasm for TV as a means of conveying information and opinion about the visual arts that I felt while making the original series of *The Shock of the New* has waned. Without accepting the extreme view of neo-conservative American critics like Hilton Kramer – that everything that can be shown or said about art on TV is a pernicious lie – I now realise that the optimistic hope I set forth above, that in some way the distortions of the artwork inherent in TV reproduction would cease to matter, as they largely have in print reproduction, has turned out to be wrong. The wish was father to the thought. By stressing the iconic content of art, by forcing images meant to be slowly contemplated into merely narrative frames, and thus imposing the fast time of TV on the slow time of painting and sculpture; by eliminating surface, texture, detail, and authentic colour, by working against the resistant physical presence and scale of the work of art, and above all by the brief attention-span it encourages, TV – even in the hands of the most sympathetic director – cannot construct a satisfactory parallel to the experience of the static artwork. This would not matter in a culture that did not confuse TV with reality. Unfortunately, America does. But the fuller truth about art is in museums, studios, galleries, and books, and cannot be fitted on the screen.

Nevertheless, my original gratitude to those with whom I worked on the original production of *The Shock of the New* remains unchanged: to Lorna Pegram, who produced the series and directed three of its eight programmes as well; to its other three directors, David Cheshire, Robin Lough, and David Richardson; and to Robert McNab, who did the picture and film research. The BBC insisted on *The Shock of the New* as the series title, and I remain grateful to my friend Ian Dunlop, whose excellent study of seven historic modernist exhibitions was published under that title in 1972, for letting us use it. Henry Grunwald and Ray Cave, successive managing editors at *Time*, were more than generous in putting up with my frequent, prolonged absences from the magazine when on location. And without Victoria Whistler, now Victoria Hughes, who sustained me through the final two years of production, neither series nor book would probably have been done at all.

THE MECHANICAL PARADISE

In 1913, the French writer Charles Péguy remarked that "the world has changed less since the time of Jesus Christ than it has in the last thirty years." He was speaking of all the conditions of Western capitalist society: its idea of itself, its sense of history, its beliefs, pieties, and modes of production – and its art. In Péguy's time, the time of our grandfathers and great-grandfathers, the visual arts had a kind of social importance they can no longer claim today, and they seemed to be in a state of utter convulsion. Did cultural turmoil predict social tumult? Many people thought so then; today we are not so sure, but that is because we live at the end of modernism, whereas they were alive at its beginning. Between 1880 and 1930, one of the supreme cultural experiments in the history of the world was enacted in Europe and America. After 1940 it was refined upon, developed here and exploited there, and finally turned into a kind of entropic, institutionalized parody of its old self. Many people think the modernist laboratory is now vacant. It has become less an arena for significant experiment and more like a period room in a museum, a historical space that we can enter, look at, but no longer be part of. In art, we are at the end of the modernist era, but this is not – as some critics apparently think – a matter for self-congratulation. What has our culture lost in 1980 that the *avant-garde* had in 1890? Ebullience, idealism, confidence, the belief that there was plenty of territory to explore, and above all the sense that art, in the most disinterested and noble way, could find the necessary metaphors by which a radically changing culture could be explained to its inhabitants.

For the French, and for Europeans in general, the great metaphor of this sense of change – its master-image, the one structure that seemed to gather all the meanings of modernity together – was the Eiffel Tower. The Tower was finished in 1889, as the focal point of the Paris World's Fair. The date of the Fair was symbolic. It was the centenary of the French Revolution. The holding of World's Fairs, those festivals of high machine-age capitalism in which nation after nation showed off its industrial strength and the breadth of its colonial resources, was not, of course, new. The fashion had been set by Victoria's Prince Albert, in the Great Exhibition of 1851. There, the greatest marvel on view had not been the Birmingham stoves, the reciprocating engines, the looms, the silverware, or even the Chinese exotica; it had been their

showplace itself, the Crystal Palace, with its vaults of glittering glass and nearly invisible iron tracery. One may perhaps mock the prose in which some of the Victorians recorded their wonder at this cathedral of the machine age, but their emotion was real.

The planners of the Paris World's Fair wanted something even more spectacular than the Crystal Palace. But Paxton's triumph could not be capped by another horizontal building, so they decided to go up: to build a tower that would be the tallest manmade object on earth, topping out – before the installation of its present-day radio and TV masts – at 1056 feet. No doubt a biblical suggestion was at work, consciously or not. Since the Fair would embrace all nations, its central metaphor should be the Tower of Babel. But the Tower embodied other and socially deeper metaphors. The theme of the Fair was manufacture and transformation, the dynamics of capital rather than simple ownership. It was meant to illustrate the triumph of the present over the past, the victory of industrial over landed wealth that represented the essential economic difference between the Third Republic and the *Ancien Régime*. What more brilliant centrepiece for it than a structure that turned its back on the ownership of land – that occupied unowned and previously useless space, the sky itself? In becoming a huge vertical extrusion of a tiny patch of the earth's surface, it would demonstrate the power of *process*. Anyone could buy land, but only *la France moderne* could undertake the conquest of the air.

The Fair's commissioners turned to an engineer, not an architect, to design the Tower. This decision was in itself symbolic, and it went against the prestige of Beaux-Arts architects as the official voice of the State; but Gustave Eiffel, who was fifty-seven and at the peak of his career when he took the job, managed to infuse his structure with what now seems to be a singular richness of meaning. Its remote inspiration was the human figure – the Tower imagined as a benevolent colossus, planted with spread legs in the middle of Paris. It also referred to the greatest permanent festive structure of the seventeenth century, Bernini's Fountain of the Four Rivers in the Piazza Navona in Rome, which (like the Tower) was a spike balanced over a void defined by four arches and (like the Fair itself) was an image of ecumenical domination of the four quarters of the world.

You could not escape the Tower. It was and is the one structure that can be seen from every point in the city. No metropolis in Europe had ever been so visually dominated by a single structure, except Rome by St. Peter's; and even today, Eiffel's spike is more generally visible in its own city than Michelangelo's dome. The Tower became the symbol of Paris overnight, and in doing so, it proclaimed *la ville lumière* to be the modernist capital – quite independently of anything else that might be written, composed, produced, or painted there. As such, it was praised by Guillaume Apollinaire, the cosmopolitan poet who had once been a Catholic and imagined, in a tone of mingled irony and delight, the Second Coming of Christ enacted in a new Paris whose centre was the Tower, at the edge of the coming millennium, the twentieth century:

At last you are tired of this old world.
O shepherd Eiffel Tower, the flock of bridges bleats this morning
You are through with living in Greek and Roman antiquity
Here, even the automobiles seem to be ancient
Only religion has remained brand new, religion
Has remained simple as simple as the aerodrome hangars
It's God who dies Friday and rises again on Sunday
It's Christ who climbs in the sky better than any aviator
He holds the world's altitude record
Pupil Christ of the eye
Twentieth pupil of the centuries he knows what he's about,
And the century, become a bird, climbs skywards like Jesus.

The important thing was that the Tower had a mass audience; millions of people, not the thousands who went to the salons and galleries to look at works of art, were touched by the feeling of a new age that the Eiffel Tower made concrete. It was the herald of a millennium, as the nineteenth century made ready to click over into the twentieth. And in its height, its structural daring, its then-radical use of industrial materials for the commemorative purposes of the State, it summed up what the ruling classes of Europe conceived the promise of technology to be: Faust's contract, the promise of unlimited power over the world and its wealth.

For the late nineteenth century, the cradle of modernism, did not feel the uncertainties about the machine that we do. No statistics on pollution, no prospect of melt-downs or core explosions lay on the horizon; and very few of the visitors to the World's Fair of 1889 had much experience of the mass squalor and voiceless suffering that William Blake had railed against and Friedrich Engels described. In the past the machine had been represented and caricatured as an ogre, a behemoth, or – due to the ready analogy between furnaces, steam, smoke, and Hell – as Satan himself. But by 1889 its "otherness" had waned, and the World's Fair audience tended to think of the machine as unqualifiedly good, strong, stupid, and obedient. They thought of it as a giant slave, an untiring steel Negro, controlled by Reason in a world of infinite resources. The machine meant the conquest of process, and only very exceptional sights, like a rocket launch, can give us anything resembling the emotion with which our ancestors in the 1880s contemplated heavy machinery: for them, the "romance" of technology seemed far more diffused and optimistic, acting publicly on a wider range of objects, than it is today. Perhaps this had happened because more and more people were living in a machine-formed environment: the city. The machine was a relatively fresh part of social experience in 1880, whereas in 1780 it had been exotic, and by 1980 it would be a cliché. The vast industrial growth of European cities was new. In 1850, Europe had still been overwhelmingly rural. Most Englishmen, Frenchmen, and Germans, let alone Italians, Poles, or Spaniards, lived in the country or in small villages. Forty years later the machine, with its imperative centralizing of process and product, had tipped the balance of population towards the towns. Baudelaire's *fourmillante cité* of alienated souls – "ant-swarming City, City full of

dreams/Where in broad day the spectre tugs your sleeve" – began to displace the pastoral images of nature whose last efflorescence was in the work of Monet and Renoir. The master-image of painting was no longer landscape but the metropolis. In the country, things grow; but the essence of manufacture, of the city, is process, and this could only be expressed by metaphors of linkage, relativity, interconnectedness.

These metaphors were not ready to hand. Science and technology had outstripped them, and the rate of change was so fast that it left art stranded, at least for a time, in its pastoral conventions. Perhaps no painting of a railway station, not even Monet's *Gare Saint-Lazare*, could possibly have the aesthetic brilliance and clarity of the great Victorian railroad stations themselves – Euston, St. Pancras, Penn Station, those true cathedrals of the nineteenth century. And certainly no painting of a conventional sort could deal with the new public experience of the late nineteenth century, fast travel in a machine on wheels. For the machine meant the conquest of horizontal space. It also meant a sense of that space which few people had experienced before – the succession and superimposition of views, the unfolding of landscape in flickering surfaces as one was carried swiftly past it, and an exaggerated feeling of relative motion (the poplars nearby seeming to move faster than the church spire across the field) due to parallax. The view from the train was not the view from the horse. It compressed more motifs into the same time. Conversely, it left less time in which to dwell on any one thing.

At first, only a few people could have this curiously altered experience of the visual world without taking a train: the crackpots and inventors with their home-made cars, and then the adventurous rich, veiled and goggled, chugging down the country lanes of Bellosguardo or Normandy. But because it promised to telescope more experience into the conventional frame of travel, and finally to burst the frame altogether, the *avant-garde* of engineering seemed to have something in common with the *avant-garde* of art.

As the most visible sign of the Future, the automobile entered art in a peculiarly clumsy way. The first public sculpture ever set up in its praise stands in a park at the Porte Maillot in Paris. It commemorates the great road race of 1895, from Paris to Bordeaux and back, which was won by an engineer named Émile Levassor in the car he designed and built himself, the Panhard-Levassor 5 – which could go at about the same speed as a jumping frog. Nevertheless, Levassor's victory was of great social consequence, and worth a memorial, since it persuaded Europeans – manufacturers and public alike – that the future of road transport lay with the internal combustion engine and not with its competitors, electricity or steam. In all justice there should be a replica of the Levassor Monument set up in every oil port from Bahrein to Houston. Yet it looks slightly absurd to us as sculpture today, suggesting the difficulties artists faced in transposing the new category of the machine into the conventions of traditional sculpture (plate 1).

It is a stone car – an idea that seems Surrealist to a modern eye, almost as wrong as a teacup made of fur. Marble is immobile, silent, mineral, brittle, white, cold. Cars are fast, noisy, metallic, elastic, warm. A human body is warm, too, but we do not think of statues as stone men because we are used to the conventions of depicting flesh with

1 Camille Lefebvre *Monument to Levassor, Porte Maillot, Paris* 1907
Marble relief after Jules Dalou 1838–1902 (photo Roger Viollet, Paris)

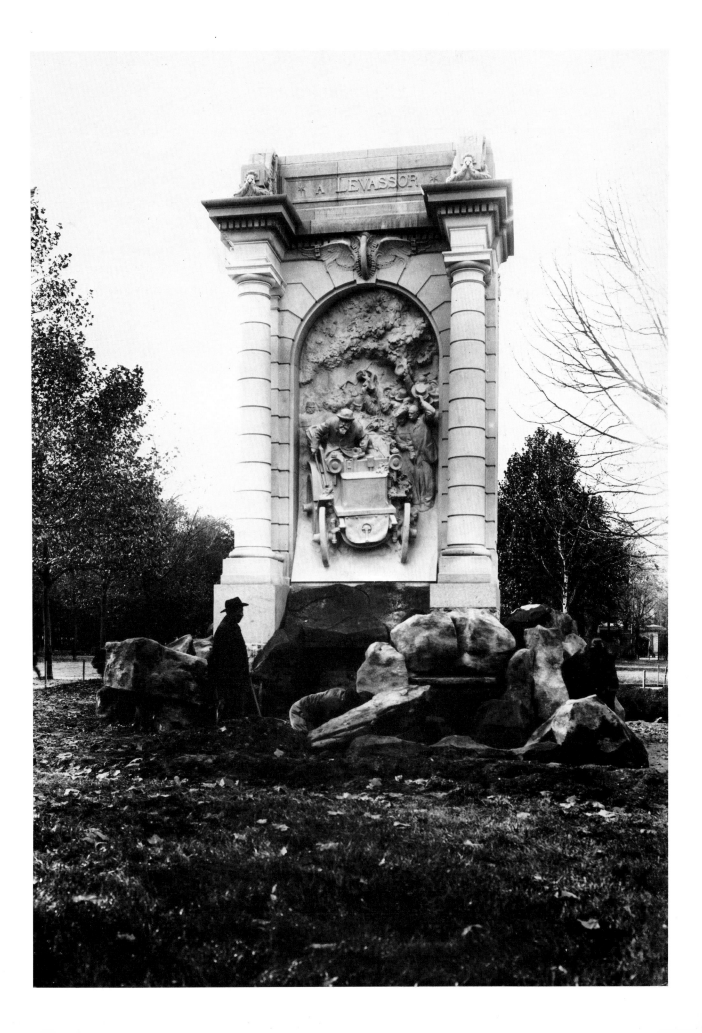

stone. (When these conventions are violated, as in the second act of *Don Giovanni* when the statue of the *Commendatore* comes alive, the effect is always spectral or comic.) The problem for Jules Dalou, who designed the Levassor Monument, was the lack of agreed conventions for depicting a headlamp or a steering wheel. Such motifs were too new, like the machine itself, so no exact representation of a car in stone could be as visually convincing as the car itself.

Yet the cultural conditions of seeing were starting to change, and the Eiffel Tower stood for that too. The most spectacular thing about it in the 1890s was not the view of the Tower from the ground. It was seeing the ground from the Tower. Until then, the highest manmade point from which Paris could be seen by the public was the gargoyle gallery of Notre Dame. Most people lived entirely at ground level, or within forty feet of it, the height of an ordinary apartment house. Nobody except a few intrepid balloonists had ever risen a thousand feet from the earth. Consequently, the bird's-eye view of nature or townscape was an extreme and rare curiosity, and when the photographer Nadar took his camera up in a balloon in 1856, his daguerreotypes were not only snapped up by the public but also commemorated, in a spirit of friendly irony, by Honoré Daumier. But when the Tower opened to the public in 1889, nearly a million people rode its lifts to the top platform; and there they saw what modern travellers take for granted every time they fly – the earth on which we live seen flat, as pattern, from above. As Paris turned its once invisible roofs and the now clear labyrinth of its alleys and streets towards the tourist's eye, becoming a map of itself, a new type of landscape began to seep into popular awareness. It was based on frontality and pattern, rather than on perspective recession and depth.

This way of seeing was one of the pivots in human consciousness. The sight of *Paris vu d'en haut*, absorbed by millions of people in the first twenty years of the Tower's life, was as significant in 1889 as the famous NASA photograph of the earth from the moon, floating like a green vulnerable bubble in the dark indifference of space, would be eighty years later. The characteristic flat, patterned space of modern art – Gauguin, Maurice Denis, Seurat – was already under development before the Tower was built. It was based on other art-historical sources: on the flatness of "primitive" Italian frescoes, on Japanese woodblock prints, on the coiling and distinct patterns of *cloisonné* enamel. When Gauguin's friend Maurice Denis wrote his manifesto *The Definition of Neo-Traditionalism* in the summer of 1890, it began with one of the canonical phrases of modernism: that "a picture – before being a warhorse, a nude woman, or some sort of anecdote – is essentially a surface covered with colours arranged in a certain order." Denis was invoking this principle in order to bring painting back to a kind of heraldic flatness, the flatness of banners and crusaders' tombslabs and the Bayeux Tapestry, in which his ambition to cover the new churches of France with Christian frescoes might prosper. The Eiffel Tower had nothing to do with his interests; but the idea of space that it provoked, a flatness that contained ideas of dynamism, movement, and the quality of abstraction inherent in structures and maps, was also the space in which a lot of the most advanced European art done between 1907 and 1920 would unfold.

The speed at which culture reinvented itself through technology in the last quarter of the nineteenth century and the first decades of the twentieth, seems almost preternatural. Thomas Alva Edison invented the phonograph, the most radical extension of cultural memory since the photograph, in 1877; two years later, he and J. W. Swan, working independently, developed the first incandescent filament light-bulbs, the technical sensation of the *Belle Époque*. The first twenty-five years of the life of the archetypal modern artist, Pablo Picasso – who was born in 1881 – witnessed the foundation of twentieth-century technology for peace and war alike: the recoil-operated machine gun (1882), the first synthetic fibre (1883), the Parsons steam turbine (1884), coated photographic paper (1885), the Tesla electric motor, the Kodak box camera and the Dunlop pneumatic tyre (1888), cordite (1889), the Diesel engine (1892), the Ford car (1893), the cinematograph and the gramophone disc (1894). In 1895, Roentgen discovered X-rays, Marconi invented radio telegraphy, the Lumière brothers developed the movie camera, the Russian Konstantin Tsiolkovsky first enunciated the principle of rocket drive, and Freud published his fundamental studies on hysteria. And so it went: the discovery of radium, the magnetic recording of sound, the first voice radio transmissions, the Wright brothers' first powered flight (1903), and the *annus mirabilis* of theoretical physics, 1905, in which Albert Einstein formulated the Special Theory of Relativity, the photon theory of light, and ushered in the nuclear age with the climactic formula of his law of mass-energy equivalence, $E = mc^2$. One did not need to be a scientist to sense the magnitude of such changes. They amounted to the greatest alteration in man's view of the universe since Isaac Newton.

The feeling that this was so was widespread. For the essence of the early modernist experience, between 1880 and 1914, was not the specific inventions – nobody was much affected by Einstein until Hiroshima; a prototype in a lab or an equation on a blackboard could not, as such, bear on the man in the street. But what did emerge from the growth of scientific and technical discovery, as the age of steam passed into the age of electricity, was the sense of an accelerated rate of change in all areas of human discourse, including art. From now on the rules would quaver, the fixed canons of knowledge fail, under the pressure of new experience and the demand for new forms to contain it. Without this heroic sense of cultural possibility, Arthur Rimbaud's injunction to be *absolument moderne* would have made no sense. With it, however, one could feel present at the end of one kind of history and the start of another, whose emblem was the Machine, many-armed and infinitely various, dancing like Shiva the creator in the midst of the longest continuous peace that European civilization would ever know.

In 1909, a French aviator named Louis Blériot flew the English Channel, from Calais to Dover. Brought back to Paris, his little wooden dragonfly of a plane was carried through the streets in triumph – like Cimabue's *Madonna*, Apollinaire remarked – and installed in a deconsecrated church, now part of the Musée des Arts et Métiers. It still hangs there, under the blue shafts of light from the stained-glass windows, slightly dilapidated, looking for all the world like the relic of an archangel. Such was the early apotheosis of the Machine. But the existence of a cult does not

mean that images appropriate to it automatically follow. The changes in capitalist man's view of himself and the world between 1880 and 1914 were so far-reaching that they produced as many problems for artists as they did stimuli. For instance: how could you make paintings that might reflect the immense shifts in consciousness that this altering technological landscape implied? How could you produce a parallel dynamism to the machine age without falling into the elementary trap of just becoming a machine illustrator? And above all: how, by shoving sticky stuff like paint around on the surface of a canvas, could you produce a convincing record of process and transformation?

The first artists to sketch an answer to all this were the Cubists.

Even today, seventy years after they were painted, the key Cubist paintings can be obscure. They seem hard to grasp; in some ways they are almost literally illegible. They do not present an immediately coherent view of life, in the way that Impressionism set forth its images of mid-bourgeois pleasure and boulevard manners. They have very little to do with nature; almost every Cubist painting is a still-life, and one in which manmade objects predominate over natural ones like flowers or fruit. Cubism as practised by its inventors and chief interpreters – Picasso, Braque, Léger, and Gris – does not woo the eye or the senses, and its theatre is a cramped brown room or the corner of a café. Beside the peacocks of the nineteenth century – the canvases of Delacroix or Renoir – their paintings look like owls. A pipe, a glass, a guitar; some yellowed newsprint, black on dirty white when it was glued on two generations ago, now the colour of a bad cigar, irrevocably altering the tonal balance of the piece. Nevertheless, Cubism was the first radically new proposition about the way we see that painting had made in almost five hundred years.

Since the Renaissance, almost all painting had obeyed a convention: that of one-point perspective. It was a geometrical system for depicting the illusion of reality, based on the fact that things seem to get smaller as they go further from one's eye. Once the construction for setting up a perspective scene is known, things can be represented on a flat sheet of paper as though they were in space, in their right sizes and positions. To fifteenth-century artists, perspective was the philosopher's stone of art; one can hardly exaggerate the excitement they felt in the face of its ability to conjure up a measurable, precise illusion of the world. In some perspective studies of Ideal Towns or Uccello's *mazzocchi*, this excitement almost becomes poetry, taking on the clarity and finality of a mathematical model. A few years ago, every art student knew the chestnut in Vasari's *Lives*, which told how Uccello would labour all night at these exercises and, when called to bed by his fretful wife, could only answer, *"O, che dolce cosa è questa prospettiva!"* ("How delightful perspective is!"). And in fact it was, since no more powerful tool for the ordering of visual experience in terms of illusion had ever been invented; indeed, perspective in the fifteenth century was sometimes seen not only as a branch of mathematics but as an almost magical process, having something of the surprise that our grandparents got from their Kodaks. Apply the method and the illusion unfolds; you press the button, we do the rest.

Nevertheless, there are conventions in perspective. It presupposes a certain way of

seeing things, and this way does not always accord with the way we actually see. Essentially, perspective is a form of abstraction. It simplifies the relationship between eye, brain, and object. It is an ideal view, imagined as being seen by a one-eyed, motionless person who is clearly detached from what he sees. It makes a god of the spectator, who becomes the person on whom the whole world converges, the Unmoved Onlooker. Perspective gathers the visual facts and stabilizes them; it makes of them a unified field. The eye is clearly distinct from that field, as the brain is separate from the world it contemplates.

Despite its apparent precision, perspective is a generalization about experience. It schematizes but does not really represent the way that we see. Look at an object: your eye is never still. It flickers, involuntarily restless, from side to side. Nor is your head still in relation to the object; every moment brings a fractional shift in its position, which results in a minuscule difference of aspect. The more you move, the bigger the shifts and differences become. If asked to, the brain can isolate a given view, frozen in time; but its experience of the world outside the eye is more like a mosaic than a perspective setup, a mosaic of multiple relationships, none of them (as far as vision is concerned) wholly fixed. Any sight is a sum of different glimpses. And so reality includes the painter's efforts to perceive it. Both the viewer and the view are part of the same field. Reality, in short, is interaction.

The idea that the looker affects the sight is taken for granted in most fields of scientific enquiry today, but one needs to be clear about what it does (and does not) mean. It does not mean that "everything is subjective anyway," so that no clear or truthful statements can be made. Nor does it mean that if I see a mouse under the chair I can will the creature out of existence as a mere construction of mind, a figment of imagination. In the real world, mice do exist and they generally go about their business whether we see them or not. It does mean, however, that my presence in the room may influence the mouse (as, on a more complex plane, the anthropologist's presence in the rain forest may alter the normal behaviour of the tribe whose patterns of action he is hoping to study). It will almost certainly not behave the same way when I am in the room as when I am not. It also means that my perception of the mouse will be affected, consciously in some degree, but mainly without my knowing it, by everything I have learned or experienced of mice up to now. Refined, this rudimentary model is a commonplace of particle physics and psychology. The eye and its objects inhabit the same plane, the same field, and they influence one another mutually and reciprocally. In the late nineteenth century, this was not generally thought to be true. The difference between, so to speak, the I and the It was strictly preserved, like the sovereign distance between the patriarch and his children. Nevertheless, towards 1900 as one sees the idea developing in its scientific form in the work of F. H. Bradley, Alfred North Whitehead, and Albert Einstein, so one artist, scientifically illiterate, ignorant of their work (as every Frenchman outside the scientific community was, and most inside it were), and living in seclusion in the South of France outside Aix-en-Provence, was labouring to explore it, give it aesthetic form, and finally to base his work on it. His name was Paul Cézanne.

A word of caution is due here. Great artists have many sides, and different ages – or even different cultures at the same moment – extract different things from them. As Lawrence Gowing has remarked, the relation between late Cézanne and Cubism is quite one-sided: he would not have imagined a Cubist painting, for his work "was reaching out for a kind of modernity that did not exist, and still does not." He would not have liked Cubist abstraction, that much is sure. For Cézanne's whole effort was directed towards the physical world – the shapes of Mont Ste-Victoire, of the tumbled inchoate rocks of the Bibémus quarry, of six dense red apples or his gardener's face. The idea of Cézanne as the father of abstract art is based on his remark that one must detect in Nature the sphere, the cone, and the cylinder. What he meant by that is anyone's guess, since there is not a single sphere, cone, or cylinder to be seen in Cézanne's work. What is there, especially in the work of the last decade and a half of his life – from 1890 onwards, after he finally abandoned Paris and settled in solitude in Aix – is a vast curiosity about the relativeness of seeing, coupled with an equally vast doubt that he or anyone else could approximate it in paint. In 1906, a few weeks before he died, he wrote to his son in Paris:

I must tell you that as a painter I am becoming more clear-sighted before Nature, but with me the realization of my sensations is always painful. I cannot attain the intensity that is unfolded before my senses. I do not have the magnificent richness of colouring that animates Nature. Here on the bank of the river the motifs multiply. . . .

These "motifs" were not merely rocks and grasses; they were the relationships between grass and rock, tree and shadow, leaf and cloud, which blossomed into an infinity of small but equally worthy and interesting truths each time the old man moved his easel or his head. This process of seeing, this adding up and weighing of choices, is what Cézanne's peculiar style makes concrete: the broken outlines, strokes of pencil laid side by side, are emblems of scrupulousness in the midst of a welter of doubt. Each painting or watercolour is about the motif. But it is also about something else – the process of seeing the motif (plate 2). No previous painter had taken his viewers through this process so frankly. In Titian or Rubens, it is the final form that matters, the triumphant illusion. But Cézanne takes you backstage; there are the ropes and pulleys, the wooden back of the Magic Mountain, and the theatre – as distinct from the single performance – becomes more comprehensible. The Renaissance admired an artist's certainty about what he saw. But with Cézanne, as the critic Barbara Rose remarked in another context, the statement: "This is what I see," becomes replaced by a question: "Is this what I see?" You share his hesitations about the position of a tree or a branch; or the final shape of Mont Ste-Victoire, and the trees in front of it (plate 3). Relativity is all. Doubt becomes part of the painting's subject. Indeed, the idea that doubt can be heroic, if it is locked into a structure as grand as that of the paintings of Cézanne's old age, is one of the keys to our century, a touchstone of modernity itself. Cubism would take it to an extreme.

The idea began in 1907, in a warren of cheap artists' studios known as the *"Bateau-Lavoir"* or "Laundry Boat," at 13 Rue Ravignan in Paris. It was touched off by a Spaniard, Pablo Picasso, then aged twenty-six. His partner in inventing Cubism was a

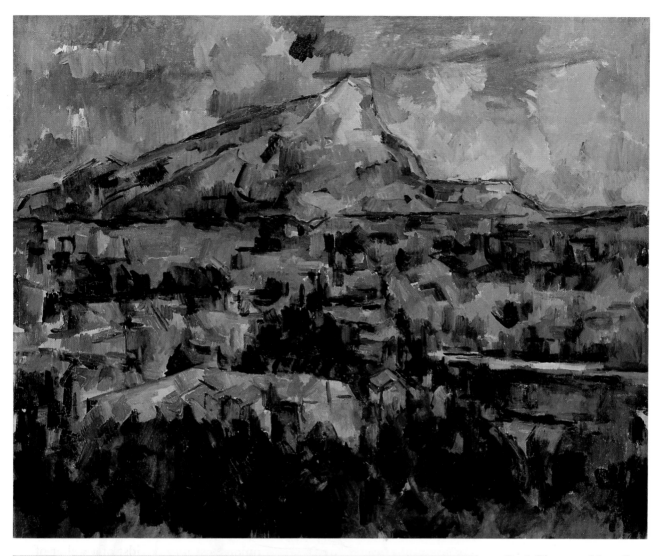

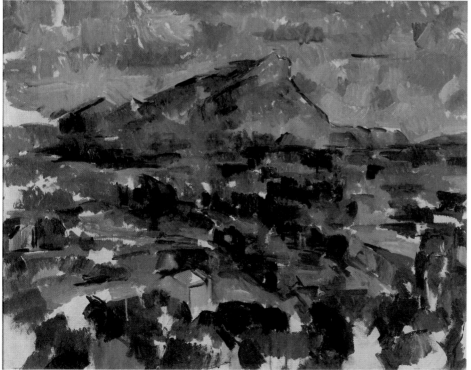

2 Paul Cézanne *Mont Ste-Victoire* 1904–6
Oil on canvas 29 × 36¼ ins
Philadelphia Museum of Art,
George W. Elkins Collection

3 Paul Cézanne *Mont Ste-Victoire* 1906
Oil on canvas 25 × 32½ ins
Kunsthaus, Zurich

younger and rather more conservative Frenchman, Georges Braque, the son of a housepainter in Normandy. Picasso already had a small reputation, based on the wistful, etiolated nudes, circus folk, and beggars he had been painting up to 1905 – the so-called Blue and Rose periods of his work. But he was so little known, and Braque so wholly unknown, that in the public eye neither artist existed. The audience for their work might have been a dozen people: other painters, mistresses, an obscure young German dealer named Daniel-Henry Kahnweiler, and one another. This might seem like a crushing isolation, but it meant that they were free, as researchers in some very obscure area of science are free. Nobody cared enough to interfere. Their work had no role as public speech, and so there was no public pressure on it to conform. This was fortunate, since they were engaged in a project which would presently seem, from the point of view of normal description, quite crazy. Picasso and Braque wanted to represent the fact that our knowledge of an object is made up of all possible views of it: top, sides, front, back. They wanted to compress this inspection, which takes time, into one moment – one synthesized view. They aimed to render that sense of multiplicity, which had been the subtext of Cézanne's late work, as the governing element of reality.

One of their experimental materials was the art of other cultures. With their appropriation of forms and motifs from African art, Picasso and then Braque brought to its climax a long interest which nineteenth-century France had shown in the exotic, the distant, and the primitive. The French colonial empire in Morocco had given the exotic images of Berber and soukh, dancing girl and war camel, lion-hunt and Riff warrior to the imagery of Romanticism, through Delacroix and his fellow Romantics. By 1900, technology in the form of the gunboat and the trading steamer had created another French empire in equatorial Africa, whose cultural artefacts were ritual carvings, to which the French assigned no importance whatsoever as art. They thought of them as curiosities, and as such they were an insignificant part of the flood of raw material that France was siphoning from Africa. Picasso thought they did matter – but as raw material. Both he and Braque owned African carvings, but they had no anthropological interest in them at all. They didn't care about their ritual uses, they knew nothing about their original tribal meanings (which assigned art a very different function to any use it could have in Paris), or about the societies from which the masks came. Probably (although the art historian piously hopes it was otherwise) their idea of African tribal societies was not far from the one most Frenchmen had – jungle drums, bones in the noses, missionary stew. In this respect, Cubism was like a dainty parody of the imperial model. The African carvings were an exploitable resource, like copper or palm-oil, and Picasso's use of them was a kind of cultural plunder.

But then, why use African art at all? The Cubists were just about the first artists to think of doing so. One hundred and thirty years before, when Benjamin West admired the tapa cloths, war-clubs, and canoe carvings that had come back from the Pacific with Captain Cook and Joseph Banks – relics of a new world that had the strangeness of moon rocks – no Royal Academicians took the cue and started painting Tahitian-

style or Maori-fashion. To depict the monuments of Easter Island, as William Hodges did, was one thing; to imitate their style, quite another. Yet this was what Picasso did with his African prototypes, around 1906–8. When he began to parody black art, he was stating what no eighteenth-century artist would ever have imagined suggesting: that the tradition of the human figure, which had been the very spine of Western art for two and a half millennia, had at last run out; and that in order to renew its vitality, one had to look to untapped cultural resources – the Africans, remote in their otherness. But if one compares a work like Picasso's *Les Demoiselles d'Avignon*, 1907, with its African source material (plates 4, 5), the differences are as striking as the similarities. What Picasso cared about was the formal vitality of African art, which was for him inseparably involved with its apparent freedom to distort. That the alterations of the human face and body represented by such figures were not Expressionist distortions, but conventional forms, was perhaps less clear (or at least less interesting) to him than to us. They seemed violent, and they offered themselves as a receptacle for his own *panache*. So the work of Picasso's so-called "Negro Period" has none of the aloofness, the reserved containment, of its African prototype; its lashing rhythms remind us that Picasso looked to his masks as emblems of savagery, of violence transferred into the sphere of culture.

With its hacked contours, staring interrogatory eyes, and general feeling of instability, *Les Demoiselles* is still a disturbing painting after three quarters of a century, a refutation of the idea that the surprise of art, like the surprise of fashion, must necessarily wear off. No painting ever looked more convulsive. None signalled a faster change in the history of art. Yet it was anchored in tradition, and its attack on the eye would never have been so startling if its format had not been that of the classical nude; the three figures at the left are a distant but unmistakable echo of that favourite image of the late Renaissance, the Three Graces. Picasso began it the year Cézanne died, 1906, and its nearest ancestor seems to have been Cézanne's monumental composition of bathers displaying their blockish, angular bodies beneath arching trees (plate 7). Its other line of descent is Picasso's Spanish heritage. The bodies of the two caryatid-like standing nudes, and to a lesser degree their neighbour on the right, twist like El Greco's figures. And the angular, harshly lit blue space between them closely resembles the drapery in El Greco's Dumbarton Oaks *Visitation*.

That Picasso could give empty space the same kind of distortion a sixteenth-century artist reserved for cloth with a body inside it points to the newness of *Les Demoiselles*. What is solid, and what void? What is opaque, and what transparent? The questions that perspective and modelling were meant to answer are precisely the ones Picasso begs, or rather shoves aside, in this remarkable painting. Instead of solids (nude and fruit) in front of a membrane (the curtain) bathed in emptiness and light, Picasso conceived *Les Demoiselles* as though it were made of a continuous substance, a sort of plasma, thick and intrusive. If the painting has any air in it at all, it comes from the colours – the pinks and blues that survive from the wistful *misérablisme* of his earlier work, lending *Les Demoiselles* a peculiarly ironic air: whatever else these five women may be, they are not victims or clowns.

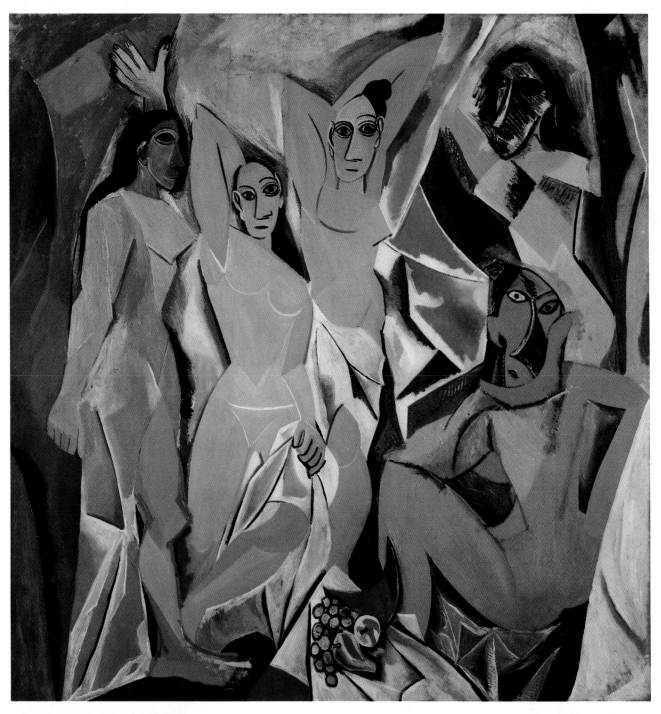

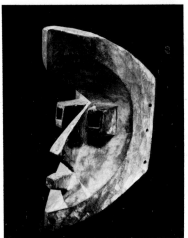

4 Pablo Picasso *Les Demoiselles d'Avignon* Paris (begun May, reworked July 1907)
Oil on canvas 96 × 92 ins: Collection, The Museum of Modern Art,
New York, Acquired through the Lillie P. Bliss Bequest

5 *Gabon Mahongwe Mask*
Wood and pigments 14 × 6 ins
Brooklyn Museum, Frank L. Babbott Fund

7 Paul Cézanne *Les Grandes Baigneuses I* 1894–1905
Oil on canvas 60 × 75½ ins: National Gallery, London

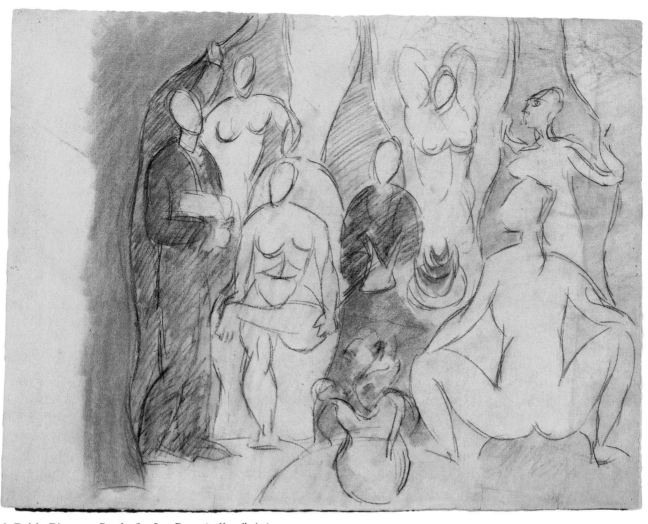

6 Pablo Picasso *Study for Les Demoiselles d'Avignon* 1907
Crayon drawing $18\frac{3}{4} \times 30$ ins: Kupferstichkabinett,
Kunstmuseum, Basle (photo Hans Hinz)

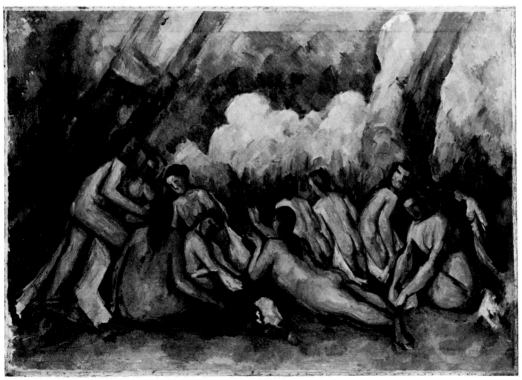

They were, as every art student knows, whores. Picasso did not name the painting himself, and he never liked its final title. He wanted to call it *The Avignon Brothel*, after a whorehouse on the Carrer d'Avinyo in Barcelona he had visited in his student days. The painting was originally meant to be an allegory of venereal disease, entitled *The Wages of Sin*, and in one of the original studies for it (plate 6), the narrative is quite clear: at the centre, a sailor carousing in a brothel, and on the left, another man, a medical student, whom Picasso represented in other studies with a self-portrait, entering with a skull, that very Spanish reminder of mortality. *Vanitas vanitatum, omnia vanitas sunt.*

In the final painting, however, only the nudes are left. Their formal aspect was a favourite of 1890s' painting, memorably captured by Degas and Toulouse-Lautrec; it is the *parade*, the moment when the prostitutes of the house display themselves to the client and he picks one.

By leaving out the client, Picasso turns viewer into *voyeur*; the stares of the five girls are concentrated on whoever is looking at the painting. And by putting the viewer in the client's sofa, Picasso transmits, with overwhelming force, the sexual anxiety which is the real subject of *Les Demoiselles*. The gaze of the women is interrogatory, or indifferent, or as remote as stone (the three faces on the left were, in fact, derived from archaic Iberian stone heads that Picasso had seen in the Louvre). Nothing about their expressions could be construed as welcoming, let alone coquettish. They are more like judges than houris. And so *Les Demoiselles* announces one of the recurrent subthemes of Picasso's art: a fear, amounting to holy terror, of women. This fear was the psychic reality behind the image of Picasso the walking scrotum, the inexhaustible old stud of the Côte d'Azur, that was so devoutly cultivated by the press and his court from 1945 on. No painter ever put his anxiety about impotence and castration more plainly than Picasso did in *Les Demoiselles*, or projected it through a more violent dislocation of form. Even the melon, that sweet and pulpy fruit, looks like a weapon.

This combination of form and subject alarmed the few people who saw *Les Demoiselles*. Georges Braque was horrified by its ugliness and intensity – Picasso, he said, had been "drinking turpentine and spitting fire," more like a carny performer than an artist – but in 1908 he painted a rather timid and laborious response to it. In Braque's *Grand Nu* (plate 8), the brusque palm-frond hatching of Picasso's faces is much softened; but from then on, Braque and Picasso would be locked in a partnership of questions and responses, "roped together like mountaineers," as Braque memorably said. It was one of the great partnerships in the history of art: Picasso's impetuous anxiety and astonishing power to realize sensation on canvas, married off to Braque's sense of order, *mesure*, and visual propriety. Some ideas are too fundamental, and contain too great a cultural loading, to be the invention of one man. So it was with Cubism.

Picasso cleared the ground for Cubism, but it was Braque who did most to develop its vocabulary over the next two years, 1908–9. The fox, as Isaiah Berlin has said, knows many things, but the hedgehog knows one big thing. Picasso was the fox, the virtuoso. Braque was the hedgehog, and the one big thing he knew was Cézanne, with

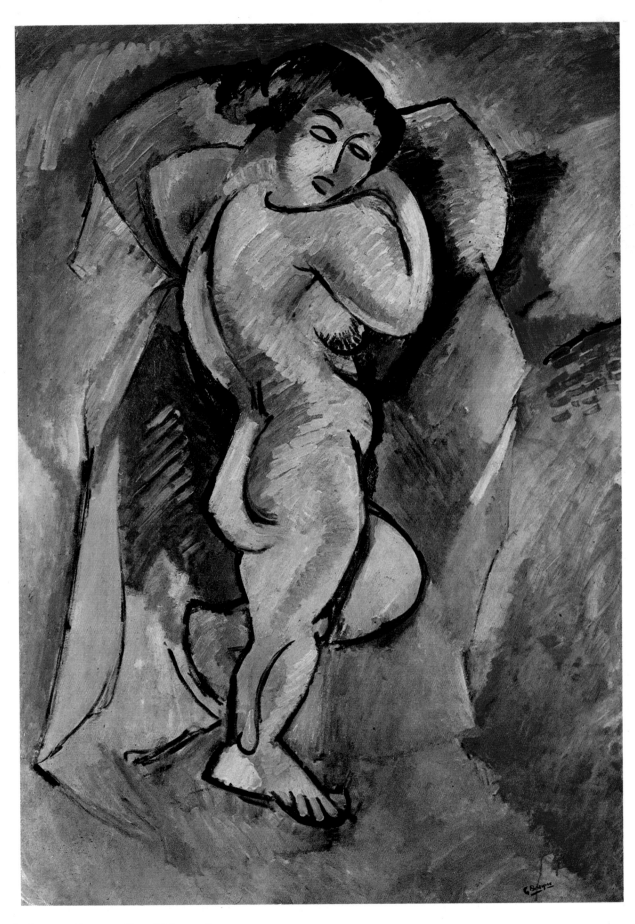

8 Georges Braque *Grand Nu* 1908

Oil on canvas $55\frac{1}{4} \times 39$ ins
Private Collection, Paris

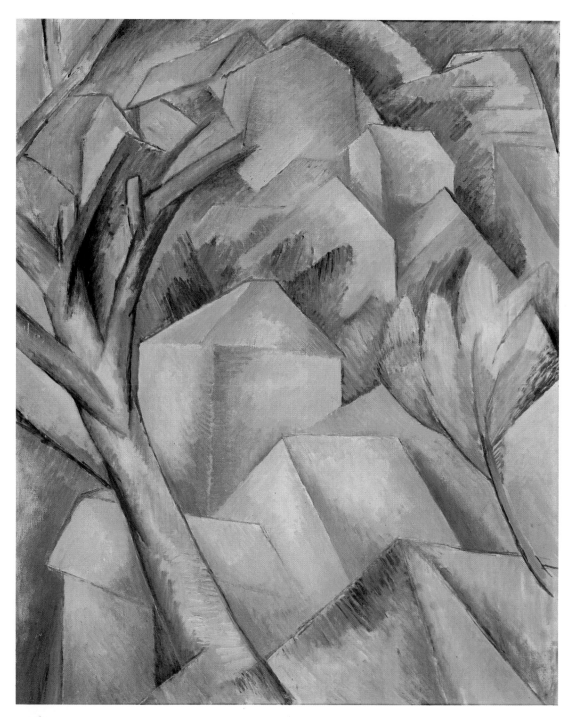

9 Georges Braque *Houses at L'Estaque* 1908
Oil on canvas $28\frac{1}{2} \times 23$ ins Kunstmuseum, Berne,
Hermann and Margrit Rupf Foundation

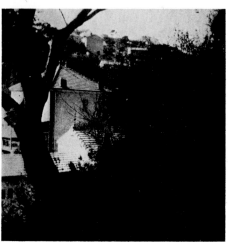

10 D. H. Kahnweiler *Photograph of Houses at L'Estaque* 1909

whom he identified almost to the point of obsession. He admired Cézanne, as he put it, for "sweeping painting clear of the idea of mastery." He loved Cézanne's doubt, his doggedness, his concentration on the truth of the motif, and his lack of eloquence. These, he knew, were expressed in the very structure of Cézanne's paintings, with its accumulated fusing of little tilted facets. And so he wanted to see if that solidity of construction and ambiguity of reading could be pushed further while a painter remained in the actual presence of his motif; Braque was not yet interested in the abstractions of the studio, and he felt a need to be on the spot. Specifically, he needed Cézanne's own motifs, and in the summer of 1908 he went off to paint in L'Estaque, in the South of France, where Cézanne had worked. His work there began as almost straight Cézanne. How it developed can best be seen by comparing a slightly later Estaque painting with a photo of the view Braque was painting: a country house seen over a bushy slope, with a tree sloping away to the left (plates 9, 10). Braque turned this simple motif into a curious play of ambiguities. Every scrap of detail is edited out of the view. One is left with an arrangement of prisms and triangles, child's-block houses, the scale of which is hard to judge: relative size was one of the first casualties of the Cubist war against perspective. Despite the bush on the right, whose branches have taken on a sprightly, emblematic quality like palm-fronds, the rest of the landscape is static, almost mineralized. In his wish to see behind the tree on the left, Braque abolished its foliage and brought into view more houses, whose planes connect into the branches and trunk of the tree, immovably locking foreground and background in the top left quarter of the painting together. Yet the houses give no feeling of solidity; their shading is eccentric, and some of their corners – notably the one of the large house at the centre of the composition, closest to the eye – could be either sticking out of the canvas or pointing back into it. The Cubist "look," of forms stacked up the canvas in a pile, as though the ground had rotated through 90 degrees to greet one's eye, was now fully fixed in Braque's work.

The second place to which Braque followed Cézanne was the village of La Roche-Guyon, in the Seine Valley some miles outside Paris. By coincidence or design, it gave him a landscape that embodied, ready-made in nature, the frontality towards which his art was moving. The valley in which La Roche-Guyon stands is lined with tall chalk cliffs, greyish-white and sown with flints. The town is built between the river and the cliffs, and its main building is a sixteenth-century castle – the *château* of the de la Rochefoucauld family. This castle is built up against the chalk cliff, and Braque made it his motif: that jumble of conical spires and triangular gables, vertically stacked. On top, there is a thirteenth-century Norman tower – the *roche* itself, a ruin in 1909, still deserted today, capping the view with a big strong cylinder. Braque first painted it from what is now the parking lot of the village hotel (plate 11). The face of the cliff blocked the perspective; the shapes of the castle ascended the hill already flattened, as it were, against the canvas. He then scrambled up the chalk bluff to the side and looked at the castle from an angle that gave him an even more complicated geometry of gables and turrets, cascading musically down into the valley (plate 12).

So could Braque have invented Cubism on his own? Quite possibly; but it would

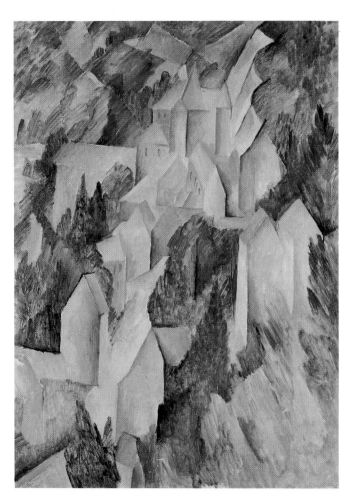

11 Georges Braque *Château de La Roche-Guyon* 1909
Oil on canvas $31\frac{1}{2} \times 23\frac{1}{2}$ ins
Moderna Museet, Stockholm

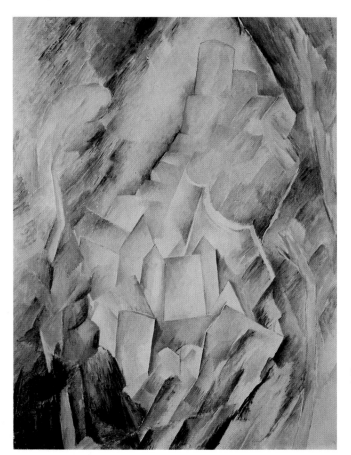

12 Georges Braque *La Roche-Guyon* 1909
Oil on canvas $36 \times 28\frac{1}{2}$ ins
Van Abbemuseum, Eindhoven

have lacked the power and tension that Picasso brought to it. For Picasso, more than any other painter of the twentieth century – and certainly more than the conceptually inclined Braque – predicated his art on physical sensation. He had an unequalled ability to realize form: to make you feel the shape, the weight, the edginess, the silence of things. This is clear from his handling of a motif similar to Braque's paintings at La Roche-Guyon. In 1909, Picasso went painting in northern Spain, in the village of Horta de Ebro. His canvas of *The Factory, Horta de Ebro*, 1909 (plate 13), has the grey impacted solidity of a galena crystal, and despite the irrationality of the shading – for the treatment of the buildings is very similar to Braque's house at Estaque – one feels that the whole image could almost be picked, like sculpture, off the canvas, including the hills in the distance behind the palm trees. And indeed, within a few years Picasso would be turning this predilection into real sculpture, so commencing a parallel career as the most succinctly inventive sculptor of the twentieth century. His Cubist constructions of around 1912, such as the metal *Guitar* (plate 51), attest to Picasso's extraordinary gift for thinking laterally, beyond the given categories. For the first time in the history of art, sculpture is conceived not as a solid mass (modelled clay, cast bronze, carved stone or wood), but as an open construction of planes. It is doubtful whether any single sculpture has ever had, by such deceptively humble means, a comparable effect on the course of its own medium. This rusty tin guitar is the point from which Russian Constructivism, via Tatlin, begins its course; in the West, it initiates a tradition which runs to David Smith and Anthony Caro, that of assembled, welded metal sculpture.

But in the meantime, the paintings of Braque and Picasso were moving rapidly towards abstraction – or rather, to that point where only enough signs of the real world remained to supply a tension between the reality outside the painting and the complicated meditations on visual language within the frame. As this happened, their styles moved together and became, at least to the casual eye, almost indistinguishable. (It goes without saying that close looking dispels this: there is a great deal of difference between the open, almost impressionistic brushmarks and gentle shading of Braque and Picasso's tighter, harsher *facture*, jagged and compressed.) By 1911 they were painting like Siamese twins, as a comparison of two images of guitarists, Braque's *The Portuguese* and Picasso's *"Ma Jolie,"* will show (plates 15, 14). There is no way of reassembling a view from these paintings. Solid, apprehensible reality has vanished. They are metaphors of relativity and connection; in them, the world is imagined as a network of fleeting events, a twitching skin of nuances. Fragments of lettering (BAL, MA JOLIE, a bar bill reading 10.40, a musical clef) and clues to real things (the strings and sound-hole of the guitar in Braque's *Portuguese*) materialize briefly in this flux, the way the backs of carp seen in a brown pond, flicking away from the surface, shimmer in the water. This stage of Cubism had something in common with the molecular view of the world that found its grandest modern realization in Seurat's *Grande Jatte* and Monet's waterlilies. But neither Picasso nor Braque was interested, as Monet supremely was, in the effects of light. Their paintings of 1911 have very little air in them, and the continuous vibration and twinkling of brush-strokes against the

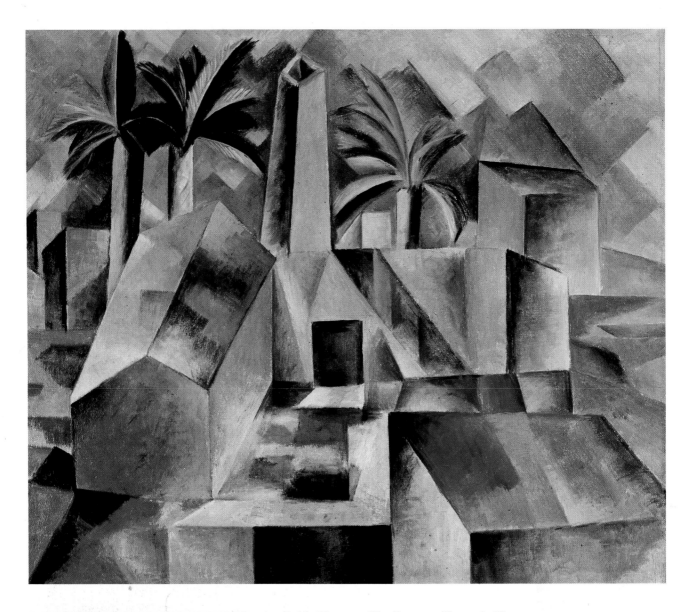

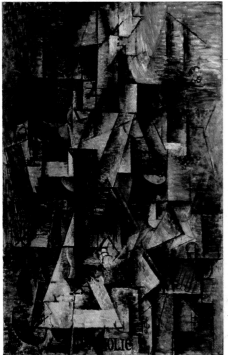

13 Pablo Picasso *The Factory, Horta de Ebro* 1909
Oil on canvas $20\frac{3}{4} \times 23\frac{1}{2}$ ins
Hermitage, Leningrad (photo Giraudon)

14 Pablo Picasso *"Ma Jolie"* Paris (winter 1911–12)
Oil on canvas $39\frac{3}{8} \times 25\frac{3}{4}$ ins
Collection, The Museum of Modern Art, New York,
Acquired through the Lillie P. Bliss Bequest

15 Georges Braque *The Portuguese* 1911
Oil on canvas $46\frac{1}{4} \times 32\frac{1}{4}$ ins
Kunstmuseum, Basle (photo Giraudon)

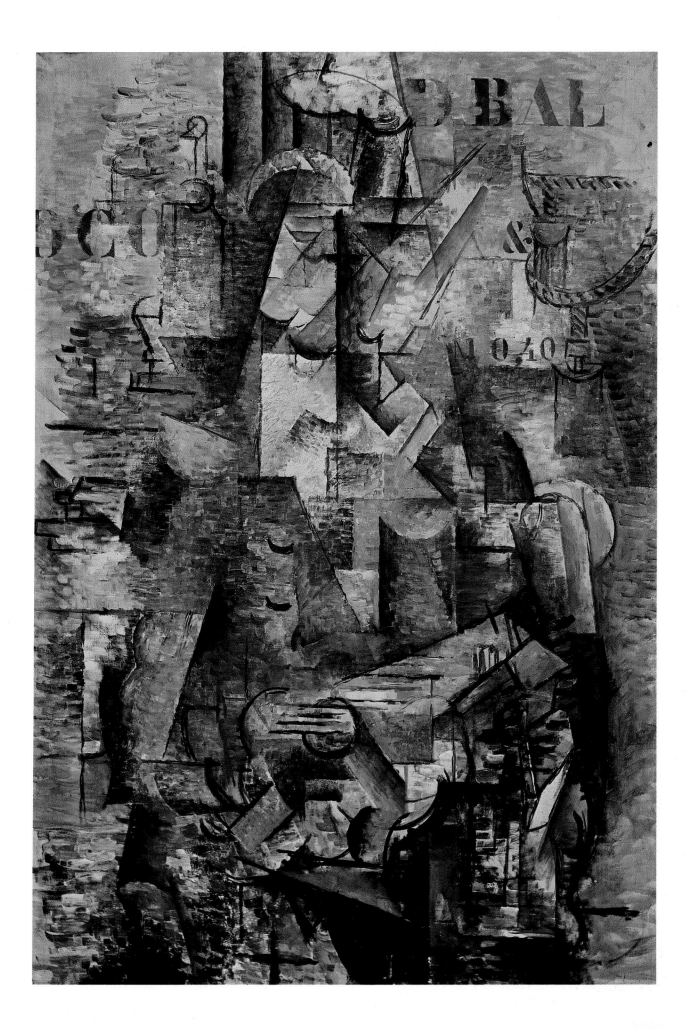

discontinuous geometry of their structure is set forth, not as light, but as a property of matter – that plasma, the colour of guitar backs, zinc bars, and smokers' fingers, of which the Cubist world was composed.

No painter had ever produced more baffling images. As description of a fixed form, they are useless. But as a report on multiple meanings, on process, they are exquisite and inexhaustible: the world is set forth as a field of shifting relationships that includes the onlooker. Braque and Picasso were not mathematicians. There is nothing Euclidean about the "geometry" that underlies these works of 1911; to the extent that their broken lines and altering angles are geometrical at all, they represent a geometry of allusion, incompletion, and frustration. Still less were they philosophers. But to study works like Braque's *Soda*, 1911 (plate 16), is to sense that they, in the sphere of painting, are part of that great tide of modernist thought which included Einstein and the philosopher Alfred North Whitehead. "The misconception which has haunted philosophic literature throughout the centuries," Whitehead wrote, "is the notion of independent existence. There is no such mode of existence. Every entity is only to be understood in terms of the way in which it is interwoven with the rest of the universe." One would be surprised to learn that either Braque or Picasso had read these lines; nevertheless, they are a useful subtext to this phase of Cubism.

Painting could not have gone much further in this direction without shedding all clues to the real world. This, neither Braque nor Picasso wanted to do. "I paint forms as I think them, not as I see them," Picasso once remarked, but he strenuously denied that he had ever painted an abstract picture in his life; the demands of sensuous reality were always too strong. So the next stage of Cubism recoiled from the abstractness of those paintings of 1911. Braque had already begun to stress the material density of his paintings with "ordinary," non-art materials, mixed with the paint to produce a gritty, sandpapery surface – sand, sawdust, or iron filings. Characteristically, Picasso pushed this to an extreme by taking an identifiable slice of the real world, a piece of oilcloth printed with a design of caning and meant to cover a café table, and sticking it in one of his still-lives (plate 17). And so collage – "glueing" – was born. The idea of making a picture by cutting and pasting was not new. It had existed in folk art throughout the nineteenth century, and many middle-class nurseries had their decorative screens covered in cherubs, animals, flowers, and the like, cut from patterns and magazines. Picasso's originality lay in introducing collage techniques into an easel painting. If he had used real chair-caning, the effect might not have been so startling. By using a printed image of caning, Picasso was placing a product of mass manufacture in the midst of its traditional opposite, the hand-made object. Real chair-caning was at least a craft product, and came from the same order of things as a painting. But the oilcloth in this still-life of 1912 opened art to the industrial present in a quite unprecedented way.

In linking Cubism back to the real world that it had almost quit in 1911, collage gave Picasso and Braque bolder and clearer shapes to play with; and these things were emblems of modernity based on industrial mass production – newsprint, product packaging, department store wallpaper, and so forth. Occasionally they were mildly

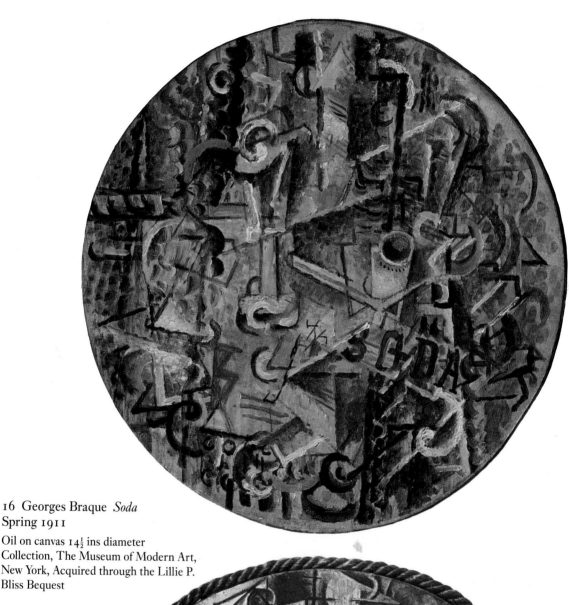

16 Georges Braque *Soda*
Spring 1911

Oil on canvas 14½ ins diameter
Collection, The Museum of Modern Art,
New York, Acquired through the Lillie P.
Bliss Bequest

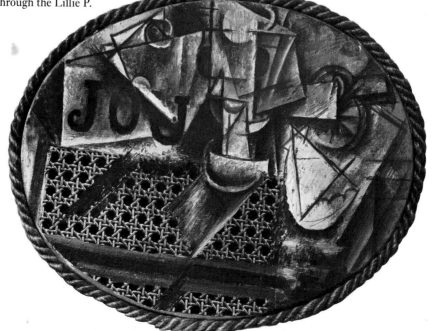

17 Pablo Picasso *Still Life with Chair Caning* 1912
Collage 10½ × 13¾ ins
Musée Picasso, Paris (photo Giraudon)

ironic allusions to a craft past that had been rendered less accessible by mechanization and the growing cost of labour: Braque, who had been a housepainter's apprentice in Normandy, thus "quoted" the techniques of painting fake woodgrain and imitation marble in his own paintings. Their paintings and collages now assumed a broader, more cogent, almost classical air; and in this they were joined by Juan Gris, in whom Cubism found its Piero della Francesca – a mind of the coolest analytical temper. Gris did not like to use found objects. They were too chancy for him; they could not possibly have the deductive finality of a painted shape, whose exact profile, hue, and tone had been arrived at through long reflection. Nevertheless, he saw the world of cheap production and mass production as a sort of Arcadia, a pastoral landscape that could be contained on the top of a studio table. A painting like *Still-Life (Fantomas)*, 1915 (plate 18), is a veritable anthology of his predilections: the calm shifts between opacity and transparency in the overlapping planes, the catalogue of *peintre-décorateur* effects – woodgrain, wallpaper dado, fake marble; the newspaper, the pipe, and the paperback thriller. With Gris's desire to extract a measured poetry from ordinary modern things, one is again in the world of Apollinaire's *Zone*:

> You read handbills, catalogues, posters that shout out loud:
> Here's this morning's poetry, and for prose you've got the newspapers,
> Sixpenny detective novels full of cop stories,
> Biographies of big shots, a thousand different titles,
> Lettering on billboards and walls,
> Doorplates and posters squawk like parrots.

Cubist Paris is receding today. It died even faster than Matisse's Côte d'Azur, buried under high rises and drugstores, bulldozed flat to make way for Beaubourg and the Halles developments, the victim of sixties chic and the relentless kitsch-modernism of *le style Pompidou*. It is still there, only in pockets: the glass and iron city of small arcades, the marble city of café tables, the place of zinc bars, dominoes, dirty chessboards, and crumpled newspaper; the brown city of old paint and pipes and panelling; history to us now, but once the landscape of the modernist dream. It was an inward city, whose main product was reverie. Only one major Cubist wanted to make a public style of his work. He was Fernand Léger (1881–1955), and his work was a sustained confession of modernist hope. Léger believed, as one cannot imagine Braque doing, that he could make images of the machine age that would cut across the barriers of class and education – a didactic art for the man in the street, not highly refined, but clear, definite, pragmatic, and rooted in everyday experience.

Léger was the son of a Normandy farmer, an instinctive socialist who became a practising one in the trenches of World War I.

I found myself [he wrote of his military service] on a level with the whole of the French people; my new companions in the Engineer Corps were miners, navvies, workers in metal and wood. Among them I discovered the French people . . . their exact sense of useful realities, and of their timely application in the middle of the life-and-death drama into which we had been plunged. More than that: I found them poets, inventors of everyday poetic images – I am

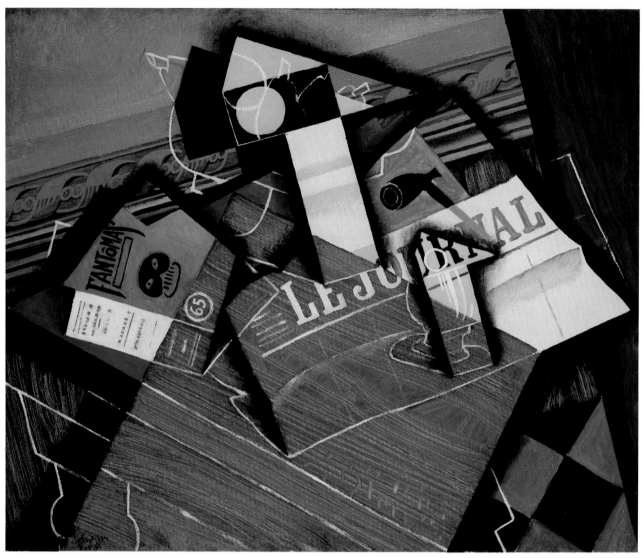

18 Juan Gris *Fantomas* 1915
Oil on canvas $23\frac{1}{2} \times 28\frac{1}{4}$ ins
National Gallery of Art, Washington DC, Chester Dale Fund

thinking of their colourful and adaptable use of slang. Once I had got my teeth into that sort of reality, I never let go of objects again.

He painted his fellow soldiers, in *The Cardplayers*, 1917 (plate 19), as though they were automata, made from tubes, barrels, and linkages; the forms of mechanized warfare – Léger confessed that his great visual epiphany in the trenches had been "the breech of a 75-millimetre gun in the sunlight, the magic of light on white metal" – are applied to the human body, and even the insignia and medals on these robots might as well be factory brands. It may all look more austere to us than it was meant to. What interested Léger about the machine was not its inhumanity – he was not a Kafka or a Fritz Lang – but its adaptability to systems, and this is the underlying theme of his grandest social image, *Three Women*, 1921 (plate 20). With its geometrically simplified bodies and furniture, as deliberate as an Alexandrine, it is one of the supreme didactic paintings of French classicism, embodying an idea of society-as-machine, bringing harmony and an end to loneliness. This philosophical harem, though dealing with a subject not unlike that of Picasso's *Demoiselles*, is far from it in spirit. Instead of Picasso's fragmented vision of *les belles dames sans merci*, we are offered a metaphor of human relationships working as smoothly as a clock, all passion sublimated, with the binding energy of desire transformed into rhymes of shape.

There were some artists to whom this mechanical age was more than a context, and very much more than a pretext. They wanted to explore its characteristic images of light, structure, and dynamism as subjects in their work. The most gifted of them in the *École de Paris*, and still the least appreciated today, was Robert Delaunay (1885–1941). For him, the master-image of culture was the Eiffel Tower, which he viewed with real ecstasy as an ecumenical object, the social condenser of a new age. He was not the only one to think so. The first regular radio broadcast system had been installed on the Tower in 1909 – "*La tour à l'Univers s'adresse*," Delaunay noted on his first study of it, dedicated to his wife and fellow painter Sonia Terk, in that year – and something of the spirit of Delaunay's renderings of the structure finds its way into Vincente Huidobro's *Eiffel Tower*, written in 1917 and dedicated to Delaunay:

> Eiffel Tower
> Guitar of the sky
>
> > Your wireless telegraphy
> > Draws words to you
> > As a rose-arbour draws bees
>
> In the night the Seine
> No longer flows
>
> > Telescope or bugle
> > Eiffel Tower
>
> And a beehive of words
> Or the night's inkwell
>
> At the dawn's base
> A spider with wire feet
> Spins its web with clouds

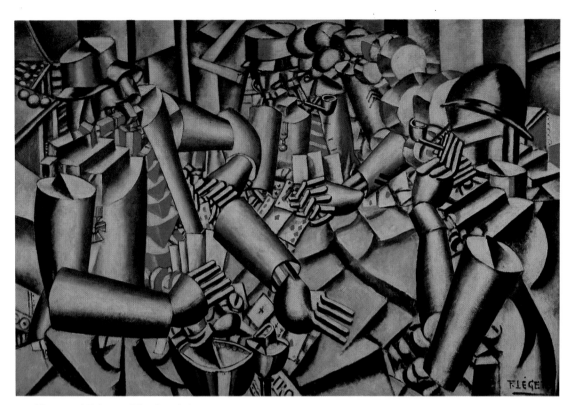

19 Fernand Léger *The Cardplayers* 1917
Oil on canvas $50\frac{1}{2} \times 76$ ins
Kröller-Müller Museum, Otterlo

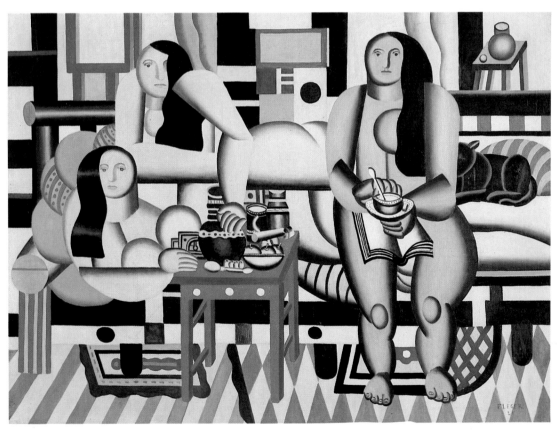

20 Fernand Léger *Three Women (Le Grand Déjeuner)* 1921
Oil on canvas $72\frac{1}{4} \times 99$ ins: Collection, The Museum of Modern Art,
New York, Mrs. Simon Guggenheim Fund


 Do
 re
 mi
 fa
 sol
 la
 ti
 do


 We are high up:
 A bird calls
 In the antennae
 Of the wireless

 It is the wind
 The wind from Europe
 The electric wind

Something of his spirit; but not all. For Delaunay avoided the pastoral imagery that colours Huidobro's lines: the rose-arbour, the beehive, the bird in the thicket of antennae. He wanted a pictorial speech that was entirely of this century, based on rapid interconnection, changing viewpoints, and an adoration of "good" technology, and the Tower was the supreme practical example of this in the daily life of Paris. His friend and collaborator, the poet Blaise Cendrars, remarked in 1924 that

No formula of art known up to now can pretend to give plastic resolution to the Eiffel Tower. Realism shrank it; the old laws of Italian perspective diminished it. The Tower rose over Paris, slender as a hatpin. When we retreated from it, it dominated Paris, stark and perpendicular. When we came close, it tilted and leaned over us. Seen from the first platform it corkscrewed around its own axis, and seen from the top it collapsed into itself, doing the splits, its neck pulled in. . . .

Delaunay must have painted the Tower thirty times, and he was almost the only artist to paint it at all – although it makes a modest appearance in an oil sketch by Seurat, and crops up now and again in the backgrounds of the Douanier Rousseau. *The Red Tower*, 1911–12 (plate 21), shows how fully Delaunay could realize the sensations of vertigo and visual shuttling that Cendrars described. The Tower is seen, almost literally, as a prophet of the future – its red figure, so reminiscent of a man, ramping among the silvery lead roofs of Paris and the distant puffballs of cloud. That vast grid rising over Paris with the sky reeling through it became his fundamental image of modernity: light seen through structure.

Delaunay extended this image into almost pure abstraction with a series of *Windows* – the sky seen through another kind of grid, an ordinary casement, with glimpses of the Tower appearing briefly to locate the scene in Paris. Guillaume Apollinaire illustrated these melting, lyrical images with words:

 Raise the blind
 And see how the window opens

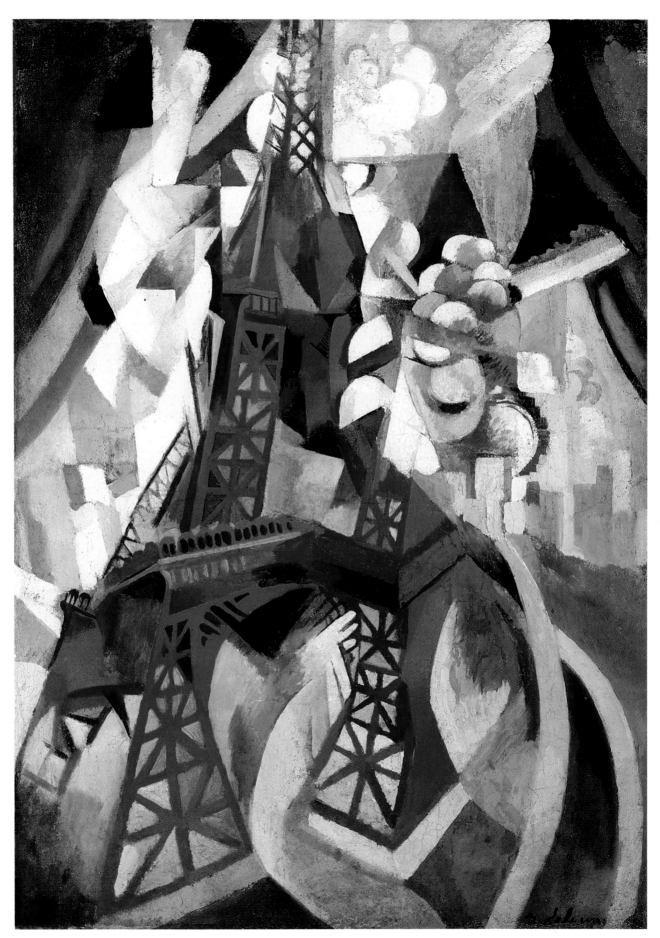

21 Robert Delaunay *The Red Tower* 1911–12
Oil on canvas 49½ × 36 ins
Solomon R. Guggenheim Museum, New York

> If hands could weave light, this was done by spiders
> Beauty pallor unfathomable indigos
>
> From the red to the green all the yellow dies
> Paris Vancouver Hyères Maintenon
> New York and the West Indies
> The window opens like an orange
> The beautiful fruit of light.

For both Robert and Sonia Delaunay, the emblem of this "beautiful fruit," this suffusing energy that simultaneously irradiated all objects, was the disc. This was the basic unit of Robert Delaunay's ambitious allegory of modernity, his *Homage to Blériot*, 1914 (plate 22). In it, all his favourite emblems of newness (Tower, radio telegraphy, aviation) are swept together into a paean to the man he called, significantly, *le grand Constructeur* – the great Constructor – a phrase meant to suggest not only that pioneer flyers had to scratch-build their craft but that a new conception of the world, a different network of ideas, was being assembled from their flights. By flying the Channel, Blériot had "constructed" a bridge more imposing than any physical structure could be. *Homage to Blériot* is almost a religious painting, an angelic conception of modernism, with its box-kite biplane floating past the Eiffel Tower in a glowing mandorla of colour and the smaller, Blériot-type monoplane rising to meet it, like a cherub; while the discs that stood for *luce intellettual, pien d'amore* in Delaunay's symbolism become assimilated to the circles of aircraft propellers, radial engines, French air-force *cocardes*, and spoked wire wheels.

Nothing dates more visibly than images drawn from technology or fashion, and the fact that Delaunay's enthusiasm for the new embodied itself in objects now so obviously old reminds us of the age, almost the antiquity, of high early modernism. Museums, with their neutral white walls (the clean box is the Aleph of art history, containing all possibilities simultaneously) and their feeling of a perpetual present, tend to make art seem newer than it is. You have to pinch yourself to remember that when the paint was fresh on the Delaunays and Cubist Picassos, women wore hobble skirts and rode around in Panhards and Bedelias. That feeling of disjuncture – the sense of the oldness of modern art – becomes acute when you reflect on the only major art movement (apart from *la pittura metafisica*, which was not so much a movement as the shortlived stylistic meeting of de Chirico and Carrá) that came out of Italy in the twentieth century.

Futurism was the invention of Filippo Tommaso Marinetti (1876–1944), part lyrical genius, part organ grinder, and, in later years, part Fascist demagogue. He was by his own account the most modern man in his own country. By any imaginable standards he was a singular creature, sired, as it were, by Gabriele d'Annunzio out of a turbine, inheriting the tireless and repetitive energy of the latter and the opportunistic dandyism of the former. For Marinetti was the first international *agent-provocateur* of modern art. His ideas affected the entire European *avant-garde*: not only in Italy, but as far afield as Russia, where the Futurist worship of the machine and

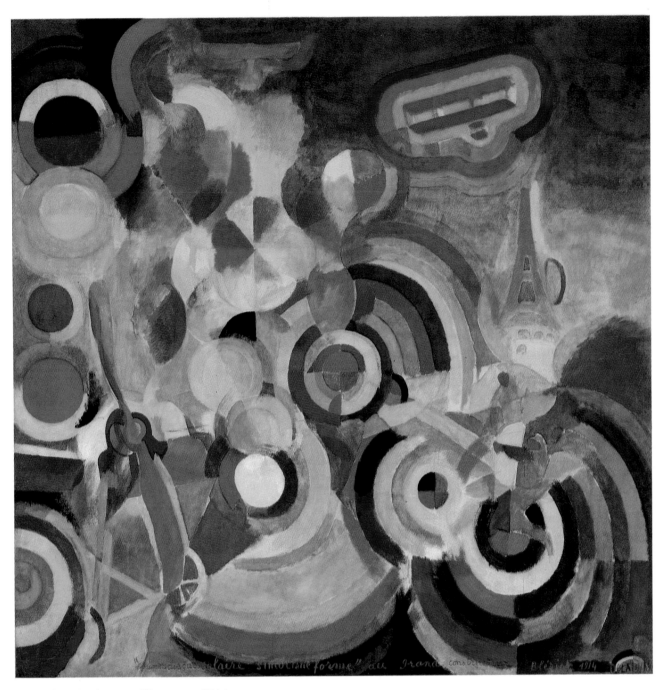

22 Robert Delaunay *Homage to Blériot* 1914

Oil on canvas $76\frac{1}{2} \times 50\frac{1}{2}$ ins: Kunstmuseum, Basle,
Emanuel Hoffmann Foundation (photo Hans Hinz)

its Promethean sense of technology as the solvent of all social ills became a central issue for the Constructivists after 1913, and as near as Switzerland, where the Futurist techniques of simultaneous sound-poems, nonsense verse, confrontation, and pamphleteering were incorporated into Dada during the war. Much of the myth of modern art was created by packaging, and Marinetti was an expert at packaging. He devised a scenario of confrontation in which every kind of human behaviour could eventually be seen as "art," and in this way he became the Italian godfather of all later performance pieces, happenings, and *actes gratuits*. He proposed a film to be called *Futurist Life*, which would include such sequences as "How a Futurist sleeps," and a "futurist stroll – study of new ways of walking," featuring the "neutralist walk," the "interventionist walk," and the "Futurist march." In 1917, he wrote sketches for one-act ballets in which a girl executed the "Dance of the Machine-Gun" and the "Dance of the Aviatrix:"

The danseuse must form a continual palpitation of blue veils. On her chest, like a flower, a large celluloid propeller . . . her face dead white under a white hat shaped like a monoplane . . . she will shake a sign printed in red: *300 meters – 3 spins – climb*. . . . The danseuse will heap up a lot of green cloth to simulate a green mountain, and then will leap over it.

He conceived a "Variety Theatre," "born as we are from electricity . . . fed by swift actuality," whose purpose would be to wrap the audience in a thunderous sensorium, "a theatre of amazement, record-breaking, and body-madness," erotic and nihilist, whose hero would be "the *type* of the eccentric American, the impression that he gives of exciting grotesquerie, of frightening dynamism, his crude jokes, his enormous brutalities. . . ." Such fantasies of absolute modernity would go deep into the stream of the *avant-garde* in the 1920s, affecting Francis Picabia, George Grosz, Vladimir Tatlin, John Heartfield, and, in fact, nearly everyone who was interested in projecting violent, ironic, and cinematic images of that great condenser of moral chaos, the City. Marinetti's verbal images of it predict what collage would later do in the realm of the eye, summoning up a demented continuum of movement, noise, imperious ads, flashing lights at nightfall:

. . . nostalgic shadows besiege the city brilliant revival of streets that channel a smoky swarm of workers by day two horses (30 metres tall) rolling golden balls with their hoofs GIOCONDA PURGATIVE WATERS crisscross of *trrr trrrrr* Elevated *trrrr trrrrr* overhead trrrombone whissstle ambulance sirens and firetrucks transformation of the streets into splendid corridors to guide push logic necessity the crowd toward trepidation + laughter + music-hall uproar FOLIES-BERGERE EMPIRE CREME-ECLIPSE tubes of mercury red red red blue violet huge letter-eels of gold purple diamond fire Futurist defiance to the weepy night. . . .

Marinetti, *The Variety Theatre*, 1913.

Marinetti's enemy was the past. He attacked history and memory with operatic zeal, and a wide range of objects and customs fell under his disapproval, from Giovanni Bellini altarpieces (old) to tango-teas (insufficiently sexy), from Wagner's *Parsifal* (moonshine) to the ineradicable Italian love of pasta – which Marinetti condemned as *passéiste* in 1930, on the grounds that "it is heavy, brutalizing, and gross

. . . it induces scepticism and pessimism. Spaghetti is no food for fighters." Even the image of the GIOCONDA PURGATIVE WATERS in the passage quoted above is proto-Dada, in which a brand name (the *Mona Lisa* has been used to advertise all sorts of products from Italian hairpins to Argentinian jam) is pressed into service to indicate that Leonardo's portrait, along with the rest of the Renaissance, gives Marinetti the shits – this, six years before Marcel Duchamp's scurrilous *LHOOQ*, the moustache on the *Mona Lisa*.

With every reason, Marinetti called himself *la caffeina dell' Europa*, "the caffeine of Europe." The name "Futurism" was a brilliant choice, challenging but vague; it could stand for any anti-historical caper, but its central idea – trumpeted forth over and over again by Marinetti and his group – was that technology had created a new kind of man, a class of machine visionaries, composed of Marinetti and anyone else who wanted to join. The machine was about to redraw the cultural map of Europe (as indeed it was, though not in the way the Futurists hoped). Machinery was power; it was freedom from historical restraint. Perhaps the Futurists would not have loved the future so much if they did not come from a country as technologically backward as Italy. "Multicoloured billboards on the green of the fields, iron bridges that chain the hills together, surgical trains that pierce the blue belly of the mountains, enormous turbine pipes, new muscles of the earth, may you be praised by the Futurist poets, since you destroy the old sickly cooing sensitivity of the earth!" This would become the credo of every Italian property developer of the seventies, and the progressive destruction of the Italian countryside and the annihilation of Italy's coastline are the prose expression of that Oedipal brutality whose poetry was Futurism.

Of all machines, the car was the most poetically charged. It formed the central image of the First Futurist Manifesto, published in *Le Figaro* in 1909:

We intend to sing the love of danger, the habit of energy and fearlessness.

Courage, audacity and revolt will be essential ingredients of our poetry.

We affirm that the world's magnificence has been enriched by a new beauty; the beauty of speed. A racing car whose hood is adorned by great pipes, like serpents of explosive breath – a roaring car that seems to run on shrapnel – is more beautiful than the Victory of Samothrace.

We will glorify war – the world's only hygiene. . . .

We will sing of great crowds excited by work, by pleasure, and by riot; we will sing of the multicoloured, polyphonic tides of revolution in the modern capitals. . . .

The problem for the artists who gathered around Marinetti before World War I was how to translate this kind of vision into paint. The first possibility seemed to be the technique of breaking light and colour down into a field of stippled dots, which derived from French neo-Impressionism and had been worked into a system under the name of Divisionism by Italian painters in the nineties. Divisionism, for young artists of the Futurist temper, had two commendable features. First, it offered a means of analyzing energy and so skirting the inherent immobility of paint on canvas. Second, it was loaded (surprisingly enough) with political implications, being widely

regarded as the style of anarchists and social reformers. Paul Signac, Seurat's closest follower, had been a committed, though non-violent, anarchist. For a painter at work in the 1900s in Italy, Divisionism was the radical style *par excellence*. The most gifted of the young Futurist artists, Umberto Boccioni – soon to fall off his horse and die during a cavalry exercise in Verona in 1916, in the war that he and Marinetti had praised as the hygiene of civilization – resorted to it on a heroic scale in *The City Rises*, 1910–11 (plate 23), his paean of joy to industry and heavy construction. Boccioni had frequented the outskirts of Milan, where new industrial construction was in full swing: "I am nauseated by old walls and old palaces," he wrote in 1907. "I want the new, the expressive, the formidable." Formidable is the word for *The City Rises*, with its muscular red horse dissolving under the power of its own energy, in a shimmer of lambent brush-strokes; the straining cables and twisting, mannered figures of workmen contain more than a memory of its apparent source, Tintoretto's *Raising of the Cross* in the Scuola di S. Marco, Venice.

But the problem of painting movement remained; and to solve it, the Futurists resorted to Cubism and to photography. They were intrigued by the new technique of X-ray photography, which saw through opaque bodies and so looked like Cubist transparency and overlap. But especially they drew on primitive cinematography, and on the sequential photos which had been taken in the 1880s by two pioneers, Eadweard Muybridge in England and Étienne-Jules Marey in France. By giving the successive positions of a figure on one plate, these images introduced time into space. The body left the memory of its passage in the air. Four centuries before, Leonardo had bought birds in the Florentine market and let them go in order to observe the beat of their wings close up for a few seconds. Now the cameras of Muybridge and Marey could describe this world of unseen movement; in fact, Marey went so far as to make what might now be seen as a precursor of Futurist sculpture, a bronze model of a bird's successive wing positions – long since lost. Some of Giacomo Balla's paintings were almost literal transcriptions of these photographs. *Dynamism of a Dog on a Leash*, 1912 (plate 24), was a glimpse of boulevard life, possibly derived from a photographic close-up, with a fashionable lady (or at least, her feet) trotting her dachshund – that low-slung, modern animal, the sports car of the dog world – along the pavement. Its modesty and humour were not to be repeated in the more ambitious paintings of moving cars that Balla made from 1913 (plate 25). In them, the boxy bug-eyed old cars – which seem so inappropriate to Marinetti's Mr. Toad-like rantings about speed and cosmic power – are merged into a general imagery of rapid transit, of glints and spirals, perspectives with staccato interruptions, Cubist transparencies, and thrusting inexorable diagonals.

The spectator, Boccioni declared in one of the Futurist *manifesti* (1912), "must in future be placed in the centre of the picture," exposed to the whole surrounding jabber of lines, planes, light, and noise that Futurism extracted from its motifs. This meant doing away with the painting as proscenium, "the small square of life artificially compressed." Boccioni thus described the aims of one of his paintings, *The Noise of the Street Penetrates the House*, 1911:

23 Umberto Boccioni *The City Rises* 1910

Oil on canvas 6 ft 6½ ins × 9 ft 10½ ins: Collection, The Museum of
Modern Art, New York, Mrs. Simon Guggenheim Fund

24

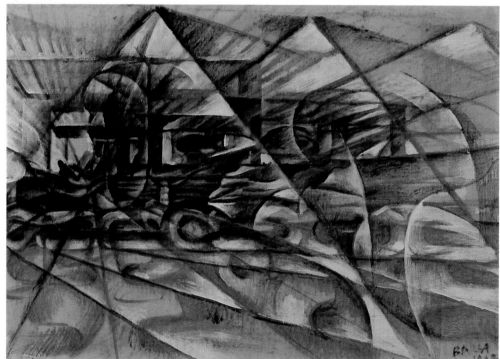

25

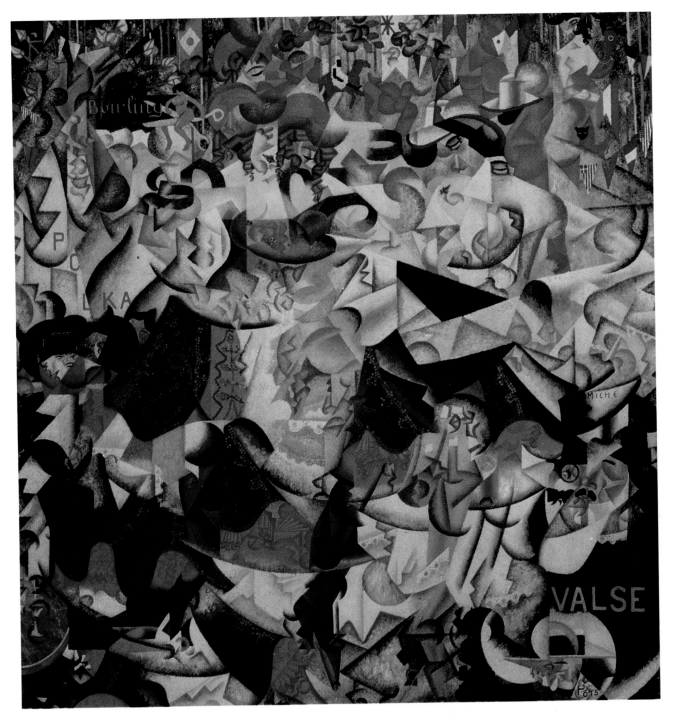

26 Gino Severini *Dynamic Hieroglyphic of the Bal Tabarin* 1912

Oil on canvas with sequins $63\frac{5}{8} \times 61\frac{1}{2}$ ins
Collection, The Museum of Modern Art, New York,
Acquired through the Lillie P. Bliss Bequest

24 Giacomo Balla *Dynamism of a Dog on a Leash* 1912

Oil on canvas $35\frac{1}{2} \times 43\frac{1}{4}$ ins: Albright-Knox Gallery,
Buffalo, Bequest of A. Conger Goodyear

25 Giacomo Balla *Speeding Auto (Auto en course, étude de vitesse)* 1913

Oil on card $23\frac{1}{2} \times 38\frac{1}{4}$ ins: Gallery of Modern Art, Milan

In painting a person on a balcony, seen from inside the room, we do not limit the scene to what the square frame of the window renders visible; but we try to render the sum total of visual sensations which the person on the balcony has experienced: the sunbathed crowd on the street, the double row of houses that stretch to right and left, the beflowered balconies, etc. This implies the simultaneousness of the environment and, therefore, the dislocation and dismemberment of objects, the scattering and fusion of details, freed from accepted logic.

That Futurism could not have realized itself without a Cubist vocabulary of "dislocation and dismemberment" is beyond doubt. Boccioni's leaning houses come straight from Delaunay's Eiffel Towers. But the difference between the emotional temperature of Cubism and Futurism was extreme, and one painting that sums it up is Gino Severini's *Dynamic Hieroglyphic of the Bal Tabarin*, 1912 (plate 26), which is filled with a kind of *louche* frenzy.

Painted from memory in Italy, Severini's big canvas is not so much a scene as a node of associations, fragmentary but charged with intense evocative power. Severini attempted to set forth the jerky, swooping rhythms of Edwardian pop music in these jagged shapes – the nervous pink petticoats, the tossing wedges of purple skirt (each stiffly embroidered with sequins to catch the light), the crumpled face of a presumably drunk *milord* in monocle and boiled shirt, the snatches of lettering, the gay, twinkling national pennants (American, French, Japanese, and, of course, Italian) slung in the background, and the Boschian sexual joke of the naked girl, an otherwise unrecorded cabaret act at the Tabarin, descending on wires, sitting astride a huge pair of emasculating scissors. It all looks like a machine, slightly out of control: a *machine à plaisir*, reflecting the frenetic and marionette-like quality of public entertainment that other artists were beginning to discern in mass culture.

For by no means all European artists before World War I felt the simple optimism about the machine that the Futurists clung to. Some saw it as threatening and dehumanizing. The idea that man's creations could rise against him and eventually destroy him was one of the fundamental myths generated by the Industrial Revolution, and given early memorable form as fiction by Mary Shelley in *Frankenstein*, 1818. Almost a century later, it gave Jacob Epstein the idea for his Vorticist sculpture, *The Rock Drill*, 1913–14 (plate 27): a sort of bronze arthropod, mounted on the legs and bit (or penis) of a pneumatic drill. "This," Epstein later wrote, "is the sinister armoured figure of today and tomorrow. Nothing human, only the terrible Frankenstein's monster into which we have transformed ourselves." Epstein never developed the possibilities of this image in other sculptures, and he performed a symbolic castration on *The Rock Drill* by discarding its machine section – legs, penis, and mechanical torso – and keeping only its thorax and masked head. Nevertheless, the analogies between machine action and sexuality were, around this time, being explored by two other artists, very distant in temperament from Epstein: Francis Picabia and Marcel Duchamp. Having been made by man, the machine had in their view become a perverse but substantially accurate self-portrait.

The machine, as Picabia put it in one of his titles (plate 28), was *La Fille Née Sans Mère*, 1916–17, the Daughter Born without a Mother – a modern counterpart to the

27 Jacob Epstein *The Rock Drill* 1913–14
Bronze 28 × 26 ins: Tate Gallery, London

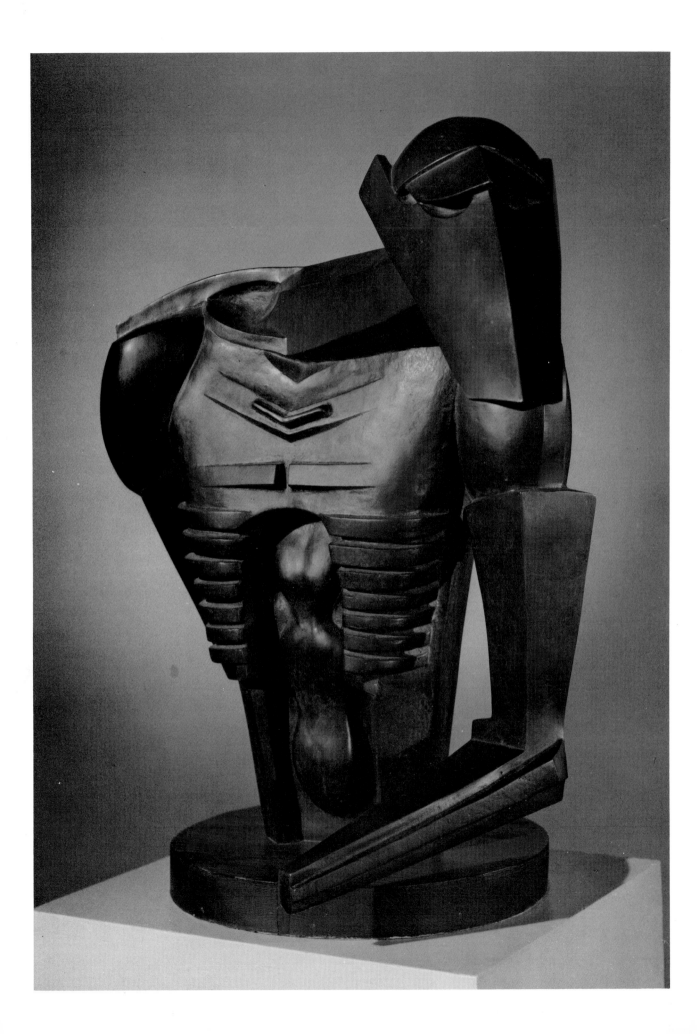

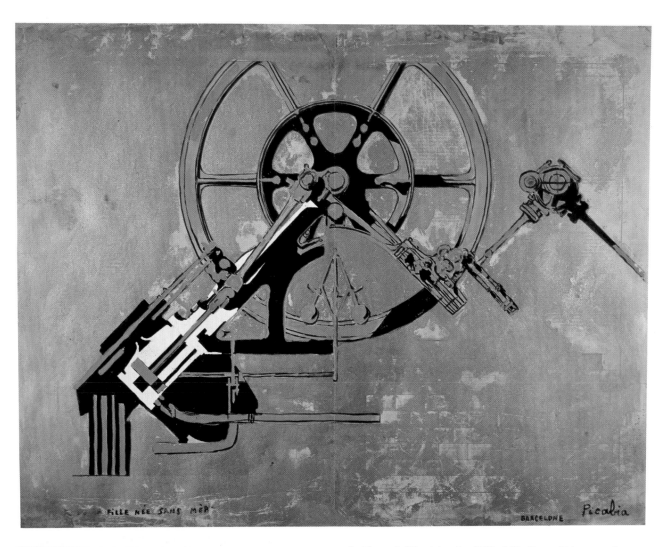

28 Francis Picabia *La Fille Née Sans Mère* 1916–17
Watercolour, metallic paint and oil on board 30 × 20 ins
Private Collection, London

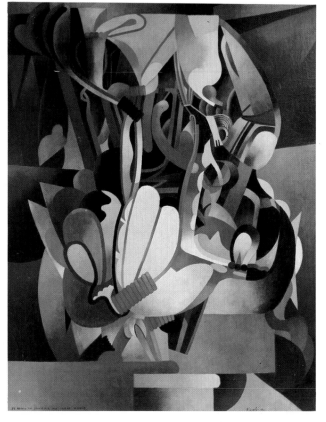

29 Francis Picabia *I See Again in Memory My
Dear Udnie* 1914, perhaps begun 1913
Oil on canvas 8 ft 2½ ins × 6 ft 6¼ ins
Collection, The Museum of Modern Art, New York,
Hillman Periodicals Fund

myth of the Virgin Birth, in which Christ, the son, was born without a father. Machinery not only parodied the Virgin Birth but other attributes of Catholicism as well: the rituals of tending it, for instance, suggested a Mass. But its main field of mimicry was sex. There was already a powerful, though obscure, undercurrent of mechano-sexual images in French experimental writing. Thus Alfred Jarry (1873–1907), author of the *Ubu* trilogy, wrote a fantasy of mechanical power in 1902 in which the hero, *le Surmâle* or Superman, wins an impossible race from Paris to Siberia, pedalling his bicycle non-stop against a five-seater cycle whose five riders have their legs all linked together with metal rods (a probable source for the mutually linked, mechanical Bachelors in Duchamp's *Large Glass*). Both machines are racing against a locomotive. *Le Surmâle* wins both the race and the girl, daughter of an American industrialist, who is riding in the train. But he cannot love the girl; he is already too mechanical for that; and so a scientist builds Superman a *fauteuil électrique*, literally an electric chair, to inspire love in him by means of jolts from an immensely powerful magneto. (The electric chair had been brought into service in America in the late nineteenth century, and it was still an object of wonder and curiosity to the French: philosophy made concrete.) Strapped in, zapped by 11,000 volts, the Superman falls in love with the chair and the magneto falls in love with him. The mechanics of sex have prevailed over sentiment.

Picabia and Duchamp knew Jarry's work intimately. Picabia was obsessed by machines, partly because their efficiency and predictability were in such soothing contrast to the neurotic vagaries of his own life, but mainly because he saw myth in them. In 1915, on a visit to New York, he declared that "upon coming to America it flashed on me that the genius of the modern world is in machinery and that through machinery art ought to find a most vivid expression . . . I mean simply to work on and on until I attain the pinnacle of mechanical symbolism." Picabia wanted to laugh the idea of traditional painting to death: he even exhibited a stuffed monkey labelled *Portrait of Cézanne, Portrait of Rembrandt, Portrait of Renoir* – but painting was the only objective outlet he could find for his machine fantasies. (The subjective one was ostentatious consumption of machines. Picabia was rich and owned, at one time or another, scores of cars and at least a dozen yachts, as though he were trying to convert himself into a mechanical centaur. He even had a racing car installed on top of a tower he owned in the South of France, and attached the chassis to a radial arm, so that he could whiz round and round like a man in a centrifuge, admiring the landscape.)

In 1914, Picabia painted a large image of a sexual encounter he had had on a trans-atlantic liner with a ballet dancer named Udnie Napierkowska, called *I See Again in Memory My Dear Udnie* (plate 29). In it, the memory of sexual pleasure, expressed in the blossoming, petal-like forms, is inextricably fused with machine symbolism, and its proper subtext was written by the novelist Joris Huysmans in *Là-Bas*, 1891: "Look at the machine, the play of pistons in the cylinders: they are steel Romeos inside cast-iron Juliets. The ways of human expression are in no way different to the back-and-forth of our machines. This is a law to which one must pay homage, unless one is either impotent or a saint."

Picabia was neither: he had, as little Alex in *A Clockwork Orange* would say, a flair for the old in-out. Mechanical sex, mechanical self. No wonder Picabia's machine-portraits still look so very sardonic. A large gear is labelled *man*, a small one *woman*; by the inexorable meshing of cogs, one dictates the movement of the other. The machine is amoral. It can only act; it cannot reflect. Nobody wants to be compared to a mechanical slave. In order to realize the shock value of Picabia's images, in all their debunking and elliptical cynicism, one needs to see them in the context of a vanished society. Today there is nothing about sex that cannot be said or represented; the public is all but shockproof. In Picabia's time, however, it was not. Most sexual imagery outside plain pornography (which, by definition, was not "art") was based on the vaguest kind of "natural" metaphors – butterflies, grottoes, moss, and so forth. Victorian pornography had been the first kind of discourse to assimilate the imagery of the Industrial Revolution to the description of sex. "Believe me," exclaims the narrator of *The Lustful Turk* by "Emily Barlow," "I had not now the power to resist the soft pleasure he now caused me to taste by the sweet to-and-fro friction of his voluptuous engine . . . that terrible machine which had so furiously agitated me with pain." Machines were the ideal metaphor for that central pornographic fantasy of the nineteenth century, rape followed by gratitude. But to bring machines into the realm of art was another thing, and Picabia's effort to set forth human relationships as mechanical processes, with its sardonic accompanying imagery of poking, stiffness, reciprocation, cylindricality, thrusting, and, above all, "meaningless" repetition, was very daring.

The definitive mechano-sexual metaphor, however, was created by Marcel Duchamp (1887–1968). In the years before he gave up the public production of art in favour of chess (and the secret construction of his last work, *Étant Données*, 1946–66), Duchamp ran variations on the available styles of the French *avant-garde*, without contributing much to them: his Fauve works are clumsy and derivative, his Cubist paintings not much more than formal exercise. His celebrated *Nude Descending a Staircase No. 2*, 1912 (plate 30), based on Marey's sequential photos, is no more advanced as either idea or form than any other Cubo-Futurist painting of the time, and if it had not been the passive focus of the public hoo-ha over the Armory Show in New York in 1913 (where it became the butt of cartoonists and was guyed as "an explosion in a shingle factory"), it might never have been thought one of the canonical images of modernism. But it did open the way to the *Large Glass*, or, to give it its full name, *The Bride Stripped Bare by Her Bachelors, Even*, which Duchamp worked on for eight years and left unfinished in 1923 (plate 31).

One might suppose, from reading what has been written about it, that the *Large Glass* was the Grand Arcanum of modern art: it may be that no single work in the entire history of painting has evoked more cant, jargon, gibberish, and Jungian psycho-babble from its interpreters. Manifestly, the *Glass* must be a rich field for interpretation, because nothing on its surface is accidental (apart from the *accepted* accidents, like the dust that Duchamp allowed to accumulate there and then preserved with fixative, or the network of cracks that appeared in the twin panes after a trucking

30 Marcel Duchamp *Nude Descending a Staircase No. 2* 1912
Oil on canvas 58 × 35 ins: Philadelphia Museum of Art,
Louise and Walter Arensberg Collection

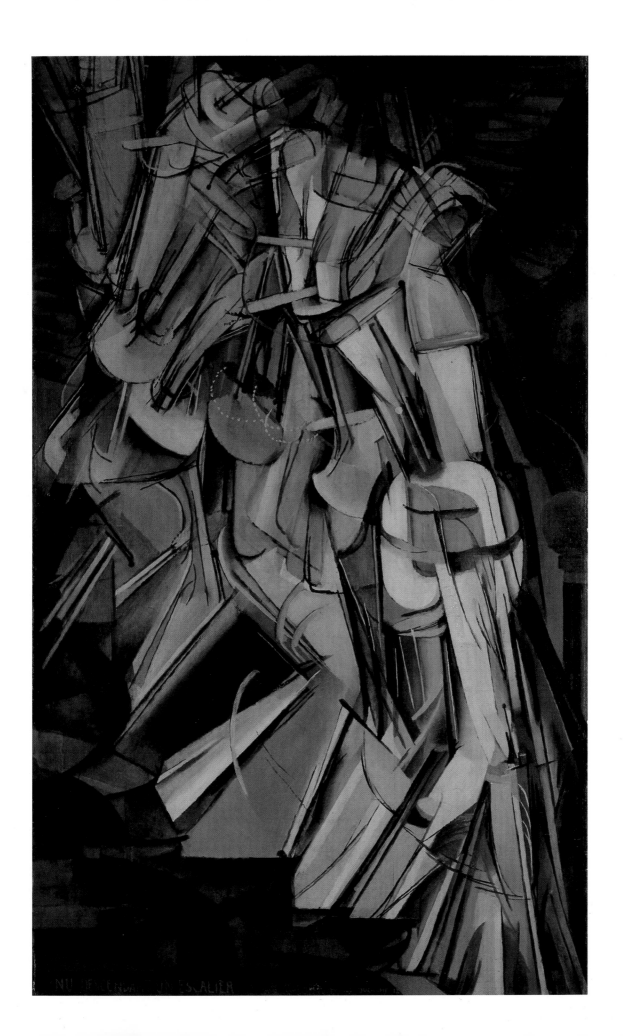

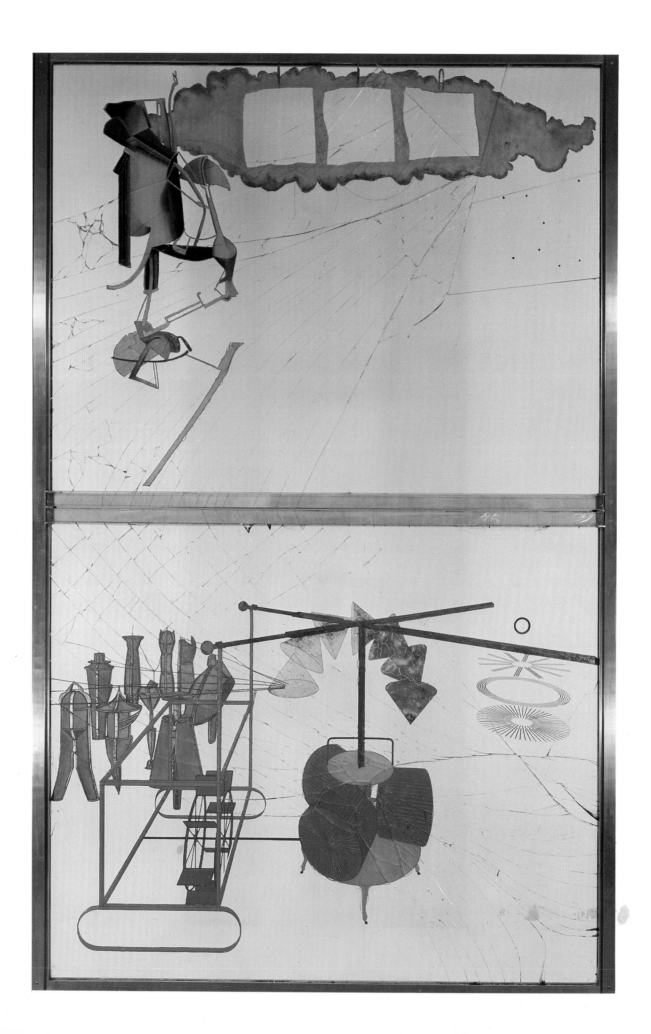

accident). Everything is there because Duchamp wanted, or put, it there. "There was nothing spontaneous about it," he remarked in 1966, "which of course is a great objection on the part of aestheticians. They want the subconscious to speak by itself. I don't. I don't care. So the *Glass* was the opposite of all that."

So what is the *Glass*? A machine: or rather, a project for an unfinished contraption that could never be built because its use was never fully clear, and because (in turn) it parodies the language and the forms of science without the slightest regard for scientific probability, sequence, cause and effect. The *Large Glass*, carefully painted and outlined in lead wire on its transparent panes, looks explicit. But if an engineer were to use it as a blueprint he would be in deep trouble since, from the viewpoint of technical systems, it is simply absurd: a highbrow version of the popular "impossible machines" that were being drawn, at the time, by Rube Goldberg. The notes Duchamp left to go with it, collected out of order in the Green Box, are the most scrambled instruction manual imaginable. But they are deliberately scrambled. For instance, he talked about the machine in the *Glass* running on a mythical fuel of his own invention called "Love Gasoline," which passed through "filters" into "feeble cylinders" and activated a "desire motor" – none of which would have made much sense to Henry Ford. But the *Large Glass* is a meta-machine; its aim is to take one away from the real world of machinery into the parallel world of allegory. In the top half of the *Glass*, the naked Bride perpetually disrobes herself; in the bottom section, the poor little Bachelors, depicted as empty jackets and uniforms, are just as perpetually grinding away, signalling their frustration to the girl above them. It is a sardonic parody of the eternally fixed desire Keats described in his *Ode on a Grecian Urn* –

> Bold Lover, never, never canst thou kiss,
> Though winning near the goal – yet, do not grieve;
> She cannot fade, though thou hast not thy bliss,
> For ever wilt thou love, and she be fair!

In fact, the *Large Glass* is an allegory of Profane Love – which, Marcel Duchamp presciently saw, would be the only sort left in the twentieth century. Its basic text was written by Sigmund Freud in *The Interpretation of Dreams*, 1900: "The imposing mechanism of the male sexual apparatus lends itself to symbolization by every sort of indescribably complicated machinery." But to Duchamp, who had reason to know, the male mechanism of the *Large Glass* was not a bit imposing. The Bachelors are mere uniforms, like marionettes. According to Duchamp's notes, they try to indicate their desire to the Bride by concertedly making the Chocolate Grinder turn, so that it grinds out an imaginary milky stuff like semen. This squirts up through the rings, but cannot get into the Bride's half of the *Glass* because of the prophylactic bar that separates the panes. And so the Bride is condemned always to tease, while the Bachelors' fate is endless masturbation.

In one sense the *Large Glass* is a glimpse into Hell, a peculiarly modernist Hell of repetition and loneliness. But it is also possible to see it as a declaration of freedom, if one remembers the crushing taboos against masturbation that were in force when

31 Marcel Duchamp *The Bride Stripped Bare by Her Bachelors, Even (Large Glass)* 1915–23
Oil and lead wire on glass 109¼ × 69 ins
Philadelphia Museum of Art, Bequest of Katherine S. Dreier

Duchamp was young. For all its drawbacks, onanism was the one kind of sex that could not be controlled by the State or the Parent. It freed people from the obligation to be grateful to someone else for their pleasures. It was a symbol of revolt against the family and its authority. Its sterile and gratuitous functioning has made it a key image for an *avant-garde* that tended, increasingly, towards narcissism. "Frigid people really make it," remarked Andy Warhol, the Dali of the seventies. So did this frigid work of art. The *Large Glass* is a free machine, or at least a defiant machine; but it was also a sad machine, a testament to indifference – that state of mind of which Duchamp was the master. Indeed, his finely balanced indifference was the divide between the late machine age and the time in which we live. The *Large Glass* was very remote from the optimism that accompanied the belief that art still had the power to articulate the plenitude of life, with which greater artists but less sophisticated men than Duchamp greeted the machine in those lost days before World War I. "When I looked at the earth," Gertrude Stein recalled of her first flight in an aircraft,

I saw all the lines of cubism made at a time when not any painter had ever gone up in an airplane. I saw there on the earth the mingling lines of Picasso, coming and going, developing and destroying themselves, I saw the simple solutions of Braque, yes I saw and once more I knew that a creator is contemporary, he understands what is contemporary when the contemporaries do not yet know it, but he is contemporary and as the twentieth century is a century which sees the earth as no-one has ever seen it, the earth has a splendor that it never has had, and as everything destroys itself in the twentieth century and nothing continues, so then the twentieth century has a splendor which is its own.

That splendour of the new age would soon be less evident. After 1914, machinery was turned on its inventors and their children. After forty years of continuous peace in Europe, the worst war in history cancelled the faith in good technology, the benevolent machine. The myth of the Future went into shock, and European art moved into its years of irony, disgust, and protest.

THE FACES
OF POWER

The Butte de Warlencourt can be seen to the left of the road, as you drive from Arras to Bapaume. It rises above the flat landscape of the Somme Valley, hardly more than a knoll, crowned by a wild thicket of bushy trees. No signpost marks it, although there is an Allied military cemetery half a mile away. At the top of this mound there is a weathered wooden cross, put there by the Germans. All around, the undeviating lines of beet-ploughing stretch away: the churned clay mud in which so many men are mingled. For about two years, from the autumn of 1916 to the Armistice, this mound was a symbol of obsession. First it was held by German machine-gunners, and then the British and Australians overran it; the Germans took it again, and then the Allies took it back; by the end of the war, it had been captured and recaptured several times. Thousands of people had died for it, and every yard of earth on and around it had been dug over by high explosive and mixed with their outraged flesh, down to a depth of six feet. At Warlencourt and all along the Somme, our fathers and grandfathers tasted the first terrors of the twentieth century. There, that joyful sense of the promise of modernity, the optimism born of the machine and of the millennial turning point of a new century, was cut down by other machines. In the Somme Valley the back of language broke. It could no longer carry its former meanings. World War I changed the life of words and images in art, radically and forever. It brought our culture into the age of mass-produced, industrialized death. This, at first, was indescribable.

In 1914, when World War I began, not one man in Europe knew what total, mechanized trench warfare would mean. Some Frenchmen, Englishmen, and Germans, the professional soldiers, had fought in colonial wars in Africa and Asia, but total war was both qualitatively and quantitatively beyond everyone's experience, including the generals'. Philip Larkin evoked the virginity – there is no better word for it – of the new armies in his poem *MCMXIV*:

> Those long uneven lines
> Standing as patiently
> As though they were stretched outside
> The Oval or Villa Park,
> The crowns of hats, the sun

> On moustached archaic faces
> Grinning as if it were all
> An August Bank Holiday lark . . .
>
> Never such innocence,
> Never before or since,
> As changed itself to past
> Without a word: the men
> Leaving the garden tidy,
> The thousands of marriages
> Lasting a little while longer;
> Never such innocence again.

Their leaders sold the war to them in a language of high rhetorical fustian which was descended from chivalry. Any diction that described the concrete realities of modern war would, by definition, have been unusable. Instead, hundreds of thousands of people were conditioned to die by the repetition of Imperial catchwords: "honour," "sacrifice," "country." Official language on both sides of the trenches riveted home the belief, through incessant propaganda (which looks naïve to us today, conditioned as we are by a century of advertising, but was deeply effective in 1914–18), that the Great War was part Armageddon – the final battle of Good against Evil, meant to establish the permanent reign of justice, the "war to end all wars" – and part mediaeval joust, with a touch of cricket thrown in. In England it had many literary voices, from Rupert Brooke to Sir Henry Newbolt, whose *Vitaï Lampada* (*The Torch of Life*) was still being memorized at a cane's end by Commonwealth schoolboys thirty-five years after the Armistice:

> The sand of the desert is sodden red, –
> Red with the wreck of a square that broke; –
> The Gatling's jammed and the Colonel dead,
> And the regiment blind with dust and smoke.
> The river of death has brimmed his banks,
> And England's far, and Honour a name,
> But the voice of a schoolboy rallies the ranks:
> "Play up! play up! and play the game!"

To take up the sword and rush on winged feet to save civilization was one matter. To spend month after month sharing a rat-infested trench with other conscripts, driven half crazy by the shelling, whilst occasionally firing one's Lee-Enfield or Mauser at a distant greyish object that moved behind the sandbags across a quarter of a mile of cratered mud and bodies: that was quite another. For the soldiers, there was no way of telling the truth about the war, except in private poetry. It was, Ernest Hemingway wrote, "the most colossal, murderous, mismanaged butchery that has ever taken place on earth. Any writer who said otherwise lied. So the writers either wrote propaganda, shut up, or fought." The same was true of painters, who, in any case, could only work at the front as official war artists. Line soldiers could not carry easels. The remarkably antiseptic quality of World War I, as portrayed by its official

artists like Paul Nash, Wyndham Lewis, and C. R. W. Nevinson, came in part from the War Office's veto on showing corpses. "I am no longer an artist," Nash complained. "I am a messenger who will bring back word from the men who are fighting to those who want the war to go on forever. Feeble, inarticulate will be my message, but it will have a bitter truth and may it burn their lousy souls." His feelings held true for artists on both sides, whether "official" or conscripts in the trenches: for Otto Dix and Max Beckmann, who fought in Flanders, or for László Moholy-Nagy.

What would the later history of modern art have been, if the Great War had never been fought? It is impossible to know. The war gutted an entire generation, and it is still an infinitely moving experience to wander among those fields of crosses in the military cemeteries of the Somme, each with its plaque reading INCONNU; or to stand beneath the immense arches of the monument on top of Thiepval Hill, whose columns carry the names of the thousands upon thousands of Englishmen whose bodies were never extricated from the mud. We know the names of some artists who died: among the painters, Umberto Boccioni, Franz Marc, and August Macke; the sculptor Henri Gaudier-Brzeska, the architect Antonio Sant' Elia, the poets Guillaume Apollinaire, Wilfred Owen, and Isaac Rosenberg. But for every one of these names there must have been scores, even hundreds, of men who never had a chance to develop. If you ask where is the Picasso of England or the Ezra Pound of France, there is only one probable answer: still in the trenches.

But one can indicate what the war did to culture. The fact that its reality was incommunicable to non-combatants, those home jingoes whom Siegfried Sassoon dreamed of slaughtering with a tank – "then there'd be no more jokes in music-halls/To mock the riddled bodies round Bapaume" – opened a vast gap of experience between the ones who had fought, mostly young men, and their civilian elders. Thus the war started the first of the exacerbated conflicts of generation that would mark modern culture right through to the 1960s. Its effect on Europe and especially Germany, in dividing the young from the old, was similar to Vietnam's impact on America. The crimes of the elders seemed boundless to the young: they had not only started a war but lost it as well, and yet the only institution that seemed intact in postwar Germany was its military machine.

After the catastrophes of Verdun and the Somme, this generation – or, at least, those of it who had done time in the trenches – knew it had been lied to. Its generals, bunglers like Haig and cattle-herders like Joffre, had lied about the nature and length of the war. Its politicians had lied about its causes, and a compliant and self-censoring press had seen to it that very little of the realities of war, not even a photo of a corpse, found its way into any French, German, or British newspaper. Never had there been a wider gap between official language and perceived reality.

When the war finally ended, it was necessary for both sides to maintain, indeed to inflate, the myth of sacrifice so that the whole affair would not be seen for what it was: a meaningless waste of millions of lives. Logically, if the flower of youth had been cut down in Flanders, the survivors were not the flower: the dead were superior to the traumatized living. In this way, the virtual destruction of a generation further

increased the distance between the old and the young, between the official and the unofficial. One result of this was a hatred, among certain artists, of all forms of authority, all traditional modes. But the main result was a longing for a clean slate. If Verdun represented the climax of the patriotic, nationalist, law-abiding culture of the fathers, then the sons would be pacifists and internationalists. Some of them, as we shall see in the next chapter, wanted to create literal Utopias of reason and social justice, created (not merely *expressed*) by architecture and art. Others were less ambitious; they simply wanted to get out of the madness. Since America was too far away, the main haven for them in Europe was Switzerland. Zurich attracted every kind of refugee intellectual, writer, and painter from northern Europe. Some of them, like Lenin or James Joyce (who wrote much of *Ulysses* in exile by the lake), were among the great figures of modern thought, but there was a considerable supporting cast as well, and their common meeting ground – their cultural homeland, so to speak, replacing the natural ones they had left or lost – was the Café Odéon.

Today, the phrase "café intellectual" is a mild, obsolete insult. Then, places like the Odéon were a medium of intellectual life, quite as much as the literary magazines. People separated from the social order, by choice or not, needed the café as their study and opera house: a place to meet, work, argue, and display themselves. It was a place for little groups, for specialists, where one met one's intellectual peers – the essence of metropolitanism, and therefore of modernism, which in its self-referring ironies and sense of civilization was an urban sensibility, born in the cities, petering out in the country. The cafés of Zurich, Berlin, Barcelona, Vienna, Milan, and Paris were the natural home of exiles, and modernism was largely the creation of exiles and polyglots, from Picasso the Spaniard to Beckett the Irishman. The Odéons, in short, were the natural theatre of the new. In them, the intellectuals, writers, and artists could feel and behave like a class, the mandarins of change. And when Stalin, the terrible simplifier who represented all that was *not* exile and cultural debate, declared war on "rootless cosmopolitans" in the 1930s, his enemy was café-culture.

Among the expatriates of the Odéon were a struggling German writer named Hugo Ball and his girl friend, a pacifist and part-time radical journalist, Emmy Hennings. Since Hennings made a living as a cabaret actress and Ball played the piano, it seemed natural for them to open their own tiny cabaret, "a centre for artistic entertainment," as Ball put it, with "daily meetings where visiting artists will perform their music and poetry." They scraped together the cash to rent space in the Spiegelgasse, a steep narrow alley where Lenin, at the time, was also living; and so the Cabaret Voltaire opened to its small, young, and noisy public in February 1916. Among its first contributors were two Rumanians, the painter Marcel Janco and a twenty-year-old poet named Sami Rosenstock who wrote under the euphonious pen-name of Tristan Tzara; a German writer, Richard Hülsenbeck; and an artist from Alsace, Jean Arp. Such was the artistic and literary *groupuscule* that, in 1916, named itself "Dada."

Nobody knows, and it is now too late to discover, who invented that most succinct of all art movement names. Hans Richter, another member of the Zurich group, always assumed that it "had some connection with the joyous Slavonic affirmative,

'Da, da' . . . 'yes, yes' to life." It is essential to grasp that Dada was never an art style, as Cubism was; nor did it begin with a pugnacious socio-political programme, like Futurism. It stood for a wholly eclectic freedom to experiment; it enshrined play as the highest human activity, and its main tool was chance. "Repelled by the slaughterhouses of the world war, we turned to art," wrote Arp, the most gifted of the Zurich Dadas. "We searched for an elementary art that would, we thought, save mankind from the furious madness of these times . . . we wanted an anonymous and collective art." The Dadaists still believed, as many artists at the time did, in the power of art to "save mankind" from political abominations; the central myth of the traditional *avant-garde*, that by changing the order of language, art could reform the order of experience and so alter the conditions of social life, had not yet collapsed – indeed, the next fifteen years would see it flourish with extraordinary optimism, before political events finally overran it.

One condition of the "elementary" art that Arp and the habitués of the Cabaret Voltaire were looking for was spontaneity, which, Ball wrote, would bring about "a public execution of false morality." How did one find the spontaneous? Partly by appealing to other cultures. The Dadaists can only have had the sketchiest acquaintance with jazz, but "we performed some stupendous Negro music (always with the big drum, boom boom, boom boom)" – closer, presumably, to a white European's stereotype of drums-and-skulls savagery than to the joyous intricacies of New Orleans sound. In the same spirit, which was essentially that of "Negro" Cubism, Marcel Janco made bright, crude masks for theatrical sketches at the café, from cardboard and poster paint. But for Dada, the two main sources of spontaneity were childhood and chance. Arp's jigsawed wooden reliefs of 1916–20 are like toys, simple and direct; against the mineral ambiguities of Cubism, he proposed an art of soft things, leaves, clouds, flesh, reduced to outline and then painted in fresh enamel colours (plate 32). Indeed, they were more spontaneous than most toys, since the bourgeois nurseries of 1916 were full of building-block sets, those ABCs of rectilinear containment on which the post-Bauhaus ideologues of the future were already cutting their teeth. Arp also tore out scraps of paper (their edges "drew themselves," without conscious intervention, by being torn) and let them drop on a sheet, fixing them where they fell, thus achieving collages made wholly in accordance with the laws of chance. These procedures were followed in writing by Tristan Tzara, who made poems of arbitrarily scrambled sentences and from words drawn, allegedly at random, from a bag.

The great influence on Zurich Dada was Futurism. Marinetti's brand of controlled hysteria and calculated exaggeration provided the rhetorical basis for most *avant-garde* "confrontation" thereafter. As Ball remarked, Dada tried to bring about "a synthesis of the romantic, dandyistic and – daemonistic theories of the nineteenth century," and Marinetti's provocative dandyism gave Tzara, in particular, his model of style. But Zurich Dadaism did not worship the machine, still less imitate Marinetti's bombinations in praise of war. "I had no love for the death's-head hussars," wrote Ball,

32 Jean Arp *Birds in an Aquarium* *c.* 1920
Painted wood relief $9\frac{7}{8} \times 8 \times$ approximately $4\frac{1}{2}$ ins
Collection, The Museum of Modern Art, New York, Purchase

Nor for the mortars with girls' names on them,
And when at last the glorious days arrived
I unobtrusively went on my way.

Marinetti wanted to destroy culture in the name of the Future, Ball for the sake of the Past: "We should burn all libraries and allow to remain only that which everyone knows by heart. A beautiful age of the legend would then begin." As Marinetti's loathing of history fed into fascism, so this aspect of Dada predicted the woozy know-nothingism that would perfuse the "counterculture" of the sixties. In their desire for a completely free, gratuitous art to stand at the end of history and serve no existing social interests (while heralding the birth of the *Dada-mensch*, the lightfoot Messiah to come), the Zurich Dadaists were to Marinetti as Marinetti had been to Nietzsche. If Marinetti's version of Zarathustra was the Machine, Dada's was the Child. Machinery, after all, had raped Europe from end to end, killing millions; the only hope lay in a fresh start, in cultural infancy. "Every word that is spoken and sung here," Ball declared, "represents at least this one thing: that this humiliating age has not succeeded in winning our respect."

But with the exception of Arp, who used the small-scale ferment in Zurich as a context in which to display his work while remaining essentially a sober, lyrical, and "constructive" artist, there was no distinctive Dada art as yet. The stage-happenings, simultaneous poems, and mock rituals that happened on the stage of the Cabaret Voltaire were transplanted Futurism, spinoffs from Marinetti's dream of the Futurist Variety Theatre, mixed with the interest in archaic ritual that caused Ball to dress himself up as a Cubist bishop in cardboard "robes" and utter long mock-sacerdotal chants in gibberish. Both the lyric and the militant sides of Dada would have to wait until the twenties to be fully developed. Their theatre would be postwar Germany.

The great lyric artist of Dadaism was Kurt Schwitters (1887–1948), who lived in Hanover and made art from oddments picked up on the street. A remarkable passage in one of Vincent van Gogh's letters, written from The Hague five years before Schwitters' birth, sets the context for this saint of reclamation:

This morning I visited the place where the streetcleaners dump the rubbish. My God, it was beautiful!

Tomorrow they are bringing a couple of interesting pieces from that garbage pile, including some broken street lamps, for me to admire or, if you wish, to use as models. . . . It would make a fine subject for a fairy tale by Andersen, that mass of garbage cans, baskets, pots, serving bowls, metal pitchers, wires, lanterns, pipes and flues that people have thrown away. I really believe I shall dream about it tonight, and in winter I shall have much to do with it in my work . . . it would be a real pleasure to take you there, and to a few other places that are a real paradise for the artist, however unsightly they may be.

That the painter of *les misérables*, the brutally oppressed paupers and peasants of The Netherlands, should have been stirred by the sight of inanimate objects which had suffered their own form of social rejection has its poetic logic; but certainly no artist before van Gogh would have carried the pathetic fallacy to such a pitch.

Schwitters took it even further. Instead of painting junk, he transposed it into art – the thing in itself, tatty, stained, peeling, rusty, bent, torn, crumpled, but capable of redeeming itself through infinite combination, under the collaborative hand of the artist. In 1920, with a torrent of verbal images clearly owing much to Marinetti's description of the Futurist Theatre, he fantasized about the mighty productions of random events that collage, wrought to its fullest energy as spectacle, might bring:

Make veils blow, soft folds fall, make cotton drip and water gush. . . . Then take wheels and axles, hurl them up and make them sing (mighty erections of aquatic giants). Axles dance mid-wheel roll globes barrel. Cogs flair teeth, find a sewing-machine that yawns. Turning upward or bowed down the sewing-machine beheads itself, feet up. Take a dentist's drill, a meat grinder, a car-track scraper, take buses and pleasure-cars, bicycles, tandems and their tires, and deform them. Take lights and deform them as brutally as you can. Make locomotives crash into one another. . . . Explode steam boilers to make railroad mist. Take petticoats and other kindred articles, shoes and false hair, also ice-skates, and throw them in the place where they belong and always at the right time. For all I care, take man-traps, automatic pistols, infernal machines, the tinfish and the funnel, all of course in an artistically deformed condition. Inner tubes are highly recommended.

This was grand opera – mechanical Wagner, in fact – and Schwitters never achieved it. His compositions were normally modest in size, made up from a "palette of objects" (to borrow Robert Rauschenberg's phrase), lovingly culled from urban waste. His system of composition was based on a firm Cubist-Constructivist grid; despite the contrast of materials, their edges, thicknesses, surfaces, and colours are exactly calibrated, and the fragments of lettering serve much the same ends as they did for Braque and Picasso – to introduce points of legible reality into the midst of flux (plate 33). Schwitters called them all "Merz" paintings: the name was a fragment of a printed phrase advertising the Kommerz- und Privat-Bank, which had turned up in one of his collages. Their common theme was the city as compressor, intensifier of experience. So many people, and so many messages: so many traces of intimate journeys, news, meetings, possession, rejection, with the city renewing its fabric of transaction every moment of the day and night, as a snake casts its skin, leaving the patterns of the lost epidermis behind as "mere" rubbish.

Schwitters' great work, the so-called *Merzbau* in Hanover, was destroyed by an Allied bomb in 1943. He had begun it in 1923 – a reliquary construction that spread through two floors of his house and colonized part of its cellar. Its proper name was the *Kathedrale des erotischen Elends* or *Cathedral of Erotic Misery*, 1923 (plate 34), known as the *K.d.e.E.* for short. The title, so curiously reminiscent of the theme of Duchamp's *Large Glass* (which Schwitters had never seen, though he may have heard of it), seems not to fit the surviving photographs, which show a proliferating Cubist structure, low on imagery. In fact, it was a supremely Joycean object, a nautilus containing memory jammed next to memory in its chambered, outward-growing grottoes – a veritable city within the larger city, mimicking its imagery as funfairs mimic the mediaeval imagery of Hell. Some nooks in the *K.d.e.E.* were dedicated to Schwitters' friends – Mondrian, Arp, Richter – and others to "classical" works of the

33 Kurt Schwitters *Merz 410:*
"Irgendsowas" 1922

Collage: Kunstmuseum, Hanover,
Sprengel Collection © COSMOPRESS

34 Kurt Schwitters *Cathedral of Erotic
Misery* 1923

Photo of Merzbau, Hanover
Kunstmuseum, Hanover, Sprengel Collection

past: a Cave of the Niebelungen, a Goethe Grotto. There was a Cave of Depreciated Heroes and even an industrial zone, the Ruhr District. The *K.d.e.E.* also boasted a Love Grotto, a Murderers' Cave, a Sex-Crime Den, and a Cavern of Hero-Worship. As it grew, its fictional space devoured Schwitters' own *Lebensraum*, so that, as Brian O'Doherty has noted, "as the author's identities are externalized on to his shell/cave/room, the walls advance upon him. Eventually he flits around in a shrinking space like a piece of moving collage" – thereby, one might add, fulfilling Schwitters' own prediction, the central premise of all future body-art, that in the Aleph-like universe of Merz, "even people can be used. . . . People can even appear actively, even in their everyday postures."

Such voracious acceptance of the non-art world into art, along with the anti-cultural bombast of Tzara and his ilk, convinced most people – and still persuades many – that Dada was against art itself, and thus self-contradictory. What painting can negate painting? What sculpture can invalidate sculpture? None: but the years around 1918 brought many pointed jabs at the middle-brow cult of art. In our time, this cult is fed by corporate gold-and-masterpiece shows, so that the art experience is replaced by the excitement of peering at inaccessible capital. Sixty years ago, the motif was art as pseudo-religion: Sensibility worshipping the Culture-Hero, the great dead artist in his posthumously appointed role as a divine creator. The best-known satire on that was Marcel Duchamp's *LHOOQ*, 1919: the moustache on the *Mona Lisa*, a gesture by now synonymous with impish cultural irreverence (plate 35). As is usual with Duchamp's puns, it works on several layers at once. The coarse title – *LHOOQ*, pronounced letter by letter in French, means: "She's got a hot ass" – combines with the schoolboy graffito of the moustache and goatee; but then a further level of anxiety reveals itself, since giving male attributes to the most famous and highly fetishized female portrait ever painted is also a subtler joke on Leonardo's own homosexuality (then a forbidden subject) and on Duchamp's own interest in the confusion of sexual roles.

Duchamp made other attempts to de-mystify art, notably with his "readymades" – common things like a snow shovel, a bicycle wheel, or a rack for drying bottles, which he exhibited as objects devoid of aesthetic interest but classified, by context, as "art." The most aggressive of these was *Fountain*, 1917, a porcelain urinal. Such things were manifestoes. They proclaimed that the world was already so full of "interesting" objects that the artist need not add to them. Instead, he could just pick one, and this ironic act of choice was equivalent to creation – a choice of mind rather than of hand.

To the Dadaists in Berlin after 1918, such semantic games would perhaps have seemed too rarefied to be interesting. (Their appeal to later generations of American and European artists who were working out of an extreme self-consciousness about the nature of art, coupled with an extreme uncertainty as to what art could actually say, was of course another matter.) It was in Berlin that Dada became overtly political, losing the mystical-anarchist cast it had in Zurich. Dada was no longer an alternative to conflict. To be modern in Berlin, in the aftermath of World War I, meant to be engaged in a theatre of politics, a city torn by shortages and every other kind of postwar

35 Marcel Duchamp *LHOOQ* 1919
Pencil on print of Leonardo's *Mona Lisa*
$7\frac{3}{4} \times 4\frac{3}{4}$ ins: Private Collection

L.H.O.O.Q.

misery, as Left battled Right for possession of the streets. Germany not only lost a war: at Versailles, it catastrophically lost the peace. In November 1918, a year after the Russian Revolution, there was a general socialist rising in Germany. The workers and Red veterans, who had borne the brunt of wartime suffering, hoped to demolish the Prussian war machine and the class it protected. They failed completely. Strikes were answered by martial law, and Communist leaders like Karl Liebknecht and Rosa Luxemburg were murdered. In those torn and exalted months when Germany seemed to be reliving the historical moment of Russia, it was clear that an artist who spent his time dropping little bits of paper on a table in accordance with the laws of chance, while other people were trying to storm the Reichstag, was not living up to the possibilities of his age. Political stress is always apt to shrink the private arena and attach it on to the public, and Weimar Germany was no exception. In that atmosphere there could be no such thing as a radical art that did not take political sides. A young, idealistic artist could only go left of the Weimar government – unless, of course, he happened to be Adolf Hitler, shivering in his garret with his watercolour box.

There was already a fierce and respectable body of anti-war protest in German art. It came from Expressionism (see Chapter 6), which by 1914 was already well enough established as a cultural force in Germany to attract the scorn of younger artists. In 1913, Franz Marc, soon to die at Verdun, had painted a vision of apocalypse overwhelming innocent life entitled *The Fate of the Animals* (plate 36). This tragic vision of matter – the earth and its plants no less than the forms of animals – sundered and broken by implacable shafts of energy now seems truly prophetic, a German equivalent to Wilfred Owen's question from the trenches: "What passing-bells for those who die as cattle?" Since Expressionism placed the self as the one knowable point at the centre of a collapsing or hostile world, it was well adapted to displays of wartime *Angst*. When Ernst Ludwig Kirchner painted himself (plate 37) as a conscript with an amputated arm, his painting arm, he wanted to be seen as a mutilated saint, a victim symbolically unmanned by the army. In fact, he had never even been wounded.

Expressionism found its spiritual home midway between an idealized German Gothic past and an unattainable Utopia. The last thing it showed any interest in was the present – that was the province of journalists and Dadaists. The self or the void; ecstasy or chaos; such was the Expressionist choice. The German Dadaists thought otherwise. They laughed at the inwardness of Expressionism, its habit of describing every event in terms of the tyrannical *Ich*. Despising mysticism as a flight from reality, they also mocked the Expressionists' political compromises and the movement's emerging claim to be "official," and thus harmless, culture. And so the 1918 Berlin Dada Manifesto was a sustained attack on Expressionism, which, in abridged form, began:

The highest art will be the one which in its conscious content presents the thousandfold problems of the day, the art which has been visibly shattered by the explosions of last week, which is forever trying to collect its limbs after yesterday's crash. Has expressionism fulfilled our expectations of such an art, which should be an expression of our most vital concerns?

NO! NO! NO!

36 Franz Marc *The Fate of the Animals* 1913
Oil on canvas $76\frac{1}{2} \times 103$ ins: Kunstmuseum, Basle

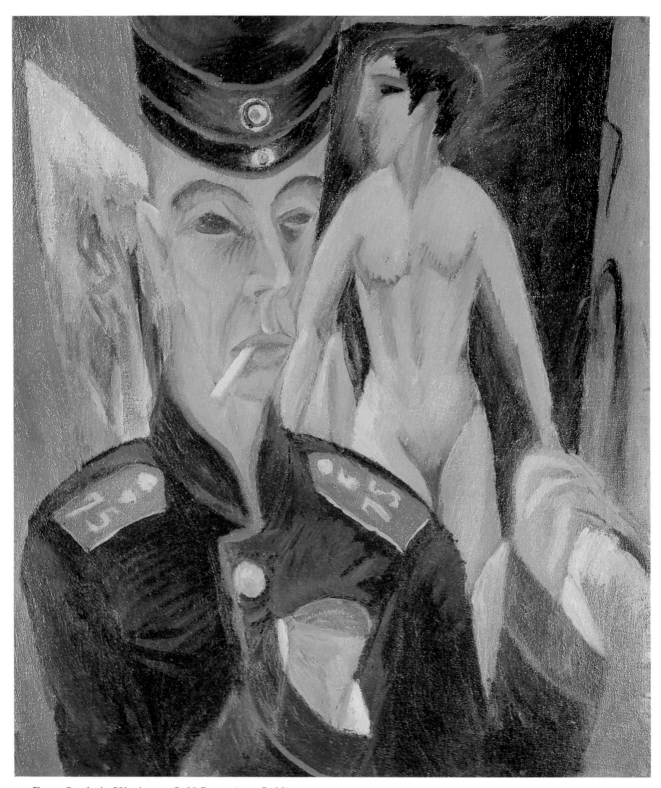

37 Ernst Ludwig Kirchner *Self-Portrait as Soldier* 1915
Oil on canvas $27\frac{1}{4} \times 24$ ins: Allen Memorial Art Museum,
Oberlin College, Ohio, Charles F. Olney Fund

Have the expressionists fulfilled our expectation of an art that burns the essence of life into our flesh?

<p align="center">NO! NO! NO!</p>

Under the guise of turning inward, the expressionists have banded together into a generation which is already looking forward to honourable mention in the histories of literature and art. . . . Hatred of the press, hatred of advertising, hatred of *sensations* are typical of people who prefer their armchair to the noise of the street. . . . The signatories of this manifesto have, under the battle cry

<p align="center">D A D A ! ! !</p>

gathered together to put forward a new art. What, then, is Dadaism? The word "Dada" signifies the most primitive relation to the reality of the environment. . . . Life appears as a simultaneous muddle of noises, colours and spiritual rhythms, which is taken unmodified, with all the sensational screams and fevers of its reckless everyday psyche and with all its brutal reality. . . . Dada is the international expression of our times, the great rebellion of artistic movements, the artistic reflex of all these offensives, peace congresses, riots in the vegetable market. . . .

This was a fine message, but what did it mean in practice? What kind of visual narrative could give art so much urgency? Some of the Berlin Dadaists – John Heartfield, George Grosz, Hannah Höch, and Raoul Hausmann – believed it was photomontage, a kind of collage done with photo-reproduced images clipped from newspapers and magazines. Directly cut from the "reckless everyday psyche" of the press, stuck next to and on top of one another in ways that resembled the laps and dissolves of film editing, these images could combine the grip of a dream with the documentary "truth" of photography. Its origins lay in popular art – genealogical trees on to which people could paste their own portrait photographs, and the like – but Grosz and Heartfield, as line soldiers during the war, would also send one another postcards on which they had made small, satirical montages whose point, not being verbal, was easily overlooked by the military censors. But the question of precedence, of who "invented" photomontage, is not important. The first artist to produce genuinely interesting work in this medium, however, was Max Ernst.

Some of Ernst's early Dada collages are astonishing revelations of dread, and perhaps none conveys it with more intensity than his *Murdering Airplane*, 1920 (plate 38). Hovering above the flat horizon, which is the shell-flattened landscape of northern France (Ernst had served in the trenches as an infantryman), the chimerical aircraft is half machine and half bad angel, and the aura of fear that it suggests is very far from the metaphors of angelic modernity that Robert Delaunay, a few years before, had extracted from Blériot's innocent monoplane. Its female arms give it an air of monstrous coquettishness, and the three tiny figures of soldiers are powerless against its visitation. It sums up the feeling of being strafed.

If Ernst had any particular interest in Weimar politics beyond a natural distrust of politicians, however, it was not manifested in his work. Indeed, he left for France as soon as he could, returning in 1921 to "my lovely land of Marie Laurencin," as he called it in the title of one of his collages.

38 Max Ernst *Murdering
Airplane* 1920
Collage $2\frac{1}{2} \times 5\frac{1}{2}$ ins: Private
Collection, USA

39 John Heartfield *Adolf, the
Superman: Swallows Gold
and Spouts Junk* 1932
Photomontage
Akademie der Künste, Berlin

40 Hannah Höch *Pretty Maiden* 1920
Montage of photographs and advertising material
$13\frac{3}{4} \times 11\frac{1}{2}$ ins: Private Collection

The most aggressive political use of photomontage was in the work of John Heartfield, who in the late twenties and early thirties brought it to a pitch of polemical ferocity that no artist has since equalled (plate 39). Here, photomontage develops a kind of truth of which painting is not capable. If Heartfield's scenes of brute power and social chaos had been drawn, they would have seemed impossibly overwrought. Only the "realism" of the photograph, its ineluctably factual content, made his work credible and, to this day, unanswerable. But the most aesthetically gifted political collagist among the Berlin Dadaists in the early twenties was a woman, Hannah Höch (b. 1889). Working on a small scale and almost never for reproduction, Höch laid forth in her photomontages an acrid, edgy vision, the figures adroitly deformed by cutting into, not around, the photo engravings, the buildings multiplied and looming as in an Expressionist film montage, interspersed with fragments of machinery, ball bearings, cogs. Like Picabia, Höch was well aware of the eroticism of machines. She had a fine sense of placement, and however dislocated the contrasts in a given piece might be – between ground view and aerial perspective, close-up and distant shot, organic and mechanical substance, and so on – the whole montage was precisely unified as a surface. From it rose a world at once estranged, bleakly funny, and poisoned at the root (plate 40).

German Dada tried to reject all tradition, but it collided with an old one: the idea of human society as a *Narrenschiff*, a ship of fools, crowded with emblematic passengers of different rank and occupation, condemned for ever to sail without arrival. The Dadaists were as fond of their stereotypes as any Lutheran tract-illustrators had been, and their work swarms with emblematic figures, as popular German woodcuts of the sixteenth century had been filled with satanic popes, hoggish monks, and farting devils. One of the obsessive emblems of Dada was the war cripple. They were on every street corner in Berlin, wretched half-men, displaying what Otto Dix, George Grosz, and their friends perceived as the body re-formed by politics: part flesh, part machine. Prosthetic man, as seen by Dix in *Cardplaying War-Cripples*, 1920 (plate 41), was also a quite specific metaphor. In the eyes of these young artists, all either Communist Party members or radical socialists of one inflection or another, the Weimar Republic too was a political mutant, a war casualty, displaying the surface marks of democracy while leaving the real power in the hands of capitalist, cop, and Prussian officer.

With his mechanical parts, the cripple was brother to the tailors' dummies that Giorgio de Chirico had painted in Italy before 1920. Raoul Hausmann adapted de Chirico's vivid image of alienation and produced the most memorable of all Dada sculptures, *The Spirit of Our Time*, 1921 (plate 42). It illustrates Hausmann's own remark that the ordinary German "has no more capabilities than those which chance has glued on the outside of his skull; his brain remains empty." And so this *Zeitgeist*, a simpering coiffeur's dummy, carries an array of knobs and numbers and even a tape measure for making judgements. It is a vapid statistic, "an O without a figure," offering as mordant a commentary on bureaucracy as Charlie Chaplin's sliding dance through the cogs of the Machine in *Modern Times* did on industrial capitalism.

The master of radical sourness in Berlin, however, was George Grosz (1893–1959).

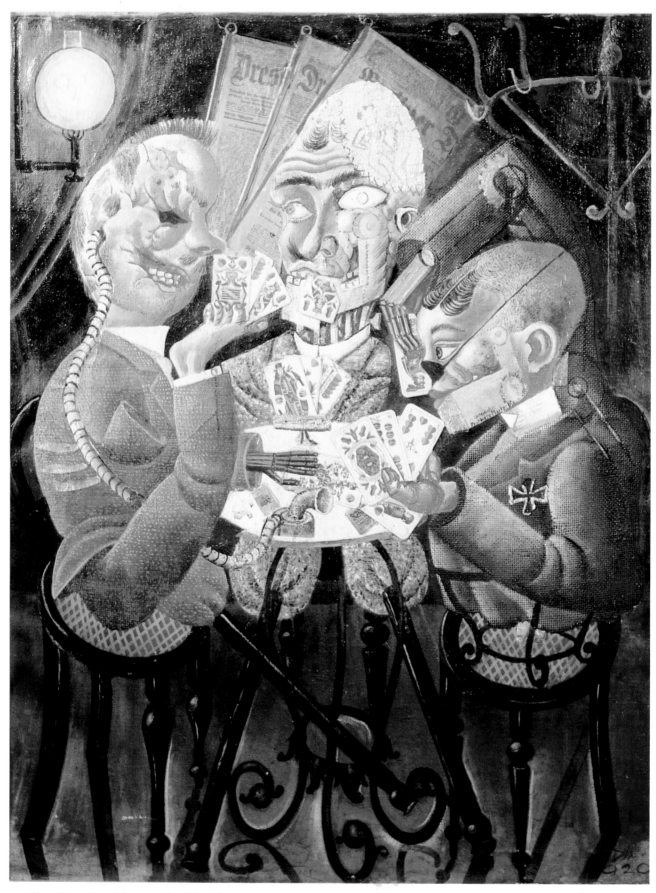

41 Otto Dix *Cardplaying War-Cripples* 1920
Oil on canvas with montage $43\frac{1}{4} \times 34\frac{1}{4}$ ins
Private Collection

One of his friends called him "a Bolshevik in painting, nauseated by painting." This was not quite true; for although Grosz more than once declared that, compared to the practical tasks of political revolution, art was "an utterly secondary affair," it was the only instrument he had, and he used it diligently. It was not painting but mankind that made him sick. To paraphrase Auden's line about W. B. Yeats, mad Germany hurt him into poetry.

He railed against the conformity of Weimar politics: the empty speeches and sloganeering, the promises of a better future to a generation half-destroyed in the Great War, the canting patriotism. In *Republican Automatons*, 1920 (plate 44), the scene is perhaps the "new" Berlin, with its blank Chicago-style warehouses and junction boxes. Two war cripples – evidently members of the bourgeoisie, to judge by their dress; one in black tie and boiled shirt, wearing an Iron Cross, the other in a stiff collar and a bowler hat – occupy the foreground. The peg-legged one waves a German flag and we can imagine the machinery below the other dummy's armpit whirring; the cogs turn; a reflexive cheer issues from his empty egg-cup of a skull.

As with the official transactions of Society, so with the unofficial ones, particularly love. *Daum Marries*, 1920 (plate 43) is in part a group in-joke: the little mechanized man, the "bachelor" on the right – it is interesting that so Duchampian a theme should crop up so often and so far from the as yet unknown *Large Glass*, which was in New York – is closely related to Hausmann's *Spirit of Our Time*, and represents the "abstract" work of the Dadaist as maker of machine-montages; while the plump "bride," one of Grosz's least sparing images of the Berlin whore as piglet, manifestly alludes to the social-realist, politically legible side of Dada. How to marry the two? But although this was partly a comment on the Dadas' own strategies and problems as an artistic group, its larger meaning is obvious. The dummy-husband is Weimar man again, a zero whom society has programmed with certain desires to turn him into an efficient consumer. Grosz makes this clear through the disembodied hands manipulating the information in his head. They rhyme neatly with the other hand, seen tickling Daum's nipple to keep her interest up. The only possible bride for such a bachelor is a whore, whose passions are as mechanical as his actions.

Grosz drew innumerable prostitutes; and he attacked them with a degree of moral vindictiveness that had scarcely been seen in art since the late Middle Ages. To him the whore was the *Giftmädchen*, the poison-maiden of German folklore, the focus of all castration anxiety: bringer of syphilis and ruin. (What closed this chapter of European imagery, after World War II, was not a change in moral attitudes but the commercial availability of penicillin.) Grosz's theatre of capitalism was as clear and memorable as the plot of an old morality play. Here was absolute evil, without qualifications. (Indeed, the Left cartoonists' beloved stereotype of the fat industrialist in a white waistcoat and top hat, sitting on top of a pile of moneybags with a Havana jammed in his face, was largely codified, if not invented, by George Grosz, and all fans of Scrooge McDuck owe him their thanks.) In Grosz's Germany, everything and everybody is for sale. All human transactions, except for the class solidarity of workers, are poisoned. The world is owned by four breeds of pig: the capitalist, the officer, the priest, and the

42 Raoul Hausmann *The Spirit of Our Time* 1921
Combine, height 12¾ ins
Musée National d'Art Moderne, Paris

43 George Grosz *Daum Marries Her Pedantic Automaton George in May 1920; John Heartfield Is Very Glad of It* 1920

Watercolour, collage, pen, pencil
$16\frac{1}{2} \times 11\frac{3}{4}$ ins: Galerie Nierendorf, Berlin

44 George Grosz *Republican Automatons* 1920

Watercolour on paper $23\frac{5}{8} \times 18\frac{5}{8}$ ins
Collection, The Museum of Modern Art, New York,
Advisory Committee Fund

hooker, whose other form is the socialite wife. It is no use objecting, as anyone reasonably could, that there were some decent officers, cultivated bankers, and honourable rich women in Weimar Berlin. One might as well have told Daumier that some lawyers were honest. The rage and pain of Grosz's images simply brushes such qualifications aside. He was one of the hanging judges of art, and his verdicts resonate, whether you like them or not, whether or not you agree with them, every time you see a thick neck in a German beer hall.

From the viewpoint of Paris – still the angle from which art historians tend to think about the art of the twenties – such images seem not only strident but *retardataire*. Worse, they are "illustrative" – but had to be, since not only Grosz but all his fellow Dadaists were anxious for mass reproduction and dissemination of their work, for the sake of political impact. Such strictures, for what they are worth (not much, in my opinion), apply equally to the work of the *Neue Sachlichkeit* or "New Objectivity" painters in Germany during the twenties. Expressionism had produced some memorable political images: one has only to think of Max Pechstein's book-cover for *An Alle Künstler*, 1919, with its artist-hero holding his heart, ablaze with Spartakist fervour, in deliberate imitation of popular Catholic chromos of Christ with his Sacred Heart. But the flaw of Expressionism was precisely that its only hero was the Self; and what worker was likely to identify with a painter's narcissism and *Angst*, however sensitively set forth? "My aim is to be understood by *everyone*," Grosz wrote in 1925. "I reject the 'depth' that people demand nowadays, into which you can never descend without a veritable diving-bell crammed with cabbalistic bullshit and intellectual metaphysics. This expressionist anarchy has got to stop . . . a day will come when the artist will no longer be this bohemian, puffed-up anarchist, but a healthy man working in clarity within a collectivist society." The coming of that day was a general hope of 1920s civilization in northern Europe – for Bauhaus Constructivist and social realist alike. The *Neue Sachlichkeit* shared it to some extent, although not all its painters had the same political fervour as Grosz: theirs was more a recoil from the isolated Expressionist self than an overture to the masses.

"Create new forms of expressionism" – that was the slogan that excited the present generation of artists in recent years. Myself, I doubt if it is possible. . . . The newness of painting, for me, dwells in the enlargement of the realm of subjects and the intensification of forms of expressionism that already exist, in embryo, in the Old Masters. For me, the object comes first, and it is the object that orients form.

Thus Otto Dix, in 1927, and he spoke for a range of artists that included Christian Schad, Rudolf Dischinger, and Karl Hubbuch. Having begun as a Dadaist, Schad by the late twenties was painting sober, tight-focused portraits and genre scenes, in which abundant references to the Renaissance interweave with a current of "Weimar" anxiety. The presiding influence over much *Neue Sachlichkeit* painting, as over Surrealism, was Giorgio de Chirico, and Rudolf Schlichter borrowed from him extensively in works like *The Rooftop Studio*, *c.* 1922 (plate 45). Against a tightly rendered city background, a gathering of various types of sexual fetish, mostly involved with bondage, rubber, leather, and flagellation, is taking place. The model on

45 Rudolf Schlichter *The Rooftop Studio* *c.* 1922
Watercolour and pen drawing 18 × 25 ins
Galerie Nierendorf, Berlin

her plinth recalls de Chirico's statues, the drafting equipment on the table refers to his "metaphysical" instruments and geometrical solids, the knowing little girl with her bucket and sailor suit certainly derives from the similarly clothed child bowling her hoop in de Chirico's *Melancholy and Mystery of a Street*, 1914. But the atmosphere is wholly Schlichter's own: an ambience at once sinister, distanced, and ironical.

Neue Sachlichkeit was part of a wider tendency in Europe and America towards precise and sober form: Charles Sheeler's precisionist American landscapes, Patrick Henry Bruce's late still-lives, Gerald Murphy's liner funnels and giant watch-faces, Fernand Léger's cityscapes, and so on. But it was also visibly and determinedly part of a social whole, and that ambition to work as exemplary public speech, to interpret and comment on and shape the fabric of the time instead of just decorating it, is what makes the culture of Weimar Germany so much more interesting than Paris in the twenties. For a time, Berlin was the leader of modernist culture. Paris Dada is mere froth and capering beside its German equivalent; there is no French architect of the period (except for Le Corbusier, a student of Peter Behrens, who built very little in the twenties) whose achievements, in theory and building, can be compared with the work of Walter Gropius, Mies van der Rohe, Bruno Taut, or Hannes Meyer; no experiment in learning comparable to the Bauhaus; no French theatre equal in vitality to the work of Brecht and Piscator; and few French films, outside the work of Jean Renoir and Vigo's masterpiece *Zéro de conduite*, can stand beside the cinema of Lang or Lubitsch. The successes of French art between 1920 and 1930 were generally those of living Old Masters (Monet in his last years at Giverny) or of men whose major opening statements had been made between 1900 and 1914 – Picasso, Braque, Léger, Matisse. Apart from Surrealism, whose major achievements belong to the thirties anyway, the rest was decor and luxury art, pumped up with copious injections of French cultural chauvinism. Weimar culture wanted to address a broad audience, directly and with constructive, economical means; Paris culture had Art Deco, the last luxury style based on the elegant display of surplus labour in privileged objects. Only the passage of time has turned the either/or of these propositions into the art historian's both/and; yet one does not need to reflect on the matter long before realizing that two such conceptions of culture were fundamentally opposed, and can only be reconciled in a culture that no longer assigns a political role to art. What does one prefer? An art that struggles to change the social contract, but fails? Or one that seeks only to please and amuse, and succeeds? As John Willett has pointed out in his excellent study *Art and Politics in the Weimar Period* (1978), there is no doubt that the political hopes of the Weimar artists failed: "In so far as any country can be said to choose its rulers, Germany chose Hitler, and bitterly as these artists had opposed him it is doubtful if they really persuaded anyone who did not already share the same views." Nevertheless, what was made in the hope of transforming the world need not be rejected because it failed to do so – otherwise one would also have to throw out a good deal of the greatest painting and poetry of the nineteenth century. An objective political failure can still work as a model of intellectual affirmation or dissent, and that is what German art of the twenties can still do today, even though its savage

ideological polarities, its moral palette of black, white, and no greys, may now seem exaggerated. But then, Berlin has long been an emblem of ideological division; and for the last thirty years, its chief symbol has cut right through the city, a literal either/or in grey concrete: the Wall.

On the other side of the Wall, in the Russian empire, not one artist in half a century has enjoyed the minimum freedom that the Dadaists, Expressionists, and *Neue Sachlichkeit* painters took for granted – the right to interpose one's art, even with no guarantees of effectiveness, between the official message and the audience. Over there, Stalin is still rolling in his sleep. But before Stalin there was one moment in Russia when advanced art served the power of the Left, not only freely but in the highest spirit of optimism and with brilliant, if short-lived, results. It happened between 1917 and 1925, when the promise of communism was new and the newness of art fused with it. And as Hitler extinguished the civilization of Weimar, so this new Russian civilization was snuffed out by Stalin and his vengeful cultural hacks in the 1930s.

It was, of course, a modern hope that there could be twin revolutions in the spheres of art and of politics, but this hope was grounded in the nature of late tsarist Russia: an all but static society, not yet industrialized, with little mass communication outside the largest cities, and a tiny élite of aristocrats and cultivated bourgeoisie forming the tip of a pyramid of illiteracy. When societies cannot read, visual image and oral legend take on great importance. For a thousand years, the Russian Orthodox Church had reached its people through the didactic art of icons. So there was reason to suppose a didactic political art might do the same; and that changing the language of art in the name of Revolution might almost be like seizing the television stations today.

And there had been a cultural *avant-garde* in St. Petersburg and Moscow before the Revolution. In 1913, Russia was in closer touch with Europe than it would ever be again after 1930. The successive impacts of Post-Impressionism, Fauvism, Cubism, and Futurism had been felt and absorbed there. Thanks to wealthy bourgeois collectors like Sergey Shchukin and Ivan Morozov, an artist (with the right connections) could see better Matisses and Gauguins than anywhere else in the world, except Matisse's own studio and the eccentric Dr Barnes's collection in Pennsylvania. Before 1914, for instance, Shchukin's collection included thirty-seven Matisses, fifty-four Picassos, twenty-six Cézannes, nineteen Monets, and twenty-nine Gauguins, and among them were many of the artists' greatest works: perhaps no staircase in the world since sixteenth-century Venice could boast painted decorations to equal Matisse's *Dance* and *Music*, installed in Shchukin's palace in 1911.

Not many original Futurist works could be seen in Russia, but this did not matter very much since the artists were free to travel. Thus between 1910 and 1914 even a casual list of the Russian artistic community in Paris would have included nearly all the major figures of the post-revolutionary *avant-garde* (with the exceptions of Kazimir Malevich and Vasily Kandinsky) – Natan Altman, Marc Chagall, Vladimir Tatlin, Eliezer Lissitzky, Ivan Puni, Aleksandra Ekster, Aleksandr Shevchenko, Lydia Popova, Naum Gabo and his brother Anton Pevsner. Cubo-Futurism, as practised by the Russians, often had a decorative or mystical, Orientalizing quality: if

Matisse could go to Morocco, after all, why should not a Russian draw inspiration from the folk arts and weavings of a country that bordered on Persia, Afghanistan, and China? "For me the East means the creation of new forms, an extending and deepening of the problems of colour," wrote Natalya Goncharova in 1912. "This will help me to express contemporaneity – its living beauty – better and more vividly." But contemporaneity meant the machine; and so in Goncharova's paintings, as in early Malevich or even Chagall, one sees incessant references to the machine aesthetic: Goncharova's steam-iron and metallically pleated shirtfront in *The Laundry*, 1912 (plate 46), or the split, flickering planes of Malevich's *Scissors Grinder*, 1912, or the Eiffel Tower that rises like a benediction of modernity in the background of Marc Chagall's *Self-Portrait with Seven Fingers*, 1913 (plate 47).

So the idea that modernism suddenly penetrated a backward tsarist Russia with the advent of the Revolution is plainly absurd. When Russian artists responded to Marinetti and his cult of the machine, they were not doing so as provincials. In fact, they were in much the same position with respect to machine-culture as Marinetti, exasperated by Italian rural life and the traditions it supported, had been in 1909. The Russian economy was still mainly rural; the machine was more a social hypothesis than a dominant fact of life, and machine production – "Americanism" – was so new in Russia that its myth acquired a grandiose, almost religious aspect. "The world," declared the poet Aleksandr Shevchenko in 1913, "has been transformed into a single, monstrous, fantastic, perpetually-moving machine, into a single huge non-animal, automatic organism . . . We, like some kind of ideally manufactured mechanical man, have grown used to living, getting up, going to bed, eating, and working by the clock – and the sense of rhythm and mechanical harmony, reflected in the whole of our life, cannot help but be reflected in our thinking and in our spiritual life: in Art." To a modern reader, such Utopian passages have the ring of a hideously dystopian future – the Stalinist machine-state of Zamyatin's *We* and its English elaboration, Orwell's *1984*. But that was not what the Shevchenkos had in mind. They were imagining a perfect state of explicitness, in which things and the relationships between them were made as clear to human sight as theologians supposed they were to the eye of God – a millennium of consciousness, which art had the enormous responsibility of bringing about. It is a measure of the importance such artists gave to art that they never doubted it could do so. In 1915, Kazimir Malevich, who (with Kandinsky) was the most spiritually oriented of the Russian *avant-gardists*, wrote an ecstatic incantation to this "heroism of modern life : "

Cubism, Futurism and Suprematism were not understood. These artists cast aside the robes of the past, came out into modern life, and found new beauty.
And I say:
That no torture-chambers of the academies will withstand the days to come.
Forms move and are born, and we are forever making new discoveries.
And what we discover must not be concealed.
And it is absurd to force our age into the old forms of a bygone age.
The void of the past cannot contain the gigantic constructions and movement of our life.

46 Natalya Goncharova *The Laundry* 1912

Oil on canvas $37\frac{3}{4} \times 33$ ins
Tate Gallery, London

47 Marc Chagall *Self-Portrait with Seven Fingers* 1913
Oil on canvas 50 × 42 ins: Stedelijk Museum, Amsterdam

What these "constructions" might be remained, for the moment, vague. In Malevich's case, they took two forms. One was the kind of pure, geometrical abstraction to which, because it represented a final disengagement of painting from reality and marked its entry into the exalted realm of pure thought, he gave the name "Suprematism;" its banner and manifesto was the painting which seemed – and in some ways still seems – to mark the farthest limit of painting's escape from its depictive role, *White on White, c.* 1918. The other was his "Architectons," Utopian structures of no clear purpose, somewhere between magic mountain and New York skyscraper, which Malevich envisaged as components of dream cities of the future; they may have had a distant effect on the grandiose, unrealized schemes for social rebuilding that the Russian Constructivists spun after 1917. At times, Malevich's architectural-sculptural fantasies took on a naïvely didactic air. What would be the right house for one of the heroes of Modernity, an aviator? What but a building shaped like a biplane made of bright blocks and slabs (plate 48)?

But whatever the forces latent in the Russian *avant-garde*, it was the October Revolution that furnished its great social metaphor. Here was process and transformation, the literal renewal of history: heroic materialism at work on the social plane, combining the fragments of an abolished reality into a new, collective pattern. One artist, Natan Altman, went so far as to claim that "futurism" (his blanket term for all radical art) was *the* form of "proletarian creation." "How terribly we need to fight against this pernicious intelligibility," he exclaimed, speaking of ordinary poster art – the muscular worker with a red flag. Instead,

take any work of revolutionary, futurist art. People who are used to seeing a depiction of individual objects or phenomena in a picture are bewildered. You cannot make anything out. And indeed, if you take out any one part from a futurist picture, it then represents an absurdity. Because each part of a futurist picture acquires meaning only through the interaction of all the other parts; only in conjunction with them does it acquire the meaning with which the artist imbued it.

A futurist picture lives a *collective life*, by the same principle on which the proletariat's whole creation is constructed.

One could say much the same of a Rubens or a Giotto – take away a piece from any highly organized structure, figurative or not, and the whole falls apart. In that sense, every work of art leads the "collective" life Altman wrote of. But the important thing was that the art of the future – however one defined it – had some general relationship to the October Revolution and its millenarian fantasy, the withering away of the State through the dictatorship of the proletariat (plate 49). The people who lent the Revolution its aesthetic voice, writers like Mayakovsky, artists like Tatlin, Rodchenko, Lissitzky, and Puni, film-makers like Eisenstein and Dziga Vertov, created an art of *expectation*: if one stood at the end of history, it was as natural to deal with the future as for a more conventional artist to deal with the past. But theirs was a future that never came: not the purges and terror in which many of them would end, not the intellectual squalor of modern oligarchic collectivism, but a future of equality and organized energy in which the arts would act as a transformer.

48 Kazimir Malevich *Suprematist Architectural Drawing* 1924
Pencil $12\frac{1}{4} \times 17\frac{3}{8}$ ins: Collection, The Museum of Modern Art, New York, Purchase

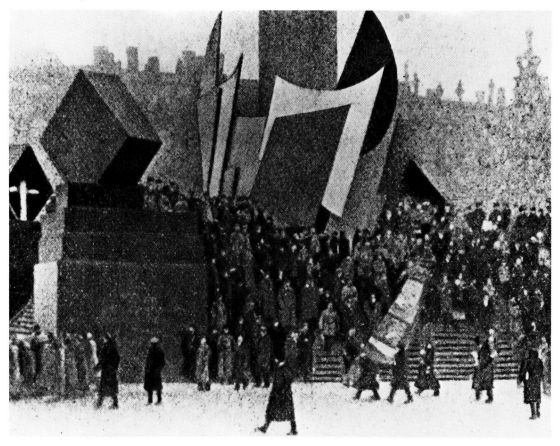

49 Natan Altman *Decoration for the Winter Palace* 1918
Collage and watercolour $11\frac{1}{4} \times 15\frac{1}{2}$ ins
Russian Museum, Leningrad (photo Centre Pompidou)

The Revolution had swept away the middle class. From now on, the only art patron would be the State. By an extraordinary stroke of luck, the Russian *avant-garde* got, from the embryo State, the patron it needed. He was Anatoly Lunacharsky, Lenin's Commissar of Education. A sensitive and idealistic writer, Lunacharsky had shown what must have struck harder revolutionaries as a singular degree of unreliability when he resigned in protest against what turned out, happily, to be a false rumour: that the Red Guards had destroyed the Kremlin and the Church of St. Basil in Moscow. This, Lunacharsky exclaimed, was "a horrible, irreparable misfortune. . . . The People in its struggle for power has mutilated our glorious capital. . . . It is particularly terrible in these days of violent struggle to be Commissar of Public Education." Lenin prevailed on his friend to resume office, and from then on Lunacharsky's intense and very Russian belief in the social centrality of art would give the *avant-garde* its daily bread. He wanted to preserve the past, preferably disinfected of "bourgeois degeneration and corruption, cheap pornography, philistine vulgarity, intellectual boredom." When these traits could not be weeded out, "the proletariat must assimilate the legacy of the old culture not as a pupil, but as a powerful, conscious and incisive critic." But the immediate task of new art was Agitprop, agitation and propaganda. "Art is a powerful means of infecting those around us with ideas, feelings and moods. Agitation and propaganda acquire particular acuity and effectiveness when they are clothed in the attractive and mighty forms of art."

Like the French revolutionaries before them, Lenin and Lunacharsky believed in propaganda-by-monument. Lenin at one point considered, but then abandoned, a plan to dot the streets of Moscow with edifying statues of revolutionary father figures: Danton, Marat, Jaurès, Victor Hugo, Voltaire, Blanqui, Zola, and even Paul Cézanne. His taste was far more conservative than Lunacharsky's, and he did not want to be commemorated as "a Futurist scarecrow;" but the very idea of "monumental" art was reinvented in Russia under his aegis. No state had ever set down its ideals with such radically abstract images, and that they were not actually built is less significant than that they were imagined. Reality was against them: Russia had no spare bronze, steel, or manpower. Artists were therefore employed on more immediate Agitprop jobs that have mostly perished – posters, street theatre floats, and parade decor (plate 50). They designed and distributed, through the Soviet propaganda system, thousands of crude, memorable ROSTA posters, printed in bright Image d'Épinal colours on cheap paper. They painted decorations and slogans on Agitprop trains and even on an "Agit-boat," the *Krasnaya Svezda*, which chugged along the Volga distributing leaflets and showing propaganda films to the peasants along the river. They also took control of the Russian art schools, those incubators of future form. Thus in 1918 the school at Vitebsk was headed by Marc Chagall, and its staff included Malevich and El Lissitzky. Lunacharsky, who was determined to see the birth of "an art of 5 kopecks" – cheap, available to everyone, and modern – created the Higher State Art Training Centre or Vkhutemas School in Moscow. It turned into the Bauhaus of Russia, the most advanced art college anywhere in the world, and the ideological centre of Russian Constructivism.

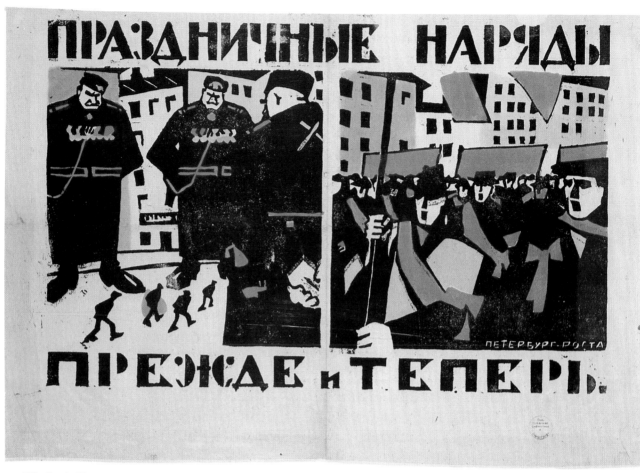

50 Vladimir Kozlinsky *Then and Now: ROSTA Window Poster* 1920–1
Linocut 25 × 15¼ ins: Russian Museum, Leningrad (photo Centre Pompidou)

Of all the tendencies in Russian art, Constructivism seemed closest to the Leninist ideal. It was dialectics made concrete. No more mysticism; instead, the articulation of materials. Instead of primitivism, modernity: the modernity of rivets, celluloid, aeroplane wings, and of stress resolved in frames rather than swallowed in mass. Instead of the static figure, the dynamic unfolding of forces. Art (its creators hoped) would be open to everyone instead of a few initiated souls; and the old class distinctions between artist and artisan, architect and engineer, would be merged in a general conception of art as production.

The most influential of the Constructivists was Vladimir Tatlin (1885–1953). He had been trained as an icon painter, and been a sailor and perhaps a marine carpenter as well; both these *métiers* fed into his sculpture, since each meant working with heterogeneous, "impure" materials – the contrast between painted surface and silver or gold appliqué work, ex-votos and the like in the icons, and the muscular, practical substances of wood, iron, wire, tar, and copper in the shipyards. Could one combine the two, in a didactic, ideal art of *proletarian* material? Tatlin thought so, but his means came from Picasso, whose sculptures of wood, cardboard, and bent tin he had seen on a visit to Paris in 1913. Picasso's constructed sculptures of 1912, especially the *Guitar* (plate 51), were the most radical change in sculpture since the invention of bronze-casting: for the first time, the emphasis shifted from mass to plane, from the lump to the cell, from sculpture as closed volume to sculpture as open assembly. Margit Rowell has pointed out that Tatlin did not share Picasso's ends, and regarded the still-life (which Picasso's sculptures generally were) as a genre tainted by bourgeois conventions. Still-life, after all, was the chief image of private property in Western art. To make "socialist" art, one must stop depicting ownable things: in short, go abstract. (Tatlin would have considered today's art market nothing less than an atrocity.) The expressive power of sculpture would then come from its *Faktura*, a term of Tatlin's which meant, roughly, the speech of material. He wanted, he said, "to combine materials like iron and glass, the materials of modern Classicism, comparable in their severity with the marble of antiquity." These substances had to be the stuff of construction: not expensive, proud materials, but common ones whose beauty was insufficiently known. Once seen, they would disclose a world of material "necessity" parallel to the one in which his hoped-for audience lived, the world of manual work. Tatlin thought of these sculptures as icons, transmitters of social truth; and he placed them where Russians put their icons, in corners (plates 52, 53).

Tatlin's belief in technology earned him the respect of the German *avant-garde*, though his work had not been seen outside Russia; at the Berlin Dada Fair of 1920, Grosz and Heartfield were photographed holding a placard that read: "Art is dead, long live Tatlin's new Machine-Art." Raoul Hausmann made a collage-portrait of him, *Tatlin at Home* (plate 54), the artist as *monteur* or engineer, his head full of mechanical dreams (contrasting with the tailor's dummy, which has human viscera), and more fantasies of heavy machinery projected on the wall behind him, with a map to suggest the internationalism of Tatlin's aesthetic. Such foreign tributes were inspired by one special project of Tatlin's. In 1919, two years after the Revolution, the

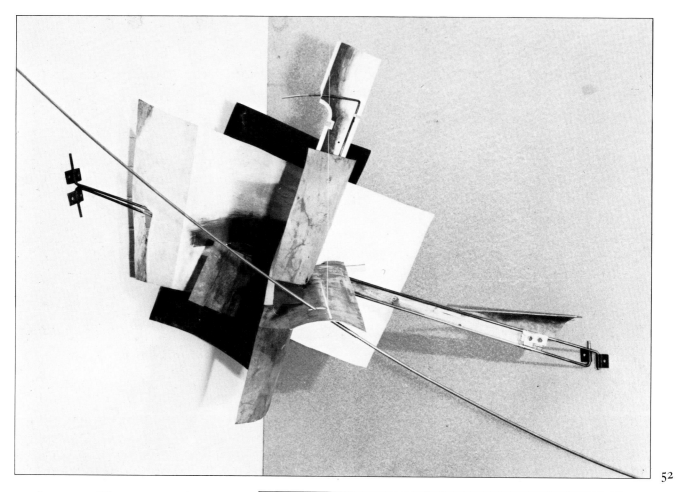

52

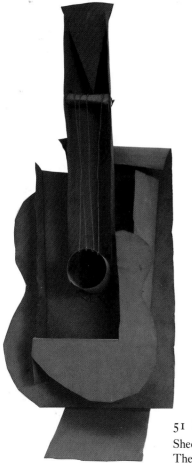

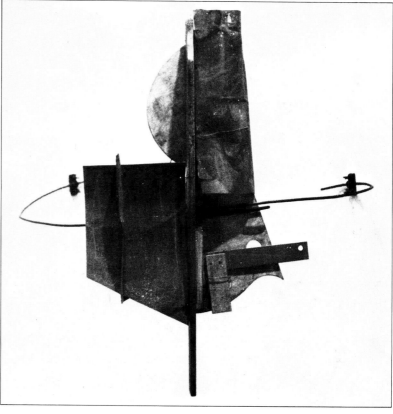

53

51 Pablo Picasso *Guitar* Paris, 1912–13
Sheet metal and wire $30\frac{1}{2} \times 13\frac{1}{8} \times 7\frac{5}{8}$ ins: Collection,
The Museum of Modern Art, New York, Gift of the artist

Vladimir Tatlin *Corner Reliefs* 1915

52 Mixed media $31\frac{1}{2} \times 59 \times 29\frac{1}{2}$ ins
53 Mixed media $33\frac{1}{2} \times 27\frac{1}{2} \times 31\frac{1}{2}$ ins
Reconstructions by Martyn Chalk,
1980 and 1979

54 Raoul Hausmann *Tatlin at Home* 1920

Collage (original lost) 16×11 ins
(photo Moderna Museet, Stockholm)

55 Vladimir Tatlin *Model for the
Monument to the Third International* 1919

The model carried in procession on
May Day 1926 at Leningrad
(photo Centre Pompidou, Paris)

People's Commissariat for Education asked him to design a monument to the Third Communist International. The model was unveiled to Russian officials in Moscow at the 8th Congress of the Soviets, in the winter of 1920.

The monument was to be a slanting tower, thirteen hundred feet high – three hundred feet higher than the Eiffel Tower (plate 55). As Eiffel's structure had been the symbolic climax of nineteenth-century technology, so Tatlin's would be the emblem of twentieth-century skills: in fact, the banner which hung above his model of the tower, bearing the words, "Engineers create new forms," was later carried through the streets of Moscow by crowds of chanting students. With its construction, Russia would have the world's highest building and Marxism-Leninism would have discovered its perfect metaphor in architecture. The metaphor was one of dynamism and dialectical change. To begin with, the tower contained three chambers. A cubic hall at the lowest level would house the legislative council of the Third International; it would turn one degree every twenty-four hours, a complete rotation every year. Above it, the pyramidal executive block would rotate once a month. Atop that, Tatlin placed a cylinder, meant to be an information centre, turning once a day; and surmounting the whole, a half dome. This structure, kept in perpetual motion by "special machinery" – it would have had to be special, indeed – was housed in an external grid, two spirals, soaring diagonally into the sky. The whole tower would be built of iron and glass. "By the transformation of these forms into reality," a contemporary description of this project runs, "dynamics will be embodied in unsurpassable magnificence, just as the pyramids expressed once and for all the principle of statics." As the immobility of the Pyramids reflected the stasis of monarchy, so the upward, perilous surge of Tatlin's tower would express the dialectic unfolding of the Revolution.

From antiquity the spiral had been a symbol of triumphant aspiration, and a partial list of the tower's precedents would include Trajan's column, the tenth-century tower of Samarra in Iraq, and Breughel's painting of the Tower of Babel in Vienna. But none of these were industrial symbols, and they did not move. In designing a monument of clearly articulated parts, and relating it at every point to utilitarian logic and the processes of the machine, Tatlin had virtually defined what Constructivism meant and what its political role might be – if the politicians were committed to it. But they could not be. There was not enough steel in all Russia to build the tower, and it was never built. It remains the most influential non-existent object of the twentieth century, and one of the most paradoxical – an unworkable, probably unbuildable metaphor of practicality.

Tatlin's Utopianism pervaded the work of other Russian artists; it was one of the traits of the post-Revolutionary ferment and Tatlin's tower was not its least realistic product – other architects were thinking of cities on springs and wings. (With hindsight, one can perhaps see that unachievable projects were the right monuments to an ideal. Because they were not built, they could not be destroyed.) Like Tatlin, El Lissitzky (1890–1941) – painter, sculptor, typographer, illustrator, *monteur*, and all-purpose designer – tried to marry abstract form to social use. His paintings, to which

he gave the name of "Prouns" (the word was a contraction of a Russian phrase meaning "projects for affirming the new"), were like plans for imaginary cities, seen from above, as though Malevich's squares and oblongs had been rendered in three dimensions (plate 57). With their intersecting planes and precise, sober, crystalline space, organized around the "dynamic" diagonal rather than the "passive" horizontal and the "authoritarian" vertical, they were meant to be "way-stations" between painting, sculpture, and architecture. Their drafted exactitude, for Lissitzky, was a sign of economy and realism – "the frayed point of the paintbrush is at variance with our concept of clarity." They would also, he hoped, lay the ground for an environmental art of the future, one of whose essays was the *Proun-Space* he installed in Berlin in 1923. It is hardly possible for us, nearly sixty years later, to expect what Lissitzky expected from art: it was, to him, nothing less than an instrument of the millennium. "After the Old Testament there came the New," he wrote in a manifesto entitled *Suprematism in World Reconstruction*, 1920. "After the New the Communist – and after the Communist there follows finally the testament of Suprematism." Only against the background of such fervid belief can one grasp the meaning of his poster, *Beat the Whites with the Red Wedge*, 1919 (plate 56). To an eye used to abstract art, it is quite decipherable, given the length of time one might normally accord it in a museum: the sharp red triangle, symbolizing the unified power of the Bolsheviks, thrust into the scattered units of the White Russians. The same motif was proposed as a public sculpture by the artist Nikolai Kolli (plate 58). But what could it have meant when glimpsed in a Russian street – let alone a country village – in 1919? Not much; the language was too new.

Many of Lissitzky's propaganda ideas were more practical. He was one of the greatest typographical designers of the century. If it had been built, his speaking platform for Lenin would have been an inspiring object, a steel space-frame bearing the Revolutionary leader upward over the heads of the crowd: the exact reverse, in its deft airiness, of tsarist or Stalinist State architecture. "Constructivism," remarked Lissitzky's Hungarian colleague, László Moholy-Nagy, "is the Socialism of vision," and the Lenin Tribune shows what he meant. Its essence is *veshch*, the "thing in itself," art declaring itself to be material-plus-work.

The most effective fusion of art and public life within the Russian *avant-garde* was made by Aleksandr Rodchenko. Rodchenko (1891–1956) was a gifted painter who turned to graphic design and photography, and he shared Lissitzky's vision of the new State as a total work of art. "Non-objective painting is the street itself, the squares, the towns, and the whole world. The art of the future will not be the cozy decoration of family homes. It will be just as indispensable as 48-storey skyscrapers, mighty bridges, wireless, aeronautics and submarines, which will be transformed into art." Not content with uttering these Futurist sentiments, Rodchenko tried to put them into practice on the modest and practical level of design and photography. In a society where the poster had become a primary form of mass communication (a partial list of Russian posters issued between 1917 and 1923 runs to about 3000), Rodchenko was its most original designer: his style, brilliant and punchy, was adapted to the

56

58

56 El Lissitzky *Beat
the Whites with the
Red Wedge* 1919

Poster 23 × 19 ins
Van Abbemuseum, Eindhoven

58 Nikolai Kolli *The Red
Wedge* 1918

Cartoon, charcoal, watercolour 13 × 8 ins
Museum of Architecture A. Shchusev,
Moscow (photo Centre Pompidou)

57 El Lissitzky *Proun Composition
c.* 1922

Gouache and ink on paper $19\frac{3}{4} × 15\frac{3}{4}$ ins
Collection, The Museum of Modern Art,
New York, Gift of Curt Valentin

57

inexpensive printing systems available, rarely using more than two colours in addition to black. His images (plate 59) were as direct and arresting as a shout in the street. They were not fantasies, like modern advertising, but organizations of what was available: what the street gave. The slogans were terse and, to a capitalist eye, naïvely unglamorous:

Anyone who is not a shareholder of DOBROLET is not a citizen of the USSR.

Down with incoherent drunkards! Drink KAYL'BAKHOVSKY beer, drink the beer with the double gold label!

All we have left from the old régime are IRA cigarettes.

and, in a worthy appeal against waste, even waste of babies' pacifiers:

There have never been such good dummies, suck 'em till you're old.

One of the copywriters who worked with Rodchenko on these posters was the national poet of Russian modernism, Vladimir Mayakovsky: they had a common workshop stamp which read "Advertisement Constructors, Mayakovsky-Rodchenko." That two such men, leaders in their respective arts, could work together on advertisements for State products at a time when T. S. Eliot was agonizing over having to work in a bank, says much about the Constructivist spirit. The aim was to develop fully every way of addressing one's fellows, not to scramble for places on the hierarchical ladder of the arts.

The best medium for achieving this aim was, of course, photography. In Rodchenko's view, photography was instant socialism: it was fast, cheap, real, and its images could be indefinitely repeated, copied, and distributed. Photography, Rodchenko argued, would supply the real monuments of the future:

> Tell me, frankly, what ought to remain of Lenin:
> an art bronze,
> oil portraits,
> etchings,
> watercolours,
> his secretary's diary, his friends' memoirs –
>
> *or*
>
> a file of photographs taken of him at work and rest,
> archives of his books, writing pads, notebooks,
> shorthand reports, films, phonograph records?
> I don't think there's any choice.
> Art has no place in modern life. . . . Every cultured modern
> man must wage war against art, as against opium.
>
> Photograph and be photographed!

This insight about the commemorative power of media was both prophetic and true. But only in a Constructivist context could the factual power of the document be thought greater than the idealizing power of the "art" portrait. Rodchenko objected to the latter because it was "synthetic" – a sum of approximations, falsely generalized

into a unity. He preferred the veracity of the distinct, free fact, the individual moment seen bare. As illusion, the still camera could not rival movies. But when the photograph was distorted and reassembled, it might do so: hence Rodchenko's photomontages, which influenced – and in turn were influenced by – the work of his friend, the Russian documentary film-maker Dziga Vertov.

How much did the work of such men do to produce a new consciousness in Russia? It is impossible to say; the tracks are too thoroughly covered. On the face of it, their work does not seem to have had any lasting effect on the proletariat. It was too new, and then it was repressed too early. The big projects could not be built because of shortages; Lenin would have been a fool to commit State funds to grandiose monumental schemes, however edifying. His attitude was summed up in a remark to Lunacharsky: "During the famine, let the *avant-garde* theatres live on their enthusiasm! We must exert every effort lest the fundamental pillars of our culture collapse." Rodchenko's montages made highly sophisticated allusions to icons, but they could hardly be recognized, let alone savoured, by a half-literate machinist from Magnetogorsk or a Black Sea fisherman. So the drift away from encouraging the new art began well before Lenin's burial; whereupon Stalin made anything that was not mass art a State crime. In his eye, the Constructivists were bourgeois formalists – specks of free imagination in the ocean of his new Russia. Some died in the purges, the rest were deprived of work by his *apparatchiks*; and so State art in Russia went back to its traditional task of reinforcing the narcissism of power.

Was this the end of all transactions between the *avant-garde* and the totalitarian régimes of Europe? By no means. We like to think that modernism is left-wing, or at least virtuously liberal, by nature. But to think so is to reckon without Futurism, which became the house style of Italian fascism in the years after Mussolini's March on Rome. Marinetti provided Mussolini with his platform style, a rhetoric of newness, youth, anti-feminism, violence, war fever, and, uniting all these social virtues, the familiar central myth of dynamism. Futurist artists proved gratifyingly amenable to *Il Duce*'s desire for self-commemoration, and for a time the Mussolinian chin bid fair to rival the Cubist guitar as one of the clichés of advanced-looking Italian art at the Venice Biennales (plate 60). The desirable thing about modern art, from the Fascist point of view, was its modernity; it signalled the renewal of history on the cultural plane, as fascism promised it on the political. In 1933, the tenth anniversary of his rise to absolute power in Italy, Mussolini decreed the organization of a cultural fair in Rome to glorify the Fascist Revolution. His architect gave an exposition building at the foot of the Pincio, outside the Muro Torto, a sleek mechano-Deco façade in black metal, with giant fasces and axes (plate 61). It was filled with room after room of didactic, environmental displays, interspersed with single murals and sculpture. The catalogue announced, in true Futurist style, that it wanted to capture

the atmosphere of the times, all fire and fever, tumultuous, lyrical, glittering. It could only take place in a style matching the artistic adventures of our time, in a strictly contemporary mode. The artists had from *Il Duce* a clear and precise order: to make something MODERN, full of daring. And they have faithfully obeyed his commands.

59 Aleksandr Rodchenko *Poster for* Trekhgornoe *Beer* 1923
Museum of Modern Art, Oxford

60 R. A. Bertelli *Head of Mussolini* 1933
Black ceramic height 19¼ ins
Imperial War Museum, London

If one were to ignore the political labels, there would be little or no difference between the more inventive rooms of the Mostra della Rivoluzione Fascista and the Russian Agitprop projects. Exactly the same techniques were pressed into service: the bombardment of slogans mixed with visual material, the use of montage, collage, and photo-enlargements, the Cubo-Futurist shapes, the cinematic projections. The exhibition contained one particularly gripping prediction of Minimal art: the Room of the Fallen Heroes, with its black slab rising in the middle of a space defined by a sweeping curve of black wall, whose surface was covered with the repeated parade-answer: *Presente, presente, presente*, the barking rollcall of Fascist loyalty.

Such spectacles, so replete with the confidence of their brutal modernism, were best described by the German essayist Walter Benjamin, who saw that the Fascist cult of war and Marinetti's delight in the "metallization of the human body" and "fiery orchids of machine-guns" were one and the same. "All efforts to make politics aesthetic culminate in one thing, war," Benjamin noted. "Fascism, as Marinetti admits, expects war to supply the artistic gratification of a sense perception that has been changed by technology. This is evidently the consummation of art for art's sake." The full reach of totalitarian aestheticism would not be seen until the Berlin Olympics of 1936 and the various Nuremberg Rallies conjoined two cultural elements that had nothing to do with painting but were equally important in Russia, Germany, and Italy – film, and the cult of the gymnastic body. But the idea that fascism always preferred retrograde to advanced art is simply a myth. Several of the artists and architects who created the paean of praise to the Rivoluzione Fascista in 1933 were later to be placed among the senior figures of Italian modernism. Thus Marino Marini, better known for his horses and riders, supplied a travertine figure of *Italy in Arms* (plate 63), while Enrico Prampolini did a mural of Mussolini's Black Shirts trampling the red flags of communism during the Fascist rising of 1919 (plate 62) in a style heavily indebted to Fernand Léger.

The only moral of this, apart from the familiar fact that artists tend to work for whoever pays them, is that modernist styles were value-free and could serve almost any ideological interest. This was equally true of that dictator's delight, neo-classicism, the house style of Hitler and Stalin. Nevertheless, each side stoutly believed that its brand of Doric wedding cake was better. Albert Speer, Hitler's architect and later his Minister of Armaments, still maintains that "the Russians in my opinion were crude in their architecture. We had a fine architecture, of course; but theirs was crude."

What Speer designed for Hitler in the thirties has little to do with modernism, except for the crucial fact that he did it in the twentieth century and that he would not have been asked to do it if Hitler did not share the fundamental beliefs of the Weimar *avant-garde* on one point: that architecture was uniquely fitted to serve as the voice of ideology. (On this, see Chapter 4, "Trouble in Utopia.") If they had been built, Speer's designs for Hitler would have been the most grandiose State structures since the time of the Pyramids – indeed, some of them were much larger than Cheops's own memorial. In 1925, a penniless nobody, Hitler was already sketching giant domes and

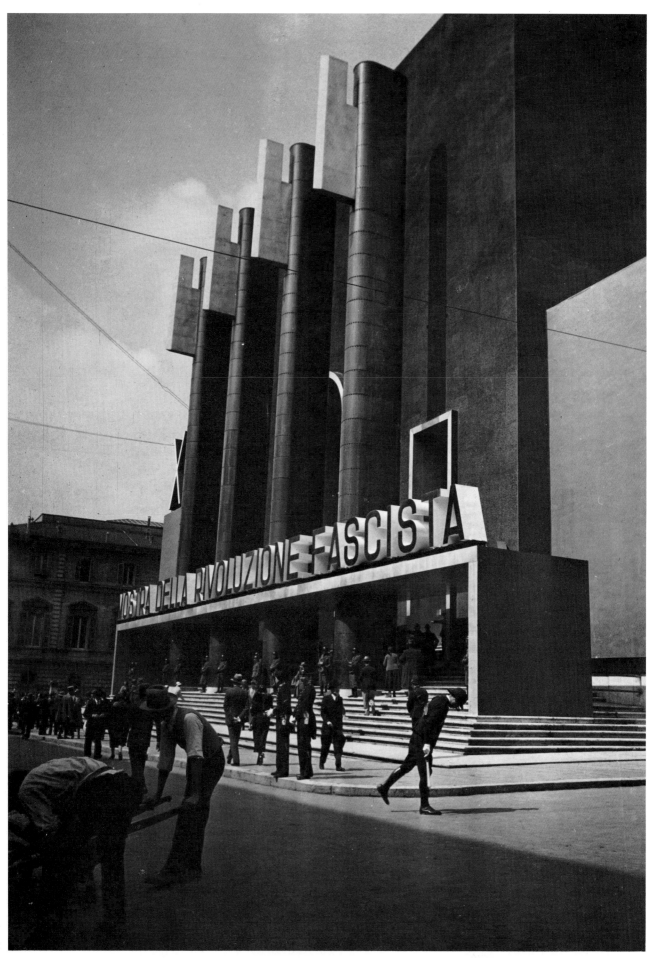

62

62 Enrico Prampolini *Mussolini's Blackshirts,*
15 April 1919 1933
Mural for Mostra della Rivoluzione Fascista

63 Marino Marini *Italy in Arms* 1933
Stone sculpture for Mostra della
Rivoluzione Fascista

61 *Mostra della Rivoluzione Fascista, Rome* 1933
Mansell Collection, London

63

arches for a remade Berlin, capital of the world. With the aid of Siemens and AEG, Germany's biggest engineering firms, Speer almost translated them into reality; only World War II stopped him. The Berlin Dome, meant to accommodate 130,000 Nazi Party members for ceremonies, declarations of war and peace, and the like, was to have been over 250 metres high and seven times the diameter of Michelangelo's dome for St. Peter's (plates 64, 65). It was so big that rainclouds would have formed inside it, from the precipitation of warm breath and crowd sweat to the top of the cupola. But the size of the dome was self-defeating, for, as Speer recalls, "In such a huge building the man who is most important, the person for whom it is really done, shrinks to nothing. One can't see him. I tried to solve the problem but I couldn't. I was going to put a huge eagle with a swastika behind him to say 'Here he is,' but Hitler would really have been invisible in the grandeur." The Berlin Dome, in fact, marked the point at which architecture must necessarily concede defeat – in a mass state – to mass media. The Nazis could not scale up the politics of the agora to the dimensions of the Thousand-Year Reich, by bringing all the people to the Führer. The solution would have been to bring the leader into everyone's living room, by television; but that had to wait another twenty-five years.

Speer knew that authority demanded an architecture of absolute regularity, like the rhythm of jackboots on concrete. Its purpose was to promote unity, not to articulate feeling. In the Nuremberg Stadium the single spectator had to be the merest cipher, for, as Speer put it:

It was not my aim that he should feel anything. I only wanted to impose the grandeur of the building on the people in it. I read in Goethe's *Travels in Italy* that, when he saw the Roman amphitheatre in Verona, he said to himself: if people with different minds are all pressed together in such a place, they will be unified in one mind. That was the aim of the Stadium; it had nothing to do with what the small man might think personally.

The Nuremberg Stadium had the same horseshoe plan as the little Roman amphitheatre in Verona, but it would have held 450,000 people. It was never built. In fact, of all the projects that Speer designed for Hitler, the domes, arches, palaces, stadia, and tombs, only one exists today – the remains of Hitler's reviewing stand at the Zeppelin Field in Nuremberg. As the Berlin Dome was the Nazi equivalent, and precise opposite, to Tatlin's tower, so this wreck of a building counterfaces Lissitzky's Lenin Tribune. The mass against the grid; centrality against dispersion; a ponderous, crushing symmetry against the play of irregular units; stone and bronze against iron and glass; absorption of stress in mass, as against visible distribution of it through a frame. Twice as long as the Baths of Caracalla, the reviewing stand would be the stone witness to the beginning of the Third Reich and the end of history. And so it is; but not quite as Speer meant it to be.

Today, only its ruin is left. The colonnade and the eagle were demolished by cannon at the end of the war. The stepped bulk that survives, with salad herbs growing in the cracks of the low-grade limestone – "I can only say, thank goodness that I am no longer working for Hitler – he would have been furious with me about the poor stone

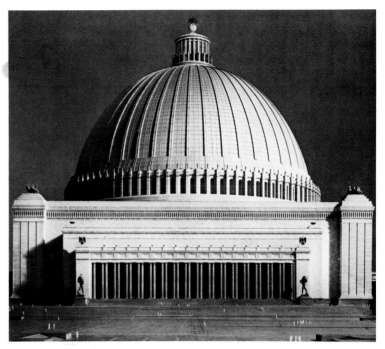

64, 65 Albert Speer *The Berlin Dome,*
"The Empire of Light"
Drawing and model

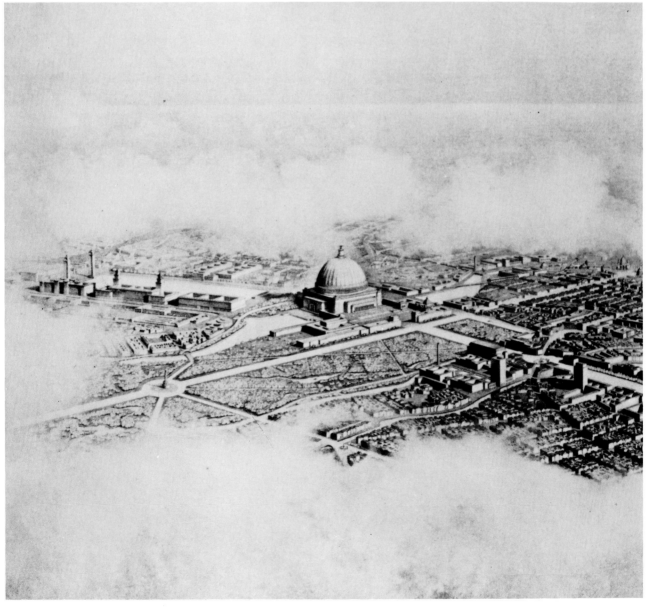

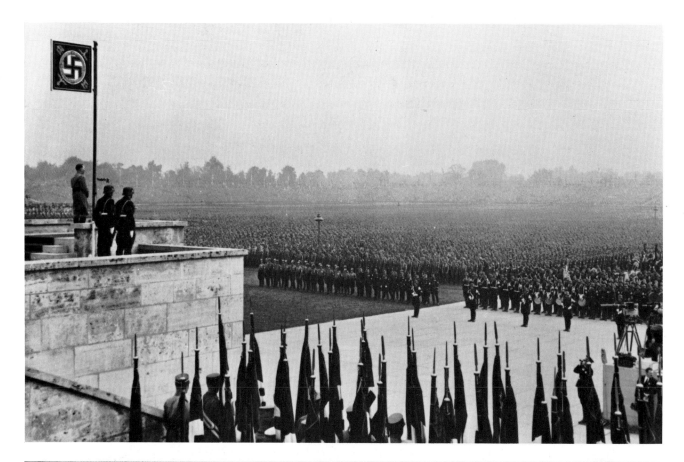

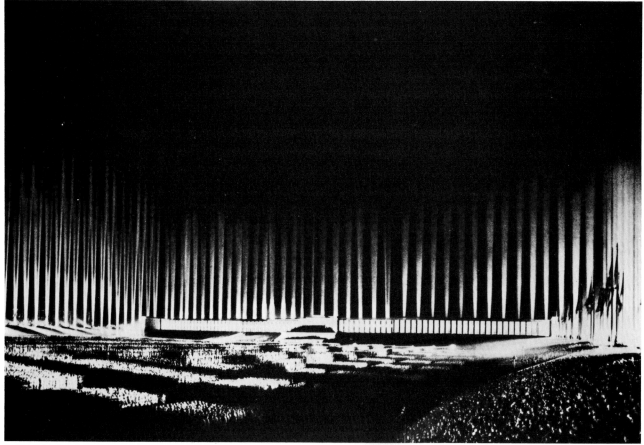

66 *Hitler's Reviewing Stand, Nuremberg* 1937 (photo Ullstein)
67 Albert Speer *Drawing for the Reviewing Stand*

quality!" jokes Speer – is still blunt and dreadful testimony to the coercive power of minimum form (plate 66, 67). An epitaph for its builder and his client was written by W. H. Auden when the Tribune was new:

> Perfection, of a kind, was what he was after,
> And the poetry he invented was easy to understand.
> He knew human folly like the back of his hand,
> And was greatly interested in armies and fleets.
> When he laughed, respectable senators burst with laughter,
> And when he cried, the little children died in the streets.

It was under Speer's influence that Mussolini, later in the thirties, switched away from modernism to a classical style of State architecture, and even built a new Italian Forum outside Rome, decorated with heroic nudes and Prampolini's mock-antique mosaics. The metaphor of such enterprises was, of course, continuity – the past underwriting the present. If Hitler had been impressed by the ruins of Rome and wanted, like many another tyrant, to surpass them, Mussolini owned the ruins themselves, and he got his architects to exploit them. There had been the Rome of the Caesars, and the Rome of the Popes, but now there would be *Terza Roma*, the Rome of Fascism, set halfway between St. Peter's and the mouth of the Tiber. Mussolini expected to finish the job by 1942, his planned date for the EUR or Rome World's Fair. The final flourish was to have been a triumphal arch, a soaring ellipse of reinforced concrete. Eventually this was built, not in concrete but in steel, and not in Rome either, but by Eero Saarinen as the "Gateway to the West" in St. Louis, Missouri.

When Hitler made his first State visit to Rome in the thirties, Mussolini had the last mile of railway track into the Stazione Termini lined with fake apartment blocks. Thousands of Italians stood on concealed scaffolding, leaning from the windows, cheering the Führer. This provoked one wag to write a pasquinade, which ran:

> *Roma di travertino*
> *Rifatta di cartone*
> *Saluta l'imbianchino,*
> *Il suo prossimo padrone*
>
> (Rome of marble, rebuilt in cardboard, salutes
> the housepainter who will be its next ruler.)

EUR, as Mussolini's Third Rome is called, is cardboard Rome: neo-classicism with a cookie-cutter. There was no need to pull it down, since it was far enough from the main city not to be a troublesome symbol. It obeys the same criteria as Speer's work, without the gigantic size – authoritarian architecture must be clear and regular on the outside, and let the passing eye deduce nothing of what goes on inside. It must be poker-faced to the point of immobility; the mask must not slip. No surviving Fascist building does this better than the Palace of Italian Civilization at EUR (plate 68). Twenty-five years later, most new American university campuses, particularly in southern California, would have at least one building that looked like it. As if by

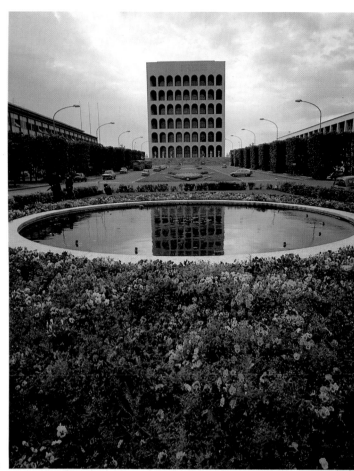

68 *Palace of Italian Civilization,
EUR, Rome*

69 *Lyndon Johnson Memorial Library,
Austin, Texas*

68

69

osmosis, it became the reigning style for cultural centres and other buildings emblematic of civic high-mindedness: the main ingredients of the architecture of State power, as imagined by the totalitarian hacks of our century, became known as the Architecture of Democracy when they crossed the Atlantic in the 1950s. What grandeur came down to was historical revival *sans* trim: not direct nostalgia, certainly not ironic parody, but solemn unconscious parody. Its examples are legion; they stretch from the Lincoln Center in New York, that vulgar parody of the Campidoglio, to the brutish blandness of the Kennedy Center for the Performing Arts in Washington, to the all-out *Mussolinismo* of the entrance to the Lyndon Johnson Memorial Library in Texas (plate 69). It was the international power style of the fifties and sixties, as Art Deco had been in the thirties: scaleless, opaque, the metaphors out of control.

The scariest example we have of it is the seat of government for New York State, Albany Mall. As Nelson Rockefeller's monument, it has a Roman coarseness and a more than Roman size: a stone plateau, modelled on the ceremonial buildings of Brasília (Chapter 4) and, if possible, even uglier than they. It is designed for one purpose and achieves it perfectly: it expresses the centralization of power, and one may doubt if a single citizen has ever wandered on its bleak plaza, so out of scale that even the marble facing seems like white formica (plate 70), and felt the slightest connection with the bureaucratic and governmental processes going on in the towers above him. This place makes Albert Speer's projects seem delicate. Its meaning is utterly simple; there are no ambiguities. All the joys of Minimalism are here. What speaks from these stones is not the difference between American free enterprise and, say, Russian socialism, but the similarities between the corporate and the bureaucratic states of mind, irrespective of country or ideology. One could see any building at Albany Mall with an eagle on top, or a swastika, or a hammer and sickle; it makes no difference to the building. For if one considers what it actually built (rather than what was said about what it built), there can be no doubt that modernist culture has its own language of political power. It is not linked to any particular ideology. It is value-free and can mean anything the patron wants. It is, in essence, an architecture of coercion. The one thing our century has not given us, in the arena of State architecture, is an image of free will.

On the other hand, what is left of the art of dissent? Very little. Diego Rivera (1886–1957), the prodigiously fecund Mexican muralist who covered acres of wall with images of production and revolution, and was perhaps the only major modern artist outside Germany and Russia to devote himself to an art of complete social eloquence, left no successors whose work could compare to his own immense energies. The scope of Rivera's art, and the national prestige it still enjoys in Mexico, came from special historical circumstances; the Mexican masses, like those of Russia, were pre-electronic, low in literacy, and used to consulting popular devotional art as a prime source of moral instruction. Elsewhere, only one humane, political work of art in the last fifty years has achieved real fame – Picasso's *Guernica*, 1937 (plate 71). It is the last of the line of formal images of battle and suffering that runs from Uccello's *Rout of San*

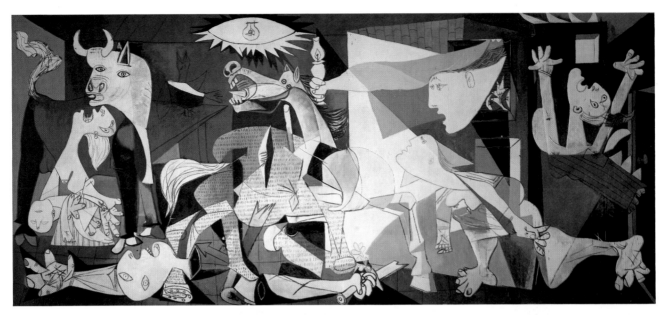

71 Pablo Picasso *Guernica* 1937
Oil on canvas 137½ × 306 ins
Prado Museum, Madrid

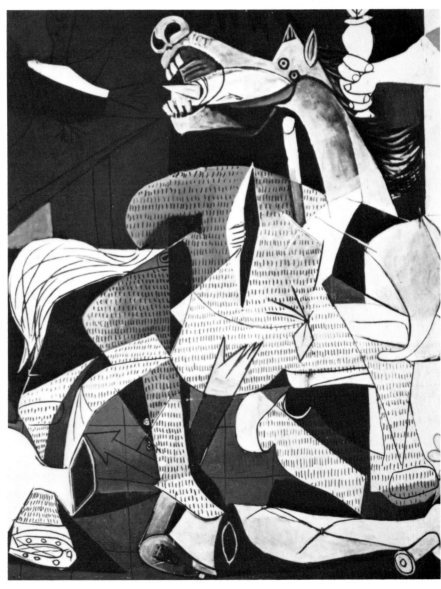

71a Detail from *Guernica*

Romano through Tintoretto to Rubens, and thence to Goya's *Third of May* and Delacroix's *Massacre at Chios*. It was inspired by an act of war, the bombing of a Basque town during the Spanish Civil War. The destruction of Guernica was carried out by German aircraft, manned by German pilots, at the request of the Spanish Nationalist commander, General Emilio Mola. Because the Republican government of Spain had granted autonomy to the Basques, Guernica was the capital city of an independent republic. Its razing was taken up by the world press, beginning with *The Times* in London, as the arch-symbol of Fascist barbarity. Thus Picasso's painting shared the exemplary fame of the event, becoming as well known a memorial of catastrophe as Tennyson's *Charge of the Light Brigade* had been eighty years before.

Guernica is the most powerful invective against violence in modern art, but it was not wholly inspired by the war: its motifs – the weeping woman, the horse, the bull – had been running through Picasso's work for years before Guernica brought them together. In the painting they become receptacles for extreme sensation – as John Berger has remarked, Picasso could imagine more suffering in a horse's head than Rubens normally put into a whole Crucifixion. The spike tongues, the rolling eyes, the frantic splayed toes and fingers, the necks arched in spasm: these would be unendurable if their tension were not braced against the broken, but visible, order of the painting. It is like a battle-sarcophagus, cracked and riven, but still just recognizable as a messenger from the ancient world – the world of ideal bodies and articulate muscular energy, working in a flat carved stone space. As a propaganda picture, Guernica did not need to be a specific political statement. The mass media supplied the agreement by which it became one, and Picasso knew exactly how and where to insert his painting into that context – through the Spanish pavilion at the Paris World Exhibition, where it was shown in 1937 as a virtually official utterance by the Republican government of Spain. Seen detached from its social context, if such a way of seeing were either possible or desirable (in Picasso's view it would not have been, but there are still formalists who disagree), it is a general meditation on suffering, and its symbols are archaic, not historical: the gored and speared horse (the Spanish Republic), the bull (Franco) louring over the bereaved, shrieking woman, the paraphernalia of pre-modernist images like the broken sword, the surviving flower, and the dove. Apart from the late Cubist style, the only specifically modern elements in *Guernica* are the Mithraic eye of the electric light, and the suggestion that the horse's body is made of parallel lines of newsprint, like the newspaper in Picasso's collages a quarter of a century before. Otherwise its heroic abstraction and monumentalized pain hardly seem to belong to the time of photography and Heinkel 51s. Yet they do: and Picasso's most effective way of locating them in that time was to paint *Guernica* entirely in black, white, and grey, so that despite its huge size it retains something of the grainy, ephemeral look one associates with the front page of a newspaper.

Guernica was the last great history-painting. It was also the last modern painting of major importance that took its subject from politics with the intention of changing the way large numbers of people thought and felt about power. Since 1937, there have

been a few admirable works of art that contained political references – some of Joseph Beuys's work (plate 245) or Robert Motherwell's *Elegies to the Spanish Republic* (plate 103). But the idea that an artist, by making painting or sculpture, could insert images into the stream of public speech and thus change political discourse has gone, probably for good, along with the nineteenth-century ideal of the artist as public man. Mass media took away the political speech of art. When Picasso painted *Guernica*, regular TV broadcasting had been in existence for only a year in England and nobody in France, except a few electronics experts, had seen a television set. There were perhaps fifteen thousand such sets in New York City. Television was too crude, too novel, to be altogether credible. The day when most people in the capitalist world would base their understanding of politics on what the TV screen gave them was still almost a generation away. But by the end of World War II, the role of the "war artist" had been rendered negligible by war photography. What did you believe, a drawing of an emaciated corpse in a pit that looked like bad, late German Expressionism, or the incontrovertible photographs from Belsen, Maidenek, and Auschwitz? It seems obvious, looking back, that the artists of Weimar Germany and Leninist Russia lived in a much more attenuated landscape of media than ours, and their reward was that they could still believe, in good faith and without bombast, that art could morally influence the world. Today, the idea has largely been dismissed, as it must be in a mass media society where art's principal social role is to be investment capital, or, in the simplest way, bullion. We still have political art, but we have no *effective* political art. An artist must be famous to be heard, but as he acquires fame, so his work accumulates "value" and becomes, ipso facto, harmless. As far as today's politics is concerned, most art aspires to the condition of Muzak. It provides the background hum for power. If the Third Reich had lasted until now, the young bloods of the Inner Party would not be interested in old fogeys like Albert Speer or Arno Breker, Hitler's monumental sculptor; they would be queuing up to have their portraits silkscreened by Andy Warhol. It is hard to think of any work of art of which one can say, *This* saved the life of one Jew, one Vietnamese, one Cambodian. Specific books, perhaps; but as far as one can tell, no paintings or sculptures. The difference between us and the artists of the 1920s is that they thought such a work of art could be made. Perhaps it was a certain naïveté that made them think so. But it is certainly our loss that we cannot.

THE LANDSCAPE OF PLEASURE

One of the projects of art is to reconcile us with the world, not by protest, irony, or political metaphors, but by the ecstatic contemplation of pleasure in nature. Repeatedly, artists offer us a glimpse of a universe into which we can move without strain. It is not the world as it is, but as our starved senses desire it to be: neither hostile nor indifferent, but full of meaning – the terrestrial paradise whose gate was not opened by the mere fact of birth.

The nineteenth century did not invent the art of pleasure; it broadened it. There was some truth in the remark of Talleyrand, Napoleon's foreign minister, that he who had not lived before the French Revolution did not know the sweetness of life. For the rich this was an absolute truth, since the pleasure principle in eighteenth-century art was the virtual property of one class: the aristocracy. The great image of civilized pleasure in painting was the Arcadian scene – a gathering of people enjoying themselves in the open air, on the green lawn of an amenable landscape, by a fountain, beneath arching trees, either naked or in formal dress: Culture preening itself in the presence of its opposite, Nature. These idealized picnics began with Giorgione and Titian in sixteenth-century Venice. They are evidence that the forest-fears of the mediaeval world have at last been exorcised: Nature is now benevolent, and can be entered, symbolically at least, without a shudder. It is in Arcadia that earlier images of Paradise as an enclosed garden – walled and bowered, to keep the demonic aspects of untamed nature at bay – joins up with the secondary image of Nature as property, belonging to the figures so that they can belong in it. Giorgione's *Concert Champêtre* is one of the first paintings in the history of art whose figures do nothing except enjoy themselves, *being* rather than *doing*. This ideal of pleasure was transmitted through Rubens in the seventeenth century to Antoine Watteau in the eighteenth as the *fête champêtre*, and in Watteau's *Departure from the Island of Cythera* it reached an exquisite culmination. The sojourn on Venus' island is over, the party is returning to its shell-backed barge and so to real life; the feathery trees, the veils of waning light in the sky, and every crinkle and pleat of silk in the gathering dusk combine in a last memory of pleasure, all the more poignant for its impending disappearance. If Watteau, with his unparalleled sense of fragility and timing, was the Mozart of this

subject, there were plenty of lesser artists to give it a general currency as court decoration; and although the *fête champêtre* had dwindled to triviality by the 1770s, it could be recombined with other modes. Thomas Gainsborough combined it with the formal portrait in *Mr. and Mrs. Andrews* (*c.* 1750) – the poised young landowning couple, contemplating Nature as condensed and epitomized in their own acres. The landscape and the figures in it, their clothes and possessions – all these objects represent the class that also owns the painting. This had always been normal in art; but within a few decades of the French Revolution there was a new ruling class in Europe, the bourgeoisie. Its members wanted their pleasures described and their existence documented, not by titillating glimpses of the Pompadour on a swing, but in terms of life as they and their children lived it.

This triumphant middle class included not only the conservative painters but some of the most advanced artists of the late nineteenth century: Édouard Manet, Edgar Degas, Auguste Renoir, Claude Monet. The first Impressionist exhibition was held in 1874, and for much of the ensuing century Impressionism – at first so disconcerting that cartoonists predicted it would cause pregnant women to miscarry – has been the most popular of all art movements. The appetite for Impressionist paintings and sketches never seems to wear off, while at the same time Impressionism seems to represent a lost world: a pre-modern world, whose images have relatively little to do with our own culture.

Both these effects are related to the same cause. Around 1870, the field of paintable pleasure dramatically widened. Impressionism found its subjects in pleasures which nearly everyone above the poverty-line could have; and it extracted the images of pleasure directly from the lives of the painters themselves, and of their friends. Renoir and Monet, Sisley and Caillebotte, Degas and Pissarro were very different artists and they saw the world in altogether different ways, not only technically but morally as well: there is a great distance between Renoir's pink *jeunes filles en fleur*, for instance, and the cool, realistic scrutiny with which Degas took in the world of women's work, at the *barre* of the Opéra or over an ironing-table. Nevertheless, all these painters had, broadly speaking, something in common. It was the feeling that the life of the city and the village, the cafés and the bois, the salons and bedrooms, the boulevards, the seaside, and the banks of the Seine, could become a vision of Eden – a world of ripeness and bloom, projecting an untroubled sense of wholeness. One might look at this world with irony, but never with the eye of despair.

By the mid-1880s, however, the Impressionist love of spontaneity was being challenged by younger artists. An Impressionist "view" was the essence of realism: it represented one thing at a given moment in time, an effect of light and colour that was by definition fugitive; ideally, an Impressionist landscape should have taken only as long to paint as it took to see. Impressionism had no governing system beyond the acuity of the artist's eye and the sensuous efficiency of his brush-strokes, knitting their pattern swiftly across the canvas. Indeed, its lack of system became one reason for its popularity. Nobody could feel intimidated or snubbed by an Impressionist painting. "*Il n'est qu'un oeil, mais, mon Dieu, quel oeil!*" ("He's only an eye, but my God, what an

eye!") Cézanne said of Monet. Cézanne's reservation was shared by some of his juniors, who saw Impressionism as the dictatorship of the eye over the mind. They wanted to give their images the permanence and dignity of classical or Oriental art: somehow, the chaos of the "view" must be made to reflect order, structure, and system. The greatest painter among them was Georges Seurat (1859–91).

Seurat was a prodigy. He was not quite thirty-two when he died. Few artists find their style so young. Seurat not only found one, but his was one of the most lucid classical styles developed since the fifteenth century, and it was based on the dot. The unit of Impressionism had been the brush-stroke, fat or thin, clean or smeared, streaky, squidgy, or transparent, always unpredictable in form, allied to drawing in its direction, and intuitively mixed to conform with the facts of sight. Seurat wanted something more stable than that. He was a child of late nineteenth-century positivism and scientific optimism. Thanks to the periodic table of the elements, it seemed that man now knew all the constituent parts of reality – the very building blocks of matter. Could one dissect sight down to its minutest particles, and so construct an objective grammar of seeing? Seurat believed one could, and his theory was based on scientific studies of colour analysis and visual perception. Of these, the one that influenced him most was *The Law of Simultaneous Colour Contrast*, 1839, by Eugène Chevreul. Local colour, Chevreul had shown, was mixed on the eye. A spot of pure colour gave the retineal impression of a halo of its complementary around it: orange rimmed with blue, for instance, red with green, purple with yellow. The "interference" of these aureoles meant that each colour changes its neighbour. Colour perception is therefore a matter of interaction, a web of connected events, rather than the simple presentation of one hue after another to the eye. Seurat resolved to make this explicit by making his colour patches tiny, reducing them to dots: hence the name, "Pointillism." Stippled side by side, the dots grew by the million like coral polyps, and (like those tiny creatures) coalesced into a stiff deposit, a composed reef of form. That there were so many of them per square inch of canvas meant that Seurat could make all the shifts of colour and value that he needed to; but of course it was not a fluid system, and it suited calm, hieratic, luminous subjects better than agitated or dramatic ones.

Most of all, it suited landscape. Seurat often visited the Channel ports of northern France. His paintings of their bare promenades, flat marine horizons, and light-struck calm reveal a breathtaking power of visual analysis. *Port of Gravelines Channel*, 1890 (plate 72), looks simple until one reflects on how seamless it is. The least error in hue could have punctured that taut, sandy, creamy membrane of dots. If the agreement between Seurat's underlying system and the larger forms it describes had relaxed for a moment, one would be left with visual measles. Instead, there is a perfect spareness, in which the haze and luminosity of the Channel air are scrupulously translated into form (not just evoked by colour). The lack of incident in the painting – whose sparse accents consist of spindly masts, a lighthouse, a bollard, and a curving angle of quay, nothing more – coaxes the eye back to reflect on that analysis of light, as its essential subject. It would be hard to find another image that displayed itself more subtly as a landscape of thought.

72 Georges Seurat *Port of Gravelines Channel* 1890
Oil on canvas 29 × 36¾ ins
Indianapolis Museum of Art, Gift of Mrs. James W. Fesler

Seurat's subject matter was that of Impressionism, but his aims were not. To make this crystal clear, he began, six years earlier than *The Gravelines Channel*, his masterpiece: *A Sunday Afternoon on the Island of La Grande Jatte*, 1884–6 (plate 73). Its traditional roots are obvious. This is the *fête champêtre*, figures enjoying themselves in Arcadia. La Grande Jatte was a real place, as Arcadia is not – it was a small grassy island in the Seine, where Parisians liked to picnic, fish, and take the children on weekends. It therefore invited Impressionist treatment. Seurat did the exact opposite. His painting proclaims, before anything else, that it is not a single moment of vision: that it was not built in a day. *La Grande Jatte* is huge, ten feet by nearly seven – the size of a big public painting by David, Gros, or Delacroix, far bigger than any Impressionist canvas. In it, the middle class at play gets the ceremonious nobility of treatment that art once reserved for gods and kings. One can see why some critics who saw it in the 1886 Salon des Indépendants either teased Seurat for hiding reality under a swarm of coloured fleas (the dots) or made fun of his "Assyrian" figures. For he wanted to paint the processional aspect of modern life – something formal, rigorous, and impressive, akin to the heroic dandyism that Charles Baudelaire had seen on the boulevards of Paris and written about thirty years before. "I want to show the moderns moving about on friezes," he declared, "stripped to their essentials, to place them in paintings arranged in harmonies of colours, in harmonies of lines, line and colour fitted to each other." Part of his inspiration for this was the work of the French artist Puvis de Chavannes (1824–98), whose frescoes still decorate the Pantheon in Paris; a painter of sober, idealized allegories *all'antica*. Puvis's use of profiles and rigid, formal poses, his chalky light and analytic compositions, struck younger Paris artists as very "modern," and his influence can be seen in Renoir, Gauguin, Matisse, Maurice Denis, and even Blue Period Picasso, as well as Seurat. In some respects, *La Grande Jatte* seems to derive from Puvis's Arcadian vision of the founding of Marseilles (plate 74). No wonder that Seurat's friend the critic Felix Fénéon could describe *La Grande Jatte* in these terms: " . . . forty or so persons are invested with a hieratic and summary style, treated strictly from the back or in front or in profile, sitting at right angles, stretched out horizontally, rigidly upright: *like a modernized Puvis*."

And so, in *La Grande Jatte*, the vision of pleasure takes on the gravity of history-painting. In constructing this large, elaborate space, Seurat gave every detail the degree of thought one might expect from Raphael or Piero della Francesca. It is linked together by rhymes and chords of shape, some of which are scarcely noticeable at first. The monkey's tail emulates the hook of the dandy's cane. The woman fishing in the left foreground has a tiny twin in the far distance. The decorum of posture and gesture, the distances people preserve between one another on that green abstracted lawn of Paradise, are turned into the decorum of classical art itself: manners elevated to aesthetics. Culture and nature play with one another, as they do in the Giorgione *Fête Champêtre* when the formal hat of the young dandy echoes the lines of the villa behind him, while the uncouth mop-head of his rustic companion resembles the unpruned trees. Seurat was mildly ironical about his middle-class moderns. They glide on the grass like tin toys on wheels, and seem to predict the serious, mechanized

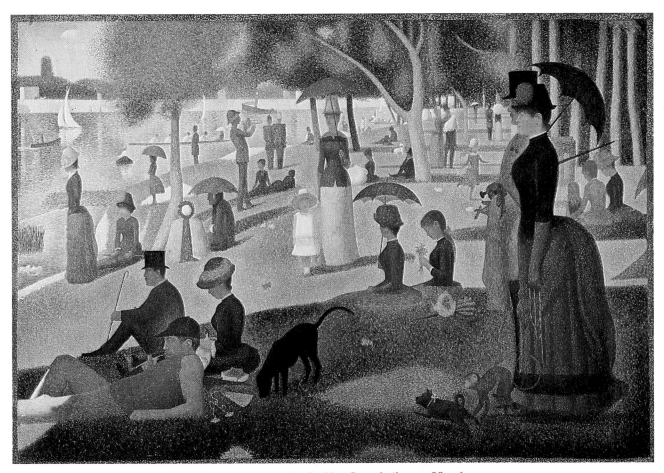

73 Georges Seurat *A Sunday Afternoon on the Island of La Grande Jatte* 1884–6
Oil on canvas 81 × 128 ins: Art Institute of Chicago, Helen Birch Bartlett Memorial Collection

74 Puvis de Chavannes *Massilia, Greek Colony* 1869
Oil on canvas mounted on wall 166½ × 222½ ins
Musées des Beaux-Arts, Marseilles (photo Giraudon)

absurdity that, forty years later, would raise Charlie Chaplin's mime to a high pitch of art. The irony is part of Seurat's modernity. Precisely because it is a distanced painting, a surface not a window, it makes one pause and reflect on its semantics. The spectacle of art as a language fascinated Seurat. It fascinates all artists; but before 1880, it had not often been made the subject of the work. Seurat had grasped that there is something atomized, divided, and analytical about modernist awareness, and his work predicted the way in which art would come more and more to refer to itself. To build a unified meaning, in this state of extreme self-consciousness, meant that the subject had to be broken down into molecules and then reassembled under the eye of formal order. Reality became permanent when it was displayed as a web of tiny, distinct stillnesses. That, ultimately, was what *La Grande Jatte* was about: infinite division, infinite relationships, and the struggle to render them visible – even at the expense of "real life."

Presently, Claude Monet was to arrive at the same place by a different route. If Monet had died in the same year as Seurat, 1891, he would still be honoured as the essential Impressionist; but his importance to modern art would not be crucial. None of the Impressionists had praised the surface of landscape more eloquently. He was to trees, sea, and sky what Renoir was to women's skin. Still, not many of the works he painted before his fiftieth birthday had the reflective permanence, the analytical stillness within the matrix of pleasure, that signals the presence of greatness. By 1880, Monet was expressing his qualms about Impressionism as a movement, and how easy it was for second-rate artists to work up a bag of Impressionist tricks. He wanted to deepen the game; to show the deeper transactions between eye and mind.

This Monet chose to do, starting in 1888, by painting the same motif over and over again, in series. He probably got this idea from Japanese prints, which were widely circulated among the artists in Paris and furnished them with a stream of motifs. He may have got it from Hokusai's *Hundred Views of Mount Fuji*. In any case, in 1891 Monet exhibited his first series of paintings: fifteen views of a group of haystacks. The rounded lumps of hay were as close to shapelessness as anything manmade can be. Monet's choice was like Courbet's determination to paint a distant bundle of sticks that he could not actually identify. The haystacks were neutral receptacles for light (plate 75). But that was their point, for Monet wanted to show fifteen of the infinite varieties of light effect that could be drawn from a motif at different times of day, in different weathers. Each haystack was meant to be seen as a sample of something both commonplace and endless, that could blot up all the inspection and discrimination a human eye can bring. "Eternity in a grain of sand, and Heaven in a flower."

Having invested haystacks with magical colour, as though they were stained-glass windows, Monet then went on to depict a Gothic cathedral as though it were a haystack. In 1892, he rented a room opposite the west front of Rouen Cathedral. He then made some twenty paintings of the same façade, under different conditions of light. Certainly, he had no religious motive in painting the building. Monet was not a pious Frenchman. Never had so historically venerable a structure been painted so resolutely in the present tense, or so famous a religious object been treated in so

75 Claude Monet *Two Haystacks* 1891
Oil on canvas $25\frac{1}{2} \times 39\frac{1}{4}$ ins: Art Institute of Chicago

secular a way. In fact there is still something a trifle disquieting about Monet's decision to treat Rouen like a poplar, a haystack, or a patch of lawn, thereby implying that consciousness is more important than any religion. The *Cathedrals* came out runny and pasty with colour, like gritty, melting ice cream (plate 76). Their density dispels atmosphere: the façade is no longer bathed in air, but encrusted in paint. By working in series, Monet declared that his subject was not a view but the act of seeing that view – a process of mind, unfolding subjectively, never fixed, always becoming. This analysis could not be done with hostile or unpleasant subject-matter; the distraction would have been too great. The motif must be *possessed*. The meditation must begin in pleasure, not pain; at the centre of the self, not at its disturbed edges. "Art is a luxury," Gustave Flaubert once remarked. "It needs white, calm hands." One of the emblems of this state of mind among painters is the garden Claude Monet made near the village of Giverny, fifty miles from Paris. He lived there from 1883 until his death in 1926, and painted what he owned.

Monet's garden developed in two stages. First there was the flower-garden in front of the house. In 1893, when he was past fifty, he began work on the second part, a water-garden across the road, fed by a little tributary of the Seine, the Ru River. The local authorities almost stopped him doing so, since Monet's pond could only be fed by diverting the Ru, and they feared it would cause a water shortage for farmers downstream. Luckily for art history, he got permission in the end. The Ru flowed in, and gradually the garden took shape, with its waterlilies, clumps of iris, weeping willows, and green wistaria-twined Japanese bridge. It gave Monet the motifs for the greatest paintings of his career.

Max Ernst used to describe how, as a child, he would watch his father painting in the back garden. One day Ernst Senior was stymied by a tree that he could not paint satisfactorily; so, to the outrage of his son the budding Surrealist, he fetched an axe and chopped it down, editing it from both life and art. This was the liberty that Monet enjoyed in his own garden. It was a work of art that provoked a continuous procession of others; and pottering about in it, with the aid of a dozen or so gardeners, he was in control not only of his paintings but of their subject. Giverny, as the art historian Kirk Varnedoe elegantly put it, was Monet's "hareem of nature." By 1891, his work was already moving away from the deep field of view in his earlier Impressionist canvases; a series of *Poplars*, painted near Giverny, reduce the scene to three flat bands of colour, sky, riverbank, and reflecting water, punctuated by the subtly undulating verticals of the tree-trunks (plate 77). In the *Waterlilies*, he took this flattening of view still further. They are a long inspection of a drowned, reflected world, in which no sky is visible except by reflection; the water fills the whole frame. Monet's *Waterlilies* are close to the ideas of his contemporary, the poet Stéphane Mallarmé, on poetry. In these paintings, emptiness matters as much as fullness, and reflections have the weight of things. Mallarmé conceived of poetry as being a structure of words *and* absences: "The intellectual armature of the poem conceals itself, is present – and acts – in the blank space which separates the stanzas and in the white of the paper: a pregnant silence, no less wonderful to compose than the verse itself." And again: "To conjure

76 Claude Monet *Rouen Cathedral, Morning* 1894
Oil on canvas $41\frac{1}{2} \times 28\frac{1}{2}$ ins
Louvre, Paris (photo Giraudon)

77 Claude Monet *Poplars* 1891
Oil on canvas $31\frac{1}{4} \times 32$ ins
Metropolitan Museum of Art, New York,
Mrs. H. O. Havermeyer Bequest

78 Claude Monet *Waterlilies* undated

Oil on canvas 79 × 168 ins
National Gallery, London

up the negated object, with the help of allusive and always indirect words, which constantly efface themselves in a complementary silence, involves an undertaking which comes close to the act of creation." Mallarmé's "negated object," the Symbolist sense of reality lurking behind its semantic veils, is also the world as glimpsed in Monet's lily-pond (plate 78).

For the pond was as artificial as painting itself. It was flat, as a painting is. What showed on its surface, the clouds and lilypads and cat's-paws of wind, the dark patches of reflected foliage, the abysses of dark blue and the opaline shimmer of light from the sky, were all compressed together in a shallow space, a skin, like the space of painting. The willows touched it like brushes. No foreground, no background; instead, a web of connections. Monet's vision of energy manifesting itself in a continuous field of nuances would be of great importance to abstract painting thirty years after his death. A work like Jackson Pollock's *Lavender Mist*, 1950, with its palpitation of paint-skeins knitted across the whole canvas, is an American prolongation of the Symbolist line that runs through Monet's garden. But even if they had had no echoes in future painting, some of the *Waterlilies* would still be among the supreme moments of vision in Western art. The pond was a slice of infinity. To seize the indefinite; to fix what is unstable; to give form and location to sights so evanescent and complex that they could hardly be named – these were basic ambitions of modernism, and they went against the smug view of determined reality that materialism and positivism give us. Their third explorer in the late nineteenth century, after Seurat and Monet, was Paul Cézanne, on whose work we have already touched.

From 1880 until the year he died, 1906, Cézanne spent most of his time working in the South of France, in a studio attached to his family home at Les Lauves, on the hill above Aix-en-Provence. This little building, which has been preserved – whereas his view from the terrace, across to Mont Ste-Victoire, could not be and is now hidden by apartment blocks – is one of the sacred places of the modern mind, a reliquary. But the irritable diabetic ghost who haunts it still baffles us, partly because he spent that quarter century in seclusion, hated to theorize about his work, and was reluctant to write letters; and partly because so much later painting claimed Cézanne as its ancestor that we still see his legacy through a roomful of competing heirs. In that sense there were almost as many Cézannes as there had been Michelangelos. He was one of those rare artists who influenced almost everyone. The Symbolists admired the decorative properties of his work. Others saw him as a late Impressionist; whereas the Cubists focused on his sense of the relativity of structure; and after them, he was praised as the founding father of abstract art. All these things are true, in the sense that they say what others made of Cézanne. But what did he make of himself? In Chapter 1, I quoted a letter from Cézanne to his son, describing his exaltation and feelings of inadequacy before the infinite shapes and relationships that the simplest view by a river set before him. It goes on: "The same subject seen from a different angle gives a motif of the highest interest, and so varied that I think I could be occupied for months without changing my place – simply bending a little more to the right or left." Only nature could free a painter from the tyranny of history; Cézanne described his

younger admirer, the painter Émile Bernard, as "an intellectual stuffed by the memory of the museums, who does not look at nature enough – and that is the great thing, to make oneself free of the school and indeed of all schools." "The real and immense study," he wrote to Bernard two years before his death, "that must be taken up is the manifold picture of nature." Cézanne loathed the stylization of Gauguin, his sinuous outlines and decorative flatness, because it was too simple, and he was trying to kick Bernard out of imitating it; but few young painters knew enough to see Cézanne's immense scrupulousness before the motif as anything but another style, and so the lesson was lost on Bernard, as it has necessarily been lost on generations of apple-faceting art students since.

The place Cézanne struggled with and submitted himself to was not some generalized Arcadia. It was his birthplace, Aix-en-Provence. To this day, even the motifs of his still-lives preserved in the studio seem to be fixtures of that landscape: the plaster cupid, the blue ginger jar, the plain Provençal stoneware, the scroll-sawed kitchen table, the floral rug, the skulls, onions, and peaches. But then, step outside! No modern artist except van Gogh so compels you to recognize his paintings in their landscape; only by walking in Provence, on the red sparse hillsides smelling of pine-resin, and looking across the turbulent brightness to where the chalky-grey ledges of the limestone massifs appear to slip and stagger in the light, can one grasp what his paintings meant – and then the sensation is realized. The landscape was in Cézanne's blood, clear, bony, and archaic, and as immediately recognizable as the taste of olives or cold water. Above all, there was Mont Ste-Victoire, which would become, thanks to the painter's obsessive scrutiny, the most analyzed mountain in art. One sees how absolutely Cézanne despised repetition, and how working *en série* was his strategy for avoiding it. He never painted the same mountain twice. Each painting attacks the mountain and its distance from the eye as a fresh problem. The bulk runs from a mere vibration of watercolour on the horizon, its translucent, wriggling profile echoing the pale green and lavender gestures of the foreground trees, to the vast solidity of the Philadelphia version of *Mont Ste-Victoire*, 1904–06 (plate 2). There, all is displacement. Instead of an object in an imaginary box, surrounded by Impressionist transparency, every part of the surface is a continuum – a field of resistant form. Patches of grey, blue, and lavender that jostle in the sky are as thoroughly articulated as those that constitute the flank of the mountain. Nothing is empty in late Cézanne – not even the bits of untouched canvas. This organized dialectic of shape and of colour is the subject of his famous remark that "Painting from Nature is not copying the object; it is realizing one's sensations." To realize a sensation meant to give it a syntax, and as the hatched, angled planes in late Cézanne become less legible as illusion, so does the force of their pictorial language become more ordered. His goal was presence, not illusion, and he pursued it with an unremitting gravity. The fruit in the great still-lives of Cézanne's late years, like *Apples and Oranges*, 1895–1900 (plate 79), are so weighted with pictorial decision – their rosy surfaces filled, as it were, with thought – that they seem twice as solid as real fruit. As Meyer Schapiro has pointed out, it was the apartness of things – their existence independent of human life – that drew

79 Paul Cézanne *Apples and
Oranges* 1895–1900

Oil on canvas 29 × 36½ ins: Jeu de Paume,
Paris (photo Giraudon)

80 Paul Cézanne *Apples, Bottle and the
Back of a Chair* 1902–6

Lead drawing and watercolour 17½ × 23¼ ins
Courtauld Institute Galleries, London

Cézanne towards his subjects: the stone mountain, the deserted quarry at Bibémus, the apples seen as separate beings rather than items of gastronomic pleasure, the chirring silence under the arching pines. Such things endured; they rebuked and put in place the conflicts of his passionate, inhibited character.

Cézanne's late watercolours are the most joyous part of his life's work (plate 80). They do not have (and could not in fact contain) the sense of massive ordering and slow construction of his oils. The medium was quick, and Cézanne used it to set down his first encounters with the motif; one can almost see the swift dabs of transparent red, yellow, and blue drying on the sketchblock in the Provençal heat, fixed by the sun so that they could be rapidly worked over. Watercolour let Cézanne record aspects of the landscape that the weightier medium could not so promptly fix: the mistiness and iridescence of light, the sparkle of early morning distances, the silvery riffling of an olive grove as the leaves turn to show first their dark upper, and then their white powdery underside.

These studies were also emblematic of a general drift among younger French painters. From the middle eighties onwards, there had been a remarkable blooming of colour in advanced French art. The colour was always connected to nature, but it was reaching for an intensity not present in the ordinary view. There was a movement south, away from Paris, towards Provence and the Côte d'Azur. What had happened, in essence, was that painters wanted a landscape that furnished the kind of sensations they wanted to heighten. Van Gogh's disappearance to Arles in 1888 was part of this move – "because," as he wrote to his brother Theo, "not only in Africa but from Arles onward you are bound to find beautiful contrasts of red and green, of blue and orange, of sulphur and lilac. And all true colourists must come to this, must admit that there is another kind of colour than that of the North." Paul Signac, the most gifted of Seurat's followers, settled in the then virgin fishing village of Saint-Tropez in 1892, and was host to Henri Matisse there in 1904; in 1905, Matisse and André Derain went painting in Collioure, further along the coast towards Spain. They were all looking for a greater purity of natural sensation; their aim was to discover in nature a special kind of chromatic energy, colour that spoke to the whole psyche and could be concentrated on a canvas. But apart from van Gogh (see Chapter 6), the man who did most at the outset to bring in the idea of independent, symbolic colour and to free its role in art was a brilliant, histrionic fugitive named Paul Gauguin (1848–1903).

Unlucky the artist on whom Hollywood fixes. Thanks to Anthony Quinn, everyone knows something about Paul Gauguin: the archetypal dropout, the man who gave up a banking career to paint, went crazy with his ear-cutting friend Vincent in the mistral-buffeted Yellow House at Arles, and left his wife (a very pretty and long-suffering woman, by the way, and not at all the pallid repressive anti-Muse of popular fiction) for the liquid embraces of the Tahitians. Gauguin was the first French artist (if one discounts the African travels of nineteenth-century Romantics) to try to find the earthly paradise a long way from France, but he was by no means the first European painter to go to Tahiti. Paradise in the South Seas had been a staple of Western art for more than a century before Gauguin. Almost from the moment of its discovery by

Captain Wallis in 1767, Tahiti had been pictured by explorers (and those who read their books) as a prelapsarian Elysium, "the garden of Eden . . . worthy of the pencil of a Boucher," as the French voyager Bougainville noted when he sailed into Matavai Bay the following year, with the brown Polynesian nymphs appearing "as Venus herself to the Phrygian shepherd, having the celestial form of that goddess." Here was the Embarkation for Cythera in real life – sharpened no doubt by six months at sea, away from women.

The first artist to paint in Tahiti was a Scot, William Hodges, who went there with Captain Cook in 1769. (Unlike Gauguin, he cannily gave up painting when he got back to England and became a banker.) But by the late nineteenth century the idea of the Noble Savage, living in blissful innocence in the fruitful bosom of nature, was one of the great fantasies of European thought; and Tahiti was still imagined as the proof of his and her existence. Besides, Paradise was a French colony, with mail services and other amenities; if the diet of breadfruit and jack proved monotonous, one could always switch – as Gauguin did, at ruinous cost – to canned sardines and imported Beaujolais.

Throughout the 1880s, as he moved in the circles of advanced French poetry and painting and became the wild pet of the Symbolists, with a following of younger artists like Maurice Denis and Émile Bernard, Gauguin's hatred of city bourgeois culture had increased to the point of suffocation. He believed he had "primitive" blood: his grandmother was a bastard half-Peruvian woman of vast militant energy, who wore herself out spreading socialist propaganda in the French provinces; further back, Gauguin liked to hint, there were traces of Martinique slave in his ancestry. He saw himself as a romantic survival, a hero of instinct displaced among the cafés and salons, and he longed to break with France. What provoked his escape was the Paris Exposition of 1889, which not only had a Peruvian mummy among its myriad exhibits (plate 193) – Gauguin identified with this withered *Ur*-relative at once, incorporating its foetally hunched body into several paintings and woodcuts as an image of ominous age – but also boasted a number of transplanted "native" villages from different parts of the French empire: Cochin-China, Morocco, and Tahiti. Gauguin was enthralled by the last, and took to heart the brochure distributed at the Exposition, which read in part: "The lucky inhabitants of Tahiti know life only at its brightest." In 1891, he set off for the South Seas from Marseilles, cheered on by friends and admirers like the Symbolist critic Octave Mirbeau. He would go native on their behalf. His luggage included a shotgun, to hunt the wild beasts of Paradise, and two mandolins and a guitar, with which to serenade the nymphs beneath the palm trees.

His other luggage was stereotypes. Gauguin knew what he wanted to see: part of the script had been written before he left, by Stéphane Mallarmé. The first line of Mallarmé's eclogue *The Afternoon of a Faun* (1876), which inspired Debussy's prelude, ran: "*Ces nymphes, je les veux perpétuer*" ("I would perpetuate these nymphs"). Gauguin echoed this to the letter from Tahiti: "These nymphs, I want to perpetuate them, with their golden skins, their searching animal odour, their tropical savours." The means of perpetuating them, his art, had already matured. The popular

fancy that Gauguin "discovered himself" as a painter in Tahiti is quite wrong. All the components of his work – the flat patterns of colour, the wreathing outlines, the desire to make symbolic statements about human fate and emotion, the interest in "primitive" art, and the thought that colour could function as a language – were assembled in France before 1891 (plate 81). The time he spent painting in Brittany, where he was the centre of one of the many artists' colonies and painting camps that dotted the coast (for Breton life, in its austerity, picturesqueness, and religious primitivism, was a favourite subject for many artists apart from Gauguin and his circle at Pont-Aven), was in some ways a rehearsal for Tahiti.

The island was far gone. Its decline had begun at the moment Captain Wallis arrived, and had been going on without interruption or help for 125 years. Instead of Paradise, Gauguin found a colony; instead of Noble Savages, prostitutes; instead of the pure children of Arcadia, listless half-breeds – a culture wrecked by missionaries, booze, exploitation, and gonorrhea, its rituals dead, its memory lost, its population down from forty thousand in Cook's time to six thousand in Gauguin's. "The natives," he lamented, "having nothing, nothing at all to do, think of one thing only: drink. Many strange and picturesque things once existed here, but there are no traces of them left today; everything has vanished."

So the Paradise Gauguin painted was deceptive, a defiled Eden full of cultural phantoms; and his Tahitians were like survivors of a Golden Age they could not remember. In a peculiar way, this suited the formal, classical side of Gauguin's work. We think of him as a modern painter, but he was not, or not entirely so: whole tracts of his imagination belong more to the Third Empire than to the twentieth century, and one of them was his fondness for allegory. He wanted his paintings to be moral fables, and portentous ones at that; he conceived of himself as a moral teacher, not just an engineer of visual sensation. This desire to preach to a wide audience on religious or ethical issues was just what most art would shed in passing from the nineteenth to the twentieth century. It would be the first casualty of the new privateness. But Gauguin thought he could find some general clues to the destiny of mankind in the ruined myth of the Noble Savage. In 1897, he painted a large canvas called *Where Do We Come From? What Are We? Where Are We Going?* (plate 82). From the Tahitian Eve in the centre, plucking the fruit from the tropical Tree of Paradise, to the whispering figures and the sibylline old woman crouched in the posture of the Peruvian mummy, it is freighted with symbolism: "a philosophical work," Gauguin wrote to a friend in France, "on a theme comparable to that of the Gospel."

It was not Gauguin's subjects but his colour that pointed to the future. The colours of Tahiti were brilliant, and although he had never been an inhibited colourist, Gauguin was now able to give his palette an even more moody, resonant intensity. He believed, as the Symbolists all did, that colour could act like words; that it held an exact counterpart for every emotion, every nuance of feeling. This was the visual counterpart to Mallarmé's sense of the "musicality" of poetry, whereby words formed constellations through latent affinities, magnetic charges which drew them together, like iron filings around the poles of a magnet, in patterns of meaning. If a poem was

82 Paul Gauguin *Where Do We Come From? What Are We? Where Are We Going?* 1897
Oil on canvas $57\frac{3}{4} \times 147\frac{1}{2}$ ins: Museum of Fine Arts, Boston

81 Paul Gauguin *Harvest in Brittany* 1889
Oil on canvas $36\frac{1}{4} \times 28\frac{3}{4}$ ins
Courtauld Institute Galleries, London

made of patches (words) arranged on white paper, then painting too – as Maurice Denis advocated – should be seen first as ordered patches on a flat blank surface. Its task was not to describe but to express. By this means, colour could claim the liberty of thought itself.

For younger artists, this was a momentous permission. But they wanted to exercise it inside France, and its natural theatre was the South. Colour was the sign of vitality, the emblem of well-being, and it did not need thick symbolical overtones. It was enough that colour should take its stand on authenticity of feeling; that it should expend and sharpen the artist's and the viewer's sense of energy, their shared *joie de vivre*. Colour would then be more a gift than an injunction.

What came out of this desire was a movement named Fauvism. What's in a name? Not much, the historian of art is bound to answer. Cubism was not about cubes, nor was Fauvism about wild beasts. When in 1905 an affable critic looked around one gallery of the Paris Salon d'Automne, which contained an Italianate bust surrounded by the works of Henri Matisse and his colleagues, he made a wisecrack about *"Donatello chez les fauves"* ("Donatello among the wild beasts"), thus giving to a short-lived movement a durable and rather misleading title. Fauvism was worked out by a small group of artists over a span of three years; by 1907, the year of Picasso's *Les Demoiselles d'Avignon*, it was over. It could roughly be defined, not in terms of unifying theory – for unlike Symbolism, it had none, and no wish to acquire one – but simply by a list of painters who, for a short time, were decisively shaped by the vision of Henri Matisse and the landscapes of the Midi: Maurice de Vlaminck and André Derain, Raoul Dufy and Georges Braque, Kees van Dongen and Henri Manguin. One can speak of general characteristics of Fauve painting – its bright, dissonant colour, crude urgency of surface, distorted drawing, and love of brisk, raw-looking sensation. But it was not a "movement" in the sense of having a strong, common practice. "One can talk about the Impressionist school," van Dongen later remarked, "because they held certain principles. For us there was nothing like that; we merely thought their colours were a bit dull."

And so, if only by comparison, they were. Put a Pissarro alongside one of the key Fauvist works, André Derain's *The Turning Road, L'Estaque*, 1906 (plate 83), and it will be blown off the wall. One can see what Derain got from Gauguin – the blue outlining of the red tree on the right, and its serpentine profile, are pure *cloisonnisme* – but the volume knob, so to speak, is turned further. Today one is apt to see such a painting as splendid decoration: weighty in design and audacious in colour, with its blaring vermilion trunks, complex blues in the shadows, and joyful pyrotechnics of green and yellow in the foliage. Seventy-five years ago it was an all-out assault on the senses, an affront to the order and *mesure* which the French had so long, and so highly, prized in art.

Within a few years, German Expressionism (see Chapter 6) would have adopted the aggressiveness of Fauve colour. What did not travel north so easily was the optimism, the ideal of sensuous wholeness, which spoke through the colour like a spirit through a medium. Everywhere in Fauvism, pleasure was celebrated: the *tricouleurs* and striped

83 André Derain *The Turning Road, L'Estaque* 1906
Oil on canvas $50\frac{1}{2} \times 76\frac{1}{2}$ ins: Museum of Fine Arts, Houston,
John A. and Audrey Jones Beck Collection

parasols in Raoul Dufy's street scenes, the rosy theatrical vigour of van Dongen's low-life scenes, the slapdash but infectious ebullience of Vlaminck's Chatou landscapes. The best sight of all, however, was Henri Matisse inventing the Mediterranean. It is still amazing to find how deeply one's images and expectations of that now vanishing coast have been marked by Matisse's skies and awnings, his lion-coloured headlands and glimpses of pink water and red masts beyond a balcony. Matisse's work was the axis of Fauvism. The liberation of colour that took place in those few years was largely his doing, and the recoil from Fauve exuberance was his necessity too. "You can't remain forever in a state of paroxysm," Georges Braque wisely remarked of his Fauve years. "The first year there was the pure enthusiasm of the Parisian who discovered the Midi. The next year, that had already changed. I should have had to push on down to Senegal to get the same result. . . ." Braque's recoil from Fauve colour was one of the roots of Cubism; Matisse's effort to discipline, prune, and sublimate the crudities of the movement he had largely created would become the basis of his mature career. And so from 1908 onwards, while Derain moved towards tighter, interlocking compositions and Old-Masterly tonal effects, while the ignorant Vlaminck plummeted into coarse self-parody, Dufy started turning out pretty little furniture-pictures, and van Dongen simply fell apart, Matisse began to live out the most august and productive artist's life, other than Picasso's, that the twentieth century would see.

Henri Matisse was born in 1869, the year the *Cutty Sark* was launched. The year he died, 1954, the first hydrogen bomb exploded at Bikini Atoll. Not only did he live on, literally, from one world into another; he lived through some of the most traumatic political events in recorded history, the worst wars, the greatest slaughters, the most demented rivalries of ideology, without, it seems, turning a hair. Matisse never made a didactic painting or signed a manifesto, and there is scarcely one reference to a political event – let alone an expression of political *opinion* – to be found anywhere in his writings. Perhaps Matisse did suffer from fear and loathing like the rest of us, but there is no trace of them in his work. His studio was a world within the world: a place of equilibrium that, for sixty continuous years, produced images of comfort, refuge, and balanced satisfaction. Nowhere in Matisse's work does one feel a trace of the alien-ation and conflict which modernism, the mirror of our century, has so often reflected. His paintings are the equivalent to that ideal place, sealed away from the assaults and erosions of history, that Baudelaire imagined in his poem *L'Invitation au Voyage*:

Furniture gleaming with the sheen of years would grace our bedroom; the rarest flowers, mingling their odours with vague whiffs of amber, the painted ceilings, the fathomless mirrors, the splendour of the East . . . all of that would speak, in secret, to our souls, in its gentle language. There, everything is order and beauty, luxury, calm and pleasure.

In its thoughtfulness, steady development, benign lucidity, and wide range of historical sources, Matisse's work utterly refutes the notion that the great discoveries of modernism were made by violently rejecting the past. His work was grounded in tradition – and in a much less restless and ironic approach to it than Picasso's. As a young man, having been a student of Odilon Redon's, he had closely studied the work

of Manet and Cézanne; a small Cézanne *Bathers*, which he bought in 1899, became his talisman. Then around 1904 he got interested in the coloured dots of Seurat's Divisionism. Seurat was long dead by then, but Matisse became friends with his closest follower, Paul Signac. Signac's paintings of Saint-Tropez bay were an important influence on Matisse's work. So, perhaps, was the painting that Signac regarded as his masterpiece and exhibited at the Salon des Indépendants in 1895, *In the Time of Harmony*, a big allegorical composition setting forth his anarchist beliefs. The painting shows a Utopian Arcadia of relaxation and farming by the sea, and it may have fused with the traditional *fête champêtre* in Matisse's mind to produce his own awkward but important demonstration piece, *Luxe, Calme et Volupté*, 1904–5 (plate 84). In it, Matisse's literary interest in Baudelaire merged with his Arcadian fantasies, perhaps under the promptings of Signac's table-talk about the future Golden Age. One sees a picnic by the sea at Saint-Tropez, with a lateen-rigged boat and a cluster of bulbous, spotty nudes. It is not, to put it mildly, a very stirring piece of *luxe*, but it was Matisse's first attempt to make an image of the Mediterranean as a state of mind.

In 1905 Matisse went south again, to work with André Derain in the little coastal town of Collioure. At this point, his colour broke free. Just how free it became can be seen in *The Open Window, Collioure*, 1905 (plate 85). It is the first of the views through a window that would recur as a favourite Matissean motif. All the colour has undergone an equal distortion and keying up. The terracotta of flowerpots and the rusty red of masts and furled sails become a blazing Indian red: the reflections of the boats, turning at anchor through the razzle of light on the water, are pink; the green of the left wall, reflected in the open glazed door on the right, is heightened beyond expectation and picked up in the sky's tints. And the brushwork has a eupeptic, take-it-or-leave-it quality that must have seemed to deny craft even more than the comparatively settled way that Derain, his companion, was painting.

The new Matisses, seen in the autumn of 1905, were very shocking indeed. Even their handful of defenders were uncertain about them, while their detractors thought them barbaric. Particularly offensive was his use of this discordant colour in the familiar form of the salon portrait – even though the "victim" was his wife, posing in her best Edwardian hat.

There was some truth, if a very limited truth, to the cries of barbarism. Time and again, Matisse set down an image of a pre-civilized world, Eden before the Fall, inhabited by men and women with no history, languid as plants or energetic as animals. Then, as now, this image held great appeal for the over-civilized, and one such man was Matisse's biggest patron, the Moscow industrialist Sergey Shchukin, who at regular intervals would descend on Paris and clean his studio out. The relationship between Shchukin and Matisse, like the visits of Diaghilev and the Ballet Russe to France, was one of the components of a Paris–Moscow axis that would be destroyed forever by the Revolution. Shchukin commissioned Matisse to paint two murals for the grand staircase of his house in Moscow, the Trubetskoy Palace. Their themes were "Dance" and "Music" (plates 86, 87).

84 Henri Matisse *Luxe, Calme et Volupté* 1904–5
Oil on canvas 37 × 46 ins : Private Collection, New York

85 Henri Matisse *The Open Window, Collioure* 1905
Oil on canvas $21\frac{3}{4} \times 18\frac{1}{4}$ ins: Private Collection, New York

86 Henri Matisse *The Dance* 1910
Decorative panel, oil on canvas $102\frac{1}{4} \times 125\frac{1}{2}$ ins
The Hermitage, Leningrad (photo ZIOLA)

87 Henri Matisse *Music* 1910
Decorative panel, oil on canvas $102\frac{1}{4} \times 153$ ins
The Hermitage, Leningrad (photo ZIOLA)

Even when seen in a neutral museum setting, seventy years later, the primitive look of these huge paintings is still unsettling. On the staircase of the Trubetskoy Palace, they must have looked excessively foreign. Besides, to imagine their impact, one must remember the social structure that went with the word "Music" in late tsarist Russia. Music pervaded the culture at every level, but in Moscow and St. Petersburg it was the social art *par excellence*. Against this atmosphere of social ritual, glittering and adulatory, Matisse set his image of music at its origins – enacted not by virtuosi with managers and diamond studs but by five naked cavemen, pre-historical, almost pre-social. A reed flute, a crude fiddle, the slap of hand on skin: it is a long way from the world of first nights, sables, and droshkies. Yet Matisse's editing is extraordinarily powerful; in allotting each of the elements, earth, sky, and body, its own local colour and nothing more, he gives the scene a riveting presence. Within that simplicity, boundless energy is discovered. *The Dance* is one of the few wholly convincing images of physical ecstasy made in the twentieth century. Matisse is said to have got the idea for it in Collioure in 1905, watching some fishermen and peasants on the beach in a circular dance called a *sardana*. But the *sardana* is a stately measure, and *The Dance* is more intense. That circle of stamping, twisting maenads takes you back down the line, to the red-figure vases of Mediterranean antiquity and, beyond them, to the caves. It tries to represent motions as ancient as dance itself.

The other side of this coin was an intense interest in civilized craft. Matisse loved pattern, and pattern within pattern: not only the suave and decorative forms of his own compositions but also the reproduction of tapestries, embroideries, silks, striped awnings, curlicues, mottles, dots, and spots, the bright clutter of over-furnished rooms, within the painting. In particular he loved Islamic art, and saw a big show of it in Munich on his way back from Moscow in 1911. Islamic pattern offers the illusion of a completely full world, where everything from far to near is pressed with equal urgency against the eye. Matisse admired that, and wanted to transpose it into terms of pure colour. One of the results was *The Red Studio*, 1911 (plate 88).

On one hand, he wants to bring you into this painting: to make you fall into it, like walking through the looking-glass. Thus the box of crayons is put, like a bait, just under your hand, as it was under his. But it is not a real space, and because it is all soaked in flat, subtly modulated red, a red beyond ordinary experience, dyeing the whole room, it describes itself aggressively as fiction. It is all inlaid pattern, full of possible "windows," but these openings are more flat surfaces. They are Matisse's own pictures. Everything else is a work of art or craft as well: the furniture, the dresser, the clock and the sculptures, which are also recognizably Matisses. The only hint of nature in all this is the trained house-plant, which obediently emulates the curve of the wicker chair on the right and the nude's body on the left. *The Red Studio* is a poem about how painting refers to itself: how art nourishes itself from other art and how, with enough conviction, art can form its own republic of pleasure, a parenthesis within the real world – a paradise.

This belief in the utter self-sufficiency of painting is why Matisse could ignore the Four Horsemen of the Apocalypse. When the war broke out in 1914, he was forty-five

88 Henri Matisse *The Red Studio* Issy-les-Moulineaux, 1911
Oil on canvas $71\frac{1}{4} \times 86\frac{1}{4}$ ins: Collection, The Museum of Modern Art,
New York, Mrs. Simon Guggenheim Fund

– too old to fight, too wise to imagine that his art could interpose itself between history and its victims, and too certain of his aims as an artist to change them. Through the war years, stimulated by a trip to North Africa, his art grew in amplitude and became more abstract, as in *The Moroccans*, 1916. In 1917 he moved, more or less permanently, to the South of France. "In order to paint my pictures," he remarked, "I need to remain for several days in the same state of mind, and I do not find this in any atmosphere but that of the Côte d'Azur." He found a vast apartment in a white Edwardian wedding cake above Nice, the Hôtel Regina. This was the Great Indoors, whose elements appear in painting after painting: the wrought-iron balcony, the strip of blue Mediterranean sky, the palm, the shutters. Matisse once said that he wanted his art to have the effect of a good armchair on a tired businessman. In the 1960s, when we all believed art could still change the world, this seemed a limited aim, but in fact one can only admire Matisse's common sense. He, at least, was under no illusions about his audience. He knew that an educated bourgeoisie was the only audience advanced art could claim, and history has shown him right. So it is fitting that the scene of so many of his greatest paintings should have been the hotel room or the apartment: the playpen of the adult mind. The common theme of Matisse's interiors is the act of contemplating a benevolent world from a position of utter security. The filter between inside and outside is the window. Sometimes it is abstracted to the point of becoming a few lines, as in the astonishingly rigorous and daring *Porte-Fenêtre à Collioure*, 1914 (plate 89). "My purpose," Matisse declared, echoing Cézanne, "is to render my emotion. This state of soul is created by the objects which surround me and which react in me: from the horizon to myself, myself included. For very often I put myself in my pictures, and I am aware of what exists behind me. I express the space and the objects in it as naturally as though I had only the sea and the sky in front of me: that is, the simplest thing in the world."

Other great painters believed that their emotional temperature was always right when they were on the Mediterranean: notably, Pierre Bonnard (1867–1947), an early votary of Gauguin and of Japanese art, who, after years of painting trips to the South, finally moved to a house at Le Cannet, near Cannes, in 1925. In the mid-twenties, Bonnard's work – a refined and intensified form of Impressionism built up of shimmering fields of high-keyed colour – looked old-hat to some artists. Picasso, for instance, thought it decadent, "a potpourri of indecision," lacking the clash and decisive contrast of forms that he valued in painting. The question of Bonnard's "modernity," however, is of no importance when seen against the profound, reflective vision of his work, a vision of such privacy and molecular intensity that it bears comparison with late Monet. In some ways Bonnard was the opposite of Matisse – the little bourgeois against the grand one. Matisse's compositions, even when they were slices of private life, carried an air of formal grandeur – declamation, in the high tradition of French art. Bonnard, on the other hand, like his fellow painter Édouard Vuillard (1868–1940) was an "intimist:" he was stirred by small, natural scenes of domestic life, where people were caught unguarded and objects became actors in a drama – but not necessarily a comedy – of little events. In still-life, Bonnard took

89 Henri Matisse *Porte-Fenêtre à Collioure* 1914
Oil on canvas $46 \times 35\frac{1}{2}$ ins
Private Collection, Paris (photo ZIOLA)

things as he found them – or at least he painted them to seem so. The arrangement of jugs, bowls, and plates on a breakfast table in *The Breakfast-Room*, 1930–1 (plate 90), may seem fragile and chancy, as if they had strayed into view, like the woman half-seen on the left. Sitting as quiet as an old tabby, Bonnard constantly surprised the familiar things in his field of view, cropping them in odd ways, taking them from unexpected angles, and vapourizing them in sudden effulgences of rose, madder, lilac, chrome yellow, viridian, and bright sun-dappled green. The brushwork is loose, knitted and impressionistic, so that the substance of these paintings appears half-formed and ready to vanish back into the light of which it is made. Everything is seen with the private, not the public eye: the food about the house, the flowers around the house, and the woman.

She was almost always the same woman, Marie Boursin, known as Marthe. Bonnard met her in 1894, and five years later she was his subject for one of the most intense sexual images ever painted – the girl sprawled in post-coital sleep, all animality in the blue dusk of the bedroom, *Blue Nude*, 1899 (plate 91). After a liaison that lasted more than thirty years he finally married her, and they lived together until 1942, when she died. He was utterly and, indeed, masochistically loyal to her: and far from being the storybook *femme d'artiste*, contentedly watering the geraniums in a cottage on the Côte d'Azur, Marthe was a nagging, neurotic shrew who made life miserable for Bonnard and his friends, knew nothing about painting, and could not even cook. But Bonnard was obsessed by the facts of domesticity and the memory of sexual pleasure: the privacy and the glimpsing, the way in which couples who have known each other for years take one another's bodies for granted, the sense that the eye is party to all secrets. At a certain point, around 1920, Bonnard decided that she would never age. When she was sixty, he was still painting her thirty-year-old body. To the end, she remained apart, self-absorbed, spied on: the perpetual Susanna in her bath, with Bonnard as the constantly peeping, anxious Elder, dissolving her in light, reconstituting her in colour, possessing her again and again from a distance. No woman in her sixties can look like the naiad who floats in Bonnard's tremendous image of the sunny bathroom, in *Nude in the Bath*, 1941–6 (plate 92). The light that fills the room, skewing its chequered space, turning its tiles to nacre and opal, is not of this world. Bonnard the *voyeur* has been given a little of what Dante saw when gazing on his beloved:

> . . . *a Beatrice tutta si converse*
> *ma quella folgorò nel mio sguardo*
> *si che da prima il viso non sofferse.*

> (. . . I turned to Beatrice
> herself; but her radiance
> so dazzled my eyes that at first
> my sight could not bear it.)

Paradiso, III, 127–9

Between the wars, another major painter of disciplined pleasure was Georges

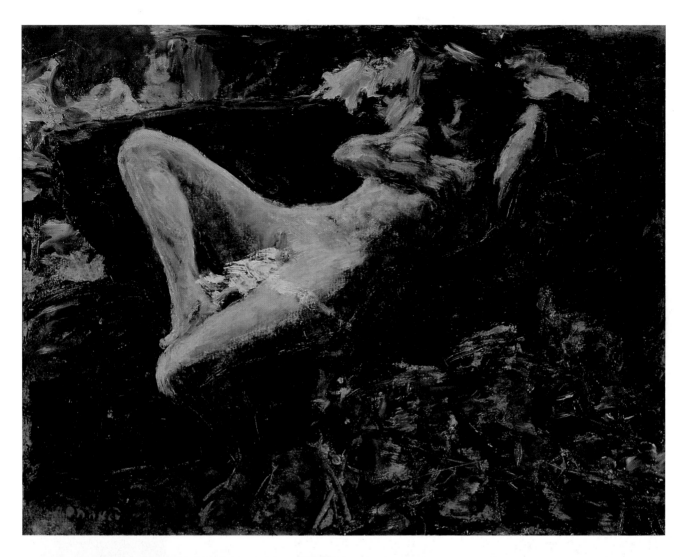

91 Pierre Bonnard *Blue Nude* 1899
Oil on canvas $11\frac{3}{4} \times 15\frac{1}{2}$ ins: Jeu de Paume,
Paris (photo Musées Nationaux)

92 Pierre Bonnard *Nude in the Bath* 1941–6
Oil on canvas $48 \times 59\frac{1}{2}$ ins: Museum of Art,
Carnegie Institute, Pittsburgh

90 Pierre Bonnard *The Breakfast-Room* c. 1930–1
Oil on canvas $62\frac{7}{8} \times 44\frac{7}{8}$ ins: Collection, The Museum of Modern Art, New York,
Given anonymously

Braque (1882–1963). (Matisse's work in the twenties and thirties temporarily declined; there is not much distance between his salon odalisques of the time, displaying themselves like late refugees from Delacroix, and the conventional Mediterranean decor of artists like Dufy.) Braque might have taken his motto from Pascal: *Le moi est haïssable* (The ego is hateful), for he was one of the arch-classicists of modern painting, and throughout his career he called himself an *artiste-peintre*, a phrase more suggestive of craft than temperament. One could not imagine a great predator like Picasso calling himself that.

Braque joined the French Army in World War I, and in 1915 he was shot in the head and had to be trepanned. There was no brain damage, but the long convalescence took him out of his own studio and removed him from the art world for several years. It separated him from the *avant-garde* and its febrile schemes and arguments. Instead of painting, he reflected, wrote, and kept journals. When he got back to the easel in 1918, he had finally decided that he could push no further towards abstraction: it was necessary to put some flesh back on the ambiguous bones of Cubism. "There is in Nature," he remarked, "a tactile, I almost mean 'manual,' space." This he explored in his still-lives of the twenties and thirties. It trained his style away from synthetic Cubist uncertainty, towards the structures of calm, overlapping planes and transparencies that appeared in the work of Juan Gris and Henri Laurens. If ever a group of paintings made concrete the desire for measure, sublimation, attention, and calm, it was these (plate 93). The objects in them are ordinary: a guitar, a bunch of green grapes, newspapers, bottles, the grain of marble – the routine material of Cubism. But each is given its exact weight; Braque skimped nothing in his quest for a perfectly clear texture of thought. He wanted to distribute the spectator's attention as evenly as possible across the painting, and the result is solider and less hypothetical than Cubism. He even took to mixing sand with his paint to give it more body, a more resistant surface, like fresco. The idea was to slow the eye down, to insist on a gradual inspection, parallel to the immense deliberation which he brought to the act of painting. There is much in common between the textures of these paintings and the mysterious, silent, grainy paint of Chardin's still-lives: a deposit of thought, quietly coating the objects. Braque was picking up and reassembling the pieces of the French still-life tradition that he, as a Cubist, had helped to shatter.

With Matisse and Picasso, Braque was the last great European artist to use his own studio as a subject. He rarely painted landscape; his essential theme was the room, a closed box, pierced with windows and cluttered with things. It was natural for him to paint his own work-place and to praise it, as a kind of secular chapel, a condenser of refined feeling. In the past, as in Vermeer or Velásquez, this subject had always implied the dignity of the artist's thought and work; so it did with Braque. Besides, to the layman, the artist's studio tends to seem a mysterious place, less explicable than a laboratory or a factory, although it has something in common with both – thought goes on there, things are made, "researches" conducted, but not by the logic of science or manufacture. The studio is a sanctum, imagination's cave, and its clutter of bottles, pots, tools, and oddities suggests the alchemist's cell, with its alembics and stuffed

93 Georges Braque *Le Guéridon* 1921–2

Oil on canvas $75 \times 27\frac{3}{4}$ ins Metropolitan Museum of Art, New York, Gift of Mrs. Bertram Smith

94 Georges Braque *L'Atelier III* 1949
Oil on canvas $57 \times 68\frac{3}{4}$ ins: Private Collection,
Basle (photo HIAZ)

crocodile. Such, at least, was the image of the *atelier de l'artiste* in France fifty years ago. The image of the studio as a privileged place of transmutation, memory, and contemplation is the key to the paintings of Braque's old age, the *Ateliers* of 1949–54, with their calm transparency and baffling layers of images, their space that keeps opening and shutting like a concertina or a zigzag screen, and their mysterious cut-out bird – an emblem of imagination, perhaps, set free in the room (plate 94).

There was not much in Picasso's work over the same thirty years that could compare with that kind of frozen music. But then, Picasso did not have a talent for serenity. His way of touching the world was always more avid than Braque's. He wanted to seize, penetrate, and immerse himself in the objects of his attention. He liked strong and specific feelings. And the strongest junction of feelings, for him, was sex. Picasso never tried to hide what he felt about it, and no artist – not even Renoir or Rubens – has left such a vivid sexual autobiography behind him. There are tracts of his work where one can follow him almost day by day, through fits of lechery, hostility, yearning, castration fear, fantasies of dominance and impotence, self-mockery, tenderness, and cock-happiness; and his feelings for whichever woman he was with seldom failed to affect his work, when that work concerned the human figure. Part of Picasso's achievement was in creating the most vivid images of sexual pleasure in all modern art. They were provoked by his affair with a blond girl whom he picked up outside the Galeries Lafayette department store in Paris in 1927. Her name was Marie-Thérèse Walter; she was seventeen and he, at forty-six, was in the last bad years of marriage to a querulous and snobbish former ballerina named Olga Khoklova. He went for this new girl (and she for him) with utter directness and intensity. There can sometimes be a point in the first few months of an affair when one's new lover fills the whole screen, and all physical sensations are modulated through, or have parallels in, the feeling of making love to her; she becomes an image of the world – "O my America, my New Found Land!", as Donne exclaimed. Go a little further and the absolute difference between one's own body and that of one's lover may seem, when making love, to falter and for a moment disappear. This was what Picasso, in some of his paintings of Marie-Thérèse Walter, was trying to find equivalents for. In the paintings her body is re-formed, not so much as a structure of flesh and bone but as a series of orifices, looped together by that sinuous line: tender, composed, swollen, moist, and abandoned (plate 95). The point is not that Picasso managed to will himself into the thoughts of this woman; he was interested in no such thing. Instead, he depicted his own state of arousal, projecting it on his lover's body like an image on a screen. Her body is re-composed in the shape of his desire, and the paintings that result describe a state of oceanic pleasure.

Throughout his career (see Chapter 5), Picasso's erotic instincts were always getting mixed in with his appetite for fantastic distortion and metamorphosis. The entire availability of his lover's body meant that it could be changed around. "To displace," he said later. "To put eyes between the legs, or sex organs on the face. To contradict. . . . Nature does many things the way I do, but she hides them! My painting is a series of cock-and-bull stories. . . ."

95 Pablo Picasso *Nude in the Garden* 1934
Oil on canvas 63¾ × 51 ins
Musée Picasso, Paris (photo Musées Nationaux)

96 Pablo Picasso *Sculptor and Reclining Model* 1933
Etching 7½ × 10½ ins: Plate from *The Vollard Suite*

It was at about this time that Picasso began to mythologize himself as the Mediterranean artist, with a series of etchings called the Vollard Suite. One aspect of this cycle is autobiographical or, at least, self-descriptive: the theme of the Sculptor and his Model, she the passive and obliging nymph, he the *genius loci*, reclining on a couch like a classical river-god (plate 96). These prints were Picasso's invocation of the classical past which, as he imagined it, was still visible on the Mediterranean. They let him place himself in Arcadia. He was then a middle-aged man, just past fifty; and one need not doubt that he saw neither Arcadia nor his capacity to fill it stretching away forever. The Vollard Suite is saturated in nostalgia, which, like every other emotion in Picasso's work, is expressed with total candour. It was in fact the last major work of art, by Picasso or anyone else, to be directly inspired by Mediterranean antiquity: the end of an immense tradition that died amid the historical disjuncture, the irony, suffering, and physical ruin brought on by war and peace in the twentieth century. Within fifty years of the completion of the Vollard Suite, officials in Athens would be seriously debating whether to take the eroding caryatids of the Erechtheum off the Acropolis and replace them with fibreglass copies, and the Greek horses would be gone forever from the façade of St. Mark's Basilica in Venice. The more the Antique receded, the more of a cultural fetish Picasso, the last Mediterranean Man, became. But none of his later Arcadian images, after World War II, could carry the same conviction as the Vollard Suite, because that war had killed the Mediterranean as a state of mind as surely as its predecessor had killed the *Belle Époque*. In a period begun by Hiroshima and Auschwitz, the idea of a complicated art based on uncomplicated, unsullied pleasure generally seemed either gratuitous or stupid. (Naturally, this time also saw the "development" of the Côte d'Azur for mass tourism, a colossal parody of the experience that Matisse and Picasso had been trying to describe.) Only seventy years elasped between Mallarmé's *Afternoon of a Faun* and Picasso's *Joie de Vivre*, 1946. *Ces nymphes, je les veux perpétuer*; but they could not be perpetuated, except as the merest decor, going through pantomimes of innocence in a sort of Hesiodic never-never land that nobody, perhaps not even Picasso, believed in any more.

But if Picasso's attempts to preserve an art of Arcadian pleasure in his old age failed, Matisse's did not. Dr. Johnson once said that the prospect of hanging concentrates a man's mind wonderfully. It did Matisse's. In 1941, now in his seventies, he nearly died of an intestinal blockage, and was bedridden for much of his remaining time. But he felt reborn – "My terrible operation," he announced, "has completely rejuvenated and made a philosopher of me" – and he changed his method of work. Instead of painting, he had his assistants cover sheets of paper with flat, brilliantly hued gouache. He then cut out shapes with scissors, and had those bright silhouettes pasted on a flat paper support. These he called his *découpages* or "cut-outs." "Cutting into colour," Matisse observed in 1947, "reminds me of a sculptor's direct carving." It also released an unstinted sense of buoyancy. He liked to talk about the "beneficent radiation" of his colour, of its power to heal, and he would prop up his paintings like sun-lamps around the bed of a sick friend. In the *découpages*, the radiation is almost enough to

give the viewer a tan. A quarter of a century after Matisse's death, the audacity of their colour remains astonishing. What other artist could handle those deep, resonant cobalt blues, those fuchsias and oranges, those velvety blacks and high yellows, without producing an effect akin to liquorice allsorts? Control was of the essence, for Matisse wanted to fix "a sort of hierarchy of all my sensations," to possess and minutely articulate the nuances of feeling. There was nothing more decisive than the actual process of cutting, the shears sliding through the painted paper, dividing the final form from its surplus. At an age when most artists are either dead or repeating themselves, Matisse had re-entered the *avant-garde* and redefined it. His cut-outs were the most advanced painting, and the most august, being made in Europe: a corrective to the witless self-indulgence of *tachisme*. They had the wholeness of gesture that most abstract painting aspired to but could not reach – a fast co-ordination of mind, hand, eye, and memory, similar in its graceful rectitude (though not in its form or intent) to the poured and dripped line of Jackson Pollock, across the Atlantic.

They were also Matisse's resolution of the two visions of nature that he, as a completely cultivated artist, had inherited from the symbolic traditions of Islam and Christianity. One was the artificial paradise-garden, whose chief example (for Matisse) was the Alhambra in Granada – nature tamed, formalized, and patterned to the highest degree of artifice and comfort. Thus *Large Decoration with Masks*, 1953 (plate 98), with its repeated grid of leaves and cloves, alludes directly to Arabic tilework. The other prototype was the natural paradise, exemplified not only by the Côte d'Azur but by Tahiti as well: Matisse had gone there in 1930, finding it "both superb and boring . . . such immutable happiness is tiring." He dived off the reefs and never forgot the colours and absinthe green water. They fill his later *découpages*, like *Polynesia, the Sea*, 1946. In the cutting and pasting, he rediscovered the incisive liberty of his Fauve years. One large cut-out now seems like Matisse's recapitulation, two years before his death, of the theme of *The Dance*, 1909 – *The Swimming Pool*, 1952 (plate 97). No artist other than Picasso could, with such economy of means, have steeped an image in such intense memories of physical sensation: sunshine and water, the ecstasy of tumbling, diving bodies. This was his farewell to a subject that had been one of the tests of an artist's virtuosity since the fifteenth century – human animals in energetic movement, the body stripped of its guilt, an end in itself.

Between 1947 and 1951, Matisse, though failing in health, immersed himself in what he called "the last stage of an entire lifetime of work, and the apex of an enormous, sincere and difficult effort." This was the decoration for a small chapel run by an order of Dominican nuns outside Cannes, across the road from his villa. In the revival of "modern" French Catholicism that followed World War II, there had been a good deal of speculation about the possibility of the Church using the best resources of modern art to regain contact with a changed intellectual climate in France. Most of its results were unremarkable – a lot of stained-glass-style abstract painting – but it left two monuments, Le Corbusier's chapel at Ronchamp and Matisse's in Vence. "Perhaps after all I believe, without being aware of it, in a second life," Matisse had said to Louis Aragon after his operation, "some paradise where I shall paint

97 Henri Matisse *The Swimming Pool* Nice, summer 1952–early 1953

Nine-panel mural in two parts, gouache on cut-and-pasted paper mounted on burlap;
a–e, 7 ft 6$\frac{5}{8}$ ins × 27 ft 9$\frac{1}{2}$ ins; f–i, 7 ft 6$\frac{5}{8}$ ins × 26 ft 1$\frac{1}{2}$ ins
Collection, The Museum of Modern Art, New York, Mrs. Bernard F. Gimbel Fund

98 Henri Matisse *Large Composition with Masks* 1953

Painted, cut and pasted paper, brush and ink 139$\frac{1}{4}$ × 392$\frac{1}{2}$ ins
National Gallery of Art, Washington DC, Ailsa Mellon Bruce Fund

frescoes. . . ." There are no frescoes in the Vence chapel (he was too infirm to work in that medium), but everything there was designed by Matisse: crucifix and altar, stained-glass windows, Stations of the Cross, vestments, the lot. Matisse's chasubles, with their refulgent and sonorous colour harmonies and unexpected relationships to the movement of the celebrant's body, are still the handsomest ecclesiastical raiment made in France since the sixteenth century; while in the main wall of stained glass, done in accordance with his cut-out maquette, the light coming through the upward-climbing leaves of its Tree of Life motif – blue, yellow, green – bathes the plain white space of the chapel in a soothing radiance. The largesse of Matisse's designs turns this otherwise uninteresting building into one of the few effective precincts of contemplation in modern art.

This was a hard act to follow. In secular terms, there was everything to be learned from Matisse: he was the most influential painter of the third quarter of the twentieth century, as Picasso had been of the second quarter, and Cézanne of the first. But there was something in his work that could not transplant across the Atlantic, into a different and more Puritan, while at the same time less measured and reasonable, society. That was his "Mediterraneanness," the ease and sensuous completeness which was rooted in Matisse's own experience, education, and legacy as a Frenchman. It was not a matter of artistic style; it issued from a complete attitude towards life and how to live it that came out of the nineteenth century and was finally crushed by the 1939–45 war. After that you could paint Matisses, but you could not be Matisse; that particular paradise was closed, especially if you happened to live in a highly utilitarian place, fuelled by pragmatism and guilt, like post-Freudian New York.

After 1950, there is no doubt that America was getting ready for an art of unalloyed pleasure. One could not, as one of his friends said of Lord Byron, live under a cataract all the time; and there was something not only exaggerated but oppressive about the moralizing *fortissimo* of Abstract Expressionists (see Chapter 6) like Mark Rothko, Clyfford Still, and Barnett Newman. The reaction at first took the form of airy, spattered, lyrically coloured and light-surfaced abstract painting whose take-off point was Jackson Pollock's "all-over" paintings from 1949. In them, line was no longer *out*line. It did not mark contours or define edges; it was not touchable, like the cut line along the edge of a Matisse pomegranate; it was almost a function of atmosphere (plate 212). The artist who did most to grasp and develop this aspect of Pollock's work was Helen Frankenthaler (b. 1928), and she did it with one exquisite painting, *Mountains and Sea*, 1952 (plate 99). It is large, about seven feet by ten, but its effect is that of a watercolour: rapid blots and veil-like washes of pink, blue, and diluted malachite green, dashed down as though the canvas were a page in a sketchbook. Its most obvious affinity is with the luminous, broken-formed landscape that rises from Cézanne's late watercolours; and the raw canvas soaked up the watery pigment just as rag paper absorbs a watercolour wash. Landscape, imagined as Arcadia, remained the governing image in Frankenthaler's work, and her titles often invoked the idea of Paradise or Eden. Sometimes the landscape was actual, as in *Cape (Provincetown)*, 1964, where the view from the waterfront is translated into a piercing lemon-yellow

99 Helen Frankenthaler *Mountains and Sea* 1952

Oil on canvas 86 × 117 ins: Collection of the artist,
on loan to National Gallery of Art, Washington DC

strip of beach and a green horizon, with diaphanous veils of blue stacked up in the sky.

Other artists, who picked up the technique of staining and dyeing the canvas from early Frankenthaler, allowed no such images into their work. It was sealed against everything but the action of colour. One of the aims of Morris Louis (1912–62) and Kenneth Noland (b. 1924) was to produce a surface which would be both impersonal and wholly decorative, in the Matissean sense of that word: that is to say, august and "life-enhancing," but offering no commentary on the contingencies of life. Anything that smacked of "character," a directional brush-stroke, a change of texture, or wrist-driven, freehand drawing, was therefore out. Louis's configurations (plate 100) were made by pleating the canvas and flooding its folds with liquid paint, or by scrubbing and blotting – anything but brush-painting. Likewise, their pictorial space was ironed down, reduced almost to nil: instead of the crumpled space of Cubism, shallow but still agitated by small flickerings in depth, there was nothing but colour stained into the weave of the canvas – a perfectly flat figure on a perfectly flat ground, freed (or deprived) of all ambiguity.

Kenneth Noland reduced the options even further, by turning drawing into taping. His paintings were based on the simplest patterns, target, chevron, and stripe – suggesting, in effect, that there was nothing inherently interesting about the shapes except their refinement of proportion and tuning, and that they were to be seen as racks for colour, nothing more. "I wanted to have color be the origin of the painting," Noland said in 1969. "I was trying to neutralize the layout, the shape, the composition in order to get at the color. Pollock had indicated getting away from drawing. I wanted to make color the generating force." In the sixties, Noland's accomplishments as a colourist were undeniable. In the best of his target paintings, like *Song*, 1958 (plate 101), he could set a splashy grey rim whirling around concentric circles of red, black, and blue with an airy energy that few American painters (and, at the time, no European ones) could equal. Like gigantic watercolours, which they were, Noland's targets and chevrons bloom and pulsate with light; they offer a pure, uncluttered hedonism to the eye.

But that is all they do offer. The paintings Frankenthaler, Noland, Louis, and Jules Olitski did in the 1960s were, as a whole, the most openly decorative, anxiety-free, socially indifferent canvases in the history of American art. Yet what was written about them was among the most narrow, prescriptive, authoritarian criticism in the history of American letters – New York formalism of the sixties, as issued to the world partly by Clement Greenberg but mainly by his epigones in *Artforum*. Alexandrian art, Roman writing. In effect, the American Puritanism the artists had sidled away from came back to act as reinforcing arguments for their work. That such heat could have been worked up over such delectable and inoffensive paintings seems odd today, and will doubtless appear barely credible by the end of the eighties. This art became the American modern museum art *par excellence*; more museum time and space was devoted to propagating it in America than to any other modernist movement or group. Nevertheless, the resources of American colour-field painting (except in the hands of Frankenthaler) were fairly soon exhausted. It kept going as a minor mandarin style,

100 Morris Louis *Alpha-Pi* 1960

Acrylic on canvas $102\frac{1}{2} \times 177$ ins
Metropolitan Museum of Art, New York, Arther H. Hern Fund

101 Kenneth Noland *Song* 1958
Synthetic polymer 65 × 65 ins
Whitney Museum of American Art, New York

huffily rebuking the novelties and ironical vulgarities of Pop, but the Matissean heart was no longer in it.

Where that informed organ continued to beat was in the work of two California-born painters, Robert Motherwell and Richard Diebenkorn. Throughout this chapter I have tried to suggest that the chief tradition within which a modernist art of pleasurable sensation has been made – an art which is rigorous and intelligent, rather than the mere evocation of agreeable feelings – is that of Symbolism: a tradition of *equivalents*, whereby the word (in poetry) or the colour patch and linear edge (in painting) achieve, without necessarily describing it, a harmony and exactness parallel to the satisfactions of the world. Within the somewhat privileged space that Symbolism demands, infinite finesse is possible but conflict is not eliminated. The artist is free to investigate the domain of feeling, not as an Expressionist splurge – the imperious I swamping everything it touches – but as a structure of exacting nuances and tonic doubts. Such paintings cannot, by their nature, be "movement" art. In front of a Diebenkorn like *Ocean Park No. 66* (plate 102), one hears neither the chant of surging millions nor even the chorus of a "movement," but one measured voice, quietly and tersely explaining why this light, this colour, this intrusion of a 30-degree angle into a glazed and modulated field might be valuable in the life of the mind and of feeling. Undoubtedly, the hinge-point in Diebenkorn's career came in 1966, when he saw Matisse's *Porte-Fenêtre à Collioure* (plate 89): it was publicly exhibited in America for the first time that year, in a show in California, and its sheer daring – the way it mingled allusions to reality with the sparest quasi-geometrical drawing – overwhelmed him. What eventually came out of this was Diebenkorn's *Ocean Park* series. Taken together, and allowing for a certain unevenness of quality, the *Ocean Parks* are surely one of the most distinguished meditations on landscape in painting since Monet's waterlilies. The landscape in question is that of the Pacific coast of southern California, seen through the large transom windows of Diebenkorn's studio. High air, planes of sea, and lines of road, fence, pier, and window frame, crystalline light, an encompassing blueness. The paintings are certainly about sensuous pleasure, but qualified and tightened by an acute sense of instability: a San Andreas fault runs, as it were, through the paradise of paint. The syntax of Diebenkorn's work is always explicit, and in its readiness to let the first impulses of thought leave their traces in the finished work, it makes the viewer witness to the process of painting: how this too obtrusive yellow is cut back, leaving its ghost along a charcoal line; how that 45-degree cut is sharpened, then blurred, then hidden by veils of overpainting. To scan the surface of a big *Ocean Park* is to watch these additions become a kind of transparency, bathing the text in calm, elevated reflection.

This is the tone of Robert Motherwell's work too, but in a more abridged and ejaculatory way. (There is a lot of violence in Motherwell, even at his suavest; in Diebenkorn, none.) Motherwell was one of the founders of the Abstract Expressionist movement in New York, and that area of his work which has most to do with the shared preoccupations of Abstract Expressionism – myth, atavistic symbolism, Surrealism, and a tragic sense of history, epitomized in the series of *Elegies to the*

102 Richard Diebenkorn *Ocean Park No. 66* 1973
Oil on canvas 93 × 81 ins
Albright-Knox Art Gallery, Buffalo, Gift of Seymour H. Knox

Spanish Republic (plate 103) whose motif he found in 1948 – will be discussed in Chapters 5 and 6. But there is also a "Mediterranean" Motherwell, whose additional sources lie in Cubist collage and in Matisse. These two do not make a split talent: they are the ends of a wide, seamless range of feeling. The business of painting, Motherwell once remarked, is "the skin of the world;" and his art, far from being abstract in any Utopian sense, is meant to be an art of subject-matter. (It is worth remembering that, in 1948, Motherwell, William Baziotes, David Hare, and Mark Rothko started an informal art school named "The Subjects of the Artist.") The question, How shall I paint?, is not easy to answer but its solution is largely technical. The harder question is, What shall I paint?, and Motherwell – unlike some of his more culturally isolated colleagues – was able to find at least a partial answer in the tradition of modernist French poetry, from Baudelaire to Éluard. "A weakness of modernist painting nowadays," Motherwell wrote in 1950, "especially prevalent in the 'constructivist' tradition, is inherent in taking over or inventing 'abstract' forms insufficiently rooted in the concrete, in the world of feeling where art originates, and of which modern French poetry is an expression. Modernist painting has not evolved merely in relation to the internal structure of painting. . . ." The Symbolist ideal of direct equivalences between sound, colour, sensation, and ideated memory struck Motherwell as one of the supreme achievements of culture – the password to modernist experience. It shows at every level of his work, not by rote, but almost instinctively – though the "instinct" comes from sedulous cultivation. As a "homely Protestant" (to quote the title of one of his early paintings), an American who thought of America as a place of constraint, the abode of the superego, he discovered in the reasoned sensuousness of the modern French masters a truly intoxicating liberty.

What are the subjects of this artist, in his lyric mode? Landscape, for one: walls in white light, the salt-white clapboard walls of Provincetown on the rim of its blue bay, the grainier and thicker walls of Cadaques or Nice, with their dark recesses and calligraphies of noon shadow, and Matissean windows framing a view. Closed orange shutters and open sea. Colour, in itself, is part of the subject, for Motherwell has an ingrained preference for "natural" colours, ones that look as though they have been sampled directly from the world's surface – ochre, black, white, yellow, and an exquisite range of blues, "Motherwell blue," as promptly identifiable as Braque brown or Matisse pink. "If there is a blue that I might call mine, it is simply a blue that feels warm, something that cannot be accounted for chemically or technically but only as a state of mind." This blue has literary prototypes – Mallarmé's *azur*, colour of oceanic satisfaction, and Baudelaire's sea, colour of escape. It is one of the signatures of well-being.

There is also the internal landscape of the studio, as alluded to in Motherwell's collages. Before it is anything else, collage is play. The rules of the game are subsumed in what is available – the mailing paper, matchboxes, cigarette packs, chocolate wrappers, stickers, and other stuff in the unstable flux of messages and signs that pass through a painter's studio. Pushing them around on the paper is pure improvisation, a game with educated guesses played out until the design clicks into some final shape.

103 Robert Motherwell *Elegy to the Spanish Republic 34* 1953–4
Oil on canvas 80 × 100 ins
Albright–Knox Art Gallery, Buffalo, Gift of Seymour H. Knox

Motherwell's collages have, at their best, an august elegance scarcely seen in the medium since Braque's Cubist *papiers collés*, to whose tradition (rather than that of Kurt Schwitters's object-laden *assemblages*) they belong. His interest in Surrealist automatism, the acceptance of chance and impromptu gesture, records itself in the fact that the shapes, when altered, are invariably torn rather than cut. One cannot predict the final shape of a ripped edge. It is manual chance. (One of Motherwell's works from the late fifties made a point of this with its Joycean title, *The Tearingness of Collaging*.) The edge of violence, rather than violence itself, is implicit along the edges of the paper, and this sense of instability within the apparent serenity is, especially in his large collages of the seventies, essential to their effect.

For it is quite wrong to see Motherwell's collage objects, as some critics persist in doing, as a form of modernist *décor de luxe* – Dick Diverish emblems of the rich life. Why not Camel packets instead of imported Gauloises? Why does the matchbook cover have to come from *La Crémaillère* in Greenwich, and the chocolate wrapper be Suchard instead of, say, a Hershey bar? Such questions proceed from inverse snobbery. An artist works with what he has, and one thing that Motherwell has never wanted in his collages is the allegiance to Pop art that Camels and Hershey bars would inevitably suggest: that would rupture the conceptual skin of his work. His collages are, in that sense, less "Pop" than Cubist *papiers collés*, which loved invoking the common objects of the street. But their references to luxury are held, so to speak, in quotes: these are the last relics of the world of measured bourgeois delectation, once common property, now distant, that made its entry with Impressionism. They attest to the desirability of that world, while their formal disjunctures suggest, more powerfully perhaps than the artist intends, that it is a lost world – as indeed it is. We know that because it was once not only attainable, but attained, and then overwhelmed by the conditions of mass culture. Whereas Utopia (to whose emblems we now turn) never happened, and so died harder.

FOUR

TROUBLE IN UTOPIA

The culture of the twentieth century is littered with Utopian schemes. That none of them succeeded, we take for granted; in fact, we have got so used to accepting the failure of Utopia that we find it hard to understand our cultural grandparents, many of whom believed, with the utmost passion, that its historical destiny was to succeed. The home of the Utopian impulse was architecture rather than painting or sculpture. Painting can make us happy, but building is the art we live in; it is the social art *par excellence*, the carapace of political fantasy, the exoskeleton of one's economic dreams. It is also the one art nobody can escape. One can live quite well (in a material sense) without painting, music, or cinema, but the life of the roofless is nasty, brutish, and wet.

What city represents modernity? Most people would say Manhattan: and for all its defects, they would be right – not because New York contains a higher proportion of the canonical buildings of the modern movement than other great cities, but because of its Promethean verticality, its metal–and–glass severity, and its incredible power as a transformer of information and desire. But one of the greatest modern architects, Le Corbusier, thought otherwise. He called New York a tragic hedgehog. He hated its contrasts, the moral and social distances between the street and the spire; he loathed its mediaeval dirt, the insuperable and *souk*-like muddle within its theoretical grid of streets, and its almost mediaeval differences of class. When the light is right it is, of course, easy to romanticize New York: there is a view, coming into the city from Kennedy Airport, which makes the long flank of the East River look like San Gimignano's towers, if not those of the New Jerusalem. But to Le Corbusier, such fancies were wholly repugnant. Manhattan, to him, was the ruined blueprint of a great idea, and he speculated at length about how the city could become Utopia: indeed, the secret cause of his intellectual war on New York was, as we shall see later, that his own idea of a Radiant City of tower blocks was cribbed from Manhattan. The idea of a New York *moralisé* is, of course, a joke to Manhattanites; they refused to take Corbusier seriously, and they were right. The fact is that if Manhattan were as rational, clean, and flawless as its best buildings, it would be much less endurable. One of the lessons of our century, learned slowly and at some cost, has been that when planners try to

convert living cities into Utopias they make them worse. The famous words of the American officer in Vietnam – "We had to destroy that village in order to save it" – are their epitaph. But some of the greater minds of the twentieth century have thought otherwise, and from 1880 to 1930, when the language of architecture changed more radically than it had done in the preceding four centuries, the ideal of social transformation through architecture and design was one of the driving forces of modernist culture. Rational design would make rational societies. "It was one of those illusions of the 20s," recalls Philip Johnson, who with the architectural historian Henry Russell Hitchcock christened this new movement the International Style. "We were thoroughly of the opinion that if you had good architecture the lives of people would be improved; that architecture would improve people, and people improve architecture until perfectibility would descend on us like the Holy Ghost, and we would be happy for ever after. This did not prove to be the case."

Utopia was the tomb of the id. Within it, there would be more aggression, and the conflicts of Mine and Thine would be resolved. It is worth remembering that one of Corbusier's aphorisms in the early twenties, when Europe was torn by radical unrest, was "architecture *or* revolution," as though all the impulses towards social violence came down to errors of housing. (Nevertheless, Corbusier's patrons, who included one or two of the largest capitalists in France, preferred on the whole to take their chances with revolution; grapeshot cost less than general rehousing.) In their belief that the human animal could be morally improved, and that the means of this betterment was four walls and a roof, the Europeans who created the modern movement – Walter Gropius, Mies van der Rohe, Bruno Taut, Antonio Sant' Elia, Adolf Loos, and Le Corbusier, to name only the best known among them – formed a concentration of idealist talent uncommon in architectural history. It expressed itself more in hypothesis than by finished buildings. The most influential architecture of the twentieth century, in many ways, was paper architecture that never got off the drawing board. And only in the twentieth century did earlier ideal schemes acquire such a retrospective importance.

For Utopia had been around on paper for several hundred years. Its first architectural state – apart from such purely illustrative images as mediaeval manuscript paintings of the Heavenly City – emerged in the fifteenth century, when the Florentines Leon Battista Alberti and Leonardo da Vinci speculated about how to build the ideal town, and Alberti's disciple Antonio Filarete (another Florentine, who worked in Milan for the duke Francesco Sforza) planned a city, named Sforzinda after his patron, whose large squares and rational articulate layout were meant to abolish the muddle and filth of the mediaeval warren. A place for every job and rank of society, and every rank and job in its place.

There was nothing fantastic, by modern standards, about such designs. The point at which the idealist impulse took off into fantasy was reached in France around 1800, in the wake of the French Revolution. As we have seen in Chapter 2, political revolutions have a way of over-oxygenating the imagination and producing all manner of didactic images, unrealizable in practice but in theory magnificent, whose

megalomania is cloaked as pragmatism; and so it was with the designs of Étienne-Louis Boullée. Boullée wanted to create Pharaonic architecture that would manifest the *volonté générale* – the collective will – of the French people. It would outdo the royal palaces in size, though not in elaborateness; neo-classical plainness was the tone, and the content would be threefold – death, authority, and the immutable grandeur of the State. Many of these designs were for tombs, since the Great Dead were the best teachers. Boullée's designs were provoked by the early Industrial Revolution, with its large "primary" industrial forms, its accompanying promise of infinite power over material. They were Faustian dreams, and they would have needed a slave-state to build them. But within thirty years of their conception, even before Victoria had ascended the English throne, the Industrial Revolution was creating another kind of slave-state. Not since the birth of Christ had the well-being of so small a class been so underwritten by the inarticulate, regimented misery of so many as in Victorian England and the advanced European nations. The Machine, by uprooting rural populations and replanting them where power – water or coal – was plentiful, had created a new class, Engels' proletariat, the very form of whose life was dictated by its mechanical master from the age of five or six onwards. This was the social reality behind the more rarefied cultural myth of the machine-as-man's-counterpart that Picabia or Fritz Lang would explore, two generations later.

For most of the nineteenth century, architecture had nothing to say about this misery, and nothing to do with it. By the word "l'architecture," an educated Frenchman of 1870 did not mean public housing, factories, or workers' clubs. He meant ceremonial buildings that demonstrated the important public functions of a bourgeois bureaucracy; banks, ministries, museums, railway stations, and palaces. The heyday of the École des Beaux-Arts, which governed all French architectural practice and was the decisive influence on design in the rest of Europe and in America, was also, by no coincidence, the time of France's greatest colonial, industrial, and governmental expansion. Since the 1800s, what amounted to a new class – the bureaucracy – had been called into being. Before Napoleon, French bureaucrats were relatively few, their offices mere appendages to the actual seat of power, the throne. But with the vast and detailed edifice of the Code Napoléon, the civil servants needed to administer the law multiplied. Moreover, though the bounds of France's colonial empire would never be wider than they were in 1870, the drive towards centralization was intense. Paris, *caput mundi*, needed an architecture of prosperous authority, intended as benevolent public display for a bourgeoisie convinced, with reason, that it had inherited the earth. Such was the object of the great Beaux-Arts structures like Charles Garnier's design for the Paris Opéra of 1875. They are demonstrations of condensed "surplus value" – acres of marble, bronze, and gilding, sumptuously orchestrated, gathering together the labour of armies of plasterworkers, stonemasons, polishers, metalfounders, and *ébénistes* – an impossible architecture today, because the craft traditions that built it are either extinct or too expensive to use on a public scale. Compared to today's public architecture – mean, scaleless, tacky, and intimidating – such a building is an act of generosity; it assures the private citizen that he or she is the

reason for the State. But it would have had nothing good to say to a poor man in 1875. The poor did not have *l'architecture*. They had slums.

By 1900, in the eyes of a few gifted and missionary designers scattered across Europe, architecture itself had become a symbol of inequality; and decorated architecture even more so. The distrust of décor in early modernism was not simply an aesthetic and economic matter. It was deeply rooted in moral attitudes as well. The underdog artist's contempt for Beaux-Arts extravagance goes back at least as far as Charles Baudelaire's sardonic description, in *Les Yeux des Pauvres* (*The Eyes of the Poor*), 1864, of a luxurious new café:

The very gaslight was flaring with the ardour of a neophyte . . . on the dazzling white of the walls, on the brilliantly polished sheet-glass mirrors, on the gilt of the mouldings and the cornices, on the friezes showing chubby-faced pages holding hounds that strained at the leash . . . on nymphs and goddesses bearing baskets on their heads piled high with pastries, fruits and game . . . all of history and all of mythology pressed into the service of gluttony.

That is Manet's landscape, seen with an even colder eye. Among architects, the anti-décor argument began in earnest during the rise of the second-last universal decorative style in world design: the Liberty Style, as it was known in Italy, or *el modernismo* in Barcelona or, as we call it today, Art Nouveau. The mannered rhythms and lavishly contradictory use of materials in Art Nouveau make up an exquisitely narcissistic protest of craft sensibility against the generalization of life – a final gesture before the hand and its work were swamped by the machine product. It was the snobbish style, and the pre-industrial world makes its last stand among these twining shoots, waving lines, and languid stained-glass lilies. It presupposes a time for inspection parallel to the amount of free time necessary to follow, savour, and digest the coiling rhythms of Marcel Proust's sentences: leisure, the property of a class.

In contrast to this class-bound opulence, modernist architecture was to be a democratic answer to social crisis, or so the founding fathers of the International Style believed. To them, the very idea of Modernity signified a unique fusion of romance and rationality, and it sprang from the same roots as Marxism. Utopia, as yet barely imaginable, was latent in technology and mass production. Technology meant precise function, a weeding out of the superfluous: in a word, planning. They realized that machine production could not be rolled back, and that the future, whatever form it might take, was not going to be found in rural French anarchist communes or even in William Morris's workshops. But the machine, applied to design, might well repeal the slavery it had created – provided the architect were given unlimited scope and responsibilities as its *metteur-en-scène*. "You will inevitably arrive," Le Corbusier wrote, "at the 'House-Tool,' the mass-production house, available for everyone, incomparably healthier than the old kind (and morally so too). . . . But it is essential to create the right state of mind for living in mass-production houses." People, no less than their shelters, needed replanning. Revise the shelter and one improves the people. Re-educate the people and they will grasp the necessity – the *moral* necessity – of a new form of shelter. Walter Gropius and Mies van der Rohe in Germany, no less

than Le Corbusier in France, believed in this mirage of the architect as seer and sociological priest. Architecture could reform society, they thought. To match an ideal architecture of steel and glass, based on prefabrication and functional clarity, a new type of person would arise – Le Corbusier's Modular figures, as it were, in flesh and blood: a lover of speed and socialism, plain food, fresh paint, hygiene, sun-baths, low ceilings, and soccer.

The architect who launched the attack on decorated architecture was Adolf Loos (1870–1933), a brilliant, verbose young Czech who lived in Vienna. Between 1893 and 1896, Loos had been in the United States, working for a time in Louis Sullivan's office in Chicago. Sullivan was not only a great poet of the structural grid but a gifted inventor of ornament to clothe it; yet he did speculate about a radical degree of plainness that building (other than industrial architecture, which was not *l'architecture* in the Beaux-Arts sense) had not known since the Prussian neo-classicists of the 1800s. "It could only benefit us," Sullivan remarked, "if for a time we were to abandon ornament and concentrate entirely on the erection of buildings that were finely shaped and charming in their sobriety."

Loos was not content to take this remark as a motto; he interpreted it with polemical fervour, and the concrete result may be seen in his Steiner House of 1910 in Vienna – a shockingly concise building, absolutely pure in surface and profile, its monasticism of detail all the more startling for being done in the same city, and within the same orbit of ideas, as the lavish and nervy decorations of Gustav Klimt (plates 104, 105). The tone of Loos's objections to anything that did not declare its utter plainness as an article of faith can be grasped from the title of an essay he wrote in 1908, *Ornament and Crime*. Like Klimt, or Kokoschka, or Egon Schiele, or for that matter the Viennese doctor Sigmund Freud, Loos believed that art was libidinous before it was anything else. "*All* art is erotic," he roundly declared, and identified body-painting as the root of ornament – a suitable practice for primitives but not for modern Europeans. "The modern man who tattoos himself is either a criminal or a degenerate. . . . If someone who is tattooed dies at liberty, it means he has died a few years before committing a murder." The abolition of ornament, Loos concluded, was as necessary a social discipline as toilet-training. "A country's culture can be assessed by the extent to which its lavatory walls are smeared. In the child this is a natural phenomenon . . . But what is natural to the Papuan and the child is a symptom of degeneracy in the modern adult. I have made the following discovery and I pass it along to the world: *The evolution of culture is synonymous with the removal of ornament from utilitarian objects.*" Clearly, Mies van der Rohe's dictum that "less is more" begins with Loos's messianic belief that ornament was excrement. To what anguish in the nursery, to what enforced play with cubical blocks (those marvels of infant education, standardized and made popular in Germany in the early nineteenth century), Loos's hygienic fanaticism may have been due cannot now be known; but one might suppose, after reading him, that anal repression ranked as a contribution to the origins of the International Style along with plate glass or stucco. Nonetheless, Loos also expanded his horror of ornament into a more reasonable economic theory. "Omission of ornament," he pointed out,

104, 105 Adolf Loos *Steiner House, Vienna* 1910
Front and back views: Österreichischen Nationalbibliothek
and Graphische Sammlung Albertina, Vienna

"means a reduction in manufacturing time and an increase in wages. The Chinese carver works for sixteen hours, the American worker for eight. If I pay as much for a smooth cigarette case as for an ornamented one, the difference in working time belongs to the worker. And if there were no ornament at all . . . man would only have to work four hours instead of eight, because half the work done today is devoted to ornament. Ornament is wasted labour power and hence wasted health." And what would be the result of the cleansing? "The time is nigh, fulfilment awaits us! Soon the streets of the city will glisten like white walls. Like Zion, the holy city, the capital of Heaven. Then, fulfilment will come!"

But it did not come yet, and when it did – though in a form which Loos had not imagined – that fulfilment arrived by osmosis from America. Meanwhile, other European visionaries were taking a somewhat different approach to the ideal of a new architecture for a new age. This was very much an issue with the Futurists, who did not, however, endow it with the overtones of social reform and equitable pay for labour that so attracted Loos. Like the Futurist painters, the two architects connected with the movement (Antonio Sant' Elia and Mario Chiattone) were enraptured by the glamour of the machine, its power to transform life no matter what class held the levers. Technology would reform culture, but in a gratuitous and socially amoral way. Its muscle would abolish history. "We are no longer the men of the cathedrals, the palaces, the assembly halls," wrote Sant' Elia and Chiattone in the *Futurist Manifesto of Architecture*, 1914, "but of big hotels, railway stations, immense roads, colossal ports, covered markets, brilliantly lit galleries, freeways, demolition and rebuilding schemes. We must invent and build the Futurist City, dynamic in all its parts . . . and the Futurist house must be like an enormous machine."

The Futurist City – *la città nuova*, their Italian name for it, has a more Dantesque ring – held one overwhelming advantage for Futurism. Old buildings could accommodate any number of Futurist pictures and sculpture, but there was no way of building a new city without wrecking an old one: Futurist architecture had to mean the dynamiting of the musty past that Marinetti hoped for. It would rise in towers and ledges of "concrete, glass and iron, without painting and without sculpture, enriched solely by the innate beauty of its lines and projections, extremely 'ugly' in its mechanical simplicity . . . on the edge of a tumultuous abyss." In designing its components, Sant' Elia had the freedom of a science-fiction illustrator, and although his drawings of *la città nuova* (plates 106–9) name the uses of the buildings in them they are, beyond their classifications, works of fantasy. If Sant' Elia had survived the war (he was killed on the Austrian front, aged twenty-eight), he could well have ended up as Mussolini's official architect; a *Terza Roma* by him and not Piacentini would have been an interesting sight. Some of the drawings are intriguing predictions of Russian Constructivist themes, and Sant' Elia's Futurist liking for mobility ran very close to Constructivism when he announced "a new ideal of beauty, still embryonic, but whose fascination is already being felt by the masses . . . We have lost the sense of the monumental, the heavy, the static; we have enriched our sensibility with a taste for the light, the practical, the ephemeral and the swift." His paper architecture –

106

108

109

107

Antonio Sant' Elia *Futurist City*

106 *New Town* 1914
Ink and crayon $20\frac{1}{2} \times 20\frac{1}{4}$ ins

107 *Terminal for Aeroplanes and Trains with Funicular* 1914
Ink and crayon $19\frac{1}{2} \times 15\frac{1}{4}$ ins

108 *Study for a Building (Theatre?)* 1913
Ink and black crayon 11×8 ins

109 *Study for a Building (Station?)* 1913
Ink and crayon $11 \times 8\frac{1}{4}$ ins
All from Museo Civico, Como

drawings influencing other drawings – did much to fix the imagery of concrete cliffs and multi-level highways (the latter derived from Leonardo da Vinci's urban schemes in the early sixteenth century) that would modulate popular fantasies about the future for another forty years. But Sant' Elia never put up a real building.

In the real world, the shapes of the future had been developing in America. They could be seen in the primary forms of its industrial buildings: the warehouses, docks, and cylindrical grain elevators. But the essence of architectural – as distinct from engineering – modernism lay in Chicago. In 1871, a fire razed the commercial centre of the city. Nothing could stop Chicago rising again – it was the goods exchange and money-pump for the whole Midwest – and architects, sensing the opportunities that Christopher Wren had had after the Great Fire of London, came seeking work there. They found their blank slate, in more than one sense: Chicago had no traditions, no polish, and no interest in either. It was a brawling, hog-gut city, whose one rule of urban development was to grab the block and screw the neighbour. It had "an intoxicating rawness, a sense of big things to be done. For 'big' was the word . . . [the Chicagoans] were the crudest, rawest, most savagely ambitious dreamers and doers in the world." So wrote Louis Henry Sullivan (1856–1924). Sullivan was, by general agreement, the giant of Chicago building and one of the precursors of modernist architecture: not because he "invented" the load-bearing steel frame, but because he worked out and shaped its aesthetic and functional content with such mastery.

The basic idea for steel-frame building already existed in wood. It was called the balloon frame, because of its lightness compared to the old-style post and timber construction, and was made possible by the advent of two new technologies: sawmills capable of turning the North American forests into an endless supply of sized timber, and the manufactured nail. Homesteaders – and commercial builders in new cities like Chicago – could easily run up the frame of a house using, say, 2 × 6 joists, 4 × 4 plates and posts, weightless by comparison with brick, stone, or sod, and then sheathing them with thin boarding to create a rigid and stable structure. The wall of the house was thus an insulated membrane (sometimes not even insulated) nailed to a wooden grid, whose vertical studs transferred the load to the foundations. In a brick or stone wall, by contrast, the wall had to carry the load. You could put up a balloon frame in a fraction of the time it took to build a brick or a stone wall, or do the laborious hewing, notching, and chinking on a log cabin. No special skills were needed; anyone who could wield a hammer and saw, and knew the sharp from the blunt end of a nail, could make his own house.

If a building's frame were steel, and its skin glass and prefabricated panels of metal or terracotta, one had the germ of the skyscraper. The problem with high construction in brick or stone is that, beyond a few storeys, the load-bearing solid wall must be so thick at the base to carry its own weight and resist the bending and overturning moments within the structure. (A high wall is also a sail, and wind pressure can topple it.) In Chicago in 1891, the architects Burnham & Root had pushed bearing-wall construction about as high as it could go – sixteen storeys – with the nobly plain brick mass of the Monadnock Building (plate 110). (The invention that rendered high-rise

possible in any material had been three decades before, in 1857, by an American named Elisha Otis; it was the safety elevator. Before that, commercial buildings had to be low simply because no businessman was going to live in daily peril of heart attack by trudging up six flights of stairs.)

A steel frame, however, would dispense with mass. All substances deflect when loaded; their use in structure depends on how much they deflect under what load, and whether they want to spring back. What makes a material useful for building is, roughly speaking, the relative relationship between its strength and its stiffness. Brick is stiff, but completely inelastic (like biscuit) and weak in bending; it breaks in tension at a stress of 800 pounds per square inch. Commercial mild steel will take 60,000 psi in tension, and it is very elastic indeed – about fifteen times more so than timber. One could therefore design a steel grid with tall unsupported columns, widely spaced, and linked with horizontal girders. The columns would carry all the load, and the walls of the building could open out into glass or lightweight panels; they would no longer have to carry anything except their own small weight.

The technique of this was not hard to grasp, and it reached a remarkable degree of refinement and expressiveness in Chicago. Thus within four years of the Monadnock Building, Burnham & Root had finished the steel-framed Reliance Building, 1890–4 (plate 111), which, with its wide "Chicago windows" – a big central pane flanked by two high narrow ones – virtually reduced the wall to a stack of transparencies separated by narrow opaque bands. But the man who did most to grasp the poetics of the steel frame was undoubtedly Sullivan. His Guaranty Building in Buffalo, 1894–5 (plate 112) states the lyric theme of all later skyscrapers – *verticality*. It was clearly divided into three parts: base, shaft, and flat-roofed top, with a jutting cornice to finish the prismatic mass. Its visual surprise depends on the fact that it does not seem layered or stacked. Sullivan underplayed his horizontals by recessing the face of the spandrels from the face of the piers. So the vertical piers dominate the pattern. They soar unimpeded to finish in arches, and are emphasized by the brilliant, graphic accents of the round top-floor windows. The structural grid and its pattern of implied stress gives the building its visual motif.

But Sullivan's greater achievement (from the viewpoint of the architecture to come) was to make the grid as expressive as the height. A modular frame of I-beams is, in itself, neither "horizontal" nor "vertical" by nature. It is additive, like a honeycomb; more open rectangles can be added on to it, either upwards or sideways, without compromising its essence as structure. With the Carson Pirie Scott department store in Chicago (1899), Sullivan stated this with the utmost lucidity (plate 113). Its fenestration (pattern of windows) is plainly controlled by its structural grid. In a sense, the Carson Pirie Scott is actually two buildings: the plainness of the upper floors forcibly contrasts with the ground-floor treatment, which Sullivan conceived as a decorated plinth, ornamented with complex cast-bronze panels, almost Cellini-like in their finesse of detail and whiplash energy. (One of the people who worked on their design was Sullivan's precocious assistant Frank Lloyd Wright, then barely out of his teens.) Purists of the International Style, whose *données* the upper floors of this

110 Burnham & Root
*Monadnock Building,
Chicago* 1889–91

Bettmann Archive Inc., New York

112 Louis Sullivan *Guaranty
Building, Buffalo* 1894–5

Brown Bros, Sterling,
Pennsylvania

113 Louis Sullivan *Carson
Pirie Scott department store,
Chicago* 1899

Chicago Architectural Photo Co.

111 Burnham & Root *Reliance Building, Chicago* 1890–4

Bettmann Archive Inc., New York

building did so much to ratify, once treated this dichotomy as a weakness – rather as people who believed Cézanne's "logic" aimed at abstraction used to regret the presence of apples and mountains in his paintings. Today, we are more apt to find pleasure in the "contradictions" of Sullivan, which from the perspective of his own time were not contradictions at all.

The skyscraper, like other things American, intrigued the European public; it seemed to be the American equivalent of the Eiffel Tower, and the *Wolkenkratzer* (or "cloud-scratcher," as Germans called it) became an object of romance and fantasy. It was identified with Promethean democracy *all'Americana*, and in this Sullivan himself heartily concurred: "With me," he remarked, "architecture is not an art, but a religion, and that religion but a part of Democracy." The modular grid was the face of equality. Yet skyscrapers did not catch on in Europe. There were many reasons for this, but perhaps the main one was reluctance to surrender any central part of the old cities – Paris, Berlin, Vienna, or Milan – to single-purpose buildings. In Chicago, the blank slate, architects could and did create a downtown area that was entirely commercial and scarcely residential at all. Moreover, official architects were conservative by nature, and preferred the Beaux-Arts to the Yankee grid and all that it implied.

The second material of the future Utopia was reinforced concrete. A concrete block is strong in compression but weak in tension: its grains pull apart easily. But if steel rods are put in where tension occurs (along the under side of a simply supported beam or slab), it becomes very strong indeed, and can span great distances, annihilating the limits of stone or brick. Moreover, because it is a thick liquid when poured, concrete can be moulded to any shape, and this opened up a world of expressive form whose analogies lay not in previous architecture but in the tiny structures of the natural world that microscopy and photography, between 1880 and 1920, had been revealing in profusion – seedpods, bracts, umbels, diatoms, plankton, the lacy architecture of coral. Audacious feats were done with concrete: Eugène Freyssinet's parabolic airship hangar at Orly, outside Paris, was over 200 feet high inside. But concrete was still an extremely unfamiliar material. In 1913, the German architect Max Berg (1870–1947) used it in his *Jahrhunderthalle* or "Century Hall" in Breslau (plates 114, 115). It was the largest dome in the world's history, some 220 feet in diameter (as compared to the Pantheon's 143 feet, or the 138 feet of St. Peter's dome), framed entirely in reinforced concrete. When the concrete had set and cured, Berg found the workmen refused point-blank to take down the wooden moulds. They were afraid the whole affair would cave in on them; Berg had to start tearing down the shuttering with his own hands before they would go back to work.

The supreme Utopian material, however, was sheet glass. For hundreds of years, stained glass had enjoyed a more or less sacramental reputation, because stained-glass windows were the great decorative feature – and source of religious instruction – in Gothic cathedrals. Sheet glass acquired a different aura of meaning. It was the face of the Crystal, the Pure Prism. It meant lightness, transparency, structural daring. It was the diametric opposite of stone or brick. It suggested a responsive skin, like the sensitive membrane of the eye, whereas brick and stone were impervious, a crust

114, 115 Max Berg *Jahrhunderthalle, Breslau* 1913
Interior and exterior views

against the world. It therefore had an importance for some German architects that verged on the mystical. "The surface of the earth," wrote one of these men, Paul Scheerbart, in 1914, "would change totally if brick buildings were replaced everywhere by glass architecture. It would be as if the Earth clothed itself in jewellery of brilliants and enamel. The splendour is absolutely unimaginable . . . and then we should have on earth more exquisite things than the gardens of the Arabian Nights. Then we should have a paradise on earth and would not need to gaze yearningly at the paradise in the sky."

These are not the accents of the rational planner, but Scheerbart was not alone in his rhapsodies. The generation of northern European architects who came of professional age between 1910 and 1920 was profoundly charged by a sense of the millennium – the literal renewal of history at the end of a thousand-year cycle, the beginning of the *twentieth* century. This, as the architectural historian Wolfgang Pehnt has pointed out, "was probably the last time when [architects] felt themselves to be a community of the chosen, probably the last time when they surrendered themselves to the cult of genius with a clear conscience." On the most familiar level, the Bauhaus – that monastery of craft and design, intended by its founders to rise as the collectively made "crystal symbol of a new faith," in Walter Gropius's phrase – cannot be understood, either as an ideal or a real set-up, outside its framework of mystical Expressionism. But there were single architects too whom the official histories of modernist architecture have tended to pass by, because their work was religious, or mystical-Utopian, or outright crazy: and they had their effect not only on the programmes, hopes, and theory of the International Style but also on what was actually designed. For mainstream modernist architecture owed much more to German Expressionism than one might suppose, and one connection between them was not only glass but a Nietzschean, Romantic idea of the architect as the supreme articulator of social effort, a Master Builder beyond politics, and (almost literally) a Messiah. "There are no architects today, we are all of us merely preparing the way for him who will once again deserve the name of architect, for that means: Lord of Art, who will build gardens out of deserts and pile up wonders to the sky." Thus Walter Gropius, functionalist, declaiming like St. John the Baptist in an official manifesto of the *Arbeitsrat für Kunst* (Work-Council for Art) amid the socialist fervours of April 1919. In less than fifteen years, what came was not the Lord of Art but the Lord of the Flies, Adolf Hitler. Yet who could have foreseen that? No ideal of building has detached itself more gladly from material or political reality than those forms of Expressionist architectural theory which were digested into "functionalism" by Gropius, Mies van der Rohe, and even Le Corbusier.

In the years before and just after World War I, German architects spun endless fantasies on the theme of glass. Its transparency associated it with Heaven and cosmic knowledge. Its crystalline facets suggested absolute shape, the perfect Platonic solids, and (to quote one of its architectural hierophants) "the secret labyrinth of the diamond, where Knowledge indwells." Like virtue itself, it was pure, unyielding, readier to break than to bend. It was associated with the Holy Grail, with ice-caves,

mountain peaks, glaciers, and the shining ramparts of the New Jerusalem – the whole machinery of Romantic sublimity, as passed down from Caspar David Friedrich and Philipp Otto Runge, through Wagner and Nietzsche, to the new century. It extended freely into German writing, in such flummery as Hermann Hesse's yearningly philosophic 1943 novel *Magister Ludi* (*The Glass Bead Game*). Moreover, to imaginations lacerated by the horrors of World War I, the ideal of glass architecture had a special meaning: a world remade of glass would have evolved beyond throwing stones – or artillery shells. Glass architecture was pacifist architecture, the very image of exalted vulnerability which, given a new social contract, would remain forever intact. The glass building was either perfect or it was not there. It admitted no moral compromise. "Hurray, three times hurray for our kingdom without force!" exclaimed the Berlin architect Bruno Taut in 1919. "Hurray for the transparent, the clear! Hurray for purity! Hurray for crystal! Hurray and again hurray for the fluid, the graceful, the angular, the sparkling, the flashing, the light – hurray for everlasting architecture!"

Since there was no prospect of building any of them, the designs took on an extreme of speculative magniloquence. Their use was almost always vague. They were secular temples, or *Stadtkronen* ("City-Crowns," intended as the culminating symbol of civic identity), or socialist palaces; but what went on in them, room by room, was not made clear. Wassily Luckhardt (1889–1972) imagined a vast "Tower of Joy," with a flattened dome above a circular glazed assembly hall and, rising from that, embedded in what looks like a glacier-fall of ruby stained glass, a glass-faced shaft, star-shaped in plan (plate 116). The schemes of Bruno Taut (1880–1938) were even grander and vaguer. In *Alpine Architecture* (plates 117, 118), a collection of drawings published in 1919, he proposed the complete reshaping of a section of the Italo-Swiss Alps into crystal *stupas* and glass-lined grottoes, like the Emerald City of Oz, while his *Die Auflösung der Städte*, 1919–20, suggested that society should be remade by abolishing the metropolis and rehousing people in Utopian communities, garden cities grouped around highly mechanized secondary industry, with appropriate "spiritual centres" for collective worship. All public buildings, he believed, should be made of glass.

Taut's glass fantasies did find some play – if not full realization – in two buildings: the Steel Industries Pavilion at the Leipzig building-trades exhibition of 1913, which he co-designed with Franz Hoffmann (an octagonal curtain-wall building framed in iron, surmounted by a gilded globe); and, more important, the exquisite little Glass Pavilion at the Werkbund Exhibition of 1914 in Cologne. Superficially, the Glass Pavilion looks like a prediction of Buckminster Fuller's geodesics, but it was of much more aesthetic interest than that. Light shone into the double-glazed dome through prisms, and was reflected from its outer skin by mirroring; the walls and steps were of glass blocks, and kaleidoscopic images were thrown into a deep violet well of water from a projector (plate 119). To emphasize the moral, couplets by Taut's friend Paul Scheerbart were inscribed on the building:

Glück ohne Glas	Happiness without glass –
Wie dumm ist das!	What an absurdity!

116 Wassily Luckhardt *The Tower of Joy* 1919 Akademie der Künste, Berlin

117 Bruno Taut *Alpine Architecture* 1919
Akademie der Künste, Berlin

118 Bruno Taut *Sketch for Alpine Architecture*
Akademie der Künste, Berlin

119 Bruno Taut *Glass
Pavilion at the Werkbund
Exhibition, Cologne* 1914
Akademie der Künste, Berlin

Backstein vergeht,	Bricks pass away
Glasfarbe besteht.	Glass colours stay.
Farbenglück nur	The joy of colour
In der Glaskultur.	Is only in glass-culture.
Grösser als der Diamant	Larger than a diamond
Ist die doppelte Glashauswand.	Is the glass-house's double wall.
Das Glas bringt uns die neue Zeit;	Glass brings a new age –
Backsteinkultur tut uns nur leid.	Brick buildings are depressing.

Such was the drama of emotion, hope, and expectation surrounding the use of glass among the Utopian architects of Germany. Naturally, other *avant-garde* architects were touched by it. It was the image of the pure and glittering prism, rather than any "functional" theory, that gave its generating idea to the early work of Ludwig Mies van der Rohe (1886–1969).

To see this, one should look at the designs Mies, at thirty-four, made for the most important architectural competition held in the first years of Weimar Germany – the Turmhaus-AG's Berlin contest for a high-rise building near Friedrichstrasse Station (plate 120). He wanted it to look like a "polished crystal," and said so; and in his drawings, it does. Its mass seems volatilized in light, leaving only profiles and reflections: this is the Expressionist tower of purity, sharp angles, crystal-shaped plan, glitter, and all. Later, Mies would reject the Expressionist content of the ice-palace, but his work always retained an obsessive interest in formal absolutes. He carried this to a degree that only Taut or Luckhardt, perhaps, could have fully sympathized with. Thus when his last successful major building, his big black Parthenon of a museum in Berlin, was going up, the administration asked him if the storage rooms (which were too small) could be extended underground; Mies refused, because he thought such an expansion, even though it was invisible, would have compromised the perfect cube of his museum.

In Mies's work, the irregularities of "alpine architecture" and its glass walls are tamed; the ice-palace is married to the Chicago grid. Mies's output was not large, but his buildings exerted an influence out of all proportion to their number because they were all, at root, about the same thing: formal absolutes approached by the rectilinear use of industrial materials. It is to Mies that the modern corporation owes its face; glass was the essence of the skyscraper, and the skyscraper has become the essence of the modern city – a parade of thin films hung on steel skeletons. No more load-bearing walls. And Mies seemed to be the epitome of reason – straight lines, rational thought, and extreme refinement of proportion and detailing. If an architect copied him, he would not be copying a style but emulating revealed Truth; and this was the secret of Mies van der Rohe's extraordinary influence on two subsequent generations of designers. "He believed in the ultimate truth of architecture," recalls Philip Johnson, who helped bring Mies to the United States in the late thirties, "and especially of his architecture: he thought it was closer to the truth, capital T, than anyone else's because it was simpler and could be learned, adapted on and on into the centuries. In a

way this was bad because it gave everyone a license – *I am doing Mies!* Every architect could say to his client, 'I can do a building cheaper than I did for you last year, because now I have a religion' – flat roof, factory made curtain walls, a rationalization for cheapness."

This fallout from his ideas was not, however, what Mies had in mind in 1923, when he published his "Working Theses," a lapidary manifesto of the new building. "Architecture is the will of the age conceived in spatial terms," he announced. In order to respond to this *Zeitgeist*, the architect must "reject all aesthetic specu-lation, all doctrine, and all formalism" – an injunction that sounds odd today, since the only architects who proved to be more doctrinaire and formalist than Mies were his imitators. But Mies thought that if only an architect could work without such preconceptions, the culture's will-to-form (not articulate yet, but implicit in the available technology and existing social needs) would speak through his work. It would be "objective," because it grew out of the machine culture of mass production and prefabrication. "The materials are concrete, iron, glass. . . . No noodles or armoured turrets. A construction of girders that carry the weight, and walls that carry no weight . . . buildings consisting of skin and bones." There was no room in this scheme for individual fantasy (another "noodle") for, as Mies chillingly put it, "the individual is losing significance; his destiny is no longer what interests us."

Not one of Mies's designs was ever successfully prefabricated, because he insisted on tolerances that mass production, as it existed for architecture, could not handle. He was a stonemason's son and his background lay in traditional craft, in the refining, shaping power of the hand on "noble" materials. Indeed, by 1930 he had recoiled from his praise of the machine-process ideal: "Whether we build high or low, with steel and glass, tells us nothing about the value of the building," and by *value* he meant spiritual and aesthetic intensity. The year before, he had built his most perfect building, and it had already been torn down. This was the German Pavilion at the Barcelona Exhibition of 1929 (plates 121, 122). It was exceedingly pure architecture, having no function except self-display, raised like a sculpture (which it virtually was) on a marble base. The thin slab of the roof floated on chrome-steel columns, and the internal walls were hardly more than screens, hints of enclosure that inflected space rather than boxed it in, as Japanese *shoji* and *byobu* (folding screens) do. Some were made of glass panels, others of highly polished, expensively bookmatched marble slabs. By volatilizing the walls but retaining a classic stringency of plan, Mies brought the little building closer to the status of a pure Idea than any twentieth-century architect had yet done; and the idea had many progeny, from Mies's own Tugendhat and Farnsworth houses to Philip Johnson's Glass House in Connecticut. The beauty of the materials, however, was vital to its effect. When he came to design the curtain wall of the Seagram Building in New York, 1956–8 (plate 123), Mies could have used steel or aluminium. But there was a particular quality of colour and shadow that he wanted, the darkness of grooves laid into a warmer surrounding darkness, and this – so he concluded – could only be achieved in bronze. The result was the most expensive

121

122

121, 122 Ludwig Mies van der Rohe *German Pavilion at International Exposition* Barcelona, Spain, 1929

Photographs courtesy Mies van der Rohe Archive, The Museum of Modern Art, New York

123 Ludwig Mies van der Rohe *Seagram Building* New York, 1956–8

Photo Alexandre Georges, New York

120 Ludwig Mies van der Rohe *Friedrichstrasse Office Building*, Berlin, Project, 1921 Perspective

Charcoal and pencil on brown paper mounted to board $68\frac{1}{4} \times 48$ ins Collection, Mies van der Rohe Archive, The Museum of Modern Art, New York, Gift of Ludwig Mies van der Rohe

123

curtain wall ever hung on a steel frame, but the most elegant as well – the elegance of the Void, an architecture of ineloquence and absolute renunciation.

In his desire for a universal grammar of architecture, Mies van der Rohe was apt to sweep aside questions of meaning within the buildings themselves; they interfered with the perfect Zero that he struggled to approach. The idea that his Gallery of the Twentieth Century in Berlin could be seen as "functional" is absurd, for he was so anxious to preserve the integrity of his ideal form, the gridded glass block, that he refused to equip its main floor with any walls on which a picture could be hung. He could take infinite pains working out how to turn a corner with I-beams and cladding, and simply ignore the social matrix in which the building was embedded. The prism-with-variations could go anywhere and serve any purpose. It was also free of ideology; there is very little difference between the building Mies proposed to Hitler as a suitable design for the Reichsbank in 1933, and those he put up in America after his emigration. In its wholeheartedly formalist indifference to sociological questions, Mies's work provided the rationale for what the Germans called *Stempelarchitektur*, rubber-stamp building, the house style of Germany's postwar "economic miracle." Though it carried no specific political loading, his style – so abstract, so regular, so obsessed with clarity of detail and repetition of units, so fond of the crystalline mass as a single dominating form – tended to appeal to the authoritarian mind.

Mies was not interested in town planning, but his German and French colleagues in the 1920s were. The central image of the new architecture was not the single building. It was the Utopian town plan, and the planners of the time saw their paper cities with the detachment granted to possessors of the bird's-eye view – very high up, very abstract, and thus nearer to God. What most of their projects had in common was an alarming obsession with social hygiene. In future, instead of lurking on streets and squares and alleys, the human beetle would be made to live in tower blocks, to commute by monorail or biplane or moving pavement, to scuttle about in allotted green space between the skyscrapers, and in general to do one thing at one time in one specified place, which accorded with the coming rationalization of all human life. And so the millennium would dawn, and the old capitals of Europe, which World War I had barely scratched – since there was no saturation bombing yet to send history back to the drawing board – would now be flattened by idealist architects.

At the humane and possible end of the scale, there were projects like the English garden cities, of which the prototype was Letchworth in Hertfordshire, or, at a higher level of density, the Cité Industrielle conceived by the French architect Tony Garnier, with its carefully organized social functions. But at the other end of the scale of social invention, the garden reared itself up and became a ziggurat, and the architectural planner a pyramid-builder. Societies must now forget the horizontal axis and group themselves around the vertical. One motif occurs over and over again, from Auguste Perret's tower blocks for the rebuilding of Paris, 1922 (plate 124), to such bleak prospects as Ludwig Hilbersheimer's perspective of an ideal city, 1924 (plate 125). It is the grid of tower blocks, laid out on a rectangular module, separated by patches of green space and joined by superhighways. With this idea that a city could be

124 Auguste and Gustave Perret *Study for Tower Blocks for Paris* 1922
Akademie der Künste, Berlin

125 Ludwig Hilbersheimer *Study for Ideal City* 1924 Akademie der Künste, Berlin

126 Le Corbusier *Drawing for the Voisin Plan* 1925 Akademie der Künste, Berlin

compressed into a series of vertical extrusions of a limited site, the form of Manhattan Island had come back across the Atlantic to haunt the Old World.

The lyric poet of this idea, which has influenced cities for the worse from Sydney to Zagreb, was Charles-Édouard Jeanneret, better known by his nickname "Le Corbusier" – the crowlike one. (Doubtless this referred to his taut and beaky frame and inquisitive eye, rather than to his harsh, carking absolutism in argument; but it seems to suit both.) Corbusier (1887–1965) was, at the level of the single building, one of the most brilliantly gifted architects who ever lived – the Bramante or Vanbrugh of the twentieth century. He was also, on the scale of the town plan, one of the most relentlessly absolutist – a combination of Swiss clockmaker, Cartesian philosopher, and *roi soleil*. His manifesto of town planning, *The City of Tomorrow* (1924), has for its last illustration an engraving of Louis XIV ordering the construction of the Invalides, accompanied by Corbusier's remark that "this despot conceived immense projects and realized them. . . . He was capable of saying 'We wish it,' or 'Such is our pleasure.'" Nostalgic self-identification could hardly go further. In a way Corbusier was quite right to admire Louis, since only despotism could have swept away the zoning laws and rights of private property that impeded the construction of his own exemplary New Jerusalem, *La Ville Radieuse*, the "Radiant City." No designer in the history of architecture has been more possessed by an idea than Corbusier was. His own tragedy was that this idea was not fulfilled. But one may be quite sure that Corbusier's disappointment, grave as it was, could not have begun to compare with the misery and social dislocation the Radiant City would have inflicted on its inhabitants, had it ever been built.

Corbusier's Voisin Plan of 1925 was the most developed of his schemes for the rationalization of Paris. It developed from his irrefutable perception that the centre of Paris was too congested, crammed, and old to support the intense motor traffic that the early twentieth century was bringing; that many of its buildings were uncomfortable, dirty, and even dangerous; and that "urban renewal," as understood by European city authorities in the early twenties, was inarticulate and patchy, where it existed at all. The Parisian street was a mediaeval relic – the "Pack-Donkey's Way," as he called it, the meandering fossil of pedestrian traffic between the old gates of Paris and its religious and commercial centre. For these clogged urban tubes and tripes, Corbusier's remedy was the knife. "The right angle," he declared, in a sort of Euclidean ecstasy, "is as it were the sum of the forces which keep the world in equilibrium. There is only one right angle; but there is an infinitude of other angles. The right angle, therefore, has superior rights over other angles; it is unique and it is constant. In order to work, man has need of constants. Without them he could not put one foot before the other. . . . The right angle is lawful, it is a part of our determinism, it is obligatory." The first Rationalizer of Paris had been Louis XIV; the second, Baron Haussmann; the third would be Le Corbusier.

The Voisin Plan (so called because its research was underwritten by the car manufacturer Voisin, after Peugeot and Citroën turned it down) required the clearing of a 600-acre L-shaped site on the Right Bank; it would have involved the total

destruction of the "particularly unhealthy and antiquated" areas around Les Halles, the Place de la Madeleine, the Rue de Rivoli, the Opéra and the Faubourg Ste-Honoré. From this *tabula rasa*, split east-west by a giant motorway (plate 126), the new commercial and residential centre of Paris would rise in its cruciform tower blocks, surrounded by green space. "Imagine all this junk, which till now has lain spread out over the soil like a dry crust, cleaned off and carted away and replaced by immense clear crystals of glass, rising to a height of over 600 feet!" That Corbusier could dismiss most of Paris' historical deposit as a dry crust of junk is the measure of his fervour, and one would be quite wrong to think he did not mean every syllable of the tirades he directed against the sentimental *passéistes* who, in the name of memory and variety, opposed his "vertical city . . . bathed in light and air." He himself, he pointed out, was not bitterly opposed to the past, but he considered it civic duty to show that it *was* past by leaving its isolated memorials with nothing to do – "my dream is to see the Place de la Concorde empty once more, silent and lonely . . . these green parks with their relics are in some sort cemeteries, carefully tended. . . . In this way the past becomes no longer dangerous to life, but finds instead its true place within it." Such was Utopia's revenge on history. But Corbusier's particular enemy was the street, and on it he waged unremitting (if, mercifully, verbal) war. The idea that there could be alternatives to traffic congestion in old urban centres – like restricting the historical quarter to foot-traffic and routing the flow of cars round it, as has recently been done in Munich – never seems to have struck him. Corbusier's frozen perspectives of giant avenues crawling with coupés and humming with biplanes mean only one thing: a hatred of random encounter, which expressed itself in a city totally dedicated to rapid transit. "We watched the titanic rebirth of the traffic. Cars, cars! Speed, speed! One is carried away, seized by enthusiasm, by joy . . . enthusiasm over the joy of power." The car would abolish the street – and everyone in Utopia would own a car. The one thing nobody in *La Ville Radieuse* could expect to have was the *esprit de quartier*, the sense of variety, surprise, and pleasant random encounter that once made living in Paris one of the supreme experiences of urban man.

Le Corbusier himself got only one chance to build high-rise mass housing in France. That was his Unité d'Habitation (1946–52), which stands a considerable way from the centre of Marseilles, on the Boulevard Michelet (plate 127). It is one proto-type unit of the Radiant City: an eighteen-storey block, 185 feet high, 420 feet long, and 60 wide, containing flats for 1600 people, the whole mass raised on concrete legs or *pilotis* above twelve acres of surrounding parkland. Surprisingly enough, the most successful and memorable part of this building is the roof. Corbusier meant it to contain a gymnasium, a paddling-pool for children, a palaestra for exercise and a bicycle track. Today the pool is cracked, the gymnasium closed (some optimist tried to resurrect it as a disco, which naturally failed), and the track littered with broken concrete and tangles of rusty scaffolding. Even so, in its decrepitude, it is one of the great roofs of the world (plate 128): a metaphor of Corbusier's social aims, the concrete garden of ideal form, giving health to those who live in it. In the raking light of an early Mediterranean morning, it has a heroic sadness approaching that of a

127, 128 Le Corbusier *Unité d'Habitation, Marseilles* 1946–52
Exterior and view of roof, Roger Viollet, Paris

Greek temple. The Greeks, Corbusier wrote in *Towards an Architecture* (1923), had "set up temples which are animated by a single thought, drawing around them the desolate landscape and gathering it into the composition. Thus, at every point of the horizon, the thought is single."

Corbusier's career offered him only one site that compared with the bare singularity of the Acropolis, and it was this roof – bony grey hills behind, sea in front, and glittering air all around. In those days Marseilles was almost as clear as Athens, and the *massif* was bare of apartment blocks. The Unité stood alone, and Corbusier turned its roof into a magnificent ceremonial space, dedicated to the cult of the sun.

The problems begin under that slab. Corbusier had been deeply influenced by the doctrines of social reform elaborated by Charles Fourier (1772–1837). He did not imagine, as Fourier did, that in the coming Utopian age the sea would lose its salt and taste like lemonade, or that the world would blossom with 37 million playwrights, each one as good as Molière; but he was influenced by Fourier's notion of the ideal community, the "phalanstery" (a contraction of "phalanx" and "monastery"). The *phalanstère* was a profit-sharing commune of about one hundred families. Corbusier could not hope that the Unité would turn sixteen hundred rehoused Marseillais into communards overnight, but he declared that many of his ideas could be traced to the "prophetic propositions of Fourier . . . at the very birth of the Machine Age." Hence the extreme monasticism of the Unité. There is little privacy in this nobly articulated beehive of raw concrete; the children's rooms are hardly more than cupboards (Corbusier had no children of his own and apparently disliked them); and the ideal of communal self-sufficiency left its fossil in the form of a "shopping mall" on the fifth floor so that, in theory, nobody would need to leave the building to go to market. As everyone in France except Le Corbusier knew, the French like to shop in their street markets. So, the "shopping mall" remained deserted; later, it was turned into a spartan and equally empty hotel, the Hôtel Le Corbusier, where the sleepless guest may listen to the spectral whining of the mistral *inside* the building. Finally, none of the Marseillais who lived there could stand Corbusier's plain, morally elevating interiors, so they soon restored the *machine à habiter* to the true style of suburban France. The flats of the Unité are crammed with plastic chandeliers, imitation Louis XVI *bergères*, and Monoprix ormolu – just the furniture Corbusier struggled against all his life. The man who wanted to assassinate Paris could not, in the end, ensure that a single concierge would buy the right rug.

Yet though he failed as a sociological architect, Corbusier was a great aesthete, and his power to invent form was extraordinary. He was in a sense the Picasso of architecture, because his designs provoke such strong sensations, contain such overmastering rhythms, and display such a muscularity of "drawing." His formal language was based on a passionate enjoyment of two systems of form which seemed diametric opposites but were, in his view, similar: classical Doric architecture, in all its lucidity, and the clear, analytic shapes of machinery. His famous comparison, in *Towards an Architecture*, is still startling: the flank of the Parthenon, with its regular rhythm of columns, and the bow-on view of a Farman biplane, with a similar rhythm

set up by the struts between its wings. With such analogies, and in his own designs, Corbusier strove to celebrate what he called the "White World" – the domain of clarity and precision, of exact proportion and precise materials, culture standing alone – in contrast to the "Brown World" of muddle, clutter, and compromise, the architecture of inattentive experience. The art he practised, he declared, could be summed up as "the informed, correct and magnificent play of forms under light." That one phrase condenses his passion for the Pentelic marble, the whitewashed Aegean walls and crystalline sea-light, amid whose Doric antiquity so much of Corbusier's imagination was shaped when he was young. No mature building of his shows more succinctly what he meant than the Villa Savoye, 1929–31, standing in what was once meadowland at Poissy, outside Paris (plates 129, 130). It was the cube the Cubists never painted – a pristine white box, raised on twenty-six delicate columns, above a curving ground-floor wall, the skinlike tautness of its stucco walls emphasized by long strips of sliding windows, the whole design setting up an exquisitely delicate play between opacity and transparency, closed form and open space. Corbusier was able to combine a rich variety of shapes and inflections – the ramps, the cylinders on the roof, the corkscrew stair and elegantly springy handrails – within the frame of the cube, and the result was perhaps the finest example (certainly the most widely published and poetically influential one) of what would come to be known as the International Style.

When they coined this phrase in 1932, Philip Johnson and Henry Russell Hitchcock had in mind the generating structure of modern architecture – the steel or concrete grid with non-load-bearing walls. But the hallmarks of the International Style went beyond that, and were summed up in the sense of etiquette the Villa Savoye conveyed. One consequence of the grid was an emphasis on truth-telling – no decoration, "no noodles," as Mies had said. This meant that even solid walls ought to look like membranes. Architects therefore wanted an opaque material that did not look as though it carried a load. They found it in stucco, or thought they had. To reduce a wall to a perfectly even sheet of plaster render, with hairline edges and no sign of modular division (like brick joints) – that was to approach the ideal planar flatness of the membrane. Then, the bulk of the structure could appropriately be seen as *volume*, generated by the intersection of planes with space flowing round them, rather than mass or simple structure. What was visible on the outside was also done inside. The "open plan" was not invented by the architects of the International Style. They took its basic idea from their diametric opposite, the great American Frank Lloyd Wright, who had been designing in terms of an "organic" spatial flow based on Japanese traditional architecture, with the least possible interference from boxy walls and alien furniture, before Gropius and Le Corbusier built their first structures. (Wright's *Collected Works*, covering his mainly domestic designs from 1893 onwards, was published in Germany in 1910, and its influence there was immense.) However, the International Style refined the idea of open planning to a pitch of abstraction that Wright would not have accepted, and the refinement had to do with material: a wall that did not carry the roof could be pierced at will, or simply dissolved into horizontal bands of opacity and transparency. Unfortunately, this Platonic style needed a

Platonic substance to build it : something thin (which stucco could seem to be) but elastic (which it was not), mass-producible in units, and weatherproof. This substance was never found – and that is why so many International Style buildings including the Villa Savoye ended up cracked, stained, crumbling, and otherwise ruined after a few years' exposure to the elements.

Although Corbusier was its chief interpreter in France, the main theatre of the machine aesthetic and the International Style in Europe during the 1920s was Germany; and its centre was a school in Weimar named the Bauhaus. Ever since, "Bauhaus" has been synonymous with rationalized, sharp-edge, machine-based style. Yet no other art school or design centre in our century exerted a comparable influence on European thought, and such an effect could hardly be expected to flow from a mere stylistic "look." The structure and philosophy of the Bauhaus, even more than its actual designs, played the decisive role.

The school came into being in 1919 when, under the young and passionately idealistic architect Walter Gropius (1883–1969), two older Weimar institutions were fused. One was the Grand Ducal Academy of Art, dating from the mid-eighteenth century; the other was a much newer affair, the Arts and Crafts School, set up in Weimar in 1902 by one of the leaders of Art Nouveau, the Belgian Henry van de Velde. Their combination was called the Staatliche Bauhaus, and the word "*Bauhaus*" – literally, "House for Building" – carried intentional overtones of the *Bauhütten* or lodges where, in the Middle Ages, masons and designers at work on mediaeval cathedrals were housed. At the very outset, the name thus suggested a close society of craftsmen, bound by more than casual ties (for the brotherhood of German Freemasonry also traced its lineage to the *Bauhütten*), sharing the load of a heroic, idealist project. The image of the cathedral as symbol of Utopian collectivism was part of the Bauhaus myth. The school's first manifesto, written by the thirty-six-year-old Gropius, had as its frontispiece a woodcut of a starlit cathedral by Lyonel Feininger (plate 131). The influence of both Marx and William Morris (the latter transmitted through van de Velde's own craft-workshop system) is plain in this document, with its call for a unity of creative effort in which all branches of design would be mobilized together:

Today the arts exist in isolation, from which they can be rescued only by the conscious, cooperative efforts of all craftsmen. . . .

Let us then create a new guild of craftsmen, without the class distinctions that raise an arrogant barrier between craftsman and artist! Together let us desire, conceive and create the new structure of the future, which will embrace architecture and sculpture and painting in one unity, and which will one day rise toward heaven from the hands of a million workers like the crystal symbol of a new faith.

All Gropius's own training had been leading up to this point; his ambition had set early in his career. In 1907, in his early twenties, he had joined the studio of the leading industrial designer in Germany, Peter Behrens (1868–1940). For a time, Behrens had not only Gropius working for him, but Le Corbusier and Mies van der Rohe as well – a concentration of talent unrivalled, perhaps, by any design office since the Cinquecento. The main client for Behrens's work was a German industrial combine,

129, 130 Le Corbusier *Villa Savoye, Poissy* 1929–31
Front view (photo Tim Benton)
Garden view (photo Charlotte Benton)

the AEG or German General Electric Company. He was the first man to carry out what has, in modern corporate practice, become a familiar procedure: he gave AEG its complete package of visual style, supervising the design of everything it used, from letterhead and catalogues to arc-lamps and factory buildings. He came as close as any designer ever did to creating a general style of design, aimed at mass production of a wide range of products from an industrial base. This point was not lost on Gropius, whose work up to 1914 was all industrial. In his precocious design for the Fagus shoe-last factory of 1911, probably the most "advanced" building of any sort put up in Europe before the Great War, Gropius not only reduced the wall to a glass skin stretched between columns – he actually made the corners of the building transparent, thus completing the ideal of the glass prism (plate 132).

Did Gropius, then, start off to convey this sense of the primacy of industry to his students? The Bauhaus did not even have an architecture department until 1924. For a third of its working life, this "House for Building" taught its students nothing about structural mechanics, building codes, strength of materials, or site procedures. Eight years after he built the Fagus factory, Gropius was exhorting his students to think in terms of wood. "The new era calls for the new form. . . . Timber is *the* building material of the present day." In 1920, Gropius and his teaching partner Adolf Meyer designed a wooden house for a sawmill owner named Sommerfeld (plate 133). It was so Teutonic, so redolent of trolls and forest with its notched log walls and pitched timber roof, that Goering could well have approved it as a hunting lodge. The "practical" reason for Gropius's *volte-face* was the depletion of industrial materials in the postwar chaos of Germany; one should build with what was available, and at least there were plenty of trees. But the real reason was Gropius's belief that, in the spiritual confusion of a lost war, only craft – in its most traditional sense – could be a guiding thread; if a new kind of spiritual guide (the "Lord of Art," as imagined by Expressionism) were to be nurtured, his sensibility must be fed on traditional materials and the collectivist, *völkisch* society they pointed to. Gropius's form of communism was Expressionist, not Marxist, and the idea of art as a quasi-religious activity dominated the Bauhaus. Whom did this "rationalist" hire as his first head teacher? None but Johannes Itten, a faddist who would have been quite at home on the coast of California in the seventies, who held purification rituals with his students, called his classroom the "Templars' Hall," insisted on a vegetarian kitchen in the canteen, and announced that hair was a sign of sin. In its Weimar years, the Bauhaus was host to every sort of romantic nitwit, Tolstoyan *Wandervögel*, and fringe prophet – the "Inflation Saints," as they were called, preaching their transcendental gospels and holding marathon readings of the *Epic of Gilgamesh* by candlelight. Not surprisingly, the citizens of Weimar were puzzled by this; then they became suspicious, and finally hostile, especially since their taxes were paying for it all. Where were the promised designs? Where was the collaboration with industry? How could two distinguished art schools have merged to produce an introverted commune of people in smocks, washing one another's feet and hacking designs on baulks of oak with home-made adzes?

Sensing the mood, Gropius fired Itten in 1923 and replaced him with the Hungarian Constructivist László Moholy-Nagy, who took charge of the Basic Course and – basic to industrial relations – the metal workshops. Gropius also organized an exhibition at the Bauhaus, entitled "Art and Technology – A New Unity." This did not mollify the authorities of the right-wing local government in Thuringia, who cut down the Bauhaus budget so far that the school had to close in 1925 and move to the more amenable climate of Dessau. But the "Art and Technology" show did sharply mark the new direction the Bauhaus would take, and it was the hinge-point in Gropius's own career. Nothing more was heard about wood as the material of Utopia. The Dessau Bauhaus was all steel, concrete, and glass (plate 134), designed by Gropius as a polemical metaphor of collaboration with industry. The school, he announced, would address itself to practical questions: mass housing, industrial design, typography, layout, photography, and the "development of prototypes." It would shape "a decidedly positive attitude to the living environment of vehicles and machines . . . avoiding all romantic embellishment and whimsy."

Mass housing was a great social issue in Weimar Germany, and hence, necessarily, for the Bauhaus. From 1924 onwards, with the Deutschmark stabilized and the madhouse inflation of 1923 curbed, the government could begin to build; and no other country built as many flats, blocks, and houses for its citizens over the next eight years. At the peak of the Weimar building boom, more than seventy per cent of all new dwellings were built, in whole or in part, with government money – most of which came from a fifteen per cent tax on the rents of private landlords. A great deal of the work was done by International Style architects: Gropius, Bruno Taut, Eric Mendelsohn, and Ernst May, the last a committed Communist Party member, who became the director of municipal building in Frankfurt with all but total power over the city's housing. The result was that classical form of social housing, the *Siedlung* or "settlement," beloved of the world's Utopians. The Siedlung was the paradise of rational housing that John Betjeman described satirically:

> I have a vision of the Future, chum:
> The workers' flats, in fields of soya beans
> Towering up like silver pencils, score on score,
> While Surging Millions hear the Challenge come
> From loudspeakers in communal canteens:
> "No right! No wrong! All's perfect, evermore."

The demonstration piece of the new housing – and of the International Style itself, within Germany – was built in 1927 as part of yet another trade fair exhibition. This was the Weissenhof ["White House"] siedlung of 1927 in Stuttgart, sponsored by the Werkbund. Corbusier, Mies, Gropius, J. P. Oud, and Taut all designed buildings for it, and twenty thousand people a day came to marvel at the flat roofs, white walls, strip windows, and *pilotis* of what Mies called "the great struggle for a new way of life" (plate 135). In fact it was a slightly mendacious exercise, since all the dwellings were built, detailed, and finished to much higher standards than real public housing could

131 Lyonel Feininger *Cathedral, Frontispiece from the first Bauhaus Manifesto* 1919

Woodcut

132 Walter Gropius and Adolf Meyer *The Fagus Shoe-last Factory, Allfeld-an-der-Leine* 1911

(photo RIBA, London)

133 Walter Gropius and Adolf Meyer *Sommerfeld House, Berlin* 1920

Bauhaus Archiv, Berlin

134 Walter Gropius *Bauhaus, Dessau* 1925–6
View from staircase window (photo Lucia Moholy, Zurich)

135 Ludwig Mies van der Rohe *Weissenhofsiedlung, Werkbund Exposition,* Stuttgart, Germany, 1927
Photograph courtesy Mies van der Rohe Archive, The Museum of Modern Art, New York

afford. In real life the housing projects, from May's Siedlung Bruchfeldstrasse in Frankfurt to Gropius's apartments in the Siemensstadt in Berlin, all tended to share an extreme concern for what the Bauhaus called *Wohnung für das Existenzminimum* – minimal housing. Thus Gropius felt no qualms about putting the Siemens employees in rooms less than seven feet high; after all, few German workers stood over six feet, and the lighting fixtures were flush with the ceiling. The *Siedlungen*, in their well-meaning regimentation of living habits, marked the high tide of the intrusion of bureaucratic master planning into German family life. Only the fact that they had been designed for the hated Weimar Republic by Communists or Jews (or, in Meyer's case, both), with degenerate flat roofs like Arab villages instead of racially healthy pointed ones like German farms, prevented the Nazis from applauding them. In all other ways they were impeccably totalitarian, but one should remember that, however depressing these serried blocks now seem, they were much better than the nineteenth-century slums that spelled "workers' housing" before Weimar.

The Bauhaus's main influence as an institution was on applied design. (By 1928, Gropius had resigned to devote himself to private practice as an architect, and from then on the workshops tended to dominate the school.) The school's view that it is far harder to design a first-rate teapot than to paint a second-rate picture was, of course, unarguably right, and the philosophy of the Bauhaus probably did more to dignify the work of modernist designers than any other cultural strategy of the last half century, at least until the foundation of the design collection at the Museum of Modern Art in New York. Much of the emphasis was on compact furniture for mass housing – folding beds, built-ins, slide-away units, stackable chairs and tables, and the like. There was also a strong link with industry: students, especially in the metalshops, were encouraged to design in terms of mass-production processes. Thus Marianne Brandt designed lighting fixtures for the Korting factory in Leipzig. The royalties from Bauhaus designs were split between the school and the designer, and half the school's share went into a welfare fund for experimental designers whose work was too "advanced" for immediate industrial use. A great many of them were. Though every teapot, watch, glass, or radio cabinet was conceived as an industrial prototype, the demand for Bauhaus purity was usually too small to justify mass production. Hence the rarity of Bauhaus objects today.

The classic case of this was Bauhaus furniture. Most of the radical new designs of chair, table, or sofa in the twenties were done by architects – Marcel Breuer and Mies van der Rohe inside the Bauhaus, Corbusier outside it. There was a clear reason for this, and it flowed from Frank Lloyd Wright's theory of Organic Architecture. "It is quite impossible," Wright had declared in 1910, "to consider the building as one thing, its furnishings as another. . . . The very chairs and tables, cabinets and even musical instruments, where practicable, are of the building itself, never fixtures upon it." So furniture would play its part in the great reform of planning, which was to do away with the idea of architectural space as "a composite of cells arranged as separate rooms." Wright was the pioneer of built-in furniture in the West, and the European modernists followed his cue to an extreme. Where furniture was visible at all, it should

be pared down to its formal essence, made into space-frames with cushions (or even without them), or perhaps done away with altogether: Marcel Breuer fantasized about replacing chairs with rising columns of air on which people would sit like Ping-Pong balls on water-jets in shooting galleries, thus eliminating all obstruction to the pure flow of space. What people outside the Bauhaus made of their designs can perhaps be guessed from Karl Rössing's caricature of a *Junger Ästhet* (plate 136) perched, with insecure pomposity, in one of Breuer's "Wassily" strap-and-chrome armchairs. And indeed, the sceptics had a point. Styles in furniture change, but the human body does not, and much of the new furniture seemed to insist that it should. These tubular metal or stick-and-leather objects were too polemical to be comfortable: the Machine for Living In had to be furnished with Arguments for Sitting In. They were in fact a kind of ecclesiastical furniture, designed to mortify the flesh of worshippers at the shrine of absolute form. *Il faut souffrir pour être belle.*

But the most severe rebuke to the body was made earlier, by a Dutch designer named Gerrit Rietveld. Rietveld was a member of an idealist group in The Netherlands named *de Stijl* – "the Style," suggesting a final consensus about form and function at the end of history, the ultimate style. Its principal members, apart from Rietveld, were the sculptor George Vantongerloo, the painters Theo van Doesburg and Piet Mondrian, and J. P. Oud the architect. Their ideas had influenced the Bauhaus, but they went far beyond Bauhaus practice in their missionary abstraction. Rietveld's "*Rood Blauwe Stoel*" or "Red and Blue Chair," 1918 (plate 137), is considered a classic of its kind, and quite rightly. It so transcends ordinary functionalist discomfort that the only buttocks suited to it would need to be a cleft perfect solid. It is not furniture, but sculpture: a three-dimensional development of the two-dimensional pattern of grid and primary colours that formed the paintings of Van Doesburg and Mondrian.

The aims of *de Stijl* were as clear as they were unattainable. Sickened by the Great War and the societies that had produced it, believing themselves to be at the end of capitalist individualism and on the edge of a new, spiritualized world order, its members wanted to be international men. Their art was conceived as a form of supranational discourse, a "universal language," like Esperanto. Down with frontiers, up with the grid: an extremely abstract version of the "White World" of Corbusier (a far more physical architect than Oud) would rise from the wreckage. It would contain no curved lines, which were "too personal." *De Stijl* stood for Masonic rectitude – against the individual, for the universal. The Bauhaus's compromises with comfort, and even décor, were not acceptable to *de Stijl*, which restricted its forms to the rectangle and its colours to the three primaries, red, yellow, and blue, plus black and white. In this way, it proposed a grammar of shape that would apply to every art, architecture no less than painting. The grave, spiritualized classicism of *de Stijl* (plate 138) would then bring about the millennium of austerity and understanding.

It did not, for art cannot cure nationalism and Dutch furniture stores were not run by idealists. But the name of *de Stijl* survives, mainly because Piet Mondrian (1872–1944) was one of the supreme artists of the twentieth century. And though his

136 Karl Rössing *Junger Ästhet* 1929
Woodcut

137 Gerrit Rietveld *Red and Blue Chair* 1918
Stedelijk Museum, Amsterdam

138 Theo van Doesburg *University Hall* 1923
Collage, tracing paper, pen and ink 25 × 57 ins
Collection C. van Eesteren, Amsterdam

paintings had no measurable effect on the real world of human transactions (none, at least, until their designs were seized on as linoleum patterns, which was not quite what *de Stijl* had in mind), they were of exceptional importance in the fictional sphere of art.

Mondrian expected them to affect both domains, and for the better. He was one of the last great painters to believe that his paintings could change the objective conditions of human life. He was far more certain of that than Cézanne had been. He stuck to this belief, despite all evidence to the contrary, for his whole working life – some forty years, until he died in New York in 1944. Mondrian's convictions can justly be called religious. He saw art not as an end but as a means to an end – spiritual clarification. All his paintings are, on some level, about the disentangling of essence from attributes: the enunciation of what is central, and what peripheral, in his (and thus the viewer's) experience of reality. No view of Mondrian is more misleading than the idea that he was a detached formalist, working towards a purely aesthetic harmony. Mondrian was a devout man who wanted to make icons, and one difficulty his career presents is that he, like Kandinsky – who came to total abstraction from Expressionism, whereas Mondrian arrived there via Cubism – accepted as truth the woolliest nonsense that Theosophy could offer. Precisely because he adhered to this new religion, his beliefs did not come with a package of appropriate images, as they would have done if he were a Buddhist or a Catholic. He had to invent his own images, and he did not live in an age of iconography. However, Mondrian seems to have been utterly convinced by the Theosophical belief that matter was the enemy of spiritual enlightenment, and that all forms of material appearance in history were about to be swept away by a new age whose prophets were Annie Besant and Madame Blavatsky. Nothing but abstraction could do justice to the imminent dawn of the spirit. There was a direct link between Mondrian's religious belief, his personal asceticism, and the development of his art. The difference between him and other harmless religious cranks, however, was that Mondrian also happened to be an artist of genius and great moral tenacity.

For two years after 1909, the year he was converted to Theosophy, Mondrian practised variations on a theme by Munch – a hermetic emblem of spiritual inwardness, the goddess of silence whom Munch had painted in *The Voice* (see Chapter 6). If such works were all that remained of Mondrian's oeuvre, he would be seen today as an interesting, but minor, Dutch Symbolist. The impulse that transformed his development, pushing it out into the deeper currents of modernist history, was Cubism. Given the link through Cubism, Mondrian's progression from nature to abstraction was utterly convincing. Not only did his mature grid style come out of Cubism; its development was the first step *beyond* Cubism taken by a major artist outside France (if one excludes Futurism, none of whose members painted works as aesthetically impressive as Mondrian's). But whereas Cubism had been grounded in cityscape, the images of café table, newspaper, printed sign, and street movement, Mondrian addressed himself to nature. The governing metaphors of his work from 1911 to the first grid paintings of 1917–18 are dunes, flat sky and sea, canals, apple trees: one might say that the grid itself comes from the insistent horizontals and

verticals of Dutch landscape. As in Cubism, the surface becomes less a pattern of objects than a field of connecting energies, inflected with great subtlety, here dense and crackling, there vaporous. His immediately pre-Cubist paintings are filled with urgency, as though the branches of the apple tree, festooning the sky with their spiky and wiry network, were carrying a violent discharge that flickers in red bolts up the trunk and irradiates the entire field of the picture (plate 139).

The effect of Cubism was to stabilize this ecstatic flow. By 1912, Mondrian's paintings were calmer, though no less ardently realized as form, and their calligraphic flourishes had given way to a measured examination of space which, he hoped, would reveal a spiritual continuity throughout nature, uniting solid and void, positive and negative, horizontal and vertical (plate 140). Nowhere is this "equilibrium of opposites," as Mondrian called it, better reached than in his seascapes of 1912–15. In them, the glitter of light and the shifting, repeated patterns of waves on the flat sheet of the northern sea become a pattern of crosses, their "arms" subtly varied in length and hence in tonal density, so that the whole austere surface seems to palpitate (plate 141). Distilled from many hours' walking and gazing on the coast at Scheveningen, where a pier (long since destroyed) used to project into the water and makes its appearance over and over again in the paintings, Mondrian's sea-images have a calm and cerebral beauty, a visual match to Paul Valéry's lines in *Cimetière Marin*, 1920:

> *Midi le juste y compose de feux*
> *La mer, la mer, toujours recommencée.*
>
> (The justice of noon composes from points of fire
> The sea, the sea, always begun again.)

This divided field of twinkling intersections became Mondrian's sign for all substance, the theatre within which every significant formal relationship could be examined and, eventually, the basis of what he took to be a universal grammar of form. One might suppose that every reference to the physical world had been purged from his work by the 1920s, and certainly he had arrived, by then, at a perfectly reduced style – no colours but red, yellow, blue, black, and white, no directions but the horizontal and vertical axis (sometimes held within a diagonally hung square canvas), and no shapes but the Platonic square and rectangle. Yet in Mondrian's late work, after he moved to New York in 1940, the passion for nature that suffuses his early years came back, with extraordinary richness, as a vision of the Ideal City. Mondrian found New York's modernity liberating. "The past has a *tyrannic* influence which is difficult to escape," he gloomily admitted. "The worst is that there is always something of the past *within us*." But that residue, which he had brought with him to the New World as a refugee from the war, could be dispelled by the tonic impact of things American. "Fortunately, we can also enjoy modern construction, marvels of science, technique of all kinds, as well as modern art. We can enjoy real jazz and its dance; we see the electric lights of luxury and utility; the window displays. Even the thought of all this is gratifying. Then we feel the great difference between modern times and the past." Although he did not look like one, Mondrian in his sixties became an enthusiastic jazz

139

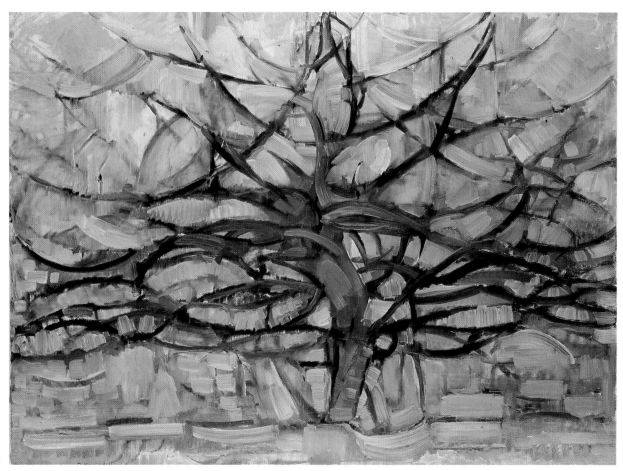

140

141 Piet Mondrian *Pier and Ocean* 1915
Oil on canvas $34\frac{1}{2} \times 45\frac{1}{4}$ ins
Gemeentesmuseum, The Hague

139 Piet Mondrian *The Red Tree* 1908
Oil on canvas $27\frac{1}{2} \times 40$ ins: Gemeentesmuseum, The Hague

140 Piet Mondrian *The Grey Tree* 1912
Oil on canvas $31 \times 42\frac{1}{4}$ ins
Gemeentesmuseum, The Hague

142 Piet Mondrian *Broadway Boogie Woogie* 1942–3
Oil on canvas 50 × 50 ins: Collection, The Museum of Modern Art,
New York, Given anonymously

dancer, though not (if the reports are true) a very fluent one. His love of boogieing fused with his belief that the New York street grid was an ideal pattern, and out of the syncopated rhythms of both he distilled his late Manhattan paintings, such as *Broadway Boogie Woogie* (plate 142).

They are not simply metaphors of New York. Still less can they be read as plans. But they are diagrams of the kind of energy and order that could and still can be seen beneath the quotidian chaos of the great, flawed metropolis. The yellow blips shuttling along their paths do not "represent" cabs, but once one has seen *Broadway Boogie Woogie*, the view from a skyscraper down into the streets is changed forever.

And why should Mondrian's last paintings still move us, whereas the Utopian city plans of architects do not? Partly, no doubt, because the space of art is the ideal one of fiction. In it, things are not used and they never decay; one cannot walk in a painting, as one walks along a street or through a building. The paintings are incorruptible. They are the real rudiments of Paradise, the building blocks of a system that has no relationship at all to our bodies, except through the ocular perception of colour.

Architecture and design, on the other hand, have everything to do with the body – and the unredeemed body, at that. Without complete respect for the body as it is, and for social memory as it stands, there is no such thing as a workable or humane architecture. Hence, most of the "classics" of Utopian planning have come to look inhuman, or even absurd; they have ceased to work, and to a point where the social pretensions behind them no longer seem credible. Who believes in progress and perfectibility any more? Who believes in masterbuilders or formgivers? Anyone who still does need only go to a major city, preferably Paris, to see what has been done in the name of social rationalization. *Quod non fecerunt barbari, fecerunt Barberini*, wrote one nameless wag after Urban VII let Bernini strip the bronze sheathing from the Pantheon – what the barbarians didn't do, the Barberini did. Corbusier's war on Paris became a tradition among architects. It was waged on cities all over the world after 1945, producing the zones of tower blocks and deserted walkways that make up the collective face of modern mass housing. To see it at full stretch, one need only visit such atrocities of bureaucratic modernism as La Défense, outside Paris, or Émile Aillaud's new town of *la Grande Borne* at Grigny, with its condescending mosaic supergraphics of Kafka and Rimbaud "enlivening" a concrete wasteland; or, worst of all, the *grands ensembles* run up by French government planners in the sixties, such as Sarcelles or Cergy-Pontoise. These are the new landscape of urban despair – bright, brutish, crime-wracked, and scarred by the vandalism they invite. They are, so to speak, the poor man's version of the *anomie de luxe* implicit in the destruction of Les Halles, and its replacement by a nasty concrete hole full of snob boutiques.

Lately, the talk about benevolent social engineering through architecture has somewhat declined. We no longer hear that the geodesic dome, that *leitmotif* of Utopian chitchat in the sixties, will rehouse the world's millions. "Alternative" housing in its various Whole Earth Catalogue forms, from Drop City to recycled plastic *yurts*, has ceased to be an interesting issue except to a few diehards. The appalling prospect that Buckminster Fuller's larger housing schemes might be

143 Buckminster Fuller *Plan for Floating Tetrahedral City*
Buckminster Fuller Archives

144 *Brasília*
(photo Robin Lough)

realized has mercifully dwindled; in the foreseeable future, there will be no Tetra-City (plate 143), designed to house one million people in 300,000 apartments grouped in a tetrahedron with each side a mile long, floating off Manhattan. Unless such schemes come to fruition, we are left with the ruins of Utopia; and of those ruins, the Paestum is situated in South America.

Only one city in the West has ever been built from scratch along the strict, Corbusian schema of Utopian modernist town planning. In the 1950s, Brazil wanted a new capital: it was necessary, in the opinion of its leader – a narcissistic and touchy *supremo* named Kubitschek – to show the world some economic vigour by conspicuously "opening up" the interior. Bureaucrats hate ports. They are too open to influence, too polyglot, too hard to control; they have too much life. That is why the capital of Turkey is Ankara, not Istanbul, and why Australia is governed from Canberra, not Sydney. Brazil already had one of the liveliest ports in the world, Rio, a natural capital if ever there was one. Kubitschek accordingly established his seat of national government some twelve hundred kilometres inland, on a red-dirt plateau where nobody lived – or indeed wanted to. Le Corbusier's two most gifted South American followers designed it, under the more or less direct inspiration of the Form-giver. Lúcio Costa did the town plan, and the main ceremonial buildings were drawn up by Oscar Niemeyer. Brasília, as this place was named, was going to be the City of the Future – the triumph of sunlight, reason, and the automobile. It would show what the International Style could do when backed by limitless supplies of cash and national pride.

Between them, Niemeyer and Costa came up with a Carioca parody of *La Ville Radieuse*: the administrative buildings along one axis, and the main traffic artery sweeping across, with the workers' flats on stilts strung along it. The zoning was clear and rigid. One thing in one place. It looked splendid in the drawings and the photographs: the most photogenic New Town on earth (plate 144). With its sweeping avenues and climactic dome, saucer, towers, and reflecting pools, Brasília seemed to be the reconciliation of Utopian modernism with the ceremonial State architecture that the Beaux-Arts had wanted to symbolize a century before. It had an excellent press, since Brazilian architectural critics did not dare criticize it, while most other critics, due to its excessive remoteness, have never actually seen it.

The reality of the place is markedly less noble. Brasília was finished, or at any rate officially opened, in 1960, and ever since then it has been falling to bits at one end while being listlessly constructed at the other: a façade, a ceremonial slum of rusting metal, spalling concrete, and cracked stone veneers, put together on the cheap by contractors and bureaucrats on the take. It is a vast example of what happens when people design for an imagined Future, rather than for a real world. In the Future, everyone would have a car and so the car, as in Corbusier's dreams, would abolish the street. This was carried out to the letter in Brasília, which has many miles of multi-lane highways, with scarcely any footpaths or pavements. By design, the pedestrian is an irrelevance – a majority irrelevance, however, since only one person in eight there owns or has access to a car and, Brazil being Brazil, the public transport system is wretched. So the

145, 146 Richard Meier *The Athenaeum, New Harmony, Indiana* 1975–9
(photos Ezra Stoller, New York)

freeways are empty most of the day, except at peak hours, when all the cars in Brasília briefly jam them at the very moment when the rest of the working population is trying, without benefit of pedestrian crossings or underpasses, to get across the road to work.

Thus Brasília, in less than twenty years, ceased to be the City of Tomorrow and turned into yesterday's science fiction. It is an expensive and ugly testimony to the fact that, when men think in terms of abstract space rather than real place, of single rather than multiple meanings, and of political aspirations instead of human needs, they tend to produce miles of jerry-built nowhere, infested with Volkswagens. The experiment, one may hope, will not be repeated; the Utopian buck stops here.

And so Brasília is emblematical. The last half century, in architecture, has witnessed the death of the Future. Like the Baroque, or the High Renaissance, the modern movement lived and died. It produced its masterpieces, some of which survive, but its doctrines no longer have the power to inspire visions of a new world; and the Expressionist idea of the architect as "Lord of Art," which gave the modern movement its evangelical drive, is dead beyond resuscitation. "We are now at the close of one epoch," as the architect and critic Peter Blake wisely remarked in 1974, "and well before the start of a new one. During this period of transition there will be no moratorium on building, and for obvious reasons. There will just be more architecture without architects." One may take it for granted – or, at least, hope to do so – that people will always be moved and delighted by the Seagram Building, just as they are by the Palazzo Rucellai or the Petit Trianon. A poetic conception as strong as Corbusier's vision of the "White World," as realized in the Villa Savoye, will almost certainly continue to give aesthetic inspiration to younger architects – as it does, seen entirely as a historical style, in Richard Meier's lapidary and brilliant Athenaeum in New Harmony, Indiana, 1979 (plates 145, 146). The crucial point, however, is that the lesson of modernism can now be treated as one aesthetic choice among others, and not as a binding historical legacy. The first casualty of this was the idea that architects or artists can create working Utopias. Cities are more complex than that, and the needs of those who live in them less readily quantifiable. What seems obvious now was rank heresy to the modern movement: the fact that societies cannot be architecturally "purified" without a thousand grating invasions of freedom; that the architects' moral charter, as it were, includes the duty to work with the real world and its inherited content. Memory is reality. It is better to recycle what exists, to avoid mortgaging a workable past to a nonexistent Future, and to think small. In the life of cities, only conservatism is sanity. It has taken almost a century of modernist claims and counterclaims to arrive at such a point. But perhaps it was worth the trouble.

THE THRESHOLD OF LIBERTY

The wish for absolute freedom is one of the constants of intellectual life, and of all the art movements of our century, the one most concerned with this essential quest was Surrealism. Surrealism wanted to set people free: to save them, as evangelists and revolutionaries promise salvation, by an act of faith. This faith was not in modernity, still less in technology. The idea that collective sport and *Siedlungen*, turbines and Maurice-Farman biplanes were about to usher in a Brave New World would have elicited hoots of derision from the pale, unathletic obsessives who made up the core of the Surrealist group. Far from believing in Utopian technology, most of them hardly knew how to change a light-bulb. They would rather have been seen as bad priests than as good engineers. Consequently a good deal of Surrealism, and of the art it inspired, was not only a solemn parody of revolutionary threats; it had, as a structure, much in common with the Catholic religion, in whose embrace nearly all of its members had grown up. It had dogmas and rituals, catechisms, saints, baptisms, excommunications, a succession of Virgin Marys, and a singularly demanding and touchy Pope: André Breton (1896–1966). In the 1920s, Breton developed into one of the great fascinators of modern art – a quality which does not always come across in the chanting, verbose cadences of his prose, especially in translation. He inspired, as one of his disciples put it, a doglike devotion, largely because he was very inventive, very perceptive, as quick and definite in approval or rejection as litmus paper, and fairly moral as well: not a combination one sees very often in French or any other cultural circles. He was immune to most of the deadly sins except pride and lust, and he believed, with evangelical seriousness, that art had not only the power but also the duty to change life.

Breton did not fight in World War I. He worked as an intern at the Saint-Dizier psychiatric centre, treating shellshock victims – an experience that deeply marked him. Helping patients to analyze their dreams "constituted," as he recalled much later, "almost all the groundwork of Surrealism . . . interpretation, yes, always, but above all liberation from constraints – logic, morality and the rest – with the aim of recovering their original powers of spirit." One patient in particular impressed him: a young, cultivated man whom trench warfare had driven into such an illusion of

invulnerability that he made up a parallel world for himself. He would stand on the parapet of the trench during a bombardment, pointing to the explosions with his finger, in the calm belief that the corpses were dummies, the wounds greasepaint, the shells blanks, and the whole war a sham played out by actors. No bullet ever touched him, and no argument could convince him that the war was real. This man, Breton thought, epitomised the relation between an artist and his chosen reality. The only poetry worth having must be so obsessive that it would create a parallel world. Art and life could then both renew themselves by contacting forbidden areas of the mind – the Unconscious. That, in turn, would refresh our sense of the world by disclosing a whole network of hidden relationships, like the "lower Paris" of sewers and catacombs that stretched below the visible city. Chance, memory, desire, coincidence would meet in new reality – a *sur*-reality, in the word he borrowed from Apollinaire, who in 1917 had described the ballet *Parade*, whose collaborators were Picasso, Jean Cocteau, Erik Satie, and Leonid Massine, as producing "*une espèce de* sur-*réalisme.*"

The dream was the instrument for this. It was the gate to art. In dreams, the id spoke; the dreaming mind was unlegislated truth, and so was neurosis, the permanent involuntary form of dreams. In this, Breton and his circle were part of the great movement of thought whose motor was the work of Sigmund Freud. But they were not, in any defensible meaning of the word, Freudians. They knew relatively little about Freud's work because none of them read German fluently and the basic works that would have interested them, his studies on hysteria and the interpretation of dreams, were not translated into French until the mid-twenties. In any case, Breton's idea of neurosis was very different from Freud's. Freud regarded neurosis as an illness, a condition to be cured. Breton was more dandyistic, and he wanted to preserve it, since he thought of madmen as oracles. In short, he was one of the more conspicuous heirs to a tradition of attitudes about insanity that filtered directly into the twentieth century from nineteenth-century Romanticism, whose core was the idea that mental derangement gave access to a whole "dark side" of the mind, the locus of painful but irrefutable truths about society, human nature, and especially art. *El sueño de la razón produce monstruos*, Goya had written below his etching of a dreaming man slumped at a desk: when reason dreams, monsters are born. The Surrealist project was to anatomize these "monsters."

André Breton was a natural clan leader, and he soon assembled a circle of friends, some touched by the edge of Dada, but all sharing certain common preoccupations: mainly, a belief in the supremacy of poetry and a loathing of the parental generation whose values had led to the insensate slaughters of the war. Max Ernst, arriving in Paris from Germany, gently caricatured them in 1922 (plate 147). Breton, in a cloak, stands at the centre, giving his pontifical benediction to other young poets: Paul Éluard (1895–1952), Louis Aragon (b. 1897), and Philippe Soupault (b. 1897). Ernst painted himself sitting like a baby on the knee of the phantom Dostoyevsky (one of the many "adopted fathers" of Surrealism) and tweaking his ectoplastic beard. But the presiding spirit of Surrealist painting is rendered as a statue, in fact, as a monument to his dead self; for by 1922, in the Surrealists' opinion, he had so betrayed his talent as to

147 Max Ernst *Rendez-vous of Friends* 1922
Oil on canvas 51 × 76 ins
Wallraf-Richartz Museum, Cologne

have become an Unperson. Giorgio de Chirico (1888–1978) was an Italian of Greek descent, whose work, seen in Paris just after the war, had seemed to Breton and his friends the very essence of disquieting poetry. De Chirico's work was the necessary link between Romantic art and Surrealism.

Below the rational and sensuous surface of nineteenth-century painting, the bright skin of Impressionism, the solid material world of Courbet, or, further back, the ideal forms of neo-classicism, there ran a fascination with dreams: with mystery, melancholy, and fear. It was a world of phantoms, and all the more vivid for not being the conscious emanations of a culture like ours; in 1820, an oneiric image had to have more pressure behind it to break through the crust of normal artistic usage than it does today. One of the most memorable of these actually hung (in reproduction) in Freud's study in Vienna. It was Henry Fuseli's *The Nightmare*. The work of English artists like Fuseli, Blake, "Mad" John Martin, and Richard Dadd now seems to link up with the most extreme moments of feeling in Delacroix and Géricault, the intense spiritual elation and melancholy of German Romantics like Philipp Otto Runge and Caspar David Friedrich, the visions of Odilon Redon and the bejewelled Symbolist fancies of Gustave Moreau, to produce an irregular but potent counter-tradition to the "reasonable" images of nineteenth-century European art. This is the tradition of the irrational, whose modern prong was named Surrealism, and it is the background to de Chirico's art. He had other sources in it. One was the German artist Max Klinger, author of a remarkable set of etchings called *The Adventures of a Glove*, in which the protagonist – a lady's long kid glove –underwent or passively witnessed a series of peculiar dream transformations, becoming the focus of unnamed (and perhaps unnameable) yearnings. This object-fetishism would presently infuse de Chirico's images of drafting instruments, biscuits, towers, and bananas.

De Chirico's main source, however, was the Swiss artist Arnold Böcklin (1827–1901), whose work he saw when he was an art student in Munich in 1906. Böcklin's paintings drew on his own travels in Italy: his famous mood-piece *The Isle of the Dead*, 1880, appears to be a combination of Venice's cemetery-island and the Borromean Islands in Lake Maggiore (plate 148). His work was drenched in an atmosphere of nostalgia and melancholy whose ideal site was the ruins and seacoasts of Italy. De Chirico found in Böcklin the very qualities that Italian Futurism most hated – mystery, nostalgia for the past, and a tremulous feeling for what is history-bound, rather than "objective" or "progressive," in human character. What fascinated him in the squares and arcades of Ferrara and Turin – the cities from which most of his motifs came – was not their solid architectural reality but their staginess. The quality de Chirico called "metaphysics" or "metaphysical painting" (*pittura metafisica*) would not have been recognizable as such to a philosopher. It was a question of mood, the sense of a reality drenched in human emotion, almost pulpy with memory. "I had just come out of a long and painful intestinal illness," he wrote of the first moment he felt it, in the Piazza Santa Croce in Florence as a youth of twenty-two, "and I was in a nearly morbid state of sensitivity. The whole world, down to the marble of the buildings and the fountains, seemed to me to be convalescent. In the middle of the

148 Arnold Böcklin *The Isle of the Dead* 1880
Oil on wood $43\frac{3}{4} \times 61$ ins: Kunstmuseum, Basle,
Gottfried Keller Stiftung (photo Hinz)

square rises a statue of Dante draped in a long cloak. The autumn sun, warm and unloving, lit the statue and the church façade. Then I had the strange impression that I was looking at these things for the first time. . . ." The form of this "convalescent world" fills de Chirico's paintings after 1912. It is an airless place, and its weather is always the same. The sun has a late-afternoon slant, throwing long shadows across the piazzas. Its clear and mordant light embalms objects, never caressing them, never providing the illusion of well-being. Space rushes away from one's eye, in long runs of arcades and theatrical perspectives; yet its elongation, which gives far things an entranced remoteness and clarity, is contradicted by a Cubist flattening and compression – de Chirico had been in Paris just before the war, at the height of Cubism, and knew Apollinaire well enough to have painted his portrait. When the picture plane is flattened but the things on it are still wrenched out of reach by de Chirico's primitive and inconsistent one-point perspective, the eye is frustrated.

Many of the images in de Chirico's work were real, and came from real places: mostly from Turin, where they can still be recognized today. A Chirican tour of Turin would include such buildings as the Torre Rosa and the eccentric Mole Antonelliana, whose tower appears in de Chirico's *The Nostalgia of the Infinite*, 1913–14, an obelisk with pennants streaming from its top (plate 149). The melancholy of this painting, plunged in the sense of impotence and an irrecoverable past, is very close to that of Gérard de Nerval's lines:

> *Je suis le ténébreux, le veuf, l'inconsolé,*
> *Le Prince d'Aquitaine à sa tour abolie . . .*

> (I am the man of shadows, the grieving widower,
> The Prince of Aquitaine by his demolished tower)

De Chirico's arcades, with their lack of mouldings and narrow deep-shadowed arches, look like cardboard architecture until one sees their real counterparts in the Piazza Vittorio Veneto. In the paintings, however, the townscape is emptied. Human society has either ceased to exist or been shrunken to tiny, faraway figures which cannot communicate in any way with the one human occupant of the townscape, the Onlooker, de Chirico himself, whose eye is the root of all perspectives. The main figures in the *piazze* are sculptures, some of them quite recognizable: de Chirico's recurrent figure of a Philosopher is taken from a curious marble statue of the Torinese savant Bottero, which stands conversationally on a low plinth in a park. The equestrian statues that recur in his paintings are also real; their prototype is an equestrian figure in the Piazza Carlo Alberto by the nineteenth-century sculptor Carlo Marochetti, who was also responsible for the figure of Richard Coeur de Lion outside the Houses of Parliament in London. In the most haunting of his compositions, *Melancholy and Mystery of a Street*, 1914 (plate 150), the statue does not come on stage; it merely announces itself quietly and ominously with the tip of its long shadow obtruding past the corner of the arcade, so that the little girl with her hoop (another quotation, this time from a similar figure in Seurat's *Grande Jatte*, plate 73) appears drawn towards it, as sleepwalkers are drawn. But the most frequently seen

150 Giorgio de Chirico *Melancholy and Mystery of a Street* 1914
Oil on canvas $34\frac{1}{2} \times 28\frac{1}{4}$ ins: Private Collection (photo Allan Mitchell, Connecticut)

149 Giorgio de Chirico *The Nostalgia of the Infinite* 1913–14? (dated on painting 1911)
Oil on canvas $53\frac{1}{4} \times 25\frac{1}{2}$ ins: Collection, The Museum of Modern Art, New York, Purchase

inhabitants of de Chirico's landscape are neither men nor art, but somewhere between: they are tailors' dummies (plate 151). These mannequins, cobbled together from parts and emblems, tools and mementoes, are metaphors of fragmented, modernist consciousness. In de Chirico's hands the mannequins became one of the great "presences" of twentieth-century art, spectral and pathetic at once, crazed but with a mute Archimedean dignity: "These fragments have I shored against my ruins."

What the Surrealists admired most in de Chirico was not his formal achievements as a modernist painter, which were very substantial indeed, but the strange encounters between objects, and the clarity, which predicted the verisimilitude of later Surrealist painters like Magritte and Dali. It made the dream look real. They also admired de Chirico's theatrical intensity. Every piazza is like a stage, and that flat plane became the normal space of much Surrealist art: a neutral place where incompatible things met in clear light. De Chirico's images seemed to be the pictorial equivalent of the phrase from Lautréamont's *Songs of Maldoror* which, more than any other, summed up the Surrealist ideal of beauty – a beauty of strangeness born of unexpected meetings of word, sound, image, thing, person. "Beautiful," it ran, "as the chance encounter, on an operating table, of a sewing machine and an umbrella." This, in Breton's view, was the beauty of de Chirico's paintings.

After 1918, de Chirico's work changed – for the worse, in the Surrealist view. It took on a candied, mock-classical flavour, and Breton denounced its author in a furious encyclical, the first of many such official expulsions. (The fact that de Chirico began faking his own early work soon after 1920, and kept on doing so to the unbounded confusion of collectors and art dealers for decades thereafter, seemed to Surrealism an obscene betrayal of the psychic integrity of the painting of 1910–17.) But by 1921, the Surrealist group – until then wholly made up of writers – had acquired its first resident artist, Max Ernst, who arrived in Paris in that year with a packet of his Dada collages. Their incongruous meetings of ready-made images, cut from catalogues and magazines, struck the Surrealist writers as Lautréamont applied to art: a view through the gap in bourgeois reality into a world rendered wholly permeable to the imagination, a pictorial equivalent to the state of mind that another proto-Surrealist hero, the poet Arthur Rimbaud, had achieved:

I accustomed myself to simple hallucination; I saw quite deliberately a mosque instead of a factory, a drummer's school conducted by angels, carriages on the highways of the sky, a salon at the bottom of a lake; monsters, mysteries, a vaudeville poster raising horrors before my eyes.

In Paris, Ernst grafted his Dada collage technique on to de Chirico, and the result was a group of the strangest fantasy images in modern art. Sometimes he quoted de Chirico straight. Thus the moustached, petrified father in *Pietà*, or *Revolution by Night*, 1923, holding his live son in his arms, is taken directly from the ominous father image in de Chirico's earlier painting *The Child's Brain*, 1914. But it is doubtful whether any artist had addressed himself quite so directly to the idea of the conflict between generations, of Oedipal struggle, before. Ernst's father, a painter in Cologne,

151 Giorgio de Chirico *The Disquieting Muses* 1916
Oil on canvas $38\frac{1}{4} \times 26$ ins: Private Collection, Milan (photo SCALA)

was a mediocre artist but a strong, dogmatic man, and Ernst's battle with him – which clearly went on, in the artist's memory, long after the old man's death – provided one of the obsessive themes of his art. His *Pietà* is a parody of Michelangelo's sculpture in St Peter's, with the roles reversed; instead of the live mother grieving over the dead son, a dead (or at least marmoreal) father holds a live son on his lap, like the unrepentant Don Giovanni in the stone grip of the Commendatore.

Other paintings from this stage of Ernst's work are simply indecipherable in their strangeness, although one can still identify their sources. The shape of the monster whose gross bulk fills the frame of *The Elephant Celebes*, 1921 (plate 152), was inspired by a photograph of a Sudanese corn bin raised from the ground on "legs;" this immediately suggested, to Ernst, a waddling animal. Its topknot obviously comes from de Chirico's assemblies of drafting instruments, and its title (according to Ernst's lifelong friend, the leader of the English Surrealist group, Roland Penrose) was extracted from a schoolboy rhyme whose anal humour amused Ernst – "The Elephant of Celebes / Has sticky, yellow bottom-grease." Moreover, the animal bears some general resemblance, in profile, to the outline of the Island of Celebes on the map, only with its "trunk" in a different position (although other Surrealists thought this island resembled an anteater, and accordingly gave it a high place in the roster of countries of Surrealist interest).

For most of Ernst's images from the early twenties, however, there is no rational explanation and no hope of one. They seem to issue from a parallel world, a place of lucid dread, as if the dream world of de Chirico had lost all its yearning, melancholy, narcissism, and historical nostalgia, and become infused with unique and sharp-edged modern fears. Ernst could compress a great deal of psychic violence into a small space, the size of a booby-trapped toy – and maintain that pitch of intensity across a long run of images. "I was born with very strong feelings of the need for freedom, liberty . . . and that also means very strong feelings of revolt. And then one is born into a period where so many events conspire to produce disgust: then it is absolutely natural that the work one produces is revolutionary work." One of the channels through which Ernst's aggression often ran was the idea of lost innocence seen, not nostalgically, but with a sort of icy derangement, as in *Two Children Are Threatened by a Nightingale* (plate 153). Parts of it look so innocuous; the house is as harmless as a cuckoo clock, the landscape pastoral. Why should a nightingale frighten anyone? And what kind of world could contain, as part of casual narrative, the idea of a "menacing" nightingale? What disturbs the viewer, knowing the title – Ernst's long, mystifying titles were an integral part of his work – is the utter disproportion between cause, the bird's song, and effect, the terror it inspires. One cannot know what is happening in this little world within the frame – nor, the collage implies, in the big one that includes the picture. In these works Ernst achieved what he had set out to do in 1919, in Germany, with his first collages:

Here I discover elements of a figuration so remote that its very absurdity provokes in me a sudden intensification of my faculties of sight – a hallucinatory succession of contradictory images. . . . By simply painting or drawing, it is enough to add to the illustrations a colour, a

152 Max Ernst *The Elephant Celebes* 1921
Oil on canvas $49\frac{1}{4} \times 42$ ins: Tate Gallery, London

2 enfants sont menacés par un rossignol /M. ernst

153 Max Ernst *Two Children Are Threatened by a Nightingale* 1924
Oil on wood with wood construction $27\frac{1}{2} \times 22\frac{1}{2} \times 4\frac{1}{2}$ ins
Collection, The Museum of Modern Art, New York, Purchase

line, a landscape foreign to the objects represented. . . . These changes, no more than docile representations of *what is visible within me* . . . transform the banal pages of advertisements into dramas which reveal my most secret desires.

Surrealism's favourite way of evoking what it called "the marvellous," that most prized quality of all experience, was by chance association. "The marvellous is always beautiful, anything marvellous is beautiful, in fact only the marvellous is beautiful," Breton wrote, claiming that the perception of beauty belonged to the same order of experience as fear or sexual desire; there was nothing intellectual in it, it could not be duplicated, only *found*. It could lurk equally well in a picture postcard, a 1900 inkstand in the Flea Market, a painting by Hieronymus Bosch, an electric sign, or a friend's suicide. Art could release it mediumistically, rather than deliberately create it. A favourite Surrealist text was Leonardo's advice to artists on the use of chance configurations:

When you look at a wall spotted with stains, or with a mixture of stones, if you have to devise some scene you may discover a resemblance to various landscapes . . . or, again, you may see battles and figures in action, or strange faces and costumes, or an endless variety of objects, which you could reduce to complete and well-drawn forms. And these appear on such walls promiscuously, like the sound of bells in whose jangle you may find any name or word you choose to imagine.

Here was a recipe for setting up fresh encounters with *le merveilleux*. In 1925, Ernst was staying in a French seaside hotel when he noticed the deeply etched grain of the old floorboards in his room. Taking paper and black crayon, he made transfer rubbings from the wood, thus producing what he called "a hallucinatory succession of contradictory images that came, one on the other, with the persistence and speed of erotic dreams." Altered and edited, these traces became plants, landscapes, and animals: stony lunar growths in a prickly, plated environment which, because each seemed to have the completeness and representative quality of a specimen, Ernst entitled his *Natural History*.

But the strongest illusion of a parallel world in Ernst's work came from the collage-novels he began to create around 1930. The first of them was a series called *La Femme 100 Têtes* (*The Hundred Headless Woman*); and four years later, he followed it with *Une Semaine de Bonté* (*A Week of Plenty*). He used Victorian steel engravings, which he cut and reassembled with fanatical illusionistic precision (plate 154). For us, fifty years later, their effect has shifted a little. They are still sinister, disturbing, and marvellous in their unrelenting power of suggestion; the peculiarity of Ernst's world never lets up or lapses into cliché, and its apparitions are always suddenly there, as if stumbled on. Moreover, the effect of patient delineation which the steel engravings themselves give continues to reinforce this strangeness, simply by suggesting that Ernst's images are sufficiently real to have been scrutinized and then drawn by some ordinary magazine illustrator of the 1880s. But what does not breathe so strongly from them (as it must have done in 1930) is the sense of an *immediate* and vicious past. Ernst's imagination was as aggressive as pornographic fiction, but not as repetitive.

154 Max Ernst Plate from *Une Semaine de Bonté* 1933
Collage novel

His collage-novels were, like pornography, a means of revenge on childhood repression. Their raw material, the late Victorian world of padded bourgeois interiors, heavy fringes, and dark massive furniture, hourglass girls, impassive technicians, and fiercely authoritarian men in boilerplate suits, looks like another civilization to us. But it was the world in which Max Ernst grew up, and to subvert it was, for him, akin to an act of terrorism – the irrational attacking the domain of ordered structures.

An initial problem for Surrealist painting was that irrationality had no given form. There was no body of traditional shapes that signified *le merveilleux*, in the way that a Doric column or the poses of the Elgin marbles signified the reign of reason over inchoate matter in neo-classical art. All the same, art had to come from somewhere. And so the Surrealists turned to three kinds of expression that had been around for a long time, but had not been taken seriously – child art, the art of the mad, and "primitive" art. All three promised images which, being untutored, were also uncensored – but the most fruitful of them was "primitive" art, the work of self-taught men and women, the Sunday painters and *naïfs* whose compulsion to set down their experiences as directly as possible seemed more valuable to the Surrealists than any amount of professional or academic painting. The half century from 1880 to 1930 was a springtime of *bricolage* and do-it-yourselfery in France, and this was true to some extent of the plastic arts too, since not everyone had a camera, and its total dominance over visual memory had not quite arrived. Only a tiny number of people today try to draw what they have seen or what has happened to them, compared to the hordes of those for whom the camera is an everyday tool. But although the *naïf* artist was a rarity in France a century ago, he was by no means extinct. The passing of folk traditions had not destroyed his kind, because the *naïf* was usually a city-dweller, convinced of his importance as an individual artist, and not a bit interested in the arts of peasant or fisherman.

The one major painter among these *naïfs* was Henri Rousseau (1844–1910). Known as "*le Douanier*," the Customs Man, from his fifteen years' service as a minor civil functionary, Rousseau was consumed by the ambition to show in the salons, in the company of Manet and Gérôme, Bouguereau and Puvis de Chavannes. If he could have painted "better" and shed his primitive traits, he would certainly have done so; luckily, he was able to show paintings every year from 1886 onwards at the Salon des Indépendents, along with the "professional" modernist artists whom the official Salon had shut out. He was not awed by most of them, if one can judge from his remark to Picasso that they were the two greatest living painters, "I in the modern manner and you in the Egyptian." The first quality that a modern eye finds enchanting in Rousseau's work, its intense stylization (plate 155), was not at all what the painter wanted. He meant his visions to be absolutely real, each figure, face, leaf, flower, and tree measured and concrete, enumerated leaf by leaf, vein by vein, hair for hair. This quality of patient earnestness combined in odd ways with Rousseau's taste for the exotic. He justified the "reality" of his jungle scenes with a tissue of fibs about how he had seen such things, while serving in the French Army in Mexico in the 1860s; it was important that these wonderful fantasy spectacles should seem *witnessed*, not

155 Henri Rousseau *The Dream* 1910

Oil on canvas $80\frac{1}{2} \times 117\frac{1}{2}$ ins
Collection, The Museum of Modern Art, New York,
Gift of Nelson A. Rockefeller

invented. In fact, they had been twice witnessed: once by the redoubtable eye of Rousseau's imagination, and once more in the Jardin des Plantes, where the old man would go strolling among the palms and caladiums to pick up the motifs for his work, listening all the while – as one can still do today – to the roaring and honking of caged animals in the zoo nearby. The clarity of Rousseau's vision further heightened its compulsive, dreamlike quality: there the image is, all at once, with no ambiguities, done (as he would have insisted) "from life."

The other *naif* whom Surrealism especially admired was not a painter but a builder who, in the obscurity of his own country garden, created what was perhaps the most elaborate, beautiful, and mysterious "unofficial" work of art made by any nineteenth-century artist. He was Ferdinand Cheval, a postman or *facteur* in the village of Hauterives, about forty miles from Lyon. The Facteur Cheval (as he is usually called) had done nothing remarkable for forty-three years of his life. But one day in 1879, on his delivery round, he picked up a pebble. It was a piece of the local greyish-white *molasse* or tufa, gnarled and lumpy, about four inches long – his "stone of escape," as he later called it. He put it in his pocket and, from them on, began first to collect more odd-looking stones, then tiles, oyster-shells, bits of glass, wire, iron, and other junk. Back in his garden, he began to lay foundations and build walls. He was, by his own account, bored with "walking forever in the same decor," and so:

. . . to distract my thoughts, I constructed in my dreams a faëry palace, surpassing all imagination, everything the genius of a humble man could imagine (with grottoes, gardens, towers, castles, museums and sculptures), trying to bring to a new birth all the ancient architectures of primitive times; the whole thing so beautiful and picturesque that the image of it remained alive in my brain for ten years at least . . . but the distance from dream to reality is great; I had never touched a mason's trowel, . . . and I was totally ignorant of the rules of architecture.

He began to take a wheelbarrow on his rounds, collecting more and more of the bizarre stones of the region, rock-collecting by night, building in the morning and evening, delivering letters by day, and sleeping very little. This routine went on for a third of a century. The result, the Facteur's Ideal Palace (plate 156), contained all his ideas – mostly based, like the Douanier Rousseau's, on pictures he had seen in magazines, photos, and almanacs like the *Magasin Pittoresque* – about the "true origins" of ancient Greek, Assyrian, and Egyptian architecture, with side-glances at the Taj Mahal, the Maison Carrée in Algiers, the mosques of Cairo, the White House, and the Amazon Jungle. Dark grottoes (which the Facteur called "Hecatombs," meaning today "Catacombs") ran through it, and wild bristlings of minarets and sculptured palms crowned its towers. Almost every surface that was not ornamented with the writhing effusions of the Facteur's imagination carried an inscription: "INTERIOR OF AN IMAGINARY PALACE: THE PANTHEON OF AN OBSCURE HERO. THE END OF A DREAM, WHERE FANTASY BECOMES REALITY." "THE WORK OF GIANTS." "REMEMBER: WILL IS POWER." And, very movingly,

FOR FORTY YEARS I DUG
TO MAKE THIS FAERY PALACE

156 "Facteur" Cheval *Ideal Palace* begun 1879
(photo Robin Lough)

RISE FROM THE EARTH.
FOR MY IDEA'S SAKE, MY BODY HAS CONFRONTED ALL:
TIME, RIDICULE, THE YEARS.
LIFE IS A SWIFT CHARGER
BUT MY THOUGHT WILL LIVE ON IN THIS ROCK.

It took this proud and certain man, by his own reckoning, 10,000 working days (or a total of 93,000 hours) to finish his Ideal Palace. When he did so in 1912, he at once set to work on the construction of his tomb in a cemetery nearby, which he also finished well before his death, at the age of eighty-eight, in 1924. Thus Breton and the other Surrealists could have met him, though they did not; it is not known when they first went to Hauterives, but the Palais Idéal immediately became one of the sacred spots of the Surrealist world. Max Ernst made a collage in praise of the Facteur Cheval, and Breton wrote a poem about him (a companion piece to the verses Apollinaire had written on the Douanier Rousseau). This, it appeared, was the palace of the unconscious mind that no architect had ever built, a nearly sublime fantasy in which the formal means of ordinary Edwardian garden-builders – grottoes, stones, shells – had suddenly shot up to the heights of obsession and revelation.

That there *was* a Surrealist world, ruled by the irrational, the magical, and the instinctive, was never doubted by the Surrealists themselves; in fact, they drew a map of it. The countries are redrawn to the scale of Surrealist interest. Thus England does not exist, but Ireland, which they saw as a place of myth, Celtic twilight, and heroic revolution, is huge. The United States has been swallowed by Mexico and Labrador. Australia just gets in, but New Guinea is almost the size of China, and Easter Island – whose stone heads were the supreme mystery of Pacific archaeology – is again huge. Africa has shrunk, probably because the Cubists had "discovered" African art; but Oceanic masks and totems were, so to speak, the cultural colony of Surrealism, and the Pacific archipelagos, especially New Ireland, are therefore much enlarged. Almost all of Europe has gone except for Paris. Russia is vast. Spain, on the other hand, does not exist – a curious omission, since two of the lynchpins of Surrealist painting (Dali and Miró) and one of its presiding fathers (Picasso) came from there.

Joan Miró (1893–1983) was unquestionably the best pure painter among the Surrealists. He resisted joining the movement; he would not sign its manifestos, and he took no part in its political entanglements. But the Surrealist group joined him. It needed his art – a free, lyrical mixture of folk tales, eroticism, sardonic humour, farmhouse scat-talk, and grotesque absurdity; the theories of Surrealism could add nothing to it except a modernist, Parisian context. The Surrealists were interested in the art of children, which they saw as one of the most generous outlets of the uncensored, polymorphous self. In this, they brought to a climax the idea, current since the end of the eighteenth century, that child art was a special cultural form with information to disclose about the growth and nature of the mind. Their admiration for children did not extend to actually having any (the pram in the hall being, so to speak, the enemy of *le merveilleux*), but they did prize the mimicry of a child's freedom by adults. "The mind which plunges into Surrealism," Breton wrote, "relives with

burning excitement the best part of childhood. Childhood comes closest to one's real life – childhood, where everything conspires to bring about the effective, risk-free possession of oneself." Miró's art seemed to fulfil this idea. But there was nothing naïve about it. Miró was a Catalan, and Barcelona, the capital of Catalonia, had become one of the junctions of European modernism when Miró was a little boy – indeed, it would not be thrust into provinciality until after the Spanish Civil War, when the victorious Franco sealed the intellectual frontiers of Spain. As an art student not yet twenty, Miró was reaching for a sharp, briskly patterned synthesis of Cubism with the high Fauve Mediterranean colour of Matisse. His early landscapes are a vision of detail: the folds of ploughed earth, the stiff arabesques of vines and trellises, the sharp-edged barns, and the animals laid out one by one, flat and bright, very like the men and creatures in the Romanesque frescoes of northern Spain.

The climax of this early work was *The Farm*, 1921-2 (plate 157). This painting was Miró's Noah's Ark. In it he set out to enumerate every detail of the farm at Montroig where he grew up. He even brought back some dried grasses from Catalonia to Paris to serve as a model. *The Farm* is a biblical counting of blessings, conducted under the pale, entranced light of a very early Catalan morning, when the sun strikes almost parallel with the ground, the moon is still in the sky, and every detail of existence springs towards the eye with impartial exactness. To mimic that precision of sight, Miró used sharp tonal contrasts but kept the darks in small areas – the curly prickles of eucalyptus leaves against the sky, for instance, and the circular, Uccello-like black mat from which the tree-trunk springs; the sharp outlines of furrow, mound, and pebble, or the crackling divisions of darkness inside the chicken-shed. The whole surface swarms with detail, and everything is equally seen, from the raggedy corn-stalk in the foreground to the distant horse hitched up to the circular corn-grinder. The multiplicity of life in *The Farm* (lizard, snail, goat, barking dog, horse's ass, rabbit, dove) predicts the swarming zoo of images that would proliferate in Miró's later work, as the scatological detail – like the child defecating near the trough – announces its Rabelaisian vitality. *The Farm* employs some of the conventions of folk art but is careful to show its modernity and cosmopolitanism. Miró, literally the Prodigal Son of this landscape, has left a copy of *L'Intransigeant*, a Paris newspaper more often read by Cubists than by Catalan countryfolk, neatly folded under the watering can.

Miró began *The Farm* in Spain and finished it in Paris, but its images continued to fascinate him; the same encounter of a lizard and a snail, for instance, crops up in *The Tilled Field*, 1923–4 (plate 158), but by now the work of metamorphosis is well under way. The eucalyptus in the barnyard at Montroig has grown an eye and an ear; the chicken seems to have plucked itself, ready for roasting; French *tricoleurs* flutter from an enlarged aloe plant, and the body of the cock that crows from its stalk has merged with a cloud behind it. Everything in this landscape has the power to become something else, and this mutability of existence – its ability to change masks under the pressure of an insistent, animal vitality – recommended Miró's work to the Surrealists. He met them through the painter André Masson, who lived next door to him in Paris, and in 1924 he took part in the first Surrealist group show.

157 Joan Miró *The Farm* 1921–2
Oil on panel $48\frac{1}{4} \times 55\frac{1}{4}$ ins
National Gallery of Art, Washington DC,
Collection of Mrs. Ernest Hemingway

158 Joan Miró *The Tilled Field* 1923–4
Oil on canvas $26 \times 36\frac{1}{2}$ ins
Solomon R. Guggenheim Museum, New York

159 Joan Miró *The Harlequin's Carnival* 1924–5

Oil on canvas 26 × 36½ ins
Albright-Knox Art Gallery,
Buffalo

160 Joan Miró *Dog Barking at the Moon* 1926

Oil on canvas 29 × 36¼ ins
Philadelphia Museum of Art, A. E. Gallatin Collection

Miró's paintings of 1924–7 worked at an almost frenzied pitch of invention. By then his bestiary was in full session, and in works like *The Harlequin's Carnival*, 1924–5 (plate 159), he became the heir to the Romanesque sculptors with their bestiaries and demons, even to Hieronymus Bosch himself. Later, Miró claimed that the hallucinations brought on by hunger and staring at the cracks in the plaster during those lean Paris years helped to loosen his imagery, as mescaline might. But the creatures that swarm and buzz in *The Harlequin's Carnival* are too consistent to be entirely the product of reverie, for they emerge from the very specific, dense, and playful sense of nature that only a rural childhood can give. This bawdy animism of Miró's, expressed with a sharp, quizzical line that springs and chirrups like a grasshopper in Catalan dust, is a matter of detail and observation: getting the nose in and keeping it there. (The word "*miró*," one is reminded, in Spanish means "he saw.") Rigorous but free, wild but exact as a knife – Miró's barnyard of primal images was one of the supreme inventions of modernist art, and he extended it for twenty years. A century before Miró's birth, William Blake had urged his readers to

> Seek those images
> That constitute the Wild:
> The lion and the Virgin,
> The Harlot and the Child.

That is the aim of Miró's early paintings. He had the range of a man who owns all his sensations and is abashed by none of his desires. At one end, the close vision, the living graffiti: the dancing hairs, the wagging and copulating genitals, the irrepressible spawning and multiplication of life. At the other, a sense of large space, not the void that provokes anguish (as in de Chirico or, sometimes, in Ernst) but a realm of possibilities: "In my pictures," Miró once said, thinking of images like *Dog Barking at the Moon*, 1926 (plate 160), "there are tiny forms in vast empty spaces. Empty space, empty horizons, empty plains, everything that is stripped has always impressed me." At times this emptiness took on an oceanic and consoling quality, and it was always tersely set forth within a diction of pure, flat colour that virtually no other modern artist of his generation (Matisse being twenty years older) had used with such mastery.

The city of Barcelona had more than a glancing connection with the development of Miró's work, and with Surrealism itself. The organic décor of Art Nouveau, the luxury style of 1900, still marks Barcelona deeper than any other European city. Indeed, Art Nouveau is to Barcelona what the Baroque is to Rome, or Art Deco to midtown New York – the pervasive style. The curling, organic, elastic quality of Miró's drawing in the 1920s has everything to do with it. So does the metamorphic fantasy. Perhaps no architect has ever immersed himself more consistently in metaphor than the master of Catalan *modernismo*, Antonio Gaudí (1852–1926), who was still active when Miró was a young man and was killed by a motorcar before finishing the designs for his climactic work, the Expiatory Temple of the Holy Family or, for short, the *Sagrada Familia* (plate 161). Gaudí began work on this tremendous edifice for Barcelona in 1903, and half a century after his death it is still going up – but

very slowly. Perhaps it will never be finished, but, complete or not, this is the last imperious monument of Catholic Spain, and it is beyond all probability that the Roman Catholic Church will attempt to raise another church like it anywhere else in the world. Here, one can truthfully say that form does follow function – sliding, dripping, dissolving, re-forming, changing colour and texture: soft architecture, juicy architecture, the architecture of ecstasy. To the classicist's eye, buildings like the *Sagrada Familia* or, even more extreme, Gaudí's *Parque Guell*, also in Barcelona, are outright madness: not a straight line or a clear imperative visible anywhere. To advanced modernist taste in the 1920s – Bauhaus taste, in a word – Art Nouveau was sickeningly gratuitous; but to the Surrealists it was a marvel. What could be more self-contradictory, more permeable to the imagination, than a large building that denied its own rigidity? It was Desire made concrete; and at the extremity of the style, occupied by Gaudí's work, there is a sense of neurasthenic irritation, of tumid, visceral energy, and of substance continuously mutating into metaphor, which was to become the legacy of a younger if somewhat more dubious Catalan genius, Salvador Dali.

For almost forty years, Dali (b. 1904) has been one of the two most famous painters alive. As a bodily trademark, his moustache was the only rival to van Gogh's ear and Picasso's testicles; though unlike them, it was adopted from Velásquez's portrait of Philip IV. Dali's success, large as it was, coincided with his decline as a serious artist. Painters often imitate themselves (and certainly Miró's late work, most of it reflexively churned out to satisfy the demands of the market, is no exception), but Dali did so with unusual zeal, and his celebrity arises from the way in which he fulfilled two ruling clichés about artists. The first was the Painter as Old Master (Raphael, Rubens); the second, the Artist as Freak (Rimbaud, van Gogh). Dali's public image contrived to give a tacky, vivid caricature of both while fulfilling neither. Here, on one hand, was early Dali: a manic and unrestrained imagination, immersed in sovereign private fantasy. On the other, the late Dali convinced an audience that could scarcely tell the difference between a Vermeer and a Velásquez that he was the spiritual heir to both painters. He did both, not so much through art as by the diffusion of small anecdotes and a stoic indifference to the pangs of self-repetition. "The difference between a madman and me," Dali is often quoted as saying, "is that I am not mad." Indeed, he is not; and in his later years the Catalan promoter, with his moustache-wax, lobster-telephones, and soft watches, managed to annihilate his earlier self – crazy Sal the Andalusian Dog, the insecure and ravenously aggressive young dandy whose tiny, enamelled visions helped create one of the extreme moments of modernist disgust and revolt.

Almost all the works of art on which Dali's fame as a serious artist rest were painted before his thirty-fifth birthday, between 1929 and 1939. Around 1926, he discovered that realism, pressed to an extreme of detail, could subvert one's sense of reality. Instead of presenting a painting as a surface, with all its inherent tensions, Dali went to the opposite extreme of treating it as a perfectly transparent window, using what he called "all the usual paralysing tricks of eye-fooling, the most discredited academism" to invoke "sublime hierarchies of thought." The painter Dali chose as his model was

161 Antonio Gaudí *Sagrada Familia, Barcelona* begun 1903
Exterior view of the Nativity Façade (photo MAS)

the late nineteenth-century academician Jean-Louis Meissonier, whose detailed canvases stood for everything that was not modern: an accuracy more than photographic, with paint as smooth and licked as bathroom porcelain.

This technique could make any vision, no matter how outrageous and irrational, seem persuasively real. But it needed a system of images, and this Dali approached through what he called his "paranoiac-critical" method. In essence, it meant looking at one thing and seeing another. This kind of trick double-reading had been used occasionally by artists since the sixteenth century – *capriccio* heads made of vegetables or fish or game, by Arcimboldo and his imitators, had as much of a vogue at the court of Rudolf II of Prague as, after Dali, they would have among chic interior decorators – but Dali took it to an extraordinary pitch of ingenuity, linking the most diverse and spatially remote objects into mutually cancelling figures-of-sight. Thus in *Metamorphosis of Narcissus*, 1937 (plate 162), the hand sprouting from the ground, holding an enormous egg – from whose cracked shell a narcissus sprouts – can be made to "turn into" the figure of Narcissus in the background, gazing into the pool. These ambiguities usually went on in a dream landscape that Dali appropriated, with refinements, from de Chirico – the flat, desert-like plane, Lautréamont's operating table, on which strange objects meet, as in the mocking verse in a thirties issue of *Punch*:

> On the pale yellow sands
> There's a pair of clasped hands
> And an eyeball entangled in string,
> And a plate of raw meat,
> And a bicycle seat,
> And a Thing that is hardly a Thing.

Close; but no cigar. The content of vintage Dali is too weird and obsessive to parody, since parody requires some sense of normality in its subject, and Dali's work had none. Its intensity placed it beyond satire. That intensity was also bound up with its small scale – the opposite, in this respect, of Abstract Expressionism, whose impact was largely dependent on the engulfing size of the canvas. With Dali, one is always looking down the wrong end of the telescope at a brilliantly clear, poisoned, and shrunken world, whose deep perspectives and sharp patches of hallucinatory shadow intrigue the eye but do not invite the body; one cannot imagine oneself walking in this landscape, or even touching it, for it is all illusion. His small paintings, like *The Persistence of Memory*, 1931 (plate 163), preserve their magic because they cannot be verified. One must accept this stretched and satiny beach, these melting watches, and that biomorphic blob (a profile of the artist, in fact, turned nose to the ground).

Dali had a brilliant sense of provocation, and if his images are to be rightly seen they must be set, in retrospect, into the context of a less sexually frank time. Today, the art world is less easily alarmed by images of sex, blood, excrement, and putrefaction, but fifty years ago it was still quite shockable and had difficulty in digesting a painting like Dali's *Lugubrious Game*, 1929 (plate 164), with its explicit imagery of masturbation – the figure on the plinth, averting its head in shame, with its enormously enlarged right

162 Salvador Dali *Metamorphosis of Narcissus* 1937
Oil on canvas 20 × 30 ins: Tate Gallery, London

163 Salvador Dali *The Persistence of Memory* 1931
Oil on canvas 9½ × 13 ins: Collection, The Museum of Modern Art, New York, Given anonymously

GRAMME

CENTIGRAMME

MILLIGRAMME

Salvador Dalí 1929

hand – and of coprophilia. The minutely painted smutch of excrement on the shorts of the gibbering man in the foreground even offended Breton, and the Surrealists conducted a serious *enquête* on whether or not turds were an acceptable dream image. Dali rightly pointed out that a censored dream was no dream at all, but a conscious construction; if his colleagues were interested in the marvellous workings of the unconscious, they must take them warts, dung, and all. Like a gland irritated by constant scratching, Dali's mind threw off many of these confessional images before the end of the 1930s. As Picasso used his erotic rage as a subject throughout his life, Dali deployed an imagery of impotence and guilt. He liked anything that was not erect, that spoke of flaccidity – runny Camembert cheese, Gaudí's stonework, melon-like lobes of flesh held up by crutches, soft watches, fried eggs, deliquescent heads. He inherited from Spanish devotional art – not the art of the Prado, rather the gaudy devotional image of the provincial church – an almost paralyzing morbidity about flesh. In Dali it suffers, scourged by light, and seems ripe as over-hung grouse: there is no such thing as the confident body, but no spiritual transcendence of the flesh either. Hence the peculiarly airless, pessimistic tone of Dali's work, another characteristic that it, like much Surrealist art, shared with pornography.

It seems right that one of the places where Dali is commemorated, standing in his Académie Française rig in a theatre box along with other representatives of middle culture and *haute couture* (Françoise Sagan, Pierre Cardin), should be the waxwork hall of the Musée Grevin, Paris' equivalent to Madame Tussaud's. It was one of the favourite spots of Surrealism in the twenties and thirties, for waxworks, like de Chirico's dummies, lie somewhere between art and life. They are failures, sinister hybrids, and from the Surrealist aspect the cruder they were the more potent they got, mocking the illusions of art while offering none of the consolations of nature. The Musée Grevin was one of several places that made up a "Surrealist itinerary" of Paris: the Tour St.-Jacques, the Porte St.-Denis, the labyrinth of arcades and glazed passage-ways like the Passage de l'Opéra, the melancholy belvedere of the Parc des Buttes-Chaumont overlooking its iron bridge of suicides, and a dozen other places in that palimpsest of a city that spoke, not of reason and ceremony but of nostalgia, chance encounter, or the terrors of the night. This "secret city" was movingly evoked by Louis Aragon in *Le Paysan de Paris* (*The Paris Peasant*), a coiling pastoral reflection on a dream townscape. Only the Cubists were as dependent on a single city for their images. Nature hardly mattered to the Surrealists. Their substitute for the variety of nature was the intricacy of culture – the endless profusion of manufactured objects that washed up in the Flea Market. Fifty years ago, junk was junk, not "antiques" or "collectibles." Almost anything could be had at the Flea Market for virtually nothing. It was like the unconscious mind of Capitalism itself: it contained the rejected or repressed surplus of objects, the losers, the outcast thoughts. There, in a real place, the sewing machine met the umbrella on the operating table – and in due course gave birth to a whole flock of progeny that made up a new, if minor, art form: the Surrealist Object.

The Object was collage in three dimensions. It was, as the American photographer and object-maker Man Ray explained,

164 Salvador Dali *Lugubrious Game* 1929
Oil and collage on canvas $16\frac{1}{2} \times 10\frac{1}{4}$ ins
Private Collection, Paris

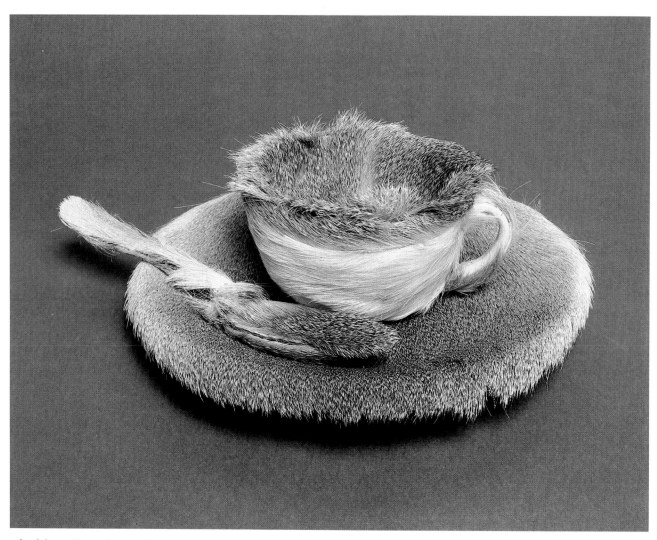

165 Meret Oppenheim *Object (Luncheon in Fur)* 1936
Fur-covered cup, saucer and spoon; cup, $4\frac{3}{8}$ ins diameter;
saucer, $9\frac{3}{8}$ ins diameter; spoon, 8 ins long; overall height, $2\frac{7}{8}$ ins
Collection, The Museum of Modern Art, New York, Purchase

the result of looking at something which in itself has no quality or charm. I pick something which in itself has no meaning at all. I disregard completely the aesthetic quality of the object; I am against craftsmanship. I say the world's full of wonderful craftsmen, but there are very few practical dreamers. . . . Nothing is really useless. You can always find a use even for the most extravagant object.

Generally, Ray's objects were not "extravagant," but so ordinary – before the twist – as to be almost invisible. Such was the flat-iron to whose sole he added a row of nails, calling the result *Gift*: a supremely useless thing, frozen in contradiction and charged with aggression. Ray's best-known object was somewhat more complex: a metronome with an engraving of an eye impaled in its wand. Its sadistic overtones are obvious enough, but what may be less so is the origin of the image, which is the Great Seal of the United States graven on the back of every dollar bill, representing the eye of Authority hovering above the pyramid of History. Hence the anarchist point of the title – *Object to Be Destroyed*.

Perhaps the most durable of Surrealist objects was made by a woman, Meret Oppenheim, in 1936. By taking a cup, saucer, and spoon and covering them with fur (plate 165), Oppenheim created a self-contradictory image of astounding power. *Luncheon in Fur* has also retained a long, secret life as a sexual emblem. The action it implies, the artist bringing her lips to a hairy receptacle full of warm fluid, makes Oppenheim's cup the most intense and abrupt image of Lesbian sex in the history of art.

The Surrealist cult of objects underlined another aspect of the movement: its belief that *le merveilleux* – that state of almost sexual excitement which Breton called "convulsive beauty" – was available everywhere, hidden just below the skin of reality. The artist who produced the best evidence for this idea was a Belgian, René Magritte (1898–1967). In the midst of a movement which specialized in provocations, attention-grabbing stunts, political embroilments, sexual scandals, ruptures of friendship, and fervid half-religious crises, Magritte seemed uncommonly phlegmatic. He lived in respectable Brussels, and stayed married to the same woman, Georgette Berger, till his death; by the standards of the Paris art world in the thirties, he might as well have been a grocer. Yet this stolid enchanter possessed one of the most remarkable imaginations of the twentieth century.

Magritte's work serves its modern audience rather as the sultans of Victorian narrative painting, the Friths and Poynters and Alma-Tademas, served theirs – as a source of stories. Modern art has been well supplied with myth makers, from Picasso to Barnett Newman. But it had few masters of the narrative impulse, and Magritte was its fabulist-in-chief. His images were stories first, paintings second, but the paintings were not slices of life or historical scenes. They were snapshots of the impossible, rendered in the dullest and most literal way: vignettes of language and reality locked in mutual cancellation. As a master of puzzle-painting, Magritte had no equal, and his influence on the formation of images – and on how people interpret them – has been very wide.

In 1923, Le Corbusier reproduced – in *Towards an Architecture*, as an emblem of

plain functional design – a pipe. Five years later, Magritte painted his riposte to Corbusier's single-level rationalism in *The Treason of Images*, 1928–9 (plate 166). "This is not a pipe." But if not, then what is it? *A painting*, the painting answers; a sign that denotes an object and triggers memory. The phrase, "*Ceci n'est pas une pipe*," has become one of the catch-lines of modern art, a condensed manifesto about language and the way meaning is conveyed, or blocked, by symbols. No painter had ever made the point that "A painting is not what it represents" with such epigrammatic clarity before. Corbusier's pipe, as redone by Magritte, was the hole in the mirror of illusion, a passage into a quite different world where things lose their names or, keeping them, change their meanings. At one border, Magritte's field of action touched on philosophy; at the other, farce.

The first characteristic of Magritte's work was dread – sometimes at the harsh, schematic level of the silent movies he doted on. The main cinematic influence on Magritte was Louis Feuillade's five-part serial *Fantomas* (1913–14), whose roster of fans also included Apollinaire and Picasso, along with the rest of Magritte's Surrealist colleagues. Feuillade's detectives in bowler hats, gravely pursuing the invincible black shadow through the salons, corridors, and rooftops of Paris, made an indelible imprint on Magritte, and they may well be the origin of his later images of expressionless businessmen (plate 167). The high degree of stylization in Feuillade's films (furniture arranged frontally to the screen, little or no camera movement) gave the utmost contrast to the bizarre actions they depicted; and this, too, was echoed in the formal solemnity with which Magritte's work set forth its paradoxes. A hunter with gun and bandolier puts his hand against a wall and is horrified to find it sunk (or sucked) into the brickwork. A pair of boots ends in real toes: a fossilization of life, or an awakening of leather? Such contradictions can produce a gaping sense of erotic alienation, as with *The Lovers*, 1928, whose two anonymous but sibling-like heads are trying to kiss one another through their integuments of grey cloth.

With his dry, matter-of-fact technique, slowly acquired and without the least trace of the "natural" painter to enliven it, Magritte painted things so ordinary that they might have come from a phrasebook: an apple, a comb, a cloud, a hat, a birdcage, a street of prim suburban houses. There was not much on this list that an average Belgian, around 1935, would not have seen or used in the course of an average day. Magritte's poetry was inconceivable without the banality through, and on, which it worked. If they did not have a reportorial air, a denial of fantasy built into their very style, his paintings would be far less eloquent. And if his art had confined itself to the administration of shock, it would have been as short-lived as any other Surrealist ephemera. But his concerns lay deeper. They were with language itself, transposed into pictorial representation. Magritte was obsessed by the hold that language has on what it describes. When (in *The Use of Words*, 1928) he labelled two virtually identical and amorphous blobs of paint "Mirror" and "Woman's Body," he was not simply making a joke about narcissism, but showing the extreme tenuousness of signs. In one of his most famous demonstration pieces, *The Human Condition I*, 1934 (plate 168), a canvas stands on an easel in front of a view through a window. The canvas bears a

166 René Magritte *The Treason of Images* 1928–9
Oil on canvas $23\frac{1}{2} \times 37$ ins
Los Angeles County Museum of Art

167 René Magritte *The Menaced Assassin* 1926
Oil on canvas $59\frac{1}{4} \times 76\frac{7}{8}$ ins: Collection, The Museum of Modern Art, New York, Kay Sage Tanguy Fund

168 René Magritte *The Human Condition I* 1934
Oil on canvas $39\frac{1}{2} \times 31\frac{1}{2}$ ins
Private Collection, France

169 René Magritte *The Threshold of Liberty*
Oil on canvas $45 \times 57\frac{3}{4}$ ins : Museum Boymans-van
Beuningen, Rotterdam Ⓒ SABAM

picture of the view. This picture exactly overlaps the view itself. Thus the play between image and reality suggests that the real world is only a construction of mind. We "know" that if we moved the easel, the view through the window would be the same as the one shown on the painting-within-the-painting; but because the whole scene is locked into the immobility and permanence of a larger painting, we cannot know it. This sense of slippage between image and object is one of the sources of modernist disquiet. If some part of the world can be shown to be irrational but coherent, Magritte's work argues, then *nothing* is certain. And so his visual booby-traps go off again and again, because their trigger is thought itself. When the cannon fires (plate 169), the screens of familiar images go down; and we stand, as the title of this painting tells us, on *The Threshold of Liberty*.

In politics, Surrealism's commitment to liberty was more ambiguous, mainly because of its alliance with Stalinism – which, after Trotsky's exile in 1929, was the French Communist Party's orthodoxy – but partly also as a result of political dilettantism. There was a deep antipathy between the means of cultural revolt that Surrealism advocated – the dream, the exploration of unconscious desire, the exaltation of chance and Eros – and the "scientific" ideals of dialectical materialism. At first, the Surrealists drew no special line between personal revolt and political revolution; like many a later writer in the sixties, they saw themselves as literary Jacobins and prattled about "the Terror" in cultural matters. Louis Aragon – later to become as infatuated a Stalinist poet as ever traipsed through the salons of the Sixteenth Arrondissement – dismissed the Russian Revolution as "on the level of ideas . . . at the most a vague ministerial crisis," and announced that all work was prostitution: "I shall never work, my hands are pure." Clearly, this was no platform from which to build a bridge to either the affections of the French proletariat or those of the Third International; but by 1925, Breton consented to see the light. Blaming the French authorities for hiding the truth about Russia, he rebuked Aragon and announced that "On the moral plane where we have decided to place ourselves, it seems as if a Lenin is absolutely unassailable."

There ensued one of the comedies of misunderstanding so much a feature of French intellectual life: a group of poets and painters struggling to accommodate to Moscow and failing to satisfy either themselves or it. Surrealism could move towards communism between 1925 and 1928 because, in Russia, the great freeze had not yet taken place; there was still some liberty of artistic expression in the Soviet Union. Moreover, the first French editions of Trotsky's writings were now available. Their acceptance of Freud, Jung, and Adler delighted Breton, and Leon Trotsky was thereupon accepted as a political exemplar by the Surrealists. He was to remain so, through his years of exile, until Stalin had him murdered in Mexico City in 1940. Yet the Surrealists were not the most apt material for institutional labours under the aegis of the French Communist Party. Breton spent a while writing reports for a cell of Communist gas-workers, and then withdrew, finding the work incompatible with poetry. Louis Aragon, on the other hand, went to Russia to attend a writers' conference in Kharkov in 1930 and came back a vociferous Stalinist, rejecting Trotsky

and Freud. Soon after reaching Paris, he wrote a squalid Agitprop poem, *Red Front*, which only the most bloodthirsty *apparatchik* could swallow.

Aragon's hymn to the Stalinist purges, enacted against the background of the Moscow show trials of the thirties, was not to Surrealist taste. Besides, from 1930 onwards, the very word "surrealism" became odious to the Stalinist leadership of the French Communist Party. What, after all, could one do with a movement whose only political images in painting seemed to be two canvases by Salvador Dali: a portrait of Lenin with one immensely elongated buttock, entitled *The Enigma of William Tell*, and another of Lenin's face appearing six times, in small golden haloes, on the keys of a grand piano? Such *jeux d'esprit* could only be anathemized, as they duly were, by good Stalinist writers. Even in England, the future mole and Surveyor of the Queen's Pictures, Anthony Blunt, attacked Surrealism in the *Left Review* in 1936 as "a flirtation with the ideology of capitalism."

Apart from Trotsky, whom Breton visited in Mexico City before his murder, the Surrealists had no durable heroes among politicians, dead or alive. But they did accumulate a list of "saints" who, in their opinion, had lived out the Surrealist ideal of liberty before its time. It was a mixed bag of Romantic heroes and heroines, given to strong feeling and unrestrained search: among others, Byron and Victor Hugo, Novalis and Lautréamont, Baudelaire, Rimbaud, Huysmans, and Jarry. Surrealism preferred Heraclitus to Plato, and Raymond Lull's mystico-alchemical fantasies to the ordered arguments of Thomas Aquinas.

The greatest of these forerunners, in terms of his place in the literature and fantasies of revolt, was the censored hero Donatien Alphonse François de Sade, whose castle at La Coste in the South of France was a sacred spot for Breton and his friends. They visited its ruins, carved their initials in the crumbling plasterwork of its roofless salon, meditated among the wild bushes that sprout from its walls, and had their photos taken there. It was, in a sense, their Delphi.

The "Divine Marquis" was one of the few eighteenth-century figures the Surrealists admired, because – at great length and with stupefying prolixity, as anyone knows who has made the effort of reading *Justine* and *Juliette* – he had argued the supremacy of Desire over all moral contracts and shown what has become a commonplace since Freud: that, in order to ensure the rule of Reason, imagination must be in some degree repressed and censored. Sade became the first writer to describe the fundamental relationship between sex and politics which, in the twentieth century, would be elaborated by writers like Wilhelm Reich.

Sade became the unthinkable answer to Jean-Jacques Rousseau's milky belief that man, left in a state of nature, is good: that all human evil and cruelty stem from the twisting of a virtuous nature by bad laws and customs. On the contrary, Sade argued, we are monsters from the beginning. Man's nature is his desires, and only by following our desires to the end can we find out what our natures are, no matter how appalling the conclusions we reach. His motto was, in effect, written by the mild Englishman William Blake: "Sooner murder an Infant in its Cradle than nurse unacted Desires." Sade composed most of his works in prison, an excellent place for thinking about the

unthinkable. His vision of Pornotopia, enacted in the libertarian confinement of villas and remote castles where insatiable aristocrats go through their rituals of blood, dung, sperm, cannibalism, and Socratic argument like figures on a demented cuckoo clock, was like some Tahiti of the id where the rain never falls, social conditions never change (since nothing, in Sade's universe, can be understood except as a function of slavery and the burning revolutionary will to invert it), food never runs out, and nature permanently rules. A blasphemer, an atheist, a traitor to his class, the aristocracy – no wonder Sade had such an appeal to the Surrealists, who were also atheists, blasphemers, and traitors to their class, the bourgeoisie. Their tributes to Sade were frequent, and their blasphemous tone – as in Man Ray's *Monument to D. A. F. de Sade*, 1933, consisting of a girl's buttocks montaged onto an upside-down crucifix – looks a trifle dated to anyone not brought up in a Catholic environment. The Surrealists, however, were nearly all baptized Catholics from France or Spain, and the French Church before World War II enjoyed a degree of social power almost unimaginable today. To attack Catholic taboos was thus a comparatively daring act, and when the Surrealists published a blurred photograph of one of their number, the poet Benjamin Peret, insulting a priest on the street, they believed they were commemorating a distinct if small step in the gradual freeing of man from superstition. (What they produced, instead, was one of the world's first documented "performance" pieces, forerunner of a thousand equally trivial actions that would be recorded on Polaroid or videotape by American artists in the seventies.) The wittiest *bestemmia* was by Max Ernst: a painting of the Virgin Mary spanking the Infant Jesus, watched by the three wise men – recognizable portraits of Paul Éluard, André Breton, and the artist.

As the main precinct of social taboo, sex was one of the great Surrealist themes; but Surrealism was only interested in one kind of sexual freedom, the man's, and a heterosexual man's at that. Breton had an intense loathing of homosexuality. For this reason (as well as for his social climbing and his unacknowledged borrowings from Surrealism in films like *Orphée*) Breton carried a lifelong grudge against Jean Cocteau, and the absorption of Surrealist devices into homosexual chic, via the couture houses and the pages of *Vogue*, appears to have cost him some sleep from the middle thirties. The Surrealist ideal of love had much in common with the ideal of mediaeval courtly love; imagination could best be set free by single-minded devotion to one woman, real or (in the case of Breton's *Nadja*, heroine of his novel) imaginary. Surrealist love was based as much on fixation as "liberated" sex in the 1970s was on promiscuity; it promised freedom through maximum attention, and was the equivalent, in human transactions, to the "obsessive" quality that Surrealism prized in objects. But it did not translate into art. The most memorable heterosexual image in Surrealist painting was Magritte's *The Rape*, 1934, in itself a magnificent protest against fixation and fetishization, where the woman's face turns with frightful clarity into the "genital face" whose blind, mute, and pathetic sexuality has a truly Sadeian character (plate 170). In general, the image of woman in Surrealist art had no real face: she was always on a pedestal or in chains. Her preferred form was a mannequin, itself (due to its

170 René Magritte *The Rape* 1934
Oil on canvas $28\frac{3}{4} \times 21\frac{1}{4}$ ins
Menil Foundation, Texas

171 Kurt Seligmann *Ultra-Furniture* 1938
(photo D. Bellon, Paris)

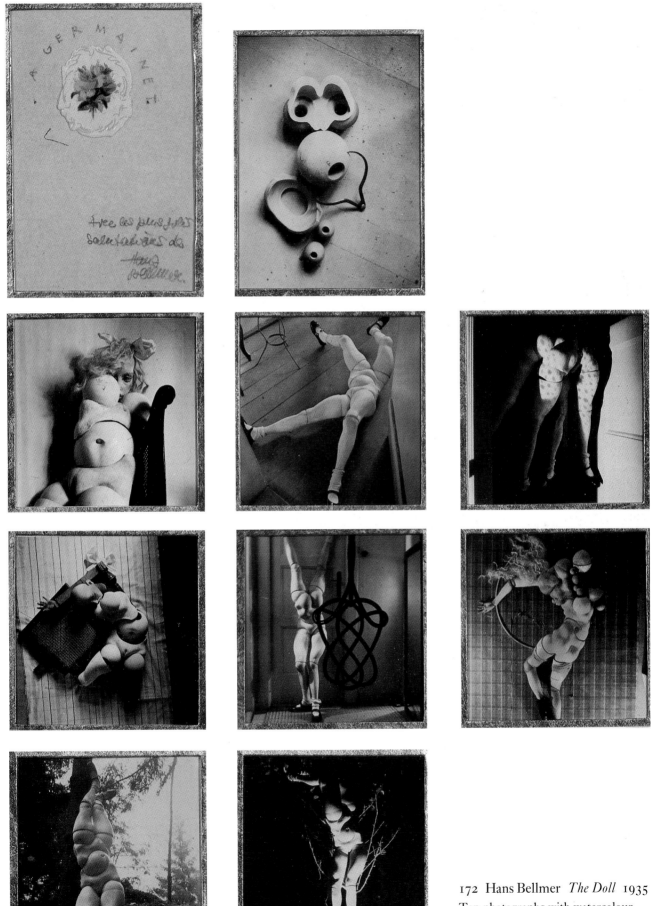

172 Hans Bellmer *The Doll* 1935
Ten photographs with watercolour
additions horizontally arranged
$30\frac{3}{4} \times 8\frac{1}{4}$ ins: Tate Gallery, London

252 / THE THRESHOLD OF LIBERTY

inevitable associations with commercial chic) a somewhat compromised object, appropriated straight from de Chirico's tailors' dummies. There are pieces of woman-furniture, but no male tables or chairs, in Surrealist art; Dali's sofa in the form of Mae West's lips, or Kurt Seligmann's *Ultra-Furniture*, 1938 (plate 171), a stool supported on three mannequin's legs, a direct transcription from the fantasies within the mad ogre Minski's castle described by Sade in *Juliette*, where the visiting orgiasts eat their dinner of roast boy while sitting on chairs "constructed" of live, interlocked slaves.

The extreme form of Sadeian imagery in Surrealist art was the work of Hans Bellmer, whose obsession with a young girl caused him to make an erotic dummy, articulated with ball-and-socket joints, called simply "The Doll." Its limbs could be splayed, bent, and combined at will, which made it an excellent vehicle for images of sexual fantasy centred on rape and violence (plate 172). Bellmer took photographs of it in different settings, a room, a corner, an alley, under a bush, which looked like police-evidence shots taken after a crime. The Doll was almost infinitely pornographic, and its manipulated, abandoned look summed up the Surrealist image of woman as "beautiful victim."

It would be hard to exaggerate the importance, not only to Surrealism but to the irrationalist imagery that followed it, of this mythology of sexual violence. Its most memorable images were created by Picasso, who was never a member of the Surrealist circle but was rightly admired by Surrealism for his sense of metamorphosis and sexual hostility. No artist since Rubens had been more entranced by women, or based his art more completely on the female figure, than Picasso. The rapturous sexuality of the Vollard Suite and the paintings associated with Marie-Thérèse Walter (see Chapter 3) had its obverse in the anguish and misogyny of many Picassos from the late twenties and early thirties. Picasso was one of art's great confessors; he was incapable of hiding what he felt from day to day, and the intensity with which he could project his fear of women was, as we have seen with *Les Demoiselles d'Avignon*, unmatched by any of his contemporaries. In paintings like *Seated Bather*, 1930 (plate 173), he raised it to a frightening pitch of feeling. The process which has produced these deformations of an innocuous body has a witch-killing defensiveness behind it. Instead of the Mediterranean nymph or metropolitan waif, woman is seen as a chthonic monster put together from bone or stone; one could imagine the painting used as a blueprint for sculpture, and the near-physical presence of its figure, plated and angular, isolated against the two bands of sea and sky, suggests an insect – a female mantis – waiting, armoured and immobile, for its unlucky mate. Its head, in particular, shows Picasso's astonishing ability to conflate several images into one. Its general form suggests an armoured helmet, with two metallic cheek-pieces. It can also be seen as a small, fierce animal with a pointed nose and two clawed arms. But these "claws" are a mouth as well; and because this mouth is vertical, not horizontal, it suggests a displacement of the *vagina dentata* back to the head. This imagery of genital warfare – in which the vagina is imagined as a toothed trap, the penis as a knife, and the act of love a mutual massacre – was particularly strong in André Masson's paintings of the early 1930s, and in sculpture it dominated the Surrealist work of Alberto

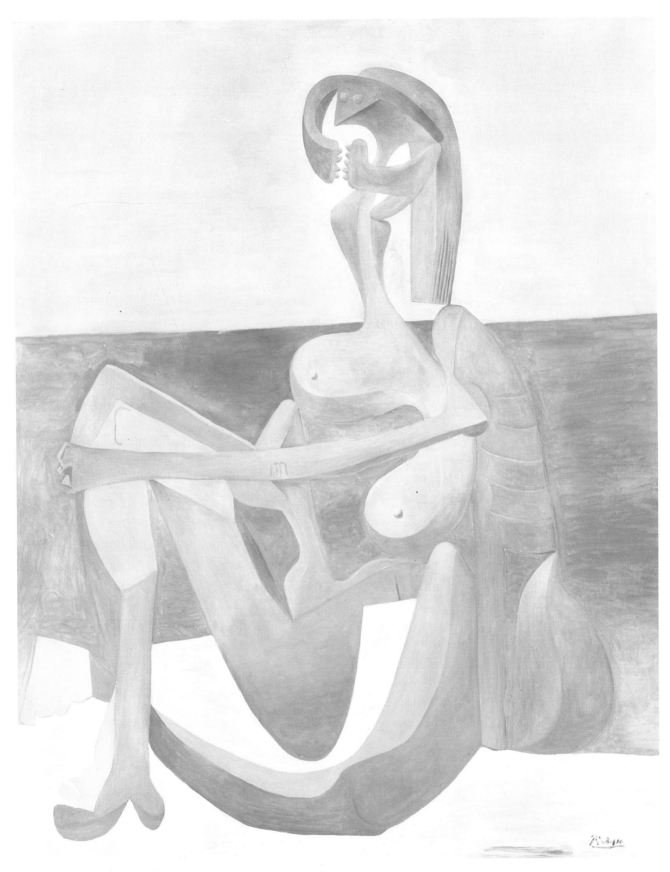

173 Pablo Picasso *Seated Bather* Paris (early 1930)
Oil on canvas 64¼ × 51 ins: Collection, The Museum of Modern Art,
New York, Mrs. Simon Guggenheim Fund

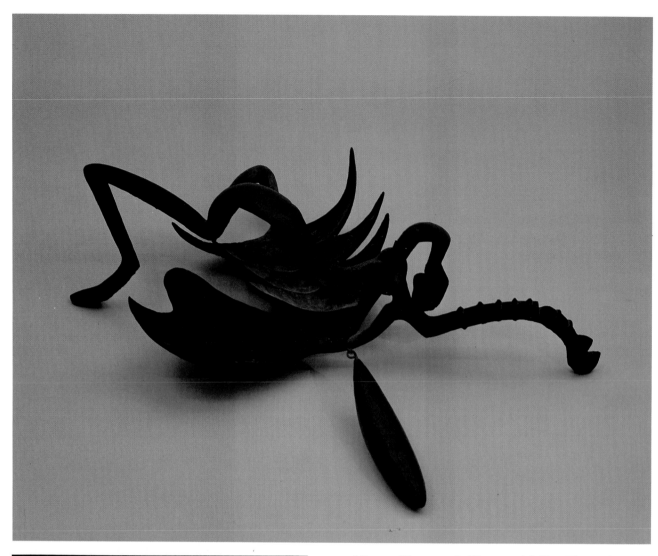

174 Alberto Giacometti *Woman with Her Throat Cut* 1932
Bronze 34½ ins: Peggy Guggenheim Collection,
The Solomon R. Guggenheim Foundation

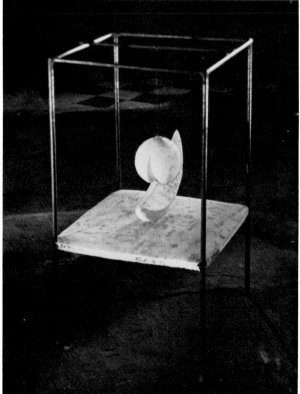

175 Alberto Giacometti *Suspended Ball* 1930–1
Plaster and metal 23½ ins: Tate Gallery, London

Giacometti (1901–66). In Giacometti's *Woman with Her Throat Cut*, 1932 (plate 174), the figure, sprawled on the floor with a knife-cut in its cervical column, is part scorpion and part sacrificial victim – spiky, bony, and malevolent. Georges Bataille's view that "copulation is the parody of crime" was widely shared in the Surrealist circle, and Giacometti's sculptures of the thirties seem to accept it as a text. They could also deliver an aching sense of frustration, as in *Suspended Ball*, 1930–1, (plate 175) in which a ball with a female cleft in it hangs just above a curved wedge, almost but not quite touching it – desire perpetually denied.

As the thirties wore on, however, the prevalent tone was not so much frustration as a sense of apocalypse. It seemed that the liberal bourgeois democracies, on whose continued existence the free speech of art depended, were being ground, one by one, to powder between the dictatorships of the Right and the Left. From the Russian purges and show trials to the Fascist subjugation of Abyssinia, from Hitler's rise in Germany to Franco's victory in Spain and the Nazi-Soviet non-aggression pact, a threatening world was being assembled, in which the quarrels and affirmations of "culture" could play, at best, a small role. The sense of foreboding that gripped artists on the eve of World War II was reflected in late Surrealist painting – in Miró's *Still-Life with Old Shoe*, 1937 (plate 176), for instance, whose lurid and fuliginous colours, glowing between encroachments of black, fill an otherwise neutral subject with such anxiety that the fork, jabbed into the bread roll, seems to be committing an act of murderous spite.

In 1940, Max Ernst began his valediction to Europe, which he finished in America two years later: *Europe After the Rain*, 1940–2 (plate 177), a panorama of a fungoid landscape seen as though in the aftermath of an annihilating, biblical deluge. Ernst got away to America when the German armies rolled into France. So did André Breton, André Masson, Yves Tanguy, and Salvador Dali. Miró went back to Spain. In hindsight, the Surrealist diaspora seems to mark the end of Paris as the centre of Western art; it would not regain that role, which was already passing to the place of Surrealist refuge, New York.

It was in New York that the remains of Surrealism took root and mutated. But one exceptional artist of the irrational was already living there in a frame house on Utopia Parkway in Queens, outside Manhattan. Until his death in 1972, Joseph Cornell was the most reclusive, subtle, and fugitive of American artists; his work was so idiosyncratic that it made nonsense of its imitators, so that there could be no *école de Cornell*. His house, where he lived for fifty-four years, represented an exile from the "art world" – that system of dealers, collectors, critics, and curators which, after 1950, would acquire such preponderant importance in Manhattan. It was crammed with cartons, dossiers, packets of old photos, clippings, reels of old film on decomposing nitrate stock, hoarded books, geegaws, and boxes; these constituted the world in which he travelled.

Cornell began in the thirties making mild, derivative collages in emulation of Ernst's *Femme 100 Têtes*. The discovery that created him as a serious artist was the Box. Cornell's boxes managed to fuse, in a most ingenious way, the power of illusion of

176 Joan Miró *Still-Life with Old Shoe* Paris, January 24–May 29, 1937
Oil on canvas 32 × 46 ins: Collection, The Museum of Modern Art, New York,
Gift of James Thrall Soby

177 Max Ernst *Europe After the Rain* 1940–2
Oil on canvas $21\frac{1}{2} \times 58\frac{1}{4}$ ins: Wadsworth
Atheneum, Hartford, Ella Gallup Sumner and
Mary Catlin Sumner Collection

Surrealist painting with the apparitional concreteness of the Surrealist Object. They did so by referring to theatre: the "fourth wall" of each box, the glass through which one looks at what is going on inside, is a miniature proscenium arch. As well as theatre, the box suggested the specimen-cabinet – a filing system, sealed off from ordinary space, in which delicate, exotic, or precious samples of an actual world (fossils, gems, butterflies, or scarab-beetles) are laid out under glass, as classified sets, so that their ordering suggests a wider organization outside the "frame." In short, the box was an exceptionally convincing way of focusing an image and presenting it as both real and private: plainly in view, but protected from the embrowning air of real life by its glass pane. One thinks – as Cornell often thought – of Victorian mementoes, the cases of stuffed birds and flowers under glass bells that used to gather dust in every country junkshop. Cornell's was an inward art, and nowhere did his fantasies touch on American life, present or even past. He loved the idea of Europe but never went there, and in fact the Europe in his boxes lasted from the fifteenth century to the *Belle Époque*, finishing with World War I; it perpetuated itself, in his work, in hotel letterheads from French spas and reverent evocations of dead dancers like Marie Taglioni and Loie Fuller. Other things in the boxes were less dated: charts of land and stars, collaged owls and jigsawed parrots, white clay pipes and mirror-glass, watchsprings, cones, cork balls, wineglasses, and tiny drawers full of red sand. There was no apparent end to this variety, although Cornell would admit nothing to his memory-theatre that was not, in some degree, elegant. This may sound like a recipe for preciosity, but it was not, because Cornell had a rigorous sense of form, strict and spare, like good New England cabinetwork: his work also had much in common with the tradition of American *trompe-l'oeil* still-life, in the exact illusions painted by Harnett and Peto. Its keynote was often a precise and poetic frugality.

Yet some of Cornell's boxes were very elaborate. The most complicated was *L'Egypte de Mlle Cléo de Mérode*, 1940 (plate 178). Cléo de Mérode had been a celebrated French courtesan of the 1890s, and Cornell had read somewhere that the Khedive of Egypt had promised her a fabulous price for a visit to Egypt. He therefore made (on behalf of her suitor, as it were) a votive cosmetic box, in which all Egypt was symbolized as souvenirs or gems for this new Cleopatra. *L'Egypte de Mlle Cléo de Mérode* contains many small phials, nested in holes in the marbled-paper interior. Each little flask holds a different attribute of Egypt, or of Cléo herself: sand, wheat, curls of paper labelled "Serpents of the Nile," pearls, the Sphinx, and so on. Since they are all related to a central theme, they do not have much to do with Surrealist incongruity. They are more like a Symbolist poem, composed of fugitive image clusters, exactly registered but separated by "blanks" – the time one takes to remove each phial from the case, inspect it, put it back, and extract another corresponds to the intervening silences and stretches of white paper that Stéphane Mallarmé valued as the background to words. Cornell worshipped Mallarmé for his exactness of feeling; a pretty symmetry, since the French Symbolists admired an earlier American, Edgar Allan Poe, whose picture of a fantasy Europe, coloured by a neurasthenic sense of "mystery and imagination," has much in common with Cornell's.

178 Joseph Cornell *L'Egypte de Mlle Cléo de Mérode:*
cours élémentaire d'Histoire Naturelle 1940
Courtesy Leo Castelli Gallery, New York

Cornell had already arrived at his style before Ernst, Masson, and Breton reached America, though not before their work got there. An exhibition entitled "Fantastic Art, Dada, Surrealism," organized by Alfred Barr at the Museum of Modern Art in 1936–7, had helped acquaint New York artists with events in Paris, and Miró's work was already known to them. The issues raised by Surrealism were of crucial importance to a number of young New York artists, later to be loosely known as the Abstract Expressionists: Jackson Pollock, Arshile Gorky, Mark Rothko, Clyfford Still, Robert Motherwell, and William Baziotes. One can perhaps exaggerate the effect that the arrival of living European "masters" in their midst had on them, but it did have one specially important result: these local painters could now see the European exiles (who included major non-Surrealist painters as well – Léger, for instance) not as remote demigods or intellectual father figures on the other shore of the Atlantic but as regular presences on the scene. This narrowed the distance, and therefore closed the provinciality of the relationship, between New York and Paris. It helped do away with the crippling sense of inferiority, the "cultural cringe," that went with colonial modernism.

Some of their tracks were obviously parallel. Many of the American painters had read Freud and Jung; Jackson Pollock spent two years (1939–41) in Jungian analysis, and they all lived in a city whose cultural circles accepted going to the shrink as a normal feature of the social landscape, as Paris did not. The deep interest that early Abstract Expressionism showed in preconscious and unconscious images as the very root of art was not, therefore, simply a mimicking of Surrealist procedures. Nevertheless the example, and presence, of André Masson mattered a good deal to the younger American painters, for he – more than any other member of the Surrealist group – had tried to close the cultural gap between the fantasies of urban, modern man and the old dark imagery of prehistoric cultures, the recurrent content of myth from the caves of France to the labyrinth of Minos. When Mark Rothko in 1943 declared his belief that "the subject is crucial and only that subject matter is valid which is tragic and timeless," he was appealing to the kind of archetypal imagery that Masson's paintings of massacres, labyrinths, and totems had invoked for the past fifteen years. This was D. H. Lawrence's "knowledge of the blood" given pictorial form.

But "tragic and timeless" subjects were not found on the street, and early Abstract Expressionism had far less contact with daily life than Surrealism. Painters like Pollock, Rothko, and Still wanted to locate their discourse beyond events, in a field not bound by historical time, that went back to pre-literate, "primitive" tribal antiquity. Somewhere in the back of every viewer's head, an ancestor crouched in the shadows of the cave; he was the audience their art wanted to address. Barnett Newman, who made no significant paintings before the late forties but was active as a propagandist for this myth-laden art, harped on the need to re-primitivize oneself to obtain cultural wholeness, by regression as it were: "Original man, shouting his consonants, did so in yells of awe and anger at his own tragic state, at his own self-awareness, and at his own helplessness before the void." That phrase, "helplessness before the void," sums up the period style: existentialist solitude with Miltonic décor, the artist posturing as a

tragic Adam who, having lost Paradise, will not content himself with the World. Of course, since this emergent American painting had no hope of imposing itself on a large audience, any claims one made for it were ipso facto irrefutable. They could not be tested. Thus the rhetoric of Newman, Still, and Rothko (of which we shall see more in Chapter 6) was in part a means of facing down, and bluffing out, the depressing sense of alienation and redundancy that came with being an artist in America in the 1940s. But it also sprang from a vigorous belief in the efficacy of images, their power to act as spells or invocations, transforming consciousness.

If art were to tap the Jungian "collective unconscious," how could it do so? The American painters were deeply suspicious of some aspects of Surrealism and would not mimic them in their work. They disliked the publicity-mongering of Dali and the political attitudinizing of his colleagues. They dismissed the literary images of the Surrealists, and their sado-masochistic fantasies. The painting as a "dream-photograph," in the tradition of de Chirico, was anathema to their role as abstract painters. But this left one very important technique: "psychic automatism," as Breton had named it, the procedures of invoking an image by chance association and random doodling. If one's work remained hospitable to chance effects, drips, unforeseen combinations, and unintended images, if it was open-ended and "discovered" in the process of making rather than decided in advance and then arrived at, it would be permeable to the unconscious. The problem was one of control. As Robert Motherwell (the most intellectually sophisticated of the group) realized, the unconscious could not be directed; it offered "none of the choices which, when taken, constitute any expression's form. To give oneself over completely to the unconscious is to become a slave." Hence, he argued, automatism "is actually very little a question of the unconscious. It is much more a plastic weapon with which to invent new forms."

The painter to whom this markedly applied was an immigrant from Armenia, Arshile Gorky (1904–48). In its brief span and tragic end by suicide, Gorky's life as a mature artist formed a kind of Bridge of Sighs between Surrealism and America; he was the last major painter whom Breton claimed for Surrealism and the first of the Abstract Expressionists as well. His apprenticeship was strict. Certain that modernism formed its own tradition, beyond which there was no valid appeal to the past (except in quoting favourite motifs from favourite painters like Paolo Uccello), Gorky closely studied and copied the work of Picasso, Kandinsky, and Miró for the best part of twenty years. Then, in the early forties, he found himself. The spidery fluent line, drawn with pencil or thin flitch, that he had derived from Miró now began to describe a wholly original landscape of organic form, suffused with the intense yet cotton-edged and indeterminate patches of colour he had acquired from pre-1914 Kandinsky. These shapes described an imaginary field of images that alternated between the very near and the very far. It was bathed in a landscape light, but the swarming, pulsating disparity of form gives the impression of looking into a tangle of grasses, close up, on a hot summer day, with the eye very close to the ground: a grasshopper view of reality, its elements still half inchoate, pulled in and out of focus by Gorky's suave but rigorous line. *The Liver Is the Cock's Comb*, 1944 (plate 179), is

179 Arshile Gorky *The Liver Is the Cock's Comb* 1944
Oil on canvas 72 × 98 ins
Albright-Knox Art Gallery, Buffalo, Gift of Seymour H. Knox

such an "internal landscape," a compost of allusion to flower stems, tendons, human sexual organs, claws, stamens, guts, and feathers, pulsating with a glandular, preconscious glow. It is full of life, but not the sort of life that makes morphological sense. It looks into the body, not out from it.

The image of the figure bulked large in early Abstract Expressionism. Its master was De Kooning, whose work had no real affiliations with Surrealism and so is discussed in the next chapter. For Pollock and Rothko, the figure was less a describable entity than an invoked presence. Totem, cave, prison, sentinel, medium, personage, priest: such were the recurrent images of the forties. For Rothko, the essential subject of art was a sacerdotal drama involving the single figure, "alone in a moment of utter immobility;" but although these myth-embodying presences were freely available to the archaic artist (who lived, Rothko thought, in "a more practical society than ours," where "the urgency for transcendental experience was understood and given an official status"), they were closed to modern man. One could only glimpse them, or perhaps remake them through the deliberate guises of abstraction: "The familiar identity of things has to be pulverized in order to destroy the finite sensations with which our society increasingly enshrouds every aspect of our environment." Rothko wrote this in 1947, when he was moving towards the transcendental abstraction of his mature work. But in the 1940s the figure, or allusions to it, still remained in such watercolours as *Vessels of Magic*, 1946 (plate 180) – a spectral entity derived from the Surrealist landscapes of Max Ernst, indistinctly seen against the theatrical planes of beach and sky.

In terms of passion, inventiveness, and their emotional energy, the strongest "atavistic" images of the forties were painted by Jackson Pollock. A quarter of a century has passed since Pollock's death, and it is now easier, in hindsight, to see the unities of theme and shape in his art. From the churning, impacted compositions of his immature paintings of the thirties, done under the spell of Siqueiros and (more remotely) Tintoretto, through the totemistic work of the forties, and so to the great webs of wide-cast energy that were made possible after 1947 by his "drip" technique, Pollock was constantly obsessed with filling a surface with a nearly equal distribution of pictorial incident, seeking fullness, loathing the void, and thus reaching for a pictorial organization which (though implied in Miró's *Constellations*) had not become explicit in European painting. But in their time, the war years, paintings like *Pasiphae*, 1943, or *Guardians of the Secret*, 1943 (plate 181), must have seemed almost without precedent. Their debt to Masson was visible, but they carried Masson's writhing surface to a further extreme of labyrinthine congestion. If these works have a choked and blurting quality – and they do – they make up for that by the intensity of feeling with which they are jammed together. The "guardian" figures that flank the central rectangle, altar or sarcophagus, in *Guardians of the Secret* draw from the furious weaving of Pollock's line a visceral energy of their own, which is transmitted and felt in every blot, speckle, scribble, and hook of paint around them; even the formal indecisions of such painting – of which there are many – imply a morality that values momentary stutters above a too fluent eloquence. With these Pollocks, painting

180 Mark Rothko *Vessels of Magic* 1946
Watercolour on paper $38\frac{3}{4} \times 25\frac{3}{4}$ ins
Brooklyn Museum, New York

181 Jackson Pollock *Guardians of the Secret* 1943
Oil on canvas $48\frac{3}{4} \times 75$ ins
San Francisco Museum of Modern Art, Albert M. Bender Bequest

became what it had hoped to be but seldom became among the Surrealists: a rummaging for the authentic residue of the self. Pollock the master would emerge later.

* * * *

No promised liberation of the mind could compare to the real liberation of Europe in 1945. As the life of art and literature, publication, exhibitions, patronage, and debate began to stir after its long and brutally enforced hibernation, it was clear that Surrealism was a dead issue in Paris, hardly even a presence. The reason was quite simple; the Surrealists had run away, and the postwar French *avant-garde* (or what passed for it, in the realm of the visual arts) was largely dominated by those who had stayed and stuck out the years of the Occupation. It was now impossible for André Breton to claim the moral authority of Jean-Paul Sartre or Albert Camus. Giacometti, on the other hand, emerged as one of the exemplary figures of the postwar years in France, not on the basis of his Surrealist work (which he all but disowned) but because of his standing or walking figures, whose gaunt frames, knobby ravaged skin, and wiry solitude in the immensities of space generated about them by their own etiolation seemed to be the visual metaphor of Existentialist Man. There was a widespread feeling that almost any affirmation of substance, any act of the will grating against the rubble of values destroyed or uprooted by the war, could form the rudiments of a new consciousness – an imagery of survival which could not (for decency's sake, as it were) allude, even wistfully, to the ordered satisfactions of the traditional French landscape of pleasure. One started with the basic protein of art: a clotted lump of paint. From this grew a mode of abstract painting, the thick soupy décor known as *Tachisme* – the French answer to Abstract Expressionism. But it also nurtured the career of Jean Dubuffet (b. 1901), the last notable artist of the irrational in France.

For the first half of his life Dubuffet made his living as a wine merchant, and he did not return to painting until he was forty-one. When he did so, he took the Surrealist desire to seek inspiration in the art of children and madmen with extreme literalness, forming an immense collection of *l'art brut* ("raw art," as he named it) and annexing whole tracts of imagery for his own work that had once been thought, by everyone except the Surrealists, to lie outside the realm of cultural debate. Scratched and trowelled in their mudlike pigment, their outlines scrawled in a sophisticated parody of the hasty genital urgency of street graffiti, Dubuffet's cruel portraits of French intellectuals and writers in the 1940s go beyond caricature; they are pathetic monsters, and together they form an ironic riposte to projects like that of the nineteenth-century photographer Nadar, who wished to preserve an entire cultural Parnassus of the great men and women of his time with the camera. Dubuffet had an unerring instinct for farce. Picasso had painted bulls, but no advanced artist since the time of Rosa Bonheur had painted a cow, and when Dubuffet did so (plate 182), he came up with an image so absurd and tender that it seemed to set itself – not unsuccessfully – against the entire tradition of animal as heroic metaphor that had culminated, before World War II, in Picasso's Minotaurs and horses. His interest in the rudimentary, the unexamined, and the inchoate meant that conventional subjects

182 Jean Dubuffet *The Cow with the Subtile Nose,*
from the Cows, Grass, Foliage series 1954

Oil and enamel on canvas 35 × 45¾ ins
Collection, The Museum of Modern Art, New York,
Benjamin Scharps and David Scharps Fund

– a face or a landscape – were dissected into their most ignoble components; a man's features would become a pop-eyed scrawl, but his beard would be elaborated into a palace of squiggles, impressive and trivial at the same time, while a landscape was reduced to a thick crust of undifferentiated mucky paint, filling the whole canvas except for a token horizon-line.

Yet though such work was farcical, it was sinister as well. A hostile French critic implicitly got the point when he greeted one of Dubuffet's shows in the late forties with a headline derived from the Dubonnet ads on the Paris Métro: "*Ubu, du Bluff, Dubuffet*" – for the spiritual father of this work was the playwright Alfred Jarry, inventor of that ludicrous and brutal monster King Ubu, prototype of the Somozas and Idi Amins of our own day. The message that the world is a dungheap ruled by absurd cocks was Dubuffet's contribution to postwar realism, but the limitations of this view become apparent across the sheer size and volubility of his output. By now the crude little turnip-men and flattened homunculi have lost their power to shock. Those in Dubuffet's claque, like the French writer Georges Limbour, claim that he is still driven by "a dedication to total liberty from all rules and conventions of representation" to "reject all previous knowledge . . . to reinvent his art and his methods for every new production." In fact, his work for the last twenty years has been totally conventional; it only repeats his own mock-primitive prototypes, with minor variations to keep the market alert. The idea that innocence is a renewable resource is the peculiar delusion of Surrealist-influenced criticism as well as art. It is the last echo of a Romantic fantasy which has recurred in Paris since the eighteenth century, but has now lost all pretence to credibility. In recent years, Dubuffet's voluble praise of instinct, convulsion, and illiteracy as poetic principles has only served to assist what is, for the most part, a spate of glibly primitivized images. One is put in mind of a *chef du premier rang* being clever with horsemeat.

Though Surrealism as a movement died long before 1966, when Breton did, it left behind a rich deposit of ideas for artists in the sixties and seventies. Claes Oldenburg's hamburgers and light switches, inflated to Brobdingnagian scale, are obviously related to the Surrealist taste for hallucinatory objects; as Jasper Johns's plaster casts of human parts, arrayed above a target, partly derive from Surrealism's dream-boxes. The idea of the "gratuitous act," named by André Gide and taken up by Surrealism – an enigmatic and seemingly unmotivated, though physically intense, disruption of normal social behaviour – was transmuted into numerous kinds of art-gesture: self-laceration or irrational confrontations, solipsistic performances and, earlier in the 1960s, happenings, which were in effect Dada-Surrealist assemblages occurring in real time with strong overtones of absurdist theatre. In 1929, Breton had written that the simplest Surrealist act – the most gratuitous one imaginable – would be to go into the street, like an anarchist terrorist, shooting a revolver at random into the crowd. Almost fifty years later, the California artist Chris Burden fired a revolver at a jet airliner taking off over Los Angeles. Luckily he missed, and designated this action as art. Would it have been a different (or "better") work of art if he had killed someone? When Man Ray tied up a sewing machine in a blanket in 1920 and entitled it *The*

Enigma of Isidore Ducasse, he could hardly have imagined that within half a century the Bulgarian artist Christo would have extracted a career from more and more grandiose packaging and wrapping projects, every one derivative of that single gesture.

So it was, too, with a good deal of body-art. Since being and naming were widely felt to be more important than the traditional artistic procedures of making – an attitude which was, in itself, another Surrealist legacy, transmitted from the older forms of Parisian dandyism – it followed that the body could be stripped of its familiarity and turned, by manipulating its context and actions, into a strange gratuitous thing, another kind of object. This produced some moments of electrifying intensity, but it often begged the very question that a lot of Surrealist activity – trance writing, free association, and other exploratory games designed to bring up core samples from the unconscious – also skimped. Is the self automatically interesting in art? Or can it only claim our attention to the extent that it produces ordered and lucid structures, full of articulate meaning? For those who suffered the big hangover of the sixties, the disagreeable end of a culture that invested so much faith in hallucination on demand (everyone his own Rimbaud), there can be only one answer to that question. For a result of that Dionysiac breakout among the children of the bourgeoisie was a caricature of the Surrealist cult of the self. Few cultures in history have been so obsessively preoccupied with the merely personal as ours, and the last twenty years are littered with the debris of attempts to claim for the exposure of the self – unmediated except by its presence in the "art context" – that conceptual dignity which is the property of art. Every kind of petty documentation, psychic laundry list, and autistic gesture has been performed, taped, pinned up, filed, and photographed. Every sort of odd act, from lurking below a ramp in a gallery and masturbating to fantasies about the people walking overhead (Vito Acconci) to patterning one's body with sunburn (Dennis Oppenheim) has come into art on the coattails of the Surrealist *acte gratuit.* They are hardly imaginable as art without their Surrealist ancestry.

Then what remains of Surrealism? Certainly, less than artists once hoped. Surrealism never realized its declared intentions; the kingdom of imagination is no nearer than the kingdom of the saints. It left behind a testament of works of art, a perfume of revolt, but not a changed world. But then, the Surrealists were the last group of artists and poets naïve enough to believe that art could alter all the conformations of society. The world they opposed is still there: a painting by Man Ray recently sold for three-quarters of a million dollars. Nothing remains unacceptable, and thus Surrealism remains, in theory, a shining example of liberty on which, in principle, nobody acts.

THE VIEW FROM THE EDGE

One of the great themes of nineteenth-century Romantic painting was the interplay between the world and the spirit: the search for images of those states of mind, embodied in nature, that exist beyond or below our conscious control. On the one hand, there was the scale of the world, seen as a place sanctified by its own grandeur, itself a reflection of the grandeur of God – the panoply of crags, storms, plains, oceans, fire at sea and in the sky, moonlight, and the vitality of plants, which gave Caspar David Friedrich, Turner, Samuel Palmer, Albert Bierstadt, and Frederick Edwin Church their subjects. "The passions of men," William Wordsworth wrote, "are incorporated with the beautiful and permanent forms of nature." On the other hand, not all painters felt Wordsworth's visionary yet empirical peace with the natural world, and the further aspect of Romantic extremity was the desire to explore and record (and so, perhaps, assuage) the dissatisfactions of the self: its conflicts and fears, hungers and barely formulated spiritual yearnings. The search for these precarious images of man and nature – so different from the fruitful security of a Rubens or a Constable – was one of the projects that the nineteenth century bequeathed to modernism. Indeed, it was one of the chief links between the nineteenth century and our own. In a time when God died and artists were not feeling too well either, it took on a special intensity, producing, among other things, the various forms of Expressionism.

One of the places where this search went on was the countryside around Arles, in the South of France; the painter was Vincent van Gogh (1853–90). Few artists have been more driven by the need for self-expression than this irritable and impatient Dutchman. Even if none of his paintings had survived, the letters he wrote to his brother Theo – more than 750 of them have been preserved – would still be a masterpiece of confessional writing, the product of a mind literally obsessed with the need to explain itself, to reveal its passions and make its most intimate crises known. As a kind of failed monk, maddened by inequality and social wrongdoing, van Gogh was one of the holy scapegoats of nineteenth-century materialism; and the pitch of what he called his "terrible lucidity" was so high that anyone can still hear it – which is why *Sunflowers*, painted in 1888, remains much the most popular still-life in the

history of art, the botanical answer to the *Mona Lisa*.

Van Gogh's greatest triumphs as a painter were achieved in Provence, and he had gone there to provoke them. The light of the South, he hoped, would fill his paintings with a chromatic intensity strong enough to act on the soul and speak to the moral faculties. No painter could have been less concerned with Impressionist happiness than van Gogh, which was just as well, since none was less equipped to enjoy it. One cannot imagine the colourists of the next generation, men like Matisse or Derain, assigning the psychological and moral weight to colour that van Gogh did; not because they were frivolous, but because their seriousness took a less didactic and religious turn than the Dutchman's. Van Gogh was one of the comparatively few artists whose anguish really was inextricable from his talent, which is why it is still difficult to visualize, without a twinge of nausea, one of those writhing, heat-struck visions from Arles or Saint-Rémy hanging in a millionaire's drawing-room.

Most of van Gogh's motifs in Arles itself have disappeared. The Yellow House has vanished, his room is no more, and the night café – in whose billiard parlour he had tried, he said, by means of an acid green and a violent red "to express the terrible passions of humanity [and] the idea that the café is a place where one can ruin oneself, run mad, or commit a crime" – was torn down decades ago. But the look of the lunatic asylum at Saint-Rémy, and the landscape around it, is still remarkably unchanged. For a year and eight days, from May 1889 to May 1890, van Gogh was under treatment there. This "treatment" consisted of little more than cold baths, and what his illness was, nobody can say with confidence. The one fact that everyone knows about its symptoms was that, in the aftermath of a raging quarrel with his friend Gauguin, he cut off his earlobe and presented it, as a mock eucharist, to a prostitute in Arles. We say he suffered from manic depression, which is a way of skirting issues of the mind that we still hardly comprehend. It did not prevent him from seeing clearly, or recording what he saw; the Saint-Rémy madhouse still looks exactly like his paintings, down to the last detail of the rough stone benches, the ochre stucco of its garden façade, and even the irises blooming in its roughly tended flowerbeds. "There are people who love nature even though they are cracked and ill," he wrote to Theo van Gogh; "those are the painters." He had fits of despair and hallucination during which he could not work, and in between them, long clear months in which he could and did, punctuated by moments of extreme visionary ecstasy.

In these moments, recorded in such paintings as *The Starry Night*, 1889 (plate 183), everything van Gogh saw was swept up in a current of energy. Sight is translated into a thick, emphatic plasma of paint, eddying along linear paths defined by the jabbing motion of his brush-strokes as though nature were opening its veins. The curling tide of stars in the middle of the sky may have been unconsciously influenced by Hokusai's *Great Wave* – van Gogh was an avid student of Japanese prints – but its rushing pressure has no parallel in Oriental art. The moon comes out of eclipse, the stars blaze and heave, and the cypresses move with them, translating the rhythms of the sky into the black writhings of their flamelike silhouette. They commit the turbulence of heaven to the earth, completing a circuit of energy throughout all nature. More alive

than any painted tree had ever been (and more so than any real cypress looks), these trees of the South, traditionally associated with death and cemeteries, had an emblematic value for van Gogh. "The cypresses are always occupying my thoughts – it astonishes me that they have never been done as I see them. The cypress is as beautiful in line and proportion as an Egyptian obelisk – a splash of *black* in a sunny landscape." Even the church spire partakes of this general heightening. There is no church near Saint-Rémy with a spire that looks remotely like the tall Gothic spike in *Starry Night*. It seems to be a northern fantasy, not a Provençal fact.

On the other hand, one can walk in the olive groves outside the asylum walls and measure the way he changed them, resolving the form of the dry grasses and the flickering blue shadows on them into sprays of paint-strokes, and turning the olive trunks themselves into bodies grown cankered and arthritic with bearing, like the knobbly Dutch proletarian bodies he had painted at Neunen. Again there is the sense of a continuous field of energy of which nature is a manifestation; it pours through the light and rises from the ground, solidifying in the trees. Because olives grow so slowly, the broad relationships of tree and field, foreground and background that van Gogh grasped in the landscape near the asylum have changed very little in the last century, so that many of the motifs he painted within five hundred yards of the gate are still quite recognizable. One can still pick, with reasonable accuracy, the spot from which he took his view over the grove towards the convulsed grey horizon of Les Alpilles, (plate 184). But there was at least one motif inside that radius which any other northern painter coming to Provence would have seized on with gratitude: one can imagine what Turner might have made of the Roman ruins of Glanum, just across the road from the asylum. Van Gogh never painted them. Only Christian ceremonial architecture interested him – that, or the humblest cottages and cafés – and presumably the relics of colonizing Rome were filled with authoritarian suggestions that he would not admit to his own field of symbols.

Art influences nature, and van Gogh's sense of an immanent power behind the natural world was so intense that, once one has seen his Saint-Rémy paintings, one has no choice but to see the real places in terms of them – without necessarily seeing what he saw. In this way the eye deduces what he wanted to typify, finding those aspects of nature that he could isolate as symbols. One of these was a complicated though ad hoc sense of rhymes within natural forms: similarities between the near and the far, which suggested a continuous thumbprint of creation, a pervasive Identity marking the world. Faced with the strange contortions of limestone that make up the low mountain range between Saint-Rémy and Les Baux, another painter might have found them formless and unpaintable; one can imagine them appealing to Mathis Grünewald, or to the Leonardo of the Deluge drawings, but never to Poussin or Corot. Van Gogh, however, found in them a perfect rhyme between their fierce plasticity when seen from afar, the tendon-like clenching and uncoiling of the boulders against the sky, and the crowding of details within the larger form: the channels, veins, and scooped hollows of the limestone and how these resemble the grain of old olive-roots, silvery-grey as well; how the macroscopic finds its echo in the microscopic view; and how

183 Vincent van Gogh *The Starry Night* 1889

Oil on canvas 29 × 36¼ ins: Collection, The Museum of Modern Art,
New York, Acquired through the Lillie P. Bliss Bequest

184 Vincent van Gogh *Les Alpilles* 1890

Oil on canvas 23¼ × 28¼ ins: Kröller-Müller Museum, Otterlo

both together accord with the twisting linework of his brush.

One of van Gogh's favourite sights was over the Plaine de la Crau, the alluvial basin that stretches away below Les Baux. Its flat fields, portioned by hedgerows and lanes, offered him a strenuous exercise in notation; their monotony demanded close looking. The plain was, he said, "as infinite as the sea" – only more interesting, because people lived on it. If he had used a routinely "expressive" way of drawing it, with all detail subjugated to generalized scribbles and blots, van Gogh's ink studies of the Plaine de la Crau would have been featureless. Instead, like one of the Japanese *sumi-e* painters he admired, he was able to work out a different kind of mark for every natural feature of the landscape, near and far, thus avoiding the narcissistic thinning out of the world that goes with shallow Expressionism. Few drawings in the history of landscape have the richness of surface that van Gogh gave to his Provençal sketches (plate 185). The life of the landscape seems to be bursting through the paper in a myriad marks, the brown ink becoming almost as eloquent as the colour in his paintings.

However concentrated they became – and some of his self-portraits, like the gaunt face that stares from its background of ice-blue whorls in the Louvre, 1889 (plate 187), bring the act of self-scrutiny to a pitch no painter since Rembrandt in his old age had reached – van Gogh's paintings were not the work of a madman; they were done by an ecstatic who was also a great formal artist. Today the doctors would give him lithium and tranquillizers, and we would probably not have the paintings: had the obsessions been banished, the exorcising power of the art could well have leaked away. Van Gogh confronted the world with an insecure joy. Nature was to him both exquisite and terrible. It consoled him, but it was his judge. It was the fingerprint of God, but the finger was always pointed at him.

Sometimes the gaze of God was, too: the disc of the sun, huge and searching, the emblem of merciless Apollo. The colour on which his search for emotional truth converged was yellow – an extraordinarily difficult colour to handle because it has few levels of value. "A sun, a light, which for want of a better word I must call pale sulphur-yellow, pale lemon, gold. How beautiful yellow is!" What van Gogh called "the gravity of great sunlight effects" filled his work and freed him to try odd emblematic compositions such as the figure of *The Sower*, 1888, a blackened silhouette, shrivelled by the chromatic pressure of the sun-disc behind it, letting fall the yellow streaks of grain (like flakes of sunlight) on the earth (plate 186). Such paintings were filled with a symbolism that one can only call religious, although it has nothing to do with orthodox Christian iconography. The dominating presence of the sun conveys the idea that life is lived under the influence of an immense exterior will, and that work like sowing and reaping is not simply work but an allegory of life and death. Explaining the companion piece to *The Sower*, a man with a sickle moving through a writhing field of pollen-coloured paint, van Gogh wrote to Theo that "I saw in this reaper – a vague figure struggling in great heat to finish his task – I saw then in it the image of death, in the sense that humanity would be the wheat one reaps; so it is, if you like, the opposite of the sower I had tried before. I find it strange that I saw like this through the iron bars of a cell."

185 Vincent van Gogh
*Landscape Near
Montmajour* 1888

Pen, reed pen and black
chalk $19\frac{1}{4} \times 24$ ins: British
Museum, London

187 Vincent van Gogh *Self-Portrait* 1889
Oil on canvas $25\frac{1}{2} \times 21\frac{1}{2}$ ins: Jeu de Paume, Paris

186 Vincent van Gogh *The Sower* 1888
Oil on canvas $12\frac{1}{2} \times 15\frac{1}{4}$ ins
Stedelijk Museum, Amsterdam

So it is wrong to suppose that van Gogh's colour – rich and exquisitely lyrical though it is – was meant simply as an expression of pleasure. Moral purpose is never distant, and rarely absent, from his Provençal landscapes; they are utterances of the religious heart, and their central premise that nature can be seen to reflect, simultaneously, the will of its Creator and the passions of its observers is one of the most striking examples of the "pathetic fallacy" in painting. It was also of central importance to later Expressionism. Van Gogh was only thirty-seven when he shot himself, but in the four years 1886 to 1890, he had changed the history of art. The freedom of modernist colour, the way emotion can be worked on by purely optical means, was one of his legacies – as it was Gauguin's, too. But van Gogh had gone further than Gauguin; he had opened the modernist syntax of colour wider, to admit pity and terror as well as formal research and pleasure. He had been able to locate more cathartic emotion in a vase of sunflowers than Gauguin, with his more refined Symbolist sense of allegory, had been able to inject into a dozen figures. Van Gogh, in short, was the hinge on which nineteenth-century Romanticism finally swung into twentieth-century Expressionism; and as he lay dying in 1890 at Auvers, many miles further to the north another artist ten years younger was preparing to take this process a step further. In van Gogh's work, the self is scratching to be let out. But in Edvard Munch's, the self is out; and it fills the void in Romantic nature left by the withdrawal of God.

Twenty-five years ago, there was no general agreement about Munch's stature. He seemed too local, too narrowly "northern" a painter, for his work to be set against the art historical values that centre on Paris; and besides, virtually all his major paintings had remained in his native city of Oslo, not a stop on the art-lover's normal itinerary. He therefore seemed more provincial after his death than he was in life, and many people who should have known better insisted on thinking of him as a gaunt psychotic troll, whose unceasing self-inspection and almost unrelieved gloom made little sense below the Arctic Circle. Today, Munch (1863–1944) seems as universal a figure as Ibsen or Strindberg, because he was the first modern painter to make a continuous study of the idea that personality is created by conflict.

Long as Munch's working life was, most of his best paintings were done within a few years of 1895, the year in which Freud published his *Studies on Hysteria* and thus founded the art, or pseudo-science, of psychotherapy. Freud and Munch had never heard of one another, but they shared one great insight: that the self is a battleground where the irresistible force of desire meets the immovable object of social constraint. Each person's fate can then be seen as at least a possible example to others, because it contains the forces common to all fettered, lusting social animals. As Freud was the diagnostician, so Munch was the tragic poet of this process, and an immensely voluble one. To describe it, he devised an elaborate code of symbols. Nothing that did not speak of strong feeling found a place in this code. The characters in his future painting, Munch wrote in 1889 (he was then twenty-six), "should be living people who breathe, feel, suffer and love. People shall understand the holy quality about them and bare their heads before them as if in church." The ambition to produce a drama

of high, exemplary emotion, whose actors were more icons than individuals, never left him, and it helps account for the consistency of his pessimism. This began in childhood – and Munch's was ghastly. His father was a ranting religious bigot, his mother a submissive wreck; his beloved sister Sophie died of tuberculosis, and, as he put it later, "Disease and insanity were the black angels on guard at my cradle. In my childhood I felt always that I was treated in an unjust way, without a mother, sick, and with threatened punishment in Hell hanging over my head."

Thus Munch's main image of family life was the sickroom (plate 188). One can almost smell the carbolic and sputum in his image of the Munch family gathered around Sophie's deathbed: the masklike faces, the averted heads, the immobile figures and small twisting hands of anxious women, all tilted upward towards the eye like actors on a sloping stage along that coppery plane of the floor, contribute to a unified image of desolation – its mutuality emphasized by the shared lumpishness of the bodies. In other variations on this theme – a series of drawings, lithographs, and pastels entitled *By the Deathbed* – Munch daringly presented the scene as if from the point of view of the dying girl, so that the wall, the shadows on it, and the frieze-like group of mourning relatives waver as though in delirium. Here, illness is used as a metaphor of visionary insight. Munch's idea of a febrile world was like T. S. Eliot's:

> The whole earth is our hospital
> Endowed by the ruined millionaire,
> Wherein, if we do well, we shall
> Die of the absolute parental care
> That will not leave us, but prevents us everywhere.

One might expect such a man's relationships with women to be neurotic, and they were. Munch was all but unable to think of women as social beings. He saw them as elemental forces, either vampires or *Ur*-mothers, implacable fertility idols. Munch believed that sex was, in all senses but that of procreation, inherently destructive – a notion borne out by the fate of his two surviving sisters, one of whom went mad and the other permanently frigid as the result of unhappy love affairs in the early 1890s. Sexual awakening is ominous and hateful: such was the message of Munch's *Puberty*, 1894–5 (plate 189), with its gooseflesh girl perched on the bed, covering her sex in a gesture of awkward fright while her own shadow rears on the wall behind her like a swollen phallus. But if one was not rejected by a timid virgin, one was bound to be castrated by a *femme fatale*. Munch imagined love as the losing struggle of the male against the female mantis, and the circle of Norwegian writers and painters to which he belonged in the 1890s thought the same. The Norwegian Symbolists shared, to an excruciating degree, the general literary obsession of the 1890s with Woman (always capitalized, always fetishized) as a *Belle Dame Sans Merci*, bringer of anguish and emotional ruin. The same tensions caused by the prospective emancipation of women that lent Ibsen's and Strindberg's dramas so much of their anxiety were also present in Munch, but he was able to express them with an even more cathartic intensity. As a result, his women oscillated between fantasies of rape (as in *Puberty*) and visions of

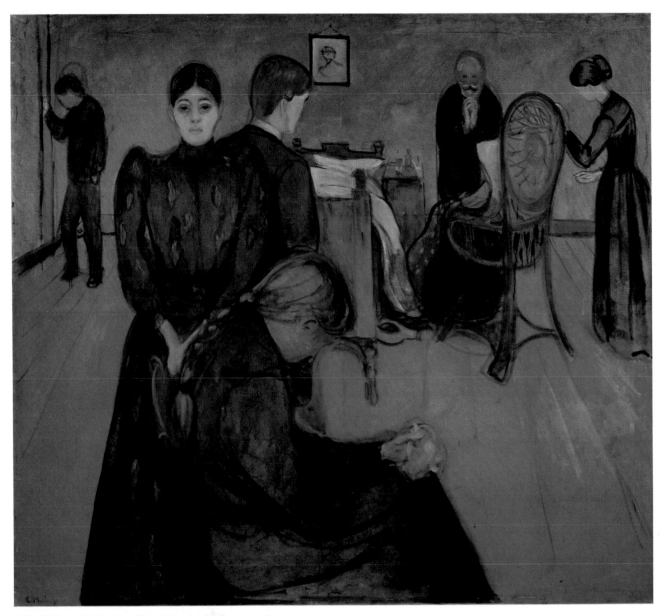

188 Edvard Munch *Death in the Sickroom* 1895
Oil on canvas 59 × 66 ins: Nasjonalgalleriet, Oslo

189 Edvard Munch *Puberty* 1894–5
Oil on canvas $59\frac{1}{2} \times 43\frac{1}{4}$ ins
Nasjonalgalleriet, Oslo

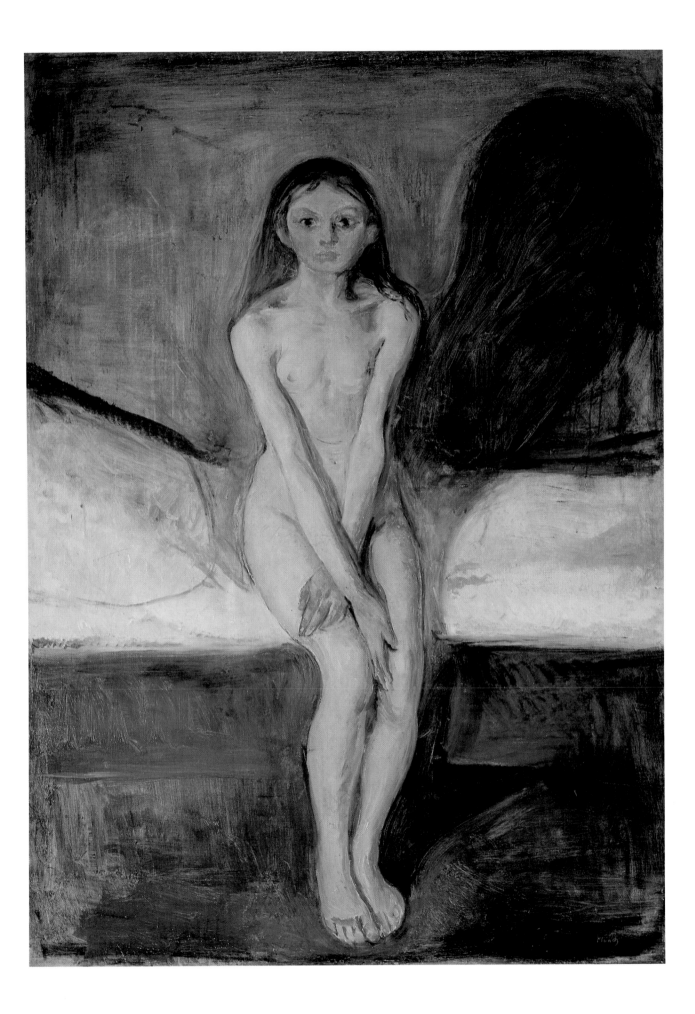

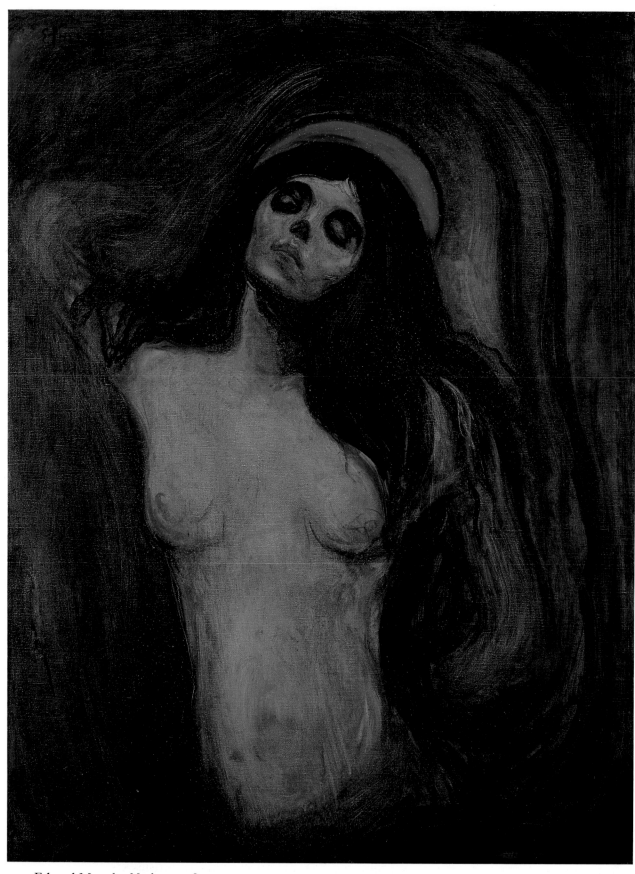

190 Edvard Munch *Madonna* 1894–5
Oil on canvas $53\frac{1}{2} \times 43\frac{1}{4}$ ins: Munch Museet, Oslo

woman as devourer, like the sinuous Lilith who rises before us in *Madonna*, 1894–5 (plate 190). To make the point of the image quite clear, Munch framed it with a hand-painted border of spermatozoa (which has since been lost). "Your face embodies all the world's beauty," he wrote – sounding rather like Walter Pater's celebrated passage on that other Fatal Woman, the *Mona Lisa* – in a text meant to accompany this painting. "Your lips, crimson red like the coming fruit, glide apart as in pain. The smile of a corpse. Now life and death join hands. The chain is joined that ties the thousands of past generations to the thousands of generations to come."

As befitted an art of extremes, Munch's craving for opposites (Virgin/Lilith, Foetus/Corpse, and so on) pervaded his sense of nature. He had a summer studio at Asgardstrand, a small fishing village on a fjord outside Oslo. Before van Gogh, cypresses were just trees; and before Munch, Asgardstrand was just a stony provincial beach, a grey horizon, a pier, rocks, and trees coming down to the water. But he made it into one of the emblematic landscapes of the modern mind, and it came to stand for alienation, loss, and yearning. The figures of men and women, gazing out to sea in a trance of solipsism, are perhaps the last descendants of the melancholy figure-in-a-landscape of Romantic art, but the landscape – far from being the reason for the figure's presence – becomes a background to the oppressed state of mind that Munch described in his journals:

My whole life has been spent walking by the side of a bottomless chasm, jumping from stone to stone. Sometimes I try to leave my narrow path and join the swirling mainstream of life, but I always find myself drawn inexorably back towards the chasm's edge, and there I shall walk until the day I finally fall into the abyss. For as long as I can remember I have suffered from a deep feeling of anxiety which I have tried to express in my art. Without anxiety and illness I should have been like a ship without a rudder.

Ne cherchez plus mon coeur, les bêtes l'ont mangé. Some of Munch's most affecting paintings are those in which he tried, with pessimistic tenderness, to close the gap between the Self and the Other. Thus in *The Voice*, 1893 (plate 191), the figure of the girl is caught between repression and the desire to speak. Her rigid stance is amplified by the strict verticals of the Asgardstrand trees: she leans forward as though timidly offering herself, while her arms are stiffly pinioned behind her in a gesture of inhibition; and the motive force of desire is represented (with unusual subtlety, by Munch's standards) in the phallic shaft of light reflected on the water from the low Arctic sun.

Munch embodied the nature of Expressionism, and lived it out before it was named. It may be summarized thus: insecurity and unease become so strong that the artist has no choice but to recoil upon himself, treating that Self as the one secure point in an otherwise hostile universe. But the narcissism that this breeds – "I love in the woman myself, my own ego raised to its greatest intensity," wrote his friend Przybyszewski – guarantees that reality must seem distant and perhaps even inauthentic, so that correspondingly exaggerated leaps of emotion must be made to pass from the Self to the Other. In solitude, the wounded artist dreams of becoming a moral example. "If only one could be the body through which today's thoughts and

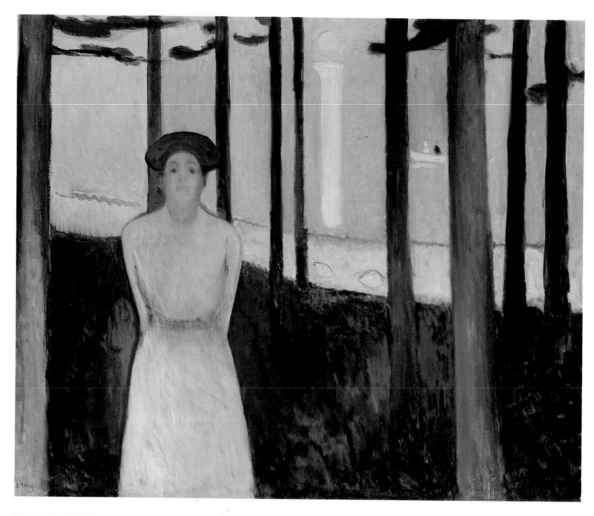

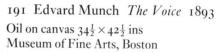
191 Edvard Munch *The Voice* 1893
Oil on canvas $34\frac{1}{2} \times 42\frac{1}{2}$ ins
Museum of Fine Arts, Boston

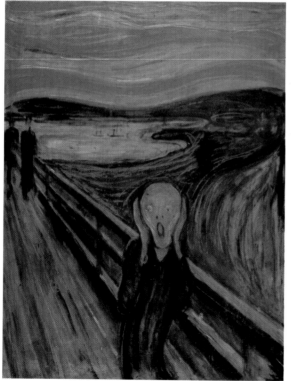

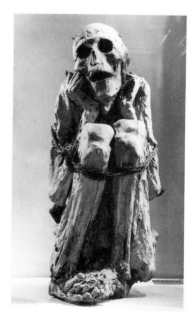

192 Edvard Munch *The Scream* 1893

Oil on cardboard 36×29 ins
Nasjonalgalleriet, Oslo

193 *Inca Mummy from Peru*

Musée de l'Homme, Paris

feelings flow," Munch wrote to a friend. "A feeling of solidarity with one's generation, but yet standing apart. To succumb as a person, yet survive an an individual entity, that is the ideal. . . . Salvation shall come from Symbolism. By that I mean an art where the artist submits reality to his rule, which places mood and thought above everything and only uses reality as a symbol."

There are no more vivid examples of this ambition at work than Munch's city scenes of the 1890s. True, Oslo can be a grim place, as anyone who has spent a rainy week there can attest; but the spectral and masklike misery that Munch conferred on the bourgeois crowd drifting along Karl Johanns Gate goes beyond ordinary social comment. However, this feeling was confined neither to Munch nor to Oslo. Since the mid-nineteenth century, as the capitals of Europe grew, the image of the metropolis as devourer of souls, the place of lonely crowds and artificial distractions, had been seeping into art and poetry. By 1900, it would be the main backdrop of *avant-garde* culture.

From the crowded boulevards and cafés of Paris, a peculiarly ironic and detached view of life was emerging, based on the sense of dandyist display – "seeming" rather than "being" – disposable and rapidly changing style, fleeting social encounters, impersonal transaction. It found its painter in Henri de Toulouse-Lautrec (1864–1901), the dwarfish cripple who had migrated from the aristocracy to become the recorder of Montmartre cabaret life. As Charles Stuckey has pointed out, Lautrec's extreme self-consciousness enabled him to create an art of watchers watching – "women looking at men who were turned to look at other women, themselves oblivious to being watched, hypnotized by someone else . . . he diagrams the routines of curiosity and anticipation he observed at public places." The special arena of mutual display was the Moulin Rouge. "Heads pass by in the crowd," a young Belgian painter wrote of it in 1893. "Oh, heads green, red, yellow, orange, violet. Vice up for auction. One could put on the door front, People, abandon all modesty here." Lautrec's masterpiece, *At the Moulin Rouge*, 1892–5 (plate 194), has been cited as the painted parallel to this, without the moralizing. The *boulevardier* gaze composes all faces as masks, formalized signs for themselves; Lautrec condensed this in the face of May Milton, lit from below in jarring contrasts of red, acid green, and whitish gaslight yellow, which rears up at the slipping right edge of the painting. Somewhat earlier, in 1888, the Belgian artist James Ensor had depicted the crowd greeting *The Entry of Christ into Brussels* as a mass of bobbing, grimacing, and stupefied heads, using it to convey the idea that society – or, to be exact, the proletariat, which Ensor hated with a paranoid passion – was not merely unreal but a sort of daemonic carnival, a collective of threatening masks.

Clearly, then, Munch's preoccupation with masks and lonely crowds was part of a general current of European Symbolism in the last years of the nineteenth century; but that did not solve the problem of how to give it painted form. Where did one go for the language of extreme expression, for the human shapes of loss and fright? Oddly enough, one of Munch's solutions came from archaeology. At the time he was in France, the lost cultures of South America were beginning to acquire a certain popular

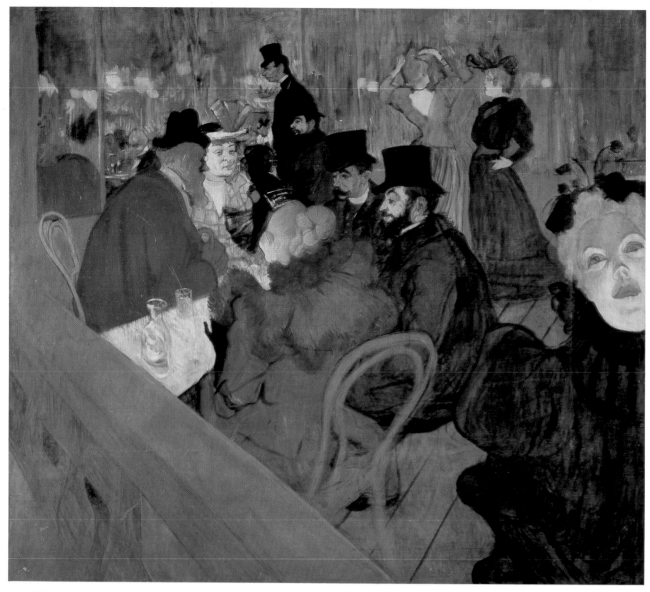

194 Henri de Toulouse-Lautrec *At the Moulin Rouge* 1892–5
Oil on canvas $48\frac{1}{2} \times 55\frac{1}{2}$ ins: Art Institute of Chicago

glamour. Indians, gold, human sacrifices, lost cities in the Andes, and cocaine (widely available in tincture, and most popular among languishing housewives under the brand name of Dr. Maraini's Inca Wine) – such were the curiosities. One of the minor sensations of the Parisian Great Exposition of 1889 was an Inca mummy (plate 193), dug up in Peru. It had been buried in a jar in the foetal position, which, whatever it may have meant to the Incas, was for a modern European one of the archetypal emblems of fright and the desire for security. It had considerable resonance among artists. Paul Gauguin was fascinated by it, and incorporated it into several of his compositions as an image of death or cronelike tribal wisdom. Munch appropriated it, too; and it is to this withered homunculus, once a man, that we owe the most famous image of neurosis in Western art, *The Scream*, 1893 (plate 192).

Who is, or was, the figure in *The Scream*? Apparently Munch himself, if one can take his account of its genesis at face value. He was strolling on a road with two friends:

I was tired and ill – I stood looking out across the fjord – the sun was setting – the clouds were coloured red – like blood – I felt as though a scream went through nature – I thought I heard a scream – I painted this picture – painted the clouds like real blood. The colours were screaming.

The figure looks nothing like Munch: a ghost with a squalling mouth, it curves with the rhythm of the sunset clouds and the viscous-looking pool of the fjord. *Can only have been painted by a madman*, Munch scribbled in the upper part of the picture, and one senses the separation between normal and neurotic experience in the two ordinary figures, walking on, for whom the sunset holds no such terrors; they cannot hear the Scream. The perspective of the railing, rushing away, with the vertiginous gulf of landscape below it, combines with the threatening sky to create one of the most baleful environments for a figure in all art. The otherness of nature has reduced man to a cipher, a worm, "an O without a figure."

The theme of the city as a condenser of anxiety also ran through German and Austrian Expressionism in the years between 1900 and 1918, and Munch's influence furnished the artists with ways of resolving it. Ernst Ludwig Kirchner (1880–1938), a former architecture student in Dresden, transposed Munch's social pessimism into the colour of van Gogh and the Fauve Matisse. Kirchner was the leader and most gifted member of a group of artists, all under thirty, which took the name of the *Künstler-Gruppe Brücke* or "Artists' Group of the Bridge," meaning a bridge to the future. Across it, one of them wrote, "all the revolutionary and surging elements" in German art would find a path. When it was formed in Dresden in 1905, it consisted of the painters Fritz Bleyl, Erich Heckel, and Karl Schmidt-Rottluff, as well as Kirchner himself. *Die Brücke* lasted nine years, dissolving at the outbreak of World War I. It was a small youth movement, part of the wider self-assertion of young men (and, to a lesser degree, young women) whose social context lay in the *Wandervogel* movement, in the enhanced nervousness of big-city culture, and in a general reaction against the moral stuffiness and repressive politics of the late Hapsburg dynasty. "As youth, we carry the future," Kirchner's manifesto of 1905 read, "and we want to create for our-

selves freedom of life and movement against the long-entrenched forces of seniority. *Everyone who reveals his creative drives with authenticity and directness belongs to us.*"

They preferred the Gothic to the classical, and in particular the German Gothic, with its dramatic, pointed, discontinuous shapes and its emphasis on mystical directness and strong feeling. They wanted direct communication by jolts of colour and shape – shaking the onlooker, rather than appealing to his sense of cultural continuity. Because Kirchner and his fellow painters identified personal truth with candour of expression, the name "Expressionist" gradually adhered to their work. Their main stylistic source, apart from Munch, was the work of the Fauves, and in particular Matisse, some of whose work Kirchner saw in Berlin in the winter of 1908–9. But in spirit, Kirchner's work was a long way from the composed, Cartesian steadiness of Matisse's vision of pleasure. In particular, Kirchner wanted to liberate himself, and German *avant-garde* art in general, from the colonizing weight of French painting. "German art has to fly with its own wings," he wrote to another Expressionist, Emil Nolde, in 1912. "We have the duty to separate ourselves from the French – it is time for an *independent* German art." Kirchner was not interested in French *mesure*, but in its exact opposite – a nervous disequilibrium of the senses, which owed something to the liberty of colour in the 1905 Matisses but pushed it to a jittery extreme.

Kirchner was a natural bohemian, and most of his subjects came from two sides of life which lay beyond the pale of "respectable" taste. One was the life of the studio, set down not only in the paintings but in his own photographs from Berlin – the young people sprawled under crooked, hand-painted hangings, the blurred white bodies (and one black one, belonging to Kirchner's friend and model Sam) posing and dancing naked amid the clutter of mock-African sculpture, a rusty bath-jug, sagging bookshelves, divans, and fringed tables. This kind of life, defiantly sexual and open to any kind of stimulus, was a chain of gestures of revolt, though with no political content. Kirchner's circle, like Expressionism in general, wanted to open up the relations between life and conscience, using the self as an experimental subject – and Kirchner himself paid heavily for it, suffering a catastrophic breakdown from morphine addiction after 1917. In his paintings of studio life, the colours of the apartment-cave are refined and heightened into shrill dissonances: purple and yellow, green and firebox red, the young dancers' and models' bodies sharply hatched with complementary shadow and radiating a lean, matter-of-fact sexuality.

The other area of his imagery was the street. "The modern light of cities, the movement in the streets – there are my stimuli," he wrote. "Observing movement excites my pulse of life, the source of creation. A moving body shows its different partial aspects, which then fuse in a complete form: the *internal* image." This rapidity and jerkiness fills the scenes of Berlin street life that Kirchner painted up to the outbreak of the war. He got his first ideas from Munch, and an early streetscape from 1909 is virtually a parody of the Norwegian's depressing views of the crowds on Karl Johanns Gate. However, by 1911 Kirchner had refined his streetscapes into their characteristically spiky, terse drawing and shrill colour. The *cocottes* who parade along

195 Ernst Ludwig Kirchner *The Red Cocotte* 1914–25
Oil on canvas $47\frac{1}{4} \times 35\frac{1}{2}$ ins: Staatsgalerie, Stuttgart

this painted "ocean of stone," as Kirchner called the Berlin streets, bear some affinity with Munch's vampires, but they are raised to a pitch of style unknown in Norway (plate 195). Thin, mincing, robed in a flurry of brush-strokes as sharp as palm-fronds in a wintergarden, they are objects of desire and envy for the men who promenade by them; but the male figures in Kirchner's street scenes usually form a kind of backdrop, a chorus line for the star women. (The choreography of cabarets, one suspects, did much to form Kirchner's arrangements.) These uniquely urban harpies, all style and cocaine nerves, take the image of the woman-as-castrator a step further from Munch, towards pure glamour.

In prewar Vienna, the leading Expressionist was the painter and occasional playwright Oskar Kokoschka (1886–1980). He had grown up in the early 1900s as a student under the influence of *Jugendstil* decorative art, particularly the imbricated, beetle-wing surfaces of Gustav Klimt's paintings. But in 1906 Kokoschka saw the work of van Gogh for the first time, and was struck by the searching, declarative intensity of his portraits – particularly the self-portraits. On an introspective young man of fragile emotional balance, a contemporary of Freud and Schönberg living in the morbidly self-regarding atmosphere of Viennese modernism, such paintings were apt to have a traumatic effect, and they did. Their result was Kokoschka's series of "Black Portraits." In these, he created a gallery of intellectuals, artists, and patrons so neurotically particularized, so worked-over and dissected, as to surpass most previous attempts at "psychological" portraiture since van Gogh. In a work like *Portrait of Adolf Loos*, 1909 (plate 196), the artist becomes the sitter's accomplice – not by giving the architect's face a socially useful mask, but by admitting to a shared neurosis. The twisting, insinuating brush-strokes suggest a complicity between Loos and Kokoschka, an intimate mutual outsidership. At other times, as in his portraits of Lotte Franzos or the Duchesse de Montesquieu, Kokoschka's paint surface took on a transparent, dithering quality, as though the character caught by it was too sensitive to be exposed to clear inspection.

Kokoschka's affair with the formidable Alma Mahler, widow of the composer Gustav Mahler and future wife of Walter Gropius and Franz Werfel, inspired him to paint *The Tempest* or *The Bride of the Wind*, 1914 (plate 197). "Inspired" is hardly an overstatement, since Kokoschka would never bring off a painting of this size and intensity again, and even though it skirts absurdity there is an almost daemonic edge to it. Lying in a cockleshell of a boat, whose timbers appear to have sprung, Kokoschka and his beloved are whirled along like Dante's lovers in the tempest. They are not carried on the sea, but in space, a turbulent vista of alpine crags and scudding mist; Kokoschka is awake with apprehension, his lover sleeps on his shoulder. Their different states of consciousness are mirrored in the way their flesh is painted – Kokoschka's riven, as though by anxiety, into strips and leaflike muscular forms of bluish pink, and Alma Mahler's more composed and unified. The mood of the painting is fixed by its livid and broken tonal structure, and amplified by the cold, jostling colours, El Greco blues and silvers relieved, here and there, by a flicker of red and green. While not highly erotic (it is more likely to give a shudder of cold than

196 Oskar Kokoschka *Portrait of Adolf Loos* 1909
Oil on canvas $29 \times 36\frac{1}{2}$ ins: Nationalgalerie, Berlin

197 Oskar Kokoschka *The Tempest* or *The Bride of the Wind* 1914
Oil on canvas $71\frac{1}{4} \times 87$ ins: Kunstmuseum, Basle (photo Hinz)

sexual *frisson*), *The Bride of the Wind* remains the last word on the subject of Expressionist love – devouring, narcissistic, and pitched to an abandoned *fortissimo*.

Perhaps as a result of his severe nervous breakdown after the war (like Kirchner, he was one of its living victims), Kokoschka did not keep working at this level. The northern Expressionist whose work, in terms of sheer intensity, remained most visible in the art of the 1920s was Max Beckmann (1884–1950). Beckmann, too, had come out of the war in a state of traumatic shock; his service as a medical corpsman in the trenches of Flanders nearly drove him mad, and he was invalided out of the army in 1915 suffering from fits of hallucination and unbearable depression – "This infinite space," he wrote, "whose foreground has always got to be filled with some rubbish or other, so as to disguise its dreadful depths.... This sense of being abandoned forever, in eternity. This loneliness." To relocate himself in the world and fight through his *horror vacui*, Beckmann – in some ways a far tougher artist than most of his German contemporaries – decided upon the unlikely course of becoming a history-painter. But since it was impossible to perform this task under the auspices of a social agreement about history, politics, and morality, as nineteenth-century artists had been able to do, Beckmann resolved to be a recorder of unofficial history – the psycho-history, so to speak, of a Europe gone mad with cruelty, ideological murder, and deprivation. He would be the Courbet of the cannibals.

"We must participate in the great misery to come," Beckmann wrote in 1920. "We have to lay our hearts and nerves bare to the deceived cries of people who have been lied to ... the sole justification for our existence as artists, superfluous and egotistic though we are, is to confront people with the image of their destiny." The proper place to be was the city; the strategy, to surpass Expressionism with a steadfast, "objective" gaze at events, one which replaced Expressionist self-pity by a larger compassion for the victims of history. Invoking the names of van Gogh, Brueghel, Cézanne, and Mathis Grünewald, he praised "the art of space and depth" as the only one that could bear the weight of social meanings: "I know I will never abandon full volumes. No arabesques, no calligraphy, but fullness, the *sculptural*." Given a less packed and dense feeling of space and volume, a painting like *The Night*, 1918–19 (plate 198), could not possibly speak with the same intensity. Beckmann locked the violence of his images into slow-moving or completely static structures, as here, of beams, tabletops, torsos, limbs: stiff elongations of form bursting out of the picture plane, like the leg of the hanged man on the left, or exaggerated connections of background with foreground space that give his scenes a crowded, impacted look, so that the spatial compression of German Gothic altarpieces – along with their bumpkin sadism – becomes the framework for modern Crucifixions and Calvaries. *The Night* is about the violence of the abortive Left risings in Germany, a point rammed home by the intentional likeness of the man on the right, in peaked cap and dustcoat, to Lenin. Much of its intensity depends on the ordinariness of its actors, like the man with a pipe, busily breaking the arm of the hanged victim. It is a brilliant synthesis of traditional signs for suffering (including the general Gothicism of the figures, sculptural and "carved," as though made of painted wood) with a sense of the

198 Max Beckmann *The Night* 1918–19
Oil on canvas $52\frac{3}{4} \times 60\frac{1}{2}$ ins: Kunstsammlung
Nordrhein-Westfalen, Düsseldorf

threatening power of the artefacts of modernity. The black gape of the gramophone horn is almost as horrible as the mouth in Munch's *Scream*.

Beckmann was an extreme case of the separation of "northern" (mainly German) from "southern" (mainly French) sensibilities between the wars. Nothing in his work was congenial to the taste of Paris or its cultural empire: his art was dismissed as hysterical, "literary," clogged with the wrong feelings and starved of the right ones. And even today, any theory of art history that addresses itself exclusively to formal properties at the expense of symbolic and moral meanings has difficulty not only with Beckmann but with Expressionism in general – unless, as we shall presently see, the Expressionism in question is abstract and (preferably) American. Expressionism, though so largely inspired by van Gogh, never took root in France. Its ethos produced only one painter of real distinction there: an ulcerated and self-doubting Jew from a Lithuanian *shtetl*, Chaim Soutine (1894–1943).

Soutine was an unrelentingly oral painter. In canvas after canvas he seemed to be trying to appropriate his subjects physically, to steal protein from them like an aphid sucking at a leaf. What the sense of moral outrage was to Beckmann, hunger was to Soutine: sometimes real hunger, for he was wretchedly poor most of his life, but always an ocular ravening to turn the substance of the world into thick, squidgy, excited paint. Few painters have ever set such a value on the unrestrained expression of feeling, while remaining so indifferent to the society about them. Soutine never produced a "socially committed" painting, perhaps because he was, in any case, a wandering cosmopolitan with no sense of place in any community. In their violence of expression, some Soutines might almost seem to be caricatures of his chosen masters – Rembrandt, El Greco, or Courbet. His sombre paintings of ox-carcasses, hung up in his studio (and painted from life, as they rotted and stank) are obvious acts of piety towards Rembrandt (plate 199); but even when the invasion of the motif approaches a form of convulsive parody, it is still a homage. Soutine had the paradoxical ambition to rival the art of the museums on one hand, while, with the other, opening the sluices of the Self as far as they could be raised. Though he claimed to dislike van Gogh's paintings, his most radical work was a sustained effort to outdo the Dutchman's animation of landscape: namely, the series of paintings Soutine made in the town of Céret, in the French Pyrenees, between 1919 and 1922. For sheer pictorial violence, the Céret landscapes had no precedents in art (plate 200). The sense of *matière* in his still-lives, where the paint that depicts the ox acquires its own fatty carnality, reaches an extreme in them, utterly distorting the descriptive content of the landscape. The houses lean as if in a gale, hills rear up, the horizon is dragged on a furious slant, and the whole scene becomes a mass of tumbling paint, like chicken-guts.

One would have supposed such a performance was inimitable, but the influence of Soutine on other painters was quite wide. His Céret canvases in particular, with their *allegro furioso* of paint and their peculiar airlessness, the result of the virtual elimination of the sky by a rising wall of pigment, greatly affected the work of Willem De Kooning (b. 1904) after he saw them in New York. The discussion of De Kooning has long been hampered by the efforts of American critics to turn him into a mythic

199 Chaim Soutine *Carcass of Beef* 1925
Oil on linen 45 × 31 ins
Minneapolis Institute of Art

200 Chaim Soutine *View of Céret* 1922
Oil on canvas 29 × 29½ ins
Baltimore Museum of Art, Gift of Mrs. George Siemonn

figure, the American answer to Picasso, a creature of Protean vitality who subsumes the history of art in his own person, becomes a touchstone of the culture, and so transcends all questions of "originality." It was on De Kooning's work that Harold Rosenberg based his idea of "Action painting," whereby the work of art was an act rather than a configuration, a by-product of some existential face-off between Will and Fate; ordinary questions like the style, sources, and syntax of his art had no place in this drama. But if one goes in a little lower and tries to see what (in the art of others) De Kooning actually looked at and wanted to emulate, Soutine's influence on him is not only obvious to the viewer but embraced by the artist. "I've always been crazy about Soutine – all of his paintings," De Kooning once remarked. "Maybe it's the lushness of the paint There's a kind of transfiguration, a certain fleshiness, in his work." The link between Soutine and De Kooning is clearest in De Kooning's paintings of the seventies, the largely incoherent work of a talent in decline, centring on the image of nudes in landscape. Their bodies splayed *à la crapaudine*, in the froggy postures of sunbathing or sex, pay distant but explicit homage to Soutine's hanging ox-carcasses and dead pullets. They are "incarnations" in an all but literal sense – manifestations of flesh in the unctuous and candied paint surface. To see what De Kooning could do with the Expressionist tradition when he was nearer the height of his powers, one must go to the *Women* he painted between 1950 and 1953.

In a sense, the *Women* grow out of the more abstract paintings that went immediately before them, like *Attic*, 1949, or *Excavation*, 1950 (plate 201). That is to say, the character of form is similar, thanks to De Kooning's "writing" – a vigorous, wristy delineation of shape, in which the thighlike bulges and elbowlike crooks of the close-packed motifs suggest the close friction of flesh. In *Excavation*, De Kooning was attending to Picasso and to the shallow, gridlike space of Cubism: though very much altered, a Cubist syntax was still there, but given tremendous pressure and eloquence by the freedom of De Kooning's drawing and by the Expressionist paint-handling. Neither Picasso nor Braque, in 1911, would have permitted themselves such forehand and backhand swinging of the loaded brush as went into *Excavation*. The directional, improvised quality of De Kooning's surface was the very opposite of the short-stroke stipplings of analytic Cubism, but it had everything to do with the kind of utterance Soutine felt impelled to make in his Céret landscapes.

The *Women* of the early fifties can hardly be said to equal, as painting, the measured fervour of these canvases. In them, the Expressionist impulse is wholly dominant, and they lose coherence as a result; but certainly it is the *Women* that bring one aspect of the European Expressionist tradition to its close in America. "I look at them now," De Kooning remarked of paintings like *Woman and Bicycle*, 1952–3 (plate 202), "and they seem vociferous and ferocious. I think it had to do with the idea of the idol, the oracle, and above all the hilariousness of it." De Kooning's interest in idols and oracles was of a piece with the primitivizing trend in early Abstract Expressionism – Pollock's she-wolves and guardian figures, Rothko's totems, Adolph Gottlieb's pictograms, and so forth. As such it was hardly unique, but De Kooning gave it a peculiarly vivid edge by connecting it both to Expressionism and to the

201 Willem De Kooning *Excavation* 1950
Oil on canvas 80 × 100 ins : Art Institute of Chicago

202 Willem De Kooning *Woman and Bicycle* 1952–3
Oil on canvas $76\frac{1}{2} \times 49$ ins
Whitney Museum of American Art, New York

then indigestible vulgarity of American mass images.

On the one hand, their lineage extended back to the women in Edvard Munch's paintings. They are emblems of otherness and domination – maternal domination, perhaps, if one can trust the impression of solid, fishwife-like dumpiness given by this fierce sisterhood. In the distorted vigour of their surface – the brush dragging the forms of breast, grin, buttocks, and belly around, like a thick disturbed membrane – they speak of Soutine. They are also extremely reminiscent of Kirchner. Being squat, inelegant, and unapproachable, they seem like uglified versions of Kirchner's streetwalkers. De Kooning's view of women (at least as set forth in the paintings) was almost Gothic, and the *Women* are the last convincing appearance, in art, of the image that Kirchner developed: the woman as *Giftmädchen*, the mediaeval poison-girl. In Kirchner, what fended the eye off was the sharp, nervy hatching of shadow, the spikiness of the bodies; in De Kooning, this defence against touch was achieved by the apoplectic tumult of the paint. In either case, the message is clear: *Noli me tangere*.

On the other hand, they are specifically American girls. Perhaps because he was a foreigner and could see America as curious, even exotic, De Kooning took frank pleasure in the admass imagery of *Life* magazine and Times Square billboards. (More "theological" Abstract Expressionists, like Rothko or Still, regarded such things as beneath contempt.) This is reflected in the *Women*, whose toothy and disturbing grins were De Kooning's version of the girl in the old Camel cigarette ads being kind to her T-Zone. In creating this Doris Day with shark teeth, an amphibian living between the atavistic and the trivial, De Kooning had come up with one of the most memorable images of sexual insecurity in American culture.

Only one other painter, after 1945, was able to incarnate such anxieties in the human body: the Anglo-Irishman Francis Bacon (b. 1909). Bacon has always denied that his work has anything to do with Expressionism – "I have nothing to express," he once told a BBC interviewer, with apparent sincerity – and certainly it shows no trace of the longing for spiritual transcendence that was one of the main features of Expressionism. On the other hand, Bacon's is perhaps the extreme voice of the *misère des hôtels*, the sense of being trapped within the city by unassuageable and once almost unnameable appetites, which Munch's urban images were the first to raise. In his work, the image of the classical nude body is simply dismissed; it becomes, instead, a two-legged animal with various addictions: to sex, the needle, security, or power. All moral relationships are erased from the world of his paintings. It is unified, instead, by the smeared documentary force of certain key images clipped, as it were, from the grainy stock of the twentieth century and then edited abruptly together. One of these was a still from Eisenstein's *Battleship Potemkin*, showing in close up the sabre-cut face of a nurse on the Odessa Steps, squalling in fright with her spectacles awry. Bacon combined this image with one of the fragments of an older tradition that lurk in his art. Velásquez's portrait of Pope Innocent X Pamphili, that supreme image of watchful power, was thus turned into Bacon's well-known motif of the "screaming Pope," 1953 (plate 203).

He disdained "naïve" source material, but liked taking didactic images out of

203 Francis Bacon *Study After Velásquez's Portrait of Pope Innocent X* 1953
Oil on canvas 60¼ × 46½ ins: Courtesy Marlborough Gallery, London

context so that their intended meaning was either lost or blurred. One of his richest sources was a manual on oral disease, another a book entitled *Positions in Radiology*, and a third Eadweard Muybridge's *Animal Locomotion*. What did such books have in common? Detachment: the clinical gaze on the human body as a specimen, all its privacy brushed aside. Bacon thought there was a strong analogy between the body's various availabilities – to inspection, sex, or political coercion. All three evoked different forms of abandonment, the condition of being a thing. Hence Bacon's liking for environments that suggested a loss of will – the grungy walls of rooms that might be detention-chambers, the racklike beds and chairs that turn into grilles, the assemblies of vaguely medical-looking tubes. The closed rooms and unidentifiable furniture, nasty in texture and colour, lit by a single unshaded bulb, are an arena for violence; in them, sex becomes a doglike grappling and all emotions are equally subsumed in rage and its hangover, the sense of isolation. While it may be true, as Bacon has more than once said, that "you only need to think about the meat on your plate" to see a general truth about mankind in his paintings, no modern artist has hammered with more repetitive pessimism at one corner of the human condition. In fact, Bacon is a highly mannered artist. It takes no mean feat of aesthetic self-removal to be able to inspect the gums and saliva of a screaming mouth as Monet did a lilypad. This distancing has enabled Bacon to master his gruesome and convulsive subject-matter, but it has also entailed a certain loss of pressure and even, on occasion, a surrender to the decorative. In the best of Bacon's art the paint has a dreadful materiality, as though the grainy, cellular structure of the pigment, swiped with a loaded brush across the canvas, were a smear of tissue. In its weaker moments, however, the tension between real paint and imagined flesh, between the oppressed energies of the bodies and the looping brushmarks that represent them, acquires a spectral lushness inappropriate to Bacon's main ambition: to be the Goya of modern history, a last painter of the tragic figure, telling a truth about human events that the camera could not.

By 1950 it seemed that there were no such truths, and the event which revealed that painting could no longer deal cathartically with modern horrors was the Holocaust. If De Kooning's *Women* and Bacon's male nudes look isolated in their time, the reason may be that, after Auschwitz, Expressionist distortion of the human body in art seemed to many sensitive minds to have no future – in fact, to be little more than an impertinence or an intrusion, a gloss on what the Nazis had done, on a vast industrial scale, to real bodies. Reality had so far outstripped art that painting was speechless. What could rival the testimony of the photograph?

Art was in fact now ill-equipped to compete with print, photography, or film in explaining what the political catastrophes of the twentieth century meant. There was a postwar flurry of "existentialist" art, especially sculpture – ragged, pinheaded figures, blow-torched or welded together, full of allusions to the death camps, Hiroshima, and the plaster casts of dead Pompeians. None of it was of lasting consequence. After World War I, as we have seen, there had been a surge of interest in Utopian abstractions by which, it was hoped, a shattered world might reconstruct itself in an ideal and final order. The years after World War II, in the moral shadow of

the A-Bomb, were conducive neither to Utopian schemes nor to any marked belief in the future. Nevertheless, the same pattern repeated itself up to a point: in the wake of catastrophe, artists once again became interested in transcendental abstraction, based on a spiritualized idea of nature. The transcendentalist ambitions of Expressionism came to the fore, and the tradition that ran from van Gogh through Kandinsky seemed more fruitful than the kind of approach which, descending from Munch, depended on the *Angst*-filled human figure.

The work of Wassily Kandinsky (1866–1944) is bound to present its admirers with problems, and these have to do with the nature of Kandinsky's own beliefs. He was, if not the "onlie begetter" of abstract art, certainly its outstanding pioneer; in the five years between 1909 and 1914, he laboured to turn a speculation about the meaning of pure form into a system of language. These were also the years in which Kandinsky was attached, with an almost missionary zeal, to the doctrines of Theosophy. It is clear from his writings that he applied the kitsch-spiritualism of Madame Blavatsky to his art in a quite literal way. It was its philosophical armature, as St. Ignatius' *Spiritual Exercises* were for Bernini. The physical world was losing its importance; it should be seen as a stumbling block, since it occluded the realities of the spirit from men's eyes. Thus caught in the webs of *maya*, of attachment to objects of earthly longing, people could only drift in endless dissatisfaction. However, the Millennium was coming in the form of what Kandinsky called "The Epoch of the Great Spirituality." On that day, History itself – the contingent pattern of human events – would stop. All political and social power would be subsumed in spiritual contemplation, and universal enlightenment would reign. This was Madame Blavatsky's version of a fantasy as old as Christianity itself: the Millennium, when Christ would come to earth for the second time, win a final victory over Satan, and establish a span of perfect earthly justice lasting one thousand years. Among the political spin-offs from this durable legend were the Marxist fantasy of the "withering away of the State" after the dictatorship of the proletariat, and Hitler's vision of the "Thousand-Year Reich." Both presupposed the end of History, and so, in its harmless way, did Kandinsky's Theosophical faith.

A special art was obviously needed for these special times to come. After the Millennium art would not be needed, since human perception of men would then be blissful and entire, like that of the blessed in Heaven. But painting had its uses until then, and in Kandinsky's view the main one was to prepare people to think and see in terms of immaterial form, rather than perceived objects like apples or nudes. "Behind matter," he wrote in *The Blue Rider* almanac in 1912, "the creative spirit is often concealed within matter. The veiling of the spirit in the material is often so dense that there are generally few people who can see through to the spirit. There are whole epochs which disavow the spirit . . . [and] this is, on the whole, still so today. People are blinded. A black hand is laid over their eyes."

At its origins, Kandinsky's work was a complicated amalgam of ideas drawn from Russia and all over Europe. He shared the Symbolists' interest in "synesthesia" – meaning the direct transfer of reactions to one sense from another, so that one might

"hear" colours and, conversely, "see" sounds. "In highly sensitive people," Kandinsky suggested, "the approach to the soul is so direct, the soul itself so impressionable, that any impression of taste communicates itself directly to the soul, and thence to the other organs of sense (in this case, the eyes)." As an exile living in Munich and then in Murnau, he was peculiarly sensitive to the mystico-romantic currents in the *Jugendstil*, that highly abstracted form of Art Nouveau whose leaders, in Munich, were Hermann Obrist and August Endell. And as a Russian exile, Kandinsky had behind him a tradition of abstraction and extreme stylization, coupled with elevated spiritual meanings and didactic aims: the tradition of the icon. Add to that his love for folk art – of almost any kind, from Russian peasant weavings to Bavarian votive glass-paintings and the wholly abstract patterns of Moslem tiles and textiles he had studied on a trip to Bavaria in 1904 – and one has some idea of the variety of his background and how it helped shape his work. Moreover, Kandinsky's belief in the possibility of an abstract language of colour was grounded in his own abnormally strong visual reactions – responses which few artists, let alone ordinary viewers, could have shared. He had a completely eidetic memory, and could visualize the shape, colours, tone, and location of any object at will, projecting it on the real world as though by a magic lantern: "All the forms I ever used come 'from themselves,' they presented themselves complete before my eyes, and I only needed to copy them" He felt some colours as strongly as others feel sounds – the heehawing of a police siren or the hateful squeak of a knife dragged across a plate – and his obsession with the "pathetic fallacy," the attribution of human feelings to what was not human, rivalled van Gogh's:

A cigarette butt lying in the ashtray, a patient white trouser button looking up from a puddle in the street, a submissive bit of bark that an ant drags through the high grass . . . a page of a calendar towards which the conscious hand reaches to tear it forcibly from the warm companionship of the remaining block of pages – everything shows me its face, its innermost being, its secret soul, more often silent than heard.

Kandinsky started to paint fairly late – he was thirty in 1896, when he came to Munich to study art – and Russian folk art (bright inlaid patches of peasant textiles, coloured decoration of log-houses) had disposed him to work in flat areas of hue. (He was short-sighted, too, and so tended to see distant things as brightly coloured patches with indistinct contours.) In his Murnau landscapes of 1909, the shapes of hill, tree, and steam-train (plate 204) bear witness to the influence of Fauvism; but their odd ballooning and bustling, as though the weight of things were unmoored by the energy of colour, pointed towards the next stage of his work, in which colour would gradually be detached from description. The Murnau landscapes present a lusciously coloured and rather toylike world of well-being, and this romantic vision of innocence continued to haunt his work in the form of references to a Slavic fairy-tale past: riders, castles, spears, rainbow-bridges, and the like. But if colour became more of an end in itself, it could discipline the too-easy associations of these images. Kandinsky feared the triviality of illustration as much as he abhorred the triviality of decor; he wanted

his painting to describe spiritual states, epiphanies of soul. How this might be done came to him in Murnau in 1908, when he thought he had been given a glimpse of a revelatory tablet, the Rosetta Stone of a new art. He recalled:

I was returning, immersed in thought, from my sketching, when on opening the studio door, I was suddenly confronted by a picture of indescribable and incandescent loveliness. Bewildered, I stopped, staring at it. The painting lacked all subject, depicted no identifiable object and was entirely composed of bright colour-patches. Finally I approached closer and only then saw it for what it really was – my own painting, standing on its side on the easel One thing became clear to me: that objectiveness, the depiction of objects, needed no place in my paintings, and was indeed harmful to them.

The dispute about who was really the first artist to make an abstract painting is sterile, but Kandinsky was certainly one of the first to expel objects from his work so as to reach a higher intensity of feeling. Abstraction for its own sake had no interest for him (in fact he repeatedly condemned it) and so, although the images in his paintings of 1910–13 are hidden by the play of rose, crimson, yellow, azure, emerald, and deep violet – the forms sunk to near-illegibility in the general saturation of the colour – they can still be deciphered, and were meant to be. Just what they mean is another matter. Kandinsky's *Little Pleasures*, 1913, clearly depicts a landscape with a rider on horseback bounding over the distant hill (plate 205); but it took the efforts of recent scholarship to show that this was really meant to be a Theosophical reinterpretation of the Apocalypse of St. John, in which the things of this world, the material reality whose small worth is alluded to by Kandinsky's title, are seen to be passing away before the arrival of the new heaven and earth promised by Revelation. The distant rider then becomes one of the Four Horsemen of the Apocalypse, and the whole painting – though radiantly floral in colour – fills with ominous and chiliastic suggestion.

By the end of 1913, however, Kandinsky's more Expressionist abstractions defied most efforts to find an allegorical content in them. One can see three scratchy black peaks, which may be mountains, in the top half of *Black Lines, No. 189*, 1913 (plate 206), but these hardly count as a subject. What does count is the sense of well-being, springlike joy, induced by the bloom and transparency of its primary colour patches – red, blue, yellow, white – softly expanding towards the eye like halation-patterns in fog. Such works represent Kandinsky at his best, and their conviction as painting rises above the eager fatuities of Kandinsky's own philosophizing. Unfortunately, the more geometrical paintings he made after 1921 do not always do so. "Modern art," he wrote, "can only be born when signs become symbols." And in his effort to fix a symbolic language of shape and colour, which went beyond all depictive efforts in its attempt to show direct Symbolist correspondences between form and feeling, Kandinsky produced a mass of worthy but rather dry and solipsistic painting. There was no guarantee that a black-edged purple triangle on a sea-green ground could "represent" the same emotions for any spectator as it did for Kandinsky, and his zeal to cook up a universal grammar of form was like the enthusiasm with which Esperantists argued their case in Kandinsky's day. The meanings with which

204 Wassily Kandinsky *Landscape Near Murnau with Locomotive* 1909

Oil on board $20 \times 25\frac{1}{2}$ ins
Solomon R. Guggenheim Museum, New York

205 Wassily Kandinsky *Little Pleasures* 1913

Oil on canvas $43\frac{1}{4} \times 47$ ins
Solomon R. Guggenheim Museum, New York

206 Wassily Kandinsky *Black Lines No. 189* 1913

Oil on canvas $51 \times 51\frac{1}{4}$ ins
Solomon R. Guggenheim Museum, New York

Kandinsky hoped to imbue his later geometrical abstracts in the twenties and thirties – fine as pattern though they are – now seem esoteric and somewhat naïve, but this is largely because the Expressionist context from which they emerged (not to mention the woolly pieties of Theosophy) is so long gone. Yet they were a coda to a lengthy tradition of German transcendentalism, and in that they were not alone.

Transcendentalism was the common interest of the painters who, with Kandinsky, formed the Expressionist group known as *Der Blaue Reiter* (The Blue Rider) in 1910. It was also a deep-set part of Bauhaus thought and practice, for, as we have seen in Chapter 4, nothing could be further from the truth than the idea that the Bauhaus represented some kind of logic opposed to the world-transforming aspirations of Expressionism. When Kandinsky taught at the Bauhaus, so did a Swiss artist named Paul Klee (1879–1940). And though Klee was not a Theosophist he was, like Kandinsky, devoted to an ideal of painting that stemmed from German idealist metaphysics.

The monument of Klee's obsession with this metaphysics was a singular book, *The Thinking Eye*, written during his teaching years at the Bauhaus – one of the most detailed manuals on the "science" of design ever written, conceived in terms of an all-embracing theory of visual "equivalents" for spiritual states which, in its knotty elaboration, rivalled Kandinsky's. Klee tended to see the world as a model, a kind of orrery run up by the cosmic clockmaker – a Swiss God – to demonstrate spiritual truth. This helps account for the toylike character of his fantasies; if the world had no final reality, it could be represented with the freest, most schematic wit, and this Klee set out to do. Hence his reputation as a *petit-maître*.

Like Kandinsky, Klee valued the "primitive," and especially the art of children. He envied their polymorphous freedom to create signs, and respected their innocence and directness. "Do not laugh, reader! Children also have artistic ability, and there is wisdom in their having it! The more helpless they are, the more instructive are the examples they furnish us" In his desire to paint "as though newborn, knowing absolutely nothing about Europe," Klee was a complete European. His work ferreted around in innumerable crannies of culture, bringing back small trophies and emblems from botany, astronomy, physics, and psychology. Music had a special influence on him. He believed that eighteenth-century counterpoint (his favourite form) could be translated quite directly into gradations of colour and value, repetitions and changes of motif; his compositions of stacked forms, fanned out like decks of cards or colour swatches (plate 207), are attempts to freeze time in a static composition, to give visual motifs the "unfolding" quality of aural ones – and this sense of rhythmic disclosure, repetition, and blossoming transferred itself, quite naturally, to Klee's images of plants and flowers. He was the compleat Romantic, hearing the *Weltgeist* in every puff of wind, reverent before nature but careful to stylize it. Klee's assumptions were unabashedly transcendentalist. "Formerly we used to represent things visible on earth," he wrote in 1920, "things we either liked to look at or would have liked to see. Today we reveal the reality that is behind visible things, thus expressing the belief that the visible world is merely an isolated case in relation to the universe and that there are many more other, latent realities"

207 Paul Klee *Fugue in Red* 1921
Watercolour $9\frac{1}{2} \times 14\frac{1}{2}$ ins
Felix Klee Collection, Berne

Klee's career was a search for the symbols and metaphors that would make this belief visible. More than any other painter outside the Surrealist movement (with which his work had many affinities – its interest in dreams, in primitive art, in myth, and cultural incongruity), he refused to draw hard distinctions between art and writing. Indeed, many of his paintings are a form of writing: they pullulate with signs, arrows, floating letters, misplaced directions, commas, and clefs; their code for any object, from the veins of a leaf to the grid pattern of Tunisian irrigation ditches, makes no attempt at sensuous description, but instead declares itself to be a purely mental image, a hieroglyph existing in emblematic space. So most of the time Klee could get away with a shorthand organization that skimped the spatial grandeur of high French modernism while retaining its unforced delicacy of mood. Klee's work did not offer the intense feelings of Picasso's, or the formal mastery of Matisse's. The spidery, exact line, crawling and scratching around the edges of his fantasy, works in a small compass of post-Cubist overlaps, transparencies, and figure-field play-offs. In fact, most of Klee's ideas about pictorial space came out of Robert Delaunay's work, especially the *Windows*. The paper, hospitable to every felicitous accident of blot and puddle in the watercolour washes, contains the images gently. As the art historian Robert Rosenblum has said, "Klee's particular genius [was] to be able to take any number of the principal Romantic motifs and ambitions that, by the early twentieth century, had often swollen into grotesquely Wagnerian dimensions, and translate them into a language appropriate to the diminutive scale of a child's enchanted world."

If Klee was not one of the great formgivers, he was still ambitious. Like a miniaturist, he wanted to render nature permeable, in the most exact way, to the language of style – and this meant not only close but ecstatic observation of the natural world, embracing the Romantic extremes of the near and the far, the close-up detail and the "cosmic" landscape. At one end, the moon and mountains, the stand of jagged dark pines, the flat mirroring seas laid in a mosaic of washes; at the other, a swarm of little graphic inventions, crystalline or squirming, that could only have been made in the age of high-resolution microscopy and the close-up photograph. There was a clear link between some of Klee's plant motifs (plate 208) and the images of plankton, diatoms, seeds, and micro-organisms that German scientific photographers were making at the same time. In such paintings, Klee tried to give back to art a symbol that must have seemed lost forever in the nightmarish violence of World War I and the social unrest that followed. This was the Paradise-Garden, one of the central images of religious romanticism – the metaphor of Creation itself, with all species growing peaceably together under the eye of natural (or divine) order.

Perhaps the principal modern artist to concern himself with healing images of idealized nature, however, was the Rumanian sculptor Constantin Brancusi (1876–1957). His work celebrated the otherness of sculpture, its ability to appear self-contained and perfect, while still displaying (as metaphor) those principles of growth and structure which underlie real birds, fish, eggs, or torsos. If the Expressionist project meant saturating the non-human world with ego, Brancusi's was to endow its forms – suitably abstracted – with something of the clarity and finality of law. His style

208 Paul Klee *Cosmic Flora* 1923
Watercolour and chalk $10\frac{3}{4} \times 14\frac{1}{2}$ ins
Kunstmuseum, Berne, Paul Klee Stiftung
(© COSMOPRESS, Geneva)

was clear as water. Its concern was the purity of carving. No other modern sculptor, not even Henry Moore, addressed himself quite so undeviatingly to how one cuts, rather than models or constructs, a form in space, developing a continuous surface that summons one's attention to the invisible core of the block.

Brancusi's work has been the victim of myth. It was *de rigueur* to see him as a seer or worker-priest – a phallic old peasant, bearded like Moses, floured in holy white dust, creating elemental images in a state of grace that was somehow untouched by his thirty-seven years in the cultural compressor of Paris. And like other obstructive myths – Picasso's supreme potency, for instance – it has a certain basis (but only a limited one) in fact. Brancusi was the son of peasants, albeit prosperous ones who could spare a son to go to Paris and study sculpture with Rodin. Growing up on a Rumanian farm, he had every chance to study not only nature but the characteristic forms of peasant culture – the log-house lintels and columns, adzed into rough prisms, sawteeth, notches, and groins; the screws and blackened beams of country wine-presses; well-heads, querns, and grooved millstones. These things (sometimes preserved in all their rough directness, as in the wooden bases Brancusi made for his sculpture) were one root of his art. Another was tribal sculpture from Africa. A third was machine technology, with its polished and regular shapes. And so in Brancusi's sculpture, the "primitive" and folkloric encountered a quintessentially modernist reduction of form.

No twentieth-century sculptor has had a more rapturous feeling for surfaces than Brancusi. It might seem that his polished, meticulously revealed curves of bronze or stone are the exact opposite of his teacher's, Rodin's, corrugations and furrows; so in a sense they are, but not entirely, for what Brancusi learned from Rodin was the importance of the sculptural skin as an expressive envelope. Rodin stated the pathetic or heroic play of tendons and bones below, as Henry Moore, in the forties, would endow his best carvings with a totemic mystery by opening out their interiors into cave- or womblike recesses. But in Brancusi there are no "works" to disclose inside. All is made clear, on the surface, in a display of perfection whose calm sign is the Apollonian reflection of light. There is no such thing as a "tragic" Brancusi; all suggestions of struggle, defeat, or even moral tension are abolished by the clarity of form and skin.

Other sculptures are built up of parts, and owe their tensions and meaning to that – the sculpture of Constructivism is essentially an art of strain, balance, asymmetry, and play-off. But with Brancusi the form is almost always unitary. Usually it is an ideal whole, pushed out of shape so that it no longer resembles a Platonic solid and can now take its place in the natural world, but "perfect" all the same. Because it does not seem put together, it cannot be taken apart. Hence the special character of Brancusi's work, which seems not only to resist analysis but to be immutable, as resistant to Time and its contingencies as the most fundamental of natural forms. One is reminded of the mediaeval argument for the immortality of the soul: since the soul is not composed of parts, it cannot be separated into parts and thus cannot undergo dissolution.

A strong sense of form at its origins is present in Brancusi's images, and sometimes it is the entire "subject" of the work, as in *The Beginning of the World*, *c*. 1924

209 Constantin Brancusi *The Beginning of the World* c. 1924
Polished bronze $7\frac{1}{2} \times 11\frac{1}{4} \times 6\frac{3}{4}$ ins
Musée National d'Art Moderne, Paris

210 Constantin Brancusi *Bird in Space* 1925
Polished bronze $75 \times 52\frac{1}{4} \times 6\frac{1}{4}$ ins
Musée National d'Art Moderne, Paris

(plate 209). A polished bronze egg – the ovoid on its side was Brancusi's repeated sign for dreaming – contemplates itself, as it were, in the polished disc on which it lies, like a cell adrift in the primal salt sea. Brancusi's love of solidity lent itself to feelings of repose, dream, and self-absorption, but it could also suggest movement – not the clattering mechanical movement that was the subject of Futurism, but a continuous gesture of marble or bronze, the upward stream through space and time that he would return to in the successive versions of *Bird in Space*, 1925 (plate 210). Brancusi did not care about "truth to material," and he made the Bird in black and white marble as well as polished metal so that he could see how the final form would behave when located in different substances: how the skin of the stone absorbs some light and gives the rest to the eye in a muted and silky effulgence, a generalized sheen that emphasizes profile, while the metal version dissolves its own mass and contours in a glitter of bladelike reflections.

Brancusi was a Theosophist, like Kandinsky and Mondrian – and it may say something about the state of religion in the twentieth century that no less than three of its greatest artists should have adhered to this sect, while not one appears to have been a practising Catholic. His utterances on sculpture centred on the familiar division of essence versus attributes: "What is real is not the external form, but the essence of things . . . it is impossible for anyone to express anything essentially real by imitating its exterior surface." Yet Brancusi's sculpture seems far more anchored in reality than Kandinsky's painting, and not just because solidity seems more "real" than paint on canvas. Beyond that, Brancusi's treatment of sculpture as a piece of matter in the world, drawing so much of its expressive power from its eloquent material presence, contradicted what Expressionism (especially Kandinsky's or Franz Marc's variety) expected art to do. For Expressionism was, so to speak, a fossil of the ancient Judaeo-Christian belief in a moral conflict between the world and the spirit. To rise above the material world, to subdue it by using its contents as emblems or abstractions, was to chalk up a victory for the spirit – even when the worship of God, the original stake in this battle, had been replaced as in Expressionism by the cult of the imperious Ego. Brancusi ignored Expressionism by asserting that a stone could be as full of meaning as anything it might be made to represent. His attitude would have been understood at once in Japan, where a whole cultural context deriving from Buddhism lay ready for it: and in fact it was not a European but a Japanese-American named Isamu Noguchi (b. 1904) who, after some years of apprenticeship to Brancusi in Paris, went on to become the finest lyric poet of stone and its qualities in late twentieth-century sculpture, perfecting a further combination between the Japanese ideal of *wabi* – "ultimate naturalness," the right juncture of things-in-the-world – and the specific enterprises of modernism.

No American artists could successfully emulate Brancusi's way with nature and material. In America, the Expressionist and transcendentalist strains predominated in "advanced" art after World War II. That they could do so was partly because of the example of Kandinsky, whose painting found in New York its last major field of influence. Due to the presence of the Museum of Non-Objective Art, run on

Guggenheim money by an eccentric European baroness of Theosophical persuasions named Hilla Rebay, there were probably more Kandinskys to be seen in New York in the 1940s than there were Picassos, Braques, or Matisses. And by a coincidence that Kandinsky himself could hardly have foreseen, his "metaphysical" ideas of 1910–14 collided in the work of younger Americans – especially Jackson Pollock – with an already deeply set strain in American culture, the vision of landscape as transcendental.

We have already seen some of the background to the "new American painting," as it came to be called, in Chapter 5: the impact of Surrealism, the interest in myth and primitive art, the concern with primal forms of experience (and particularly Jung's theory of archetypes, which put great weight on the social importance of images from the individual's unconscious). Surrealism and psychoanalysis were European imports, and none of the painters had any direct contact with "primitive" peoples, in America or out of it. But there was one national legacy that bore on their art, and it came out of epic scale in nature – American nature.

Throughout the nineteenth century, America seemed to be a repository of sublime landscape effects, from the solitude of its forests as described by de Tocqueville – "a silence so deep, a stillness so complete, that the soul is invaded by a kind of religious terror" – to the Edenic expanse of its plains, apostrophized by Walt Whitman as "that vast Something, stretching out on its own unbounded scale, unconfined, which there is in these prairies, combining the real and the ideal, and beautiful as dreams." The showplaces of Romantic American consciousness were natural prodigies like the Grand Canyon or Yosemite or Niagara Falls. They were interpreted as sacred spots, the architecture of the Great Builder, his unedited manuscript exposing plan and details of the universal Creation. It was pointless (and almost blasphemous) to treat such spectacles as images of the human soul. No soul is so big; and thus the prevailing tone of American Romantic landscape painting was less a description of the troubled self than a sustained homage to vastness and antiquity. This was the common thread between the painters of panoramic, spectacular wilderness like Albert Bierstadt, Frederick Church, and Thomas Moran, and the Luminists who, eschewing the baroque drama of such images, concentrated on the most pellucid and spiritual aspect of landscape: its enveloping light, holding the scene in suspension. In the work of such nineteenth-century artists as Martin Johnson Heade and Fitzhugh Lane, society vanishes as nature expands. There are no figures (except for the occasional tiny watcher, sharing the contemplation of the Infinite with the viewer of the painting), no cities, no animals, no action of any sort, no weather effects beyond the searching calm of the air; nothing moves or is moved; the images have already narrowed themselves, if not to abstraction, then at least towards it, channelling feeling into a state approaching trance – the degree zero of contemplation. There is a more than cursory likeness between the taut, light-filled planes of sea and sky in a marine painting by Fitzhugh Lane and the hovering oblongs of colour stacked up in a 1950s Rothko. Both come out of a similar transcendentalist urge, embedded in the landscape experience of Americans since the days before the Civil War.

This transcendentalism, disclosing itself in "vastness" and "clarity," in startling

211 Georgia O'Keeffe *Light Coming on the Plains* III 1917
Watercolour on paper 12 × 8 ins: Courtesy Amon Carter Museum, Fort Worth

juxtapositions of the near and the far, preserved itself in earlier twentieth-century art. Its outstanding exponent was the American painter Georgia O'Keeffe (b. 1887). O'Keeffe's magnified flowers, whose swooping forms of petal and stamen fill the entire surface of the canvas, have the amplitude of landscape itself. And her concern for images of light-filled, unbounded space, virtually abstract but still recognizable (in the division between sky and earth) as landscape (plate 211), was as pantheistic as any of Kandinsky's *Improvisations*.

It was in Jackson Pollock's "all-over" paintings, however, that the transcendentalist impulse most conspicuously renewed itself in America after the war; and the main catalyst for this was again Kandinsky's work, which was exhibited in depth – a retrospective of more than two hundred paintings and drawings – at the Museum of Non-Objective Art in New York in 1945. This show was the climax of a steady exposure to Kandinsky that the New York *avant-garde* had enjoyed since that museum opened in 1939 (it even had Bach and Chopin issuing from concealed speakers, to reinforce the analogies with music that Kandinsky insisted his art possessed). Kandinsky affected Pollock in several ways. The young American painter – he was only thirty-three when the war ended – had already spent some time in Jungian analysis. Jung's theory of shared, unconscious images, modifying the collective experience of the world, was satisfyingly close to Kandinsky's idea of the *Geist*, the "spiritual essence" he thought lay below all appearances. Pollock, not a widely read man but by no means the cowboy aesthete of myth, owned and often perused a copy of Kandinsky's essay *Concerning the Spiritual in Art*. Nor was he, in any orthodox sense of the word, religious, yet he was preoccupied with such metaphysical questions as he thought art could pose; and the role of art Kandinsky insisted on, an evocation of the "basic rhythms" of the universe and their vague but imaginable relationship to inner states of mind, was of the most passionate concern to Pollock. In short, Kandinsky gave him a way of incorporating the metaphysical yearnings of American Romanticism into a specifically modern style. In some of Pollock's drawings of 1945–6, one sees the turgid, visceral forms of his earlier "totemic" images loosening, becoming airy and scribbly under the Russian's influence, expanding into a continuum of signs and graphic flourishes that circle around an imaginary point at the centre of the page and gradually expand towards its edges. This was the origin of Pollock's "all-over" manner, which has been hailed – not without reason – as the most striking innovation in pictorial space since Picasso's and Braque's analytical Cubist paintings of 1911.

In the late forties, Pollock began to drip paint onto a canvas laid flat on the floor. His tools were sticks and old caked brushes. This process, which sounded (and to many people still sounds) like a recipe for incoherence, clarified his work. "On the floor," he declared, "I am more at ease. I feel nearer, more a part of the painting, since this way I can walk around it, work from the four sides and literally be *in* the painting. This is akin to the method of the Indian sand painters of the West" – who made ephemeral ritual images by dribbling coloured sand through their fingers on to the earth. Pollock had never been a natural draftsman; his line had a laboured, blurting character, an inherent clumsiness of the hand. But by 1948, after he had mastered this new way of

painting "from the hip," swinging the paintstick in flourishes and frisks that required an almost dancelike movement of the body, Pollock's drawing had gone to the opposite extreme. On their short flight to the canvas, the skeins and spatters of paint acquired a singular grace. The paint laid itself in arcs and loops as tight as the curve of a trout-cast. What Pollock's hand did not know, the laws of fluid motion made up for.

The result was a series of large canvases ("heroic" was the approved word for their size) in which the flung pigment filled the whole surface with its web, leaving no "holes" or figure-ground contrasts. The effect was rather like Monet's waterlilies; the picture plane turned into a continuum of small incidents, turns and dabs of the brush in Monet's case, and in Pollock's the loops and spatters of paint. Nobody could deny, after examining the exquisitely tuned surface of a work like *Lavender Mist*, 1950 (plate 212), with its close harmony of blues, lilac-greys, white, and silver, the degree of Pollock's control over his risky process. There being so few contrasts of light and dark, the surface became the literal "mist" of its title, a subtly inflected and airy space which, at last, owed nothing to the Cubist grid. It was as though the shallow, plasma-like surface of analytical Cubism, with its occasional swirl and break of recognizable fragments, had finally shed its last vestiges of three-dimensional form. There were no more receding planes: no in-and-out movement of the eye in depth – only the weaving, serpentine, darting movement of particles *across* the surface.

The best Pollocks of his best years, 1948–50, as well as some later and more isolated works, are decorative. If one sets aside the Wagnerian gush which has been decanted on *Blue Poles*, 1952, over the years and considers the painting instead, it will seem more like an abstract Tiepolo, all airy blue space and incisive "drawing," than a message from the Abstract Sublime. Yet in the atmospheric space of his "all-over" paintings, in their lavish eddyings of energy and the seemingly unbounded run of their optical fields, Pollock was certainly evoking that peculiarly American landscape experience, Whitman's "vast Something," which was part of his natural heritage as a boy in Cody, Wyoming – and of his cultural inheritance as an adult painter in mid-century America.

By the early 1950s, the idea of a general movement named Abstract Expressionism was more a critics' convenience than anything else. The styles of the New York artists were too divergent. On the one hand there were painters whose work was wholly or mainly based on gestural drawing: not only De Kooning and Jackson Pollock, but Robert Motherwell too, whose *Elegies to the Spanish Republic* – black brooding arrays of phallic or egglike forms, roughly edged, dripping, and full of rhetorical intensity – partook of the nature of collage as well, their edges seeming as much torn as brushed (plate 103). Tearing, in Motherwell, is drawing. They were among the few Abstract Expressionist works in which one could point to a specific subject as a starting point: in this case, the destruction of Spanish democracy by Franco.

On the other hand, Clyfford Still (1904–80), Mark Rothko, and Barnett Newman relied on large fields of colour to produce solemn and elevated effects. These three painters made up the "theological" side of Abstract Expressionism. For all his interest in archetype and anima, his study of Kandinsky and his concern for invocatory ritual

212 Jackson Pollock *Lavender Mist Number 1, 1950*

Oil, enamel and aluminium paint on canvas $86\frac{1}{2} \times 119$ ins
National Gallery of Art, Washington DC, Ailsa Mellon Bruce Fund

(echoed physically in the "dance" of creation around the edges of the canvas on the studio floor), Pollock made no metaphysical claims for his art. Rothko, Still, and Newman did, sometimes in an absurdly bombastic way. "I had made it clear [around 1946]," Still wrote, "that a single stroke of paint, backed by work and a mind that understood its potency and implications, could restore to man the freedom lost in twenty centuries of apology and devices for subjugation." An artist who could go on believing this could probably believe anything his ego dictated. However, such effusions – as well as the metaphysically ambitious tone of the actual paintings by Still, Newman, and Rothko – were a muffled response to the history of their time. Human dignity and spiritual aspirations had been appallingly injured between 1939 and 1945, and an art that set out to transcend the physical might be one way to heal the trauma. Paul Klee's prescient remark made in 1915, "The more fearful the world becomes, the more art becomes abstract," still held true three decades later.

The case against Still's work is not hard to make. His sense of colour relationships was poor, so that he had to get his effects from merely local colour and strong clashes of tone. Thus everything tends to hector the eye in the same strained, crusty way. Still had very little of the range that greater romantic artists – Turner, or, in his own milieu, Pollock – could play across between the small, exactly registered perception and generalized grandeur of effect. His paint surface is usually gauche, either too dry or oilily clotted. And despite its energy and scale, Still's drawing, with its Night-on-Bald-Mountain jaggedness of silhouette, is beset by clichés.

A degree of visionary ineloquence, however, is woven into the American sense of the epic; the artist must seem tongue-tied, lest he be thought insincere. This applies to Still's work, which is meant to repudiate the cult of the "well-made picture." From the beginning he opposed the Cubist tradition of small size and ambiguous space. What Still wanted, and had found by 1947, was a simpler and more declarative kind of structure: opaque, ragged planes of colour rearing up the surface like cliffs and peaks, emphatic in brushwork and engulfing in their sheer size (plate 213). If Cubism was the art of hypothesis, Still would counter it with an art of explicit visual fact, without ambiguities, heraldic in impact. Virtually no modernist paintings done before 1945 look like his, and even the influence of Surrealism is less apparent on Still than anywhere else in Abstract Expressionism. His career thus gives an impression of hell-fire conviction and straightness. Finding his style early, he stuck to it for more than thirty years with only minor variations.

The link between Still's work and nineteenth-century American landscape painting is obvious. These fissures and flames, dark promontories and turbid ravines of colour inherit the theatrical, even operatic diction of Bierstadt and Moran, in the same way that (as we shall see) Rothko's more sensitive talent took up some of the characteristics of the Luminist painters. While it is true that Still's works should not be read as literal metaphors of the Grand Canyon or the Rockies, it is equally true that they are meant to provoke the same kind of emotions as painters once looked for in such convulsions of nature: a "heroic" sense of enterprise and spectacle, a mood of pantheistic energy and a coercive tone of voice.

213 Clyfford Still '*1954*' 1954
Oil on canvas $113\frac{1}{2} \times 156$ ins
Albright-Knox Art Gallery, Buffalo

By the end of the 1950s, Abstract Expressionism was becoming a period style, a national institution and a dealers' gold mine, all at once. In the mêlée of interpretation that attended "The Triumph of American Painting," as one U.S. art historian chauvinistically named it, declarations were all too often taken for spiritual achievements, and the main beneficiary of this all-too-willing suspension of disbelief was an artist who had entered the New York School relatively late in the 1940s, Barnett Newman (1905–70).

Despite his often-quoted remark that "I thought our quarrel was with Michelangelo!", Newman was by far the least formally gifted of the group. On the evidence of his early drawings, he had no discernible talent as a draftsman. But he was tenacious and argumentative, and his reductive cast of mind served him well in the studio. His career as a painter begins, in essence, with one motif – his "zip," as it came to be known, a vertical stripe dividing the canvas. It made its debut in a small painting named *Onement I*, 1948, but its origins probably lie in certain earlier canvases by Clyfford Still, such as *July 1945-R (PH-193)*, 1945, where a dark central field is split, down the canvas, by a jagged white line like a lightning flash. Newman, however, made his division as straight as a column or the crack between two doors; and whatever its origins, this minimal form came to be invested with powers one might hesitate to attribute to *Paradise Lost* or Beethoven's Ninth Symphony. It was, Harold Rosenberg wrote, "recognized by Newman as his Sign; it stood for him as his transcendental self . . . the divided rectangle took on the multiplicity of an actual existence – and a heroic one." Other critics compared the zip to God's primal act of creation, to the division of light from darkness, to the figure of Adam, and to passages in the Kabbalah.

This reputation was paid for in inflated currency. By the time Newman's critics were through, the lingo of American transcendentalism – in so far as it applied to art – had been debased to fustian. Newman's modicum of originality now seems to have lain more in the formal attributes of his huge, meticulously painted canvases like *Vir Heroicus Sublimis*, 1950–1 (plate 214), than in the imaginary moral virtues that his admirers, avid for just one more hero in an age of entropy, pasted on them. The vertical lines, dividing their flat ground of intensely saturated colour, became echoes of the framing edge rather than modulators of part-to-part relationship within the canvas. This idea of the surface as a "field" rather than a "composition," overwhelming the eye with one main colour, would become a big issue in 1960s painting and sculpture – though usually a pedantic, or at least professorial, one. The polemical numbness of Minimalism is prefigured in Newman's paintings. Their simple, assertive fields of colour hit the eye with a curiously anaesthetic shock. They do not seem sensuous: sensuality is all relationships. Rather, they appear abolitionist, fierce, and mute.

The most complete painter on the "theological" wing of the New York School was undoubtedly Mark Rothko (1903–70). He, too, painted to the large "American" scale, but for different reasons than either Still's or Newman's, because (he said):

214 Barnett Newman *Vir Heroicus Sublimis* 1950–1
Oil on canvas $95\frac{3}{8} \times 213\frac{1}{4}$ ins
Collection, The Museum of Modern Art, New York, Gift of Mr. and Mrs. Ben Heller

. . . I want to be very intimate and human. To paint a small picture is to place yourself outside your experience, to look upon an experience as a stereopticon view or with a reducing glass However you paint the larger picture, you are in it. It isn't something you command.

We have already seen something of Rothko's liking for "tragic and timeless" subjects. In his work, the quest for archetypal imagery was bound up with a strong sense of theatre: the planes of beach and sky behind his figures of the late forties are almost a conventional stage, and this desire for ritual, histrionic "presence" also helped shape Rothko's abstract language. (From it derived his desire to control the light in which his paintings were seen, his fondness for painting *en série*, as though inventing a chorus, and his dislike of showing his work mixed with anyone else's.) In Rothko's wholly abstract paintings, this "presence" is transferred from the figure to landscape. His formula, which he established in 1949 and repeated with minor variations until his suicide in 1970, was a series of colour rectangles, soft-edged and palpitant of surface, stacked vertically up the canvas; often the divisions and intervals between them suggest a horizon or a cloud-bank, thus indirectly locating the image in the domain of landscape. This format enabled him to eliminate nearly everything from his work except the spatial suggestions and emotive power of his colour, and the breathing intensity of the surfaces, which he built up in the most concentrated way, staining the canvas like watercolour paper and then scumbling it with repeated skins of overpainting, so that in such Rothkos as *Ochre and Red on Red*, 1954 (plate 215), one seems to be peering into depths of mist or water, lit from within. This obsession with the qualities of light, issuing from motionless emblems which are themselves fixed in a completely frontal pictorial structure, exactly repeats the procedures of American Luminism and its "small, still voices" of inner contemplation; only the landscape itself is missing. Their spiritual content was summed up, long before Rothko painted them, by an American evangelist of the thirties who declared that his idea of the deity was "a great, luminous, oblong blur." But in their slow construction, their faith in the absolute communicative power of colour, and their exquisite sense of the nuance, they should perhaps be seen as a prolongation into the late twentieth century of a line drawn between Mallarmé and Monet – the subtle, atomistic consciousness of Symbolism:

> *Patience, patience,*
> *Patience dans l'azur!*
> *Chaque atome de silence*
> *Est la chance d'un fruit mûr.*
> (Patience, patience,
> Patience in the blue!
> Each atom of silence
> Is the chance of a ripe fruit.)

This, however, was not enough for Rothko. He was not only a Jew but a Russian Jew, obsessed with the moral possibility that his art could go beyond pleasure and carry the full burden of religious meanings – the patriarchal weight, in fact, of the Old

215 Mark Rothko *Ochre and Red on Red* 1954
Oil on canvas 90 × 69 ins: Phillips Collection, Washington DC

216 *The Rothko Chapel, Houston*

217 Mark Rothko *Centre Triptych for the Rothko Chapel* 1966
Courtesy of the Rothko Chapel, Houston

Testament. What was more, he expected it to do so at the high tide of American materialism, when all the agreements about doctrine and symbol that had given the religious artists of the past their subjects had been cancelled. Rothko would have needed a miracle to bring this off, and the miracle, naturally enough, did not happen. But his efforts to make it do so were recorded, shortly before his death, in a cycle of paintings, 1964–7, commissioned by the de Menil family in Houston, as the objects of contemplation in a non-denominational chapel attached to Rice University (plates 216, 217).

It is hard to enter the Rothko Chapel without emotion, for its huge obscure paintings, almost monochrome in their blacks, tarnished plum reds, and Stygian violets, have had the memorial dignity of funeral stelae given them by Rothko's death. Subjectless, formless (except for the shape of the framing edges), and almost without internal relationships (except for the merest whispers of tonal adjustment in the darkness), they represent an astonishing degree of self-banishment. All the world has drained out of them, leaving only a void. Whether it is The Void, as glimpsed by mystics, or simply an impressively theatrical emptiness, is not easily determined, and one's guess depends on one's expectation. In effect, the Rothko Chapel is the last silence of Romanticism. The viewer is meant to confront the paintings in much the same way as the fictional viewers, gazing on the sea in a Caspar David Friedrich, were seen confronting nature: art, in a convulsion of pessimistic inwardness, is meant to replace the world.

CULTURE AS NATURE

Unlike our grandparents, we live in a world that we ourselves made. Until about fifty years ago, images of Nature were the keys to feeling in art. Nature – its cycles of growth and decay, its responses to wind, weather, light, and the passage of the seasons, its ceaseless renewal, its infinite complexity of form and behaviour on every level, from the molecule to the galaxy – provided the governing metaphors within which almost every relationship of the Self to the Other could be described and examined. The sense of a natural order, always in some way correcting the pretensions of the Self, gave mode and measure to pre-modern art. If this sense has now become dimmed, it is partly because for most people Nature has been replaced by the culture of congestion: of cities and mass media. We are crammed like battery hens with stimuli, and what seems significant is not the quality or meaning of the messages, but their excess. Overload has changed our art. Especially in the last thirty years, capitalism plus electronics have given us a new habitat, our forest of media.

The problem for art, then, was how to survive here, how to adapt to this habitat – for otherwise, it was feared, art would go under. Everything in the new century's culture of mass media conspired against the ways in which art had been experienced before. The present has more distraction than the past. Works of art once had less competition from their surroundings. Thus the background to the organized sound of Gregorian chant, in a mediaeval monastic community, was not random noise. Silence – the silence of nature itself, in which the random noises of culture were swallowed up – was one of the dominant facts of mediaeval life, outside the cloister as well as inside it. Against the quietness that enveloped the ear, and the tracts of unaltered nature – wood, bramble, heath, swamp – that made up its solid equivalent, any designed structure of sound or stone acquired a corresponding rarity and singularity. In an ill-articulated world, a place not yet crammed with signs, images, and designed objects, the impact of a choir heard in the vast petrified forest of a Gothic cathedral might well have exceeded anything we take for "normal" cultural experience today. Now we see the same cathedral through a vast filter that includes our eclectic knowledge of all other cathedrals (visited or seen in photographs), all other styles of building from primitive *nuraghi* to the World Trade Center, the ads in the street outside it, the

desanctification of the building, its conversion into one more museum-to-itself, the secular essence of our culture, the memory of "mediaeval" sideshows at Disney World, and so on and so forth; while similar transpositions have happened to the matrix in which we hear the music. The choir competes, in our unconscious, with jack-hammers, car brakes, and passing 747s, not merely with the rattle of a cart or the lowing of cattle. Nor does the chant necessarily seem unique, for one can go home and listen to something very like it on the stereo. Because nothing could be retrieved or reproduced, the pre-technological ear listened to – as the pre-technological eye was obliged to scrutinize – one thing at a time. Objects and images could not, except at the cost of great labour, be reproduced or multiplied. There was no print, no film, no cathode-ray tube. Each object, singular; each act of seeing, transitive. The idea that we would live immersed in a haze of almost undifferentiated images, that the social function of this image-haze would be to erode distinction rather than multiply the possible discriminations about reality, would have been unthinkable to our great-grandparents – let alone to our remote ancestors.

Today, the object splits into a swarm of images of itself, clones, copies. The more famous an object is – the supreme example is perhaps the *Mona Lisa* – the more cultural meaning it is assumed to have, and the more "unique" people say it is. But the more it breeds. How many people by now can say that their experience of the *Mona Lisa* as a painting is more vivid than their memory of it as a postcard? Very few; perhaps only those who have seen "her" with the glass off, out of the moisture- and temperature-controlled cabinet in which she hangs on the Louvre wall, and without the swarm of tourists and guides in front. To most people, the painting is a green, subaqueous ghost, a dimly perceived mould from which all the millions of replicated smiles are run off. Its "uniqueness" is a function of its ability to multiply images of itself.

Mass production strips every image of its singularity, rendering it schematic and quickly identifiable, so that it resembles a sign. A sign is a command. Its message comes all at once. It means one thing only – nuance and ambiguity are not important properties of signs – and is no better for being hand-made. Works of art speak in a more complicated way of relationships, hints, uncertainties, and contradictions. They do not force meanings on their audience; meaning emerges, adds up, unfolds from their imagined centres. A sign dictates meaning, a work of art takes one through the process of discovering meaning. In short, paintings educate but signs discipline; mass language always tends to speak in the imperative voice.

The idea of sitting down and painting the environment of signs and replications that made up the surface of the modern city was obviously absurd. But how could art defend itself against a torrent of signs that were more vivid than its own images? How could it defend itself against the incursions of a mass environment? By assimilating them. By grafting the vitality of media onto what had become a wilting language. That, at least, was the hope.

In the nineteenth century, the Industrial Revolution began to appear in landscape painting, slowly pushing its way into a fixed aesthetic category of the pastoral world,

218 Vincent van Gogh *The Huth Factories at Clichy* 1887

Oil on canvas $21\frac{1}{4} \times 28\frac{3}{4}$ ins: St. Louis Art Museum,
Gift of Mrs. Mark C. Steinberg

like an intruder in Paradise (plate 218) – manufacture invading nature. The sign found its way into art a little later. Obviously, it was difficult for painting to assimilate: its presence in a painting had to mean that two different systems of image were competing for the same space, one verbal and conceptual, the other purely pictorial. That is why signs rarely appear in Impressionist painting; one cannot read the absinthe label in a Degas, or the book titles in a Cézanne portrait. Up to then, the only writing tolerated in a painting had been emblematic – an inscription below a saint, a motto on a scroll. But if there was no longer a seamless pictorial field for it to rupture, the language of signs could enter painting without difficulty, and this happened after 1910 with Cubism, whose pictorial surface was a patchwork of varying degrees of reality, ranging from the purely abstract play of airy brown marks through generalized allusions to still-life, like map markers (a glass's rim, the fret of a violin, a guitar's parallel strings), to the most real objects of all, fragments of lettering and newsprint (plates 14–18). The Cubist surface was a reflection of the new surface of Paris, plastered with ads and *affiches*, a hive of mass-produced imperatives. Artists and poets could not fail to realize that print was all around them, and that it made up a visual field which art, up to then, had scarcely even scratched. Their environment was not as message-laden as ours, but they were not used to it, and so its vividness had not staled.

The true home of the quick message, after World War I, was New York City. Its shapes were already a subject for American artists by 1920. For Joseph Stella, an Italian migrant painter – as, in the late twenties, for the Ohio-born Hart Crane – the Brooklyn Bridge was the supreme image of collective creativity, tying past and present into one epigram of social coherence (plate 219). It was the New World's answer to the Eiffel Tower; or, as Stella put it, "the shrine containing all the efforts of the new civilization, America – the eloquent meeting-point of all the forces arising in a superb assertion of their powers; an apotheosis". In 1914, Stella had painted an ambitious answer to Gino Severini's *Dynamic Hieroglyphic of the Bal Tabarin*, 1912 (plate 26): a vision of New York's funfair by night, *Battle of Lights, Coney Island*, 1914 (plate 220). Though Stella was not a member of the Futurist group, the *Battle of Lights* is one of the supreme *manifesti* of the Futurist aesthetic. All the preoccupations are there: the flashing lights, the repetitious, gyring, darting mechanical movement, the flashing signs announcing [LUNA] PARK, the violent clash of motion against structure, the sense of turbulent, unappeasable crowds, all circling around its central apex, the Tower of Light, which in its heyday was lit by 100,000 electric bulbs and could be seen for thirty miles.

But apart from Stella, very few American artists in the late twenties and early thirties were interested in the lingo of the streets, the flashing ads in lights which astounded every out-of-towner in New York who made the statutory visit to the Great White Way. (Matisse, who pronounced himself "completely ravished" by the mass of gold and black that was downtown Manhattan seen from the deck of his liner, found "no lasting interest" on Broadway. "The Eiffel Tower illuminated is a much finer object," he sniffed. "The Americans themselves admit it." Perhaps the Americans to whom he had been talking were New York artists.) Advertisement smelt too much of

220 Joseph Stella *Battle of Lights, Coney Island* 1914
Oil on canvas $76 \times 84\frac{1}{4}$ ins: Yale University Art Gallery, New Haven

219 Joseph Stella *New York Interpreted V: The Bridge* 1922
Oil on canvas $88\frac{1}{2} \times 54\frac{1}{4}$ ins: Newark Museum

the ephemeral, the manipulative. It stood for the commercialism that serious art felt bound to repudiate. The heroism of work – the straining backs of Thomas Hart Benton's ploughboys, the ordered rows of the Midwestern agricultural paradise as rendered by Grant Wood, or the noble precision of a grain-elevator in a Charles Sheeler – that was an acceptable subject. But the signs that sold the products of work were not. Very occasionally, other artists would resort to the sign language of the city. Thus in 1928, Charles Demuth painted a visual equivalent to his friend William Carlos Williams's image of a fire-truck roaring down a Manhattan street, with its engine-company number glittering on its red flank under the streetlamps, entitled *I Saw the Figure 5 in Gold*, 1928 (plate 221). But the iconic blatancy of this painting was unusual in Demuth's work; it was, in any case, a private affair, made for an audience of one, the poet Williams, whose name appears in various guises and combinations on the canvas. Only one American artist between the wars seemed willing to turn away from Nature altogether and look only to Culture. He was Stuart Davis, and he loved what he called "the New York visual dialect."

Stuart Davis was born in 1894. He belonged to the same generation as Hemingway and Gerald Murphy. Like them, he went to Paris, but later; he did not manage to make the trip until the late twenties, and by then Cubism – what he could see of it in America – had already formed his style. But instead of sticking to the usual objects of Cubist contemplation for his still-lives (which would have struck him as inappropriate, perhaps, since America did not have a café culture and the guitar on the round marble table was not the first thing one saw of a New York evening in 1925), he went for the kind of thing one could buy in a five-and-ten: an eggbeater, a sack of Bull Durham, a packet of Sweet Caporals, or a mouthwash-dispenser. The signs and brand names dominated Davis's paintings of the twenties as they had never been allowed to dictate the structure of a Braque or a Picasso; what had been an allusion was becoming a main theme. *Odol*, 1924 (plate 222), with its hard declarative drawing and centred image, was in this respect the ancestor of much American Pop art.

In 1950, Davis declared: "I like popular art, Topical Ideas, and not High Culture or Modernistic Formalism. I care nothing for Abstract Art as such, but only as it evidences a contemporary language of vision suited to modern life." He did not like the heroic attitudinizing, the cloudy redemptive metaphysics of artists like Rothko, Still, or Newman; and in his instinct for the quotidian and the matter-of-fact, he remained close to Léger all his life. "Real Art determines culture," Davis argued, "when its Image is a Public View of Satisfaction of Impulse – not merely an S.O.S. from a Subjective Event . . . Painting is not an exhibition of Feelings." And the artist, as he put it in a terse phrase, was "a cool Spectator-Reporter at an Arena of Hot Events." This idea of subject-matter as a democratic spectacle described by a tough, laconic eye was the crux of Davis's mature paintings. *The Mellow Pad*, 1945–51 (plate 223), shows the degree to which Davis could orchestrate congestion and give it a sparkling, crowded lucidity: the bopping rhythm of nervous shapes, superimposed over what began as a formalized view of the street from a New York window (which leaves its traces in the rectangular background outline of warehouse windows and

221　Charles Demuth　*I Saw the Figure 5 in Gold*　1928

Oil on composition board 36 × 30 ins: Metropolitan
Museum of Art, Alfred Stieglitz Collection

222 Stuart Davis *Odol* 1924
Oil on canvas 24 × 18 ins
Private Collection, Courtesy
Andrew Crispo Gallery, New York

223 Stuart Davis *The Mellow Pad* 1945–51
Oil on canvas $10\frac{1}{4} \times 16\frac{1}{2}$ ins
Edith and Milton Lowenthal Collection, New York

bays, and the fragment of brick wall seen in yellow and green in the lower left corner),
is a vastly more sophisticated version of the kind of abstract "musical" form that Walt
Disney, five years before, had attempted in *Fantasia*. The musician's period slang of
the title is echoed in the syncopations of the painting, for Davis believed that jazz was
the first real American modernism – a vernacular, rigorous, free, and spontaneous, to
which European prototypes had contributed nothing at all. What had influenced his
paintings, he was asked, and in 1943 Davis made a list:

. . . the brilliant colors on gasoline stations, chain-store fronts, and taxi-cabs; the music of
Bach; synthetic chemistry; the poetry of Rimbeau [*sic*]; fast travel by train, auto and
aeroplane, which brought new and multiple perspectives; electric signs . . . 5 & 10 cent store
kitchen utensils; movies and radio; Earl Hines hot piano and Negro jazz music in general, etc.
In one way or another the quality of these things plays a role in determining the character of
my paintings . . . Paris school, Abstraction, Escapism? Nope, just Color-Space Compositions
celebrating the resolution in art of stresses set up by some aspects of the American scene. The
development of modern art in Europe is probably at an end.

But in their time, the forties and fifties, Davis's images of mass culture were on their
own. They ran counter to the romantic mainstream, and did not belong to the
conventions that Surrealism had engendered. No other major American artists were
ready to go so far into the badlands of other media, or to do it with that uniquely
balanced mixture of cool and brashness. Then, around 1955, some others did enter
them, but from a different direction.

If one buys a half-pound of bacon in a supermarket, one gets an ounce and a half of
cardboard and plastic wrapping with it. If one stocks up on toilet items in a drugstore,
razor, blades, shaving soap, lip-salve, they leave a pyramid of packaging behind. If an
electric iron goes on the fritz, who takes it to the repairman? It is easier to get a new
iron than a new wire. The New York City dump testifies that Manhattan throws away
more manufactured goods in a week than eighteenth-century France produced in a
year. American consumption means disposability, not durability; replacement, not
maintenance.

During the fifties, some American artists began to realize what the Dadaists in
Europe had known about three decades before: that there might be a subject in this
landscape of waste, this secret language of junk, because societies reveal themselves in
what they throw away. Why should a work of art not be a dip into the vast unconscious
middenheap that the city secretes every day? Street junk was to these artists what the
Flea Market had been to the Surrealists. And among them there was one budding
master, a man in his twenties from Port Arthur, Texas, named Robert Rauschenberg.

Rauschenberg is one of the most wildly uneven artists in American history. In his
work, cliché and self-parody are mixed with dazzling spurts of invention and moments
of poetic insight. He has never permitted himself, for long, the pleasure of working in a
typical style, and for that reason (among others) he was loathed by formalist critics in
the 1960s, for whom his work embodied everything in modernism that was jumpy,
eclectic, self-indulgent, impure, and "not serious." As Brian O'Doherty neatly put it,
Rauschenberg did not seem house-trained. Yet it is plain that there has not been much

anti-formalist American art that Rauschenberg's prancing, fecund, and careless talent did not either hint at or help provoke. To him is owed much of the basic cultural assumption that a work of art can exist for any length of time, in any material (from a stuffed goat to a live human body), anywhere (on a stage, in front of a TV camera, underwater, on the surface of the moon, or in a sealed envelope), for any purpose (turn-on, contemplation, amusement, invocation, threat) and any destination it chooses, from the museum to the trashcan. In one way or another, Rauschenberg has been a benign uncle, a giver of permissions to many of the *avant-garde* enterprises of the last twenty years: to conceptual art, for instance, with his formal erasure of a De Kooning drawing, or his telegram that read: "This is a portrait of Iris Clert if I say so"; to performance art, with his numerous happenings and dance collaborations like *Pelican*, 1966; but above all, to Pop art and its related activities in the 1960s. As the art historian Robert Rosenblum remarked, he has the character of "a protean genius. . . . Every artist after 1960 who challenged the restrictions of painting and sculpture and believed that all of life was open to art is indebted to Rauschenberg."

When he settled in New York in the fall of 1949, Rauschenberg found himself living in the midst of a junk-crammed environment, a landscape of dismissed objects and ephemeral messages. He was acquainted with Duchamp's "readymades," commonplace things like a shovel or a bicycle wheel which, isolated and placed in a fine-art context, had become cult-objects in the New York *avant-garde*. He also knew about the Surrealist tradition of the "poetic" object, the incongruous relic salvaged from the tidal beach of the street and the attic. An afternoon's stroll in downtown Manhattan could and did furnish him with a complete "palette" of things to make art with: cardboard cartons, broken striped barrier-poles, sea-tar, a mangy stuffed bird, a broken umbrella, discarded tyres, a shaving mirror, old postcards. "I actually had a kind of house rule. If I walked completely around the block and didn't find enough to work with, I could take one other block and walk around it in any direction – but that was it. The works had to look at least as interesting as anything that was going on outside the window." Rauschenberg did not want to interfere too much with the objects; he was intrigued by their "given" quality. (This preference even extended to colour. Once he found some unlabelled cans of house-paint on sale for 5¢ each, bought them, and painted with whatever colour he found inside.) He did not want to impose on them the kind of romantic effulgence that still clings to many Surrealist *objet-poèmes*. Instead, he tried to preserve their factuality, and the artist from whom he took his cues in this regard was the German Dadaist Kurt Schwitters. Schwitters liked to organize his surfaces in terms of a Cubist grid of horizontals and verticals. This too appealed to Rauschenberg, and in his early "combines" – as his large assemblages were called – he followed it to the letter. He showed a preference, in these pieces, for loosely stringing together a set of associative images around one theme. In the case of *Rebus*, 1955, it was flight: photos of a bee, a dragonfly, a mosquito, a fly's multicellular eye, and the Winds from Botticelli's *Birth of Venus*. "I tended," he remarked two decades later, "to work with things that were either so abstract that nobody knew what the object might be, or so mangled that you couldn't recognize it any more, or so

obvious that you didn't think about it at all."

Yet the presence of one thing coloured the meaning of another, and a code of accumulative meaning runs through some of Rauschenberg's combines from the fifties. The title of *Odalisk*, 1955–8 (plate 224), directs us to a favourite image of those two sultans of French art, Ingres and Matisse: the harem nude. The box on its post, totemic in looks, thus alludes to a human figure – a torso, whose "foot" is firmly planted on a cushion that indicates, and parodies, the notion of *luxe, calme et volupté*. The sides are filled with pin-ups and reproductions of classical nudes, punctuated with the ropy ejaculations of paint that were Rauschenberg's homage to Abstract Expressionism. The gauzy enclosure of the box resembles a harem veil. Finally, the stuffed chicken on top reminds us that one of the many French terms for an expensive courtesan is "*poule de luxe*."

Rauschenberg's combines, like the frugal and epigrammatic work of his mentor Marcel Duchamp, are seeded with such puns and quirks of meaning. Like Duchamp, he was fond of embedding an ironic lechery in his images. The best case of this was *Monogram*, 1955–9: the goat in the tyre (plate 225). It only came into being through a piece of luck – Rauschenberg's discovery of a stuffed angora goat in the window of a Manhattan store that sold second-hand typewriters – but it was of some autobiographical meaning, since as a child in Port Arthur he had a pet goat whose death, at the hands of his father, scarified him emotionally. The goat was therefore able to take its place with the other creatures that populate Rauschenberg's combines, the eagle, the chicken, and so forth, as a mute emissary from Eden – a survivor of Nature in a flood of Culture, an innocent witness to events before the Fall. Its title is self-explanatory, since monograms are drawn with their letters lacing through one another, as the goat laces through the tyre. But if one asks why it has lasted, why *Monogram* became Rauschenberg's best-known work, the most often reproduced and the most memorable, or why it has contrived to keep its power of surprise intact despite two decades of exposure and discussion in the history books and art magazines, the answer is probably sexual. Goats are the oldest metaphors of priapic energy. This one, with its paint-smutched, thrusting head and its body stuck halfway through the encircling tyre, is one of the few great icons of male homosexual love in modern culture: the Satyr in the Sphincter, the counterpart to Meret Oppenheim's fur cup and spoon (plate 165). In dealing so sweetly and humorously with what, in its time, was forbidden territory, Rauschenberg's goat fulfilled André Breton's description of the Surrealist ideal: "Beauty will be erotic-veiled, explosive-fixed, magical-circumstantial, or it will not be at all." But no such explicit image of male homosexuality could have escaped Breton's censorious eye, and this may suggest how far Rauschenberg, in his prankish and colloquial way, did expand the subject-matter available to American art in the 1950s.

The artist with whom Rauschenberg was always bracketed at that time was Jasper Johns. In fact, the two men were utterly unlike one another in temperament and style. Where Rauschenberg's combines were garrulous, Johns's paintings were terse. Rauschenberg breathed out, but Johns breathed in. If Rauschenberg dealt with the

224 Robert Rauschenberg *Odalisk* 1955–8
Freestanding combine $80\frac{3}{4} \times 17\frac{1}{4} \times 17\frac{1}{4}$ ins
Museum Ludwig, Cologne

225 Robert Rauschenberg *Monogram* 1955–9
Freestanding combine $42 \times 64 \times 64\frac{1}{2}$ ins
Moderna Museet, Stockholm

sociable profusion of signs, Johns explored what was hermetic in them. His work was about difficulty, a subtle didacticism projected through an interest in the ready-made image. From the moment he appeared in 1958 – a reclusive young southerner from Atlanta, who had been eking out a living as a window-decorator in Manhattan since 1952 and was suddenly thrust into the spotlight by a show at the Leo Castelli Gallery which, in retrospect, seems to have been the model of all the later success-panics of the New York art world in the sixties – Johns's work had an emblematic quality. Slowly painted and irregularly seen, it served as a still, enigmatic centre to the turmoil of Pop it had helped provoke. In Johns, the fifties artist – imagined as "hot," expressive, and tragic, the Romantic culture hero as evoked by Harold Rosenberg – was displaced by the didactic onlooker of the sixties: a man of distances, margins, and blocks, detachedly rendering the nuances of ambiguity through the most commonplace objects. For Johns wanted to use things so simple and familiar that, as he put it, they left him free to work on other levels. New York painting in the forties and fifties had been full of inventions, of displays of character. Johns would show what could be done with things that were not invented – things so well known that they were not well seen.

Between 1955 and 1961, Johns chose and developed most of his principal motifs: the targets, the stencilled words and numbers, the flags, the rulers, the fragments of human anatomy. No period in his later work would quite equal this one for vitality and daring. A work like *White Flag*, 1955 (plate 226), has lost the aura of scandal that clung to it when it was first seen. Instead, it has moved into the company of works like Pollock's *Lavender Mist*, as one of the classics of American modernism: a painting of such authority, intelligence, and opulent technical skill that one can hardly believe its pale, dense, encaustic skin was made by a twenty-five-year-old. "Using the design of the American flag," Johns once remarked, "took care of a great deal for me because I didn't have to design it. So I went on to similar things like targets – things the mind already knows." His main theme would be the difference between signs and art, and no Johnsian image was better fitted to display this than a target. Everyone knows what you do with a target. It is the simplest of signs. It has one meaning: receptivity. You pick up a gun and shoot at it. Anyone who has shot on a range knows that looking at a target is an extreme case of hierarchical perception – score 10 for the bull, 9 for the inner, and so on. All your attention is fixed on the bull: it is the target's unique point of interest. No marksman concentrates on the outer circles.

The target is a test, and Johns took it with a sort of deadpan irony to test what one expects a work of art to do. For a painted target automatically negates the use of a real one. Once a target is seen aesthetically, as a unified design, its use is lost. It stops being a sign and becomes an image. We do not know it so clearly. Its obviousness becomes, in some degree, speculative. The centre is not more important than the rings. In *Target with Plaster Casts*, 1955 (plate 227), the target's five rings present themselves as painting alone: an even, edible skin of wax encaustic, no part of it visually "superior" to the rest. Despite its target format, the painting is actually in the tradition of visual "all-overness," a continuous matrix of marks, that ran from Seurat to Jackson Pollock. The idea of putting a bullet through it seems absurd. What would one aim at? A sign,

226 Jasper Johns *White Flag* 1955
Encaustic and collage on canvas $78\frac{1}{2} \times 120\frac{3}{4}$ ins
Collection of the artist, Courtesy Leo Castelli Gallery, New York

227 Jasper Johns *Target with Plaster Casts* 1955
Encaustic and collage on canvas with objects 51 × 44 ins
Mr. & Mrs. Leo Castelli Collection, Courtesy Leo Castelli Gallery, New York

which can only be stared at, becomes a painterly image, which must be scanned. Meanwhile, the plaster casts of bits of the human body, set in their boxes above the painting, are transformed in exactly the opposite way. Their anonymity as specimens, twice removed from life – first cast, then dipped in monochrome paint – makes them like fossils or, even more, like words, signs that stand for classes of things. "Ear," "hand," "penis": one would like to see them as elements of a portrait, but they cannot be read in that way. They are images turning into signs. And so, in *Target with Plaster Casts*, two systems of seeing are locked in perfect mutual opposition, the sign becoming a painting and sculpture becoming a sign.

Was this more than a game of conceits? Johns's liking for paradox seemed, to many people raised on the Abstract Expressionist ideal of authenticity, quite dandified and pointless – Art complacently regarding its own cleverness, in an emotional void. What one tends to forget, a quarter of a century after the event, is how badly some corrective to the clichés and slop of late Abstract Expressionism was needed, and how bracingly Johns supplied it, by forcing his viewers to think about representation and the paradoxes it entails, instead of merely producing evidence of turmoil. His dismantling of *idées reçues* about how images should function and paint should operate was, in itself, a whole demonstration of vision. So with his maps of America, whose descriptive use is abolished by the storms and flurries of brushmarks, and by his use of words, in which the letters RED turn out to be rendered in blue or yellow. His work is not without episodes of deadpan comedy: one was *Painting with Two Balls*, 1960, a hilariously literal satire on the then highly esteemed machismo of Abstract Expressionism, where a surface plastered in vigorous flourishes is split by an empty space through which the two wooden balls obtrude like apparitions of mistaken meaning. But the strength of his work always lay in the subtlety of its linguistic disputes, embodied as they were in memorable images.

Perhaps the best examples of this were his flags. No country has a more elaborate cult of its flag than America, or a more general reverence for the flag as a kind of eucharistic symbol. It is hard to imagine the post-Imperial English, for instance, being stirred by any misuse of the Union Jack to the outrage that Americans felt in 1979 when they saw photographs of Iranian "students" carrying garbage from the captured U.S. Embassy in Teheran in a Stars and Stripes. No social sign is more resistant to aesthetic transformation. One's eye recognizes Old Glory in a flash, and passes on. It is one of the best-known signs in Western culture. How can any meaning be added to it? Johns's strategy involved the fact that the art of painting is to delay the eye. This (plate 226), he insists, is not a flag. Its motto comes from Magritte (plate 166): "This is not a pipe." Why? Because it is a painting. Johns's object is a painting too. It shares some of its characteristics with the American flag. It has stars and stripes; its design is carried on cloth. But it is no more meant to be seen as a flag than Johns's targets are meant to be shot at. It cannot wave in the air; it is immobile, the stripes drawn out with diagrammatic precision. Its flatness is the flatness of art, not of cloth. We see the painting first, that pale, perfect skin; but the flag beneath it, the sign, has lost its power to command. Flags are only as abstract as this in the ideal space of

art. Paint, we learn, can make anything abstract, even a subject as highly charged as the American flag. But to use the word "subject" in Johns's case is wrong, since there is no actual difference between the painting and the flag it purportedly "represents." The distance between the medium and the message has shrunk almost – though not quite – to zero. All that proves its existence is Johns's performance as a virtuoso painter, setting down one spare, delectable mark after another with a diffident sensuousness no other American painter could rival. Inevitably one thinks of such works, not in the context of Pop art – which did not yet exist – but as the end of a tradition of still-life that began with Chardin. And yet Johns's effort to fuse subject and object in one problematic field was going to have deep effects on art, especially American art, in the 1960s. As the critic Max Kozloff put it, Johns reduced his flags and targets to "merely so many abstract forms upon which social usage had conferred meaning, but which now, displaced into their new context, cease to function socially. From this tremendous insight alone have sprung the momentum of Pop art and the huge quantities of abstraction that is emblematic in character." Johns was no more a Pop artist than Cézanne was a Cubist, but his work, in tandem with Rauschenberg's, set free the attitudes that made Pop seem culturally acceptable, rather as Cézanne's work became the ground for a modernism that the recluse of Aix would not himself have recognized. For Johns's work was always intended as a defence of painting in the face of a mass-culture environment; and that defence, in the sixties, became more arduous than it had ever been for American artists before.

One would have thought the stage was set for Pop art in America in the 1950s. Certainly the materials were there: the raw stuff of a culture which, to critics like Jacques Barzun or Dwight Macdonald, was split and terraced into permanently separated levels of masscult, midcult, and highbrow. The hostility with which American defenders of *le beau et le bien* viewed the products of mass culture in the fifties was given its special edge by their sense of isolation and embattlement: their frail precincts, the universities, small magazines, and art schools, were threatened by McCarthy as well as by philistinism. The Romantic vision of the heroic artist creating a grand, exemplary, and for that reason permanently unpopular art, accessible to kindred spirits but not to the herd, made what may prove to have been its last appearance in Western culture – and was duly assimilated into popular form through books like *The Agony and the Ecstasy* and *Moulin Rouge*. Any overt interest in mass culture was viewed as a capitulation, a form of moral treachery, by the artists themselves; one crack in the dyke, unplugged, could release a turbid flood of banality into the studios, dissolving all values, drowning all distinctions. The first glimmer of another attitude perhaps came as early as 1940, in Walt Disney's *Fantasia*, when Mickey Mouse was seen to mount the podium and shake hands with Leopold Stokowski; but for most serious writers, composers, and especially painters and sculptors, there could be no *rapprochement* between the imagery, let alone the values, of high and low art. Indeed, there was no low *art* as such. There was only kitsch, foisted upon a dumb manipulated public by flacks, sellouts, and moguls; and from that, art had nothing to learn. There was nothing remotely exotic or pleasing about the

giant plaster doughnut or the Westinghouse billboard. Such things were the nightmare from which art struggled to avert its gaze, the Other from which it had to defend itself, the void with which no *avant-garde* could compete.

In England, the problem was otherwise. For some young artists there in the fifties the landscape of commercial America, that vast rain forest of signs and commercial messages that flourished on the far shore of the Atlantic, was deeply intriguing. They saw the gross sign language of American cities with the kind of distant longing Gauguin felt for Tahiti – a mythical world of innocent plenty, far from the austerities of a victorious but pinched England. *Ces nymphes, je les veux perpétuer . . .* For them, the imagery of American capital was an equalizer, an escape from class: and "good" culture in England was inextricably bound up with social ranking, the property of the genteel and the paternal whose spiritual home lay between I Tatti and *Brideshead Revisited*. Their artist enemies, on the other hand, had grown up with rationing, Yank comics, and National Health teeth. They were the grubby brats who had been unwillingly evacuated to Brideshead; and later, Hollywood had shaped their dreams – forever young, forever sexy, potently artificial, and swollen with abundance. Their definition of culture was dominated by two large facts. First, cultural alternatives were now multiple, not vertically ranked; they spread across a field of choice generated by mass production and machine reproduction, and did not rise from the corner sweetshop to the Athenaeum Club. Second, books and painting were no longer socially dominant media; movies, LP records, and the TV screen had displaced them and supplied the ruling diction. As Lawrence Alloway, the English critic who was the first to use the phrase "Pop art," put it in 1959:

Mass production techniques, applied to accurately repeatable words, pictures and music, have resulted in an expendable multitude of signs and symbols. To approach this exploding field with Renaissance-based ideas of the uniqueness of art is crippling. Acceptance of the mass media entails a shift in our notion of what culture is. Instead of reserving the word for the highest artifacts and the noblest thoughts of history's top ten, it needs to be used more widely as a description of "what society does."

The main impetus of English Pop came out of discussions, from 1952 onwards, between writers like Alloway, John McHale, and the architectural critic Reyner Banham, and such artists as Eduardo Paolozzi and Richard Hamilton. This group put on a pioneering exhibition at the London Institute of Contemporary Art (ICA) in 1956, called "This Is Tomorrow" – a quasi-anthropological, semi-ironic, but wholly enthusiastic look at the mass imagery of the early electronic age. Hamilton exhibited a small but densely prophetic collage called *Just What Is It That Makes Today's Homes So Different, So Appealing?*, 1956 (plate 228). In it, the word "Pop" makes its first appearance in art, emblazoned on the hilarious phallic sucker the muscle-man is holding. Moreover, all the chief image sources of later Pop art are compressed into the collage: a literally framed *Young Romance* comic on the wall (Lichtenstein), the packaged ham on the table (Rosenquist), the TV set, brands like the Ford logo on the table lamp, the movie theatre with its cut-off kneeling Al Jolson billboard visible

228 Richard Hamilton *Just What Is It That Makes Today's Homes So Different, So Appealing?* 1956
Collage $10\frac{1}{4} \times 9\frac{3}{4}$ ins: Kunsthalle, Tübingen

through the window, the brand-new vacuum cleaner and tape recorder, the harsh motel bed with its premonition of Oldenburg's zebra-striped motel suite of the sixties, and the Health and Beauty couple displaying their lats, pects, and tits as Product. This collage fulfilled almost to the letter what Hamilton wrote down as the desiderata of Pop art in 1957, an art which did not yet exist except as uncoalesced subject-matter. Pop, he declared, should be:

> Popular (designed for a mass audience)
> Transient (short-term solution)
> Expendable (easily forgotten)
> Low-cost
> Mass-produced
> Young (aimed at youth)
> Witty
> Sexy
> Gimmicky
> Glamorous
> Big Business . . .

Such an art could not be made by the people; it was not folk art. It came out of what Hamilton would later call "a new landscape of secondary, filtered material." Pop art, far from being "popular" art, was made "by highly professionally trained experts for a mass audience." It was done *to* the people. It grew by analogy to what it admired, advertising and the media through which advertisements were replicated. And it grew dandyistically, casting itself in the role of the detached, amused, lenient, but inflexibly ironic spectator at the vast theatre of desire and illusion which the mass media of the twentieth century had erected. By far the most powerful of these was television.

More than four decades ago Walter Benjamin, dazzled and fascinated by the crude, tentative beginnings of mass culture as we have it today, wrote that it was going to be hard and perhaps even impossible for any child raised in the howling blizzard of signals to find his way back into the "exacting silence" of a book. How radically would a culture of distraction alter all discourse within it? Benjamin died in 1940, but what he feared from radio, movies, and advertising came a thousandfold truer with mass television. The box has done more to alter the direct, discursive relationship of images to the real world, on which painting used to depend, than any other invention in our century. This is not really a matter of good or bad programming. Everyone knows that television, especially American television, is a cornucopia of dung most of the time; the point is that some, at least, of its cultural effects are intrinsic to its form rather than its content.

In a cinema, we do not confuse film with reality in the same way. We see movies in a ceremonial space, a screen populated by giants. The television set, by contrast, is just a box sitting in one's room, issuing images which become part of the furniture. It is more intimate than film, and more casual in size.

When watching a movie, one has only two choices – go or stay. With television,

there is a third: change the channel. Hundreds of millions of people thus spend time every day flipping from one channel to the next, editing their own montages based on chance whilst looking for the news programme or game show that takes their fancy. They do not think of these montages as "imagery." They are simply a by-product of changing the channel. But they see them all the same; and what they see, and take for granted, is a stream of images whose juxtapositions are often Surrealist in their incongruity. With this parade of interchangeable ghosts, and in a chaotic way, we make our own montages in between watching the montages of others. Thus one of the dreams of the Russian Constructivist film-makers (Dziga Vertov) and the German Dadaists (Heartfield, Höch, Hausmann) finally came true with TV. Whole societies have learned to experience the world vicariously, in terms of swift montage and juxtaposition. But its effect has not been (as artists in the twenties hoped) to convey us towards the heart of reality, wherever that organ may be, but rather to insulate and estrange us from reality itself, turning everything into ˉdisposable spectacle: catastrophe, love, war, soap. Ours is the cult of the electronic fragment.

Being so intimate and casual, the box worked on us in other ways too. Its images had a weirdly contradictory tone. They were real, *there*, present in the room. But they were also artificial, because their illusion would not hold. They kept creeping up the screen, or breaking off into dots and lines and jabber; few TV images had, or have, the technical "finish" of projected cinema film. But if the reality of TV was provisional, its colour was ultra-vivid and wholly abstract, especially in America: electron colour, not the colour of ink or nature or paint. Its artificiality accentuated the feeling that TV messages came in small packets, discontinuously. One did not scan the screen as one scans a painting, or inspect it as one might inspect a Chinese vase. And the fate of its messages and images, in all their casual brightness, was to be equalized, to pour forth in an overwhelming glut. Like radiation, which in fact they are, they are everywhere; and they have affected art.

One of the artists they most affected in the sixties was Rauschenberg. In 1962, he began to apply printed images to canvas with silkscreen – the found image, not the found object, was incorporated into the work. "I was bombarded with TV sets and magazines," he recalls, "by the refuse, by the excess of the world . . . I thought that if I could paint or make an honest work, it should incorporate all of these elements, which were and are a reality. Collage is a way of getting an additional piece of information that's impersonal. I've always tried to work impersonally." With access to anything printed, Rauschenberg could draw on an unlimited bank of images for his new paintings, and he set them together with a casual narrative style. In heightening the documentary flavour of his work, he strove to give canvas the accumulative flicker of a colour TV set. The bawling pressure of images – rocket, eagle, Kennedy, crowd, street sign, dancer, oranges, box, mosquito – creates an inventory of modern life, the lyrical outpourings of a mind jammed to satiation with the rapid, the quotidian, the real. In its peacock-hued, electron-sweetbox tints, this was an art that Marinetti and the Berlin Dadaists would have recognized at once: an agglomeration of memorable signs, capable of facing the breadth of the street. Their subject was glut.

Rauschenberg's view of his landscape of media was both affectionate and ironic. He liked excavating whole histories within an image – histories of the media themselves. A perfect example is the red patch at the bottom right corner of *Retroactive I* (plate 229). It is a silkscreen enlargement of a photo by Gjon Mili, which he found in *Life* magazine. Mili's photograph was a carefully set-up parody, with the aid of a strobo- scopic flash, of Duchamp's *Nude Descending a Staircase*, 1912 (plate 30). Duchamp's painting was in turn based on Marey's photos of a moving body. So the image goes back through seventy years of technological time, through allusion after allusion; and a further irony is that, in its Rauschenbergian form, it ends up looking precisely like the figures of Adam and Eve expelled from Eden in Masaccio's fresco for the Carmine in Florence. This in turn converts the image of John Kennedy, who was dead by then and rapidly approaching apotheosis as the centre of a mawkish cult, into a sort of vengeful god with a pointing finger, so fulfilling the prophecy Edmond de Goncourt confided to his journal in 1861:

The day will come when all the modern nations will adore a sort of American god, about whom much will have been written in the popular press; and images of this god will be set up in the churches, not as the imagination of each individual painter may fancy him, but fixed, once and for all, by photography. On that day civilization will have reached its peak, and there will be steam-propelled gondolas in Venice.

From television, film, and photography we receive a stream of images every day. There is no way of paying equal attention to all that surplus, so we skim. The image we remember is the one that most resembles a sign: simple, clear, repetitious. Everything the camera gives us is slightly interesting. Not for long; just for now. The extension, on the human level, of this glut of images is celebrity, which replaces the Renaissance idea of fame.

Fame was the reward for manifest deeds. It stood for a social agreement about what was worth doing; hence the traditional pairing of *fama* and what the Renaissance called *virtù*, "prowess" or "accomplishment." The celebrity, as Daniel Boorstin pointed out, is famous for being famous – nothing else; hence his gratuitousness and disposability.

The artist who understood this best and became best known for understanding it was Andy Warhol (b. 1930). In him, the culture of packaging produced its characteristic painter, and Warhol filled this role brilliantly from 1962, when he emerged, to 1968, when his powers of invention appear to have fizzled out. No seriously taken artist of the twentieth century, with the possible exception of Salvador Dali, had devoted so much time and skill to the cultivation of publicity. Instead of Dali's heat, which claimed to transform everything it touched, Warhol projected an ironic and affectless cool, which let everything be itself. Warhol's insight was that you do not have to act crazy; you can let others do that for you. To the media, Warhol seemed barely explicable and therefore infinitely intriguing – a slightly eerie vacuum, which needed to be filled with gossip and speculation. He became a well-known artist by silently proclaiming that Art could not change Life, whereas Dali did so by noisily

229 Robert Rauschenberg *Retroactive I* 1964
Silkscreen: Wadsworth Atheneum, Hartford

giving the impression that it could. Like a Rorschach blot, Warhol's work has attracted its share of inflated comparisons from art historians who might have known better. One commentator in the sixties, John Coplans, went so far as to claim that his work "almost by choice of imagery alone it seems, forces us to squarely face the existential edge of our existence." The existential edge of Warhol's, for the last decade, has satisfied itself with doing perfunctory social portraits. Nevertheless, although Warhol began as a commercial illustrator and seems to have ended as one, he did, for a short while, have something to say.

What he extracted from mass culture was repetition. "I want to be a machine," he announced, in memorable contrast to Jackson Pollock, who fifteen years before had declared that he wanted to be nature: a mediumistic force, unpredictable, various, and full of energy. Warhol loved the peculiarly inert sameness of the mass product: an infinite series of identical objects – soup cans, Coke bottles, dollar bills, Mona Lisas, or the same head of Marilyn Monroe, silkscreened over and over again.

Other and earlier artists had painted in series: Monet, for instance. But when Monet painted his haystacks and lily-ponds, his specific aim was to show, in the most resplendent detail of nuances, that phenomena are not standardized. His "re-petitions" were done to glorify the eye, to show how it could discern tiny differences, and how these differences added up to a continuous alteration of reality. Discrimination within abundance was the essence of such painting. Today, we have sameness within glut, and that was what Warhol painted (plate 230). The difference between these approaches is like the difference between high bourgeois French cooking at the end of the nineteenth century, with its strict formats enclosing a continuous variation and metamorphosis of the ingredients, and what one sees in a modern American supermarket.

Warhol's work in the early sixties was a baleful mimicry of advertising, without the gloss. It was about the way advertising promises that the same pap with different labels will give you special, unrepeatable gratifications. Advertising flatters people that they have something in common with artists; the consumer is rare, discriminating, a connoisseur of sensation. If Warhol was once subversive – and in the early sixties he was – it was because he inverted the process on which successful advertising depends, becoming a famous artist who loved nothing but banality and sameness. Nothing would be left in the sphere of art except its use as a container for celebrity, and at one stroke (although it took the art world some time to realize it) the idea of the *avant-garde* was consigned to its social parody, the world of fashion, promotion, and commercial manipulation: a new model artwork every ten minutes. *I want to be a machine*: to print, to repeat, repetitiously to bring forth novelties. This was the most cunning sort of dandyism, especially when allied to Warhol's calculatedly grungy view of reality, suggesting the smudged graininess of newsprint, the reject layout, the uneven inking. His images (plate 231) were less painted than registered. The silkscreen was without nuances – a surface with slips, but no adjustments. It looked coarse, ephemeral, and faintly squalid. It wanted to be glanced at like a TV screen, not scanned like a painting. And like American television in the sixties, it was morally

230 Andy Warhol *200 Campbell's Soup Cans* 1962
Oil on canvas 72 × 100 ins
Private Collection, Courtesy Leo Castelli Gallery, New York

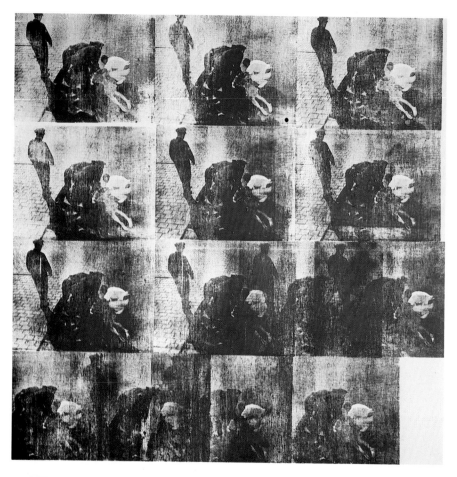

231 Andy Warhol *Suicide* 1963
Acrylic and silkscreen enamel
on canvas 82 × 82 ins
Courtesy Leo Castelli
Gallery, New York

232 Andy Warhol *Marilyn
Monroe Diptych* 1962

Oil on canvas, in two panels 82 × 114 ins
Tate Gallery, London

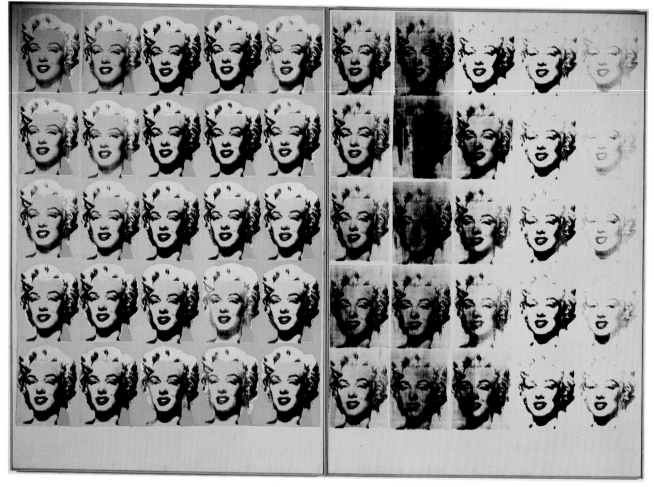

numb, haunted by death, and disposed to treat all events as spectacle. The violence Warhol enjoyed, the dismembered wreckage of metal and flesh in his Disaster paintings, the brooding presence of the electric chair, was filtered through an indifferent medium. Thus the images had one subject in common. Not just death; rather, the condition of being an uninvolved spectator.

Warhol's autistic stare was the same for heroes and heroines as for death and disaster. As extremity promotes indifference, so that one accident is all accidents, so celebrity breeds clones (plate 232) – thousands of signs for itself, a series without limit. What this added up to was one piercing insight about the nature and effects of media. But that was it, and Warhol's capabilities as a formal artist were so cramped that he was unable to develop it further in the realm of aesthetics. The idea had a half-life, like a radioactive isotope. It sent out a lot of radiation in the sixties and early seventies; then it became feeble, and then dead. Boredom at last became boring, and probably Warhol's achievement will eventually be seen to lie in the sociology of art rather than in the domain of painting itself. Warhol did more than any other painter alive to turn the art world into the art business. By turning himself into pure product, he dissolved the traditional ambitions and tensions of the *avant-garde*. In his hands art aspired to become a low-rating mass medium, while the élite corps of criticism struggled in the sixties to codify its high-art credential and endow it with a problematic or critical content that it did not possess. For younger artists, Warhol became a popular role model precisely because he pointed to the line of least resistance.

Meanwhile, the nature of mass imagery fascinated other artists in the sixties as well. If Warhol and Rauschenberg were taken by television, Roy Lichtenstein (b. 1923) went to print. His best-known source was American comic strips of the forties and fifties – the visual fodder that artists of his generation, who made the Pop movement, grew up on. These designs, flat, candid, and schematic (in contrast to the plunging space and almost baroque elaboration of detail in today's superhero strips), provided him with a fertile ground of improvisation (plates 233, 234). Lichtenstein's avowed intention in the early sixties was to paint a picture so ugly nobody would hang it, but this traditional *avant-gardist* assault on the middle-class collector was doomed to fail; within a few years half the art buyers in America were lining up to possess these icons of supposed bad taste. Indeed, the cynic might suppose that since the new class of American collectors who made up the audience for Pop, whose most spectacular representatives were Robert and Ethel Scull, *had* no taste or historical memory, they were shockproof to begin with. The critics, however, were not, and Max Kozloff brought off one of the few pieces of true gut-Ruskin invective of the early sixties when he tore into the Pop artists, those "New Vulgarians," as inventors of "the pin-headed and contemptible style of gum-chewers, bobby-soxers and, worse, delinquents."

But it presently became clear that there was more to Lichtenstein's work than aggression against an existing painterly look, although nothing could have been more opposed to the brushy, clotted surface of late Abstract Expressionism than Lichtenstein's mechanical profile drawing taken (it seemed) without comment or transformation from the public prints. For Lichtenstein was by far the most formalist

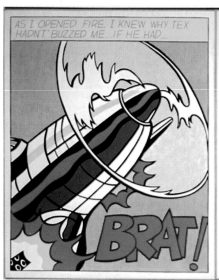

233 Roy Lichtenstein *As I Opened Fire* 1964
Magna on canvas $68 \times 168\frac{1}{4}$ ins
Stedelijk Museum, Amsterdam

234 Roy Lichtenstein *Drowning Girl* 1963

Oil and synthetic polymer paint on canvas $67\frac{5}{8} \times 66\frac{3}{4}$ ins: Collection, The Museum of Modern Art,
New York, Philip Johnson Fund and Gift of Mr. and Mrs. Bagley Wright

of the Pop artists, and the numerous editings and additional grace-notes (the thickness of a line re-formed, the relation between dots and contour made large and explicit) spoke less of vulgarity than of elaborate mannerism. As Lichtenstein remarked in 1969, his work was

dealing with the images that have come about in the commercial world, because there are certain things about them which are impressive or bold. . . . It's that quality of the images that I'm interested in. The kind of texture the dots make is usable to me in my work. But it's not saying that commercial art is terrible, or "look what we've come to" – that may be a sociological fact, but it is not what this art is about.

He was also fond of mildly sophomoric in-jokes, directed to his own life as an artist. "What do you know about my *image duplicator*?" snarls one of his figures; a worried girl muses that "M-Maybe he became ill and couldn't leave the studio!" The enlarged printer's dots, which were the basis of Lichtenstein's style, were a way of distancing the image, making it seem both big and remote, like an industrial artefact. Its mannerism counteracted any tendency the painting might have to "envelop" the spectator, as some Abstract Expressionist paintings sought to do. His work also addressed the same kind of paradox as Johns's, whereby a simple narrative sign – an image from a comic strip, not meant to be aesthetically scanned, existing only to tell a story – asked to be given the kind of detailed and all-over attention proper to art in a museum.

Lichtenstein's difficulty has been that his system could neither be developed (though it underwent refinements) nor changed, without the risk of losing its "typical" look. In other words, he had the same problem as Warhol by the end of the sixties. His solution, a partial one at best, was simply to apply it to many different kinds of ready-processed images, mirrors, Picassos, Matisse's *Dance*, thirties mechano-capitalist décor, egg-and-dart mouldings, Ionic temples, pyramids. Behind the variations of subject-matter, however, exactly the same kind of cool removal was going on, and by the seventies it had come to look genteel and routinely ingenious: almost as conventional, in fact, as the original comic strips and ads had been when Lichtenstein began to use them, though far more elegant.

Another fruitful source in mass imagery was the billboard, that inescapable, mural-size adjunct to the American city. James Rosenquist used to paint them for a living, and the giant images he was accustomed to dealing with – "hundreds of square feet of Franco-American spaghetti, and a large beer glass sixty feet long" – surfaced again in his fine-art work in the sixties as a montage of huge, bland fragments. Their odd juxtapositions derived, ultimately, from Surrealism; but they also seemed to refer to the American streetscape where, looking down a suburban strip, one sees billboard after billboard racked up and overlapping, one across the other, producing a screen of cut-offs and incongruous meetings of image, all at the largest scale. They were a painted equivalent to the casual-portentous, side-of-the-mouth prophetic tone that had come into American poetry in the fifties, through Allen Ginsberg and the Beat writers under the threat of the atom bomb. Rosenquist aspired to be an American

history-painter, as Rauschenberg had become, and in an interview with the late Gene Swenson in 1965 he described how his most ambitious painting began:

While I was working in Times Square and painting signboards, the workmen joked around and said the super-center of the atomic target was around Canal Street and Broadway. That's where the rockets were aimed from Russia. . . . The Beat people, like Kerouac and Robert Frank, Dick Bellamy, Ginsberg and Corso, their first sensibility was of [the bomb] being used immediately and they were hit by the idea of it, they were shocked and sort of threatened. So this is a restatement of that Beat idea, but in full color.

"This" was a painting Rosenquist finished in 1965, called *The F-111* (plate 235). It summed up Rosenquist's vision of America as a flawed and self-destructive Eden, a paradise based on exaggerated and obsessive consumption of images and things. The title was the name of a fighter-bomber the United States was using against the Vietnamese; its fuselage runs the length of Rosenquist's enormous painting, its sleek profile, now glittering and now silhouetted, interrupted by emblems of the Good Life at its simplest level of self-advertisement – cake, flowers, a hairdryer, a winsome little girl, and so forth. "All the ideas in the whole picture are very divergent," Rosenquist then remarked, "but I think they all go towards some basic meaning. . . . I think of the picture as being shoveled into a boiler. The picture is my personal reaction . . . to the heavy ideas of mass media and communication. I gather myself up . . . to produce something that could be exposed as a human idea of the extreme acceleration of feelings." This idea of painting as overload, as a yowling discharge of images in torrential sequence, was Rosenquist's peculiar and memorable contribution to Pop art; elsewhere, it hardly existed in painting, and its received context was poetry or the lyrics of some pop singers, like Bob Dylan.

The size and brashness of Pop images led to the belief that they were in some way less "élitist" than other kinds of painting, as if they could stand up to their mass media sources on equal terms. It was a delusion. Pop art could not survive outside the museum, since contact with a message-crammed environment at once trivialized it – a growing problem for all public art since the fifties. On the street, real mass culture would have simply crushed its ironizing cousin. This gap between art and life was not closed, and could not have been. Now and again an artist would try putting a big picture among the billboards, like Alex Katz's Times Square mural: a set of pretty upper-bourgeois American profiles with one black face thrown in as a concession to 42nd Street. Failures of this sort – for what conceivable point could such a mural have, except as an advertisement for the artist? – merely underline the probability that, in a culture of mass communication, art can only survive two ways: by stealth, or by living in those game parks we call museums. No country in the world makes this clearer than America, the home of the most enlightened patronage of the visual arts, and the most profound indifference to them, that our century has known. The impossibility of competing with streetscape sometimes reaches the proportions of farce, and one place where it necessarily does so is Las Vegas. One cannot imagine public "art," let alone a museum, on the Vegas strip. It would have nothing to do there except look high-

235 James Rosenquist *The F-111* 1965
Oil on canvas with aluminium, in four parts, 120 × 1032 ins
Private Collection, New York

minded and insignificant. Here the idea of art simply evaporates, it flies off in the face of the stronger illusions with which this place is saturated: sudden wealth, endless orgasm, Dean Martin. Vegas is the Disney World of terminal greed, and part of its appeal to the Pop sensibility was that it contained an infinity of signs all plugging the same product: luck. The product is abstract. Only the signs are real. Vegas sums up a certain kind of American giganticism, that of the huckster rather than the builder – not because the place is big, but because (at least at night) it seems to be. Its monuments, the city lights, are conceived on a scale far beyond anything that most artists ever get to work on. The town is a work of art: bad art, but art all the same, just as the unconscious medley of San Gimignano seen beneath the patina of eight hundred years constitutes, for us, a work of good art. To various artists and critics in the sixties – the most prominent of whom was the architect Robert Venturi – this festive junk food for the eyes had a special meaning. It was the final refutation of the "Either/Or" of traditional high culture; its manic inclusiveness, which coarsely parodied all cultures from Augustan Rome to Sinatra Shag, was a large illustration (erected, not by artists, but by every kind of Mafia brute and block-grabbing Vegas shark) of what John Cage had in mind when writing of Jasper Johns: "The situation must be Yes-and-No not either-or. *Avoid a polar situation.*" Orgy City could only be experienced in a mode of ironic removal – if you like it, it rolls over you; hate it, and it does the same – and so it pointed to an architecture of irony and semantic Ping-Pong. There was, however, no way that museum art could rival the commercial extravaganzas of the real world, which Vegas summed up. Certainly the artists who worked with neon in the 1960s could not; their efforts were as pointless as building a souvenir that rivalled the Eiffel Tower. In fact, there was only one artist who took on the full weight of the American commonplace – its giganticism, its power as spectacle. But he did it by irony, and his work went beyond the limits one would ordinarily assign to the Pop sensibility. He was Claes Oldenburg (b. 1929), the thinking person's Walt Disney.

That Oldenburg was the most radical and inventive of the Pop artists in the sixties seems obvious now. His conversion job on the world was wider than anyone else's; there seemed to be no area of human appetite into which the metaphors of his art did not reach from their broad range of technique and vocabulary. Other artists were content to imitate the slick, processed surface of pop culture. Oldenburg, in his desire to touch, squash, stroke, absorb, digest, and become what he saw, converting the most unlikely objects into metaphors of the body and the self, deployed a startling variety of textures and substances, from the "warm," excremental, blobby paint and gesso of his early Ray Gun and Store images, through to the "cold" and shiny folds of vinyl or the rigidity of Cor-Ten steel. "I am for an art that is political-erotical-mystical," he wrote in 1967, "that does something other than sit on its ass in a museum." The second part of this declaration was not, obviously, fulfilled; Oldenburg's work spends as much time, if not more, sitting in museums as any other successful artist's. But the long doxology that followed that sentence – a kind of *Song of Solomon* rewritten by Walt Whitman in praise of city life – vividly adumbrates the concerns of his work. First,

its roots in mess, the same ground of junk and assemblage that had inspired Rauschenberg:

> I am for the art of things lost or thrown away . . . I am for the art of teddy-bears and guns and decapitated rabbits, exploded umbrellas, raped beds . . .
> I am for the art of abandoned boxes, tied like pharaohs . . .

But then, elsewhere, in comes the newer imagery of merchandising:

> I am for Kool-Art, 7-UP art, Pepsi-art, Sunshine art, 39 cents art, Vam art, Menthol art . . . I am for U.S. Government Inspected Art, Grade A art, Regular Price art, Yellow Ripe art, Extra Fancy art, Ready-to-eat art. . . .

The recurrence of food in Oldenburg's imagination is not, of course, an accident. One might say that his art is alimentary: it involves a continuous chewing, rumination, breaking down of raw material, and their reconstitution as metaphors of the body, of pleasure, and waste. Nothing is more banal, less surprising in taste, or more culturally "fixed" than American short-order food. In a piece like *Two Cheeseburgers, with Everything*, 1962 (plate 236), that very quality of the "excruciatingly banal" (as he put it) is celebrated. The enamel on the cheeseburgers, dripping in its gloopy parody of Abstract Expressionism, is like syrup. One imagines a gross, tawdry taste on the tongue, as bright and synthetic as the colour itself, and shudders. The mockery of desire is an image of frustration. Appetite and repulsion are built into the same object. This self-contradiction is fundamental to much of Oldenburg's work. "I do things that are contradictory. I try to make the art look like it's part of the world around it. At the same time I take great pains to show that it doesn't *function* as part of the world around it."

Oldenburg is a highly formal artist. The pragmatism of his work went hand in hand with a continual criticism of the object itself, its edge, volume, line, texture, colour. "What Oldenburg proposes," writes Barbara Rose in 1969, "is a low, vulgar, representational art of formal significance." His work suggests a permeable world full of things which are always shedding one meaning and growing another. They change size, material, texture, structure. A double light-switch, vastly expanded and remade in soft vinyl, acquires the pathos of a middle-aged torso, with the switch-arms transformed into two sagging breasts. Or in its hard version, it takes on a "male" rigour. "I have a condition I want to express about form, and then an object fits into that condition; I then take the object without thinking too much about it. This [light-switch] could just as well have been a bank vault door . . . I was looking for something geometric and uncomplicated." In their multiplicity of meanings, their openness to change, Oldenburg's things are thus cousins to some of the most disturbing European art of the 1920s: Picasso's grotesque Dinard *Bathers*, for instance, or Dali's swooning Camembert watches on the beach (plate 163). Their amplitude parodies America's traditional vision of itself, a fixture since the days of John White and the Virginia colony, as a Land of Cockayne, filled with natural bounty – the fat turkey, the striped bass migrating in shoals so dense that one could almost walk across the water on their backs, the swollen berries and fruit.

236 Claes Oldenburg *Two Cheeseburgers, with Everything
(Dual Hamburgers)* 1962
Burlap soaked in plaster, painted with enamel $7 \times 14\frac{3}{4} \times 8\frac{5}{8}$ ins
Collection, The Museum of Modern Art, New York,
Philip Johnson Fund

Virginia,
Earth's onely paradise.
Where Nature hath in store
Fowle, Venison and Fish,
And the Fruitfull'st Soyle
Without your Toyle,
Three harvests more . . .

Perhaps the best examples of the recomplication of an ordinary thing back into an image are Oldenburg's projects for sculptural monuments. Most of them have not been built, and in fact could not be. They exist only as drawings, done with a beautifully free and elegant line: a baseball bat spinning "at the speed of light" so that its motion is imperceptible until it causes some catastrophic injury, a giant pair of scissors to replace the Washington Obelisk (plate 237), a prodigious Chicago fire hydrant masquerading as a nude with breasts and nipples, and so forth. "I like to take an object and deprive it of its function completely" – and once this is done, the thing becomes a stranger to the world but, as a monument, a dominating stranger. Hence the peculiar sense of threat, qualified by humour and laced with puns and art references, that such projects, if completed, exhale. What could be more ordinary than a clothes-pin? But you would have to go some way before encountering anything more dreamlike and gratuitous than a clothes-pin forty feet high (plate 238). Like a monster in a movie, this object suggests that the real world has somehow contrived to rise against its owners. It represents the Magrittean experience of the giant apple in the room, or the magically enlarged comb leaning over the suddenly diminutive bed, but puts it into a real city. At the same time, the clothes-pin is not simply that. Its jaws, facing one another and bound together by the spring-clip, refer to Brancusi's embracing lovers, fused into one mass of cubical stone; while the whole clothes-pin has two legs, and so encourages one to read it as the effigy of a man. The spring-clip on its "torso," magnified and gleaming against the rust, suggests compression, force, military inhibition. All the angles are sharp. It is an authority figure, a parody of the Hero in sculpture – in fact, a modern Colossus of Rhodes, supplying Oldenburg's alternative to the classical tradition of monumental sculpture, once mordantly summed up by him as "bulls and greeks and nekkid broads."

In his power of invention and his ability to create singular, obsessive images of metamorphosis, Oldenburg comes nearer to Picasso's metamorphic powers than any American artist has yet done. There is also something Picassian in his ability to project himself, fears and all, on the objects he transmutes, so that they are all tinged in some way with the image of the artist's own imperfect body. But for every artist of Oldenburg's seriousness, there were dozens of bandwagoners. The "democratic," uncritical view of mass reality that was supposed to be part and parcel of Pop – although it was never shared by Oldenburg – had begun, by 1965, to affect the very structure of the art world itself, altering its implied contracts, changing what the audience (and so the artists) expected of art. A culture of instant gratification had arrived, and the art world was a footnote to it. It ran all the way from "establishment"

237 Claes Oldenburg *Proposed Monument to Replace the*
Washington Obelisk, Washington DC: Scissors in Motion 1967
Crayon and watercolour 30 × 19¾ ins: Courtesy Leo Castelli Gallery, New York

238 Claes Oldenburg *Clothespin, Philadelphia* 1976
Height 540 ins: Courtesy Leo Castelli Gallery, New York

collectors who expected their new discoveries to become overnight stars, to the Oedipal caterwaulings of "revolutionaries" of the New Left; and the one common thread was the belief – one of the guiding superstitions of the 1960s – that anything could be validated as long as one could find the correct strategies for getting and holding the attention of the media. In art, this became aggravated by the sudden rush of art investment – not yet the mania it would become in the seventies, but large enough nearly to abolish, for a time, the idea that an artist's thought and performance needed to mature, gradually, out of the limelight, in a reflective silence – better to get known, as fast as possible, for any identifiable gesture. Everyone, as Andy Warhol presciently remarked, would be famous for fifteen minutes. The *avant-garde* would take over the Electronic Village, and the prophet of this idea, a Canadian professor named Marshall McLuhan, was one of the last thinkers in the world to believe that artists were still dictating the terms of the game they played. "The artist," he announced in an interview on British television in 1967, "is the enemy. But in our time, the artist has become the very basis of any scientific power of perception or making contact with reality."

This last flicker of the Romantic idea of the artist as legislator of knowledge found its expression in various attempts, in the late sixties and early seventies, to bring about collaborations between artists and research laboratories; they did not come to much, because it was apparent to almost everyone except McLuhan and those who hung on his words that the game had finally got ahead of the artist. In an age of increasing scientific and technological complexity, of techniques closed to the amateur, what could art offer the *scientific* power of perception? Not much, but perhaps it could organize something called "information"; and "information" – meaning any amount of random, unordered data – became one of the vogue words of the time, as "gesture" had been a decade before. Since the medium was the message, the quality of this "information" was not held to matter. The sheer amount of it was so glamorous. "When you surround people with electric information," McLuhan had said, "the overload of information becomes fantastic. The amount of information in the environment under electric conditions is many times greater than that of the normal human environment pre-electric; and there's only one natural response to such overload, and this is pattern recognition." To contemplate the Fantastic Overload, like a poet regarding the Illimitable Ocean, was in some quarters an effective substitute for creativity.

One institution which opened in Philadelphia in 1976, the Living History Center, was conceived as a clicking, strobing temple of McLuhanist "information" – a shrine of bombardment, a parody of the Pop museum of the future, where no visitor could be assumed to have an attention span of more than 2.9 seconds and every fact is subordinated to the sludge of "pattern recognition." There, children have what is conventionally called a non-élitist, multi-dimensional learning experience, looking at automatic index wheels full of period bus-tickets and fruit labels, and listening to snatches of the Declaration of Independence on the phone. The medium is the message here, and it turns the brain to cornflakes.

239 Robert Cottingham *Roxy* 1972
Oil on canvas 78 × 78 ins
Serpentine Gallery, London

In the narrower domain of art, the vogue for "information" went two ways in the early seventies. One took the form of conceptual art; the other, a direct descendant of Pop, was Photo-Realism. No art had ever celebrated the random sight with such enthusiasm: these literal snapshots of store windows, suburban shopping malls, motorcycles, aircraft engines, or rodeo horses, enlarged and then rendered in fulsome detail with an air-brush, derived much of their popularity from the sheer accumulation of data in them. They had the same kind of appeal to collectors as Victorian story-paintings, except that their address to the eye was not sentimental but "tough," deadpan, and full of post-Pop affectlessness (plate 239). They fed the appetite for images that, in the sixties, had been starved by abstract art. But photography itself offered a richer diet, and the apparent daring of an art based on everything that was most literal in the 35mm slide was soon cancelled by the meteoric rise, in the seventies, of the photograph – almost any photograph – as a fine-art object. As more and more areas of popular or technical culture came within the scope of the museum and the art market, and thus were given status equivalent to painting, so the area that painting could raid began to shrink. By 1975 there seemed to be little more of novelty that painting could extract from the big media, and the word "information" was a period piece in itself. Perhaps it was symptomatic of this general recoil from the Pop experience that so many American artists turned to pre-industrial craft sources – quilts, peasant weavings, naïve religious decoration, Islamic tile patterns, and the like – for the *données* of their work in the seventies.

If other media no longer exert the same fascination for painters that they did up to the end of the sixties, they have not ceased to affect art or the way art is read by the public. However, there seems to be a general recognition that, in a showdown between painting and mass discourse, painting cannot compete on level terms. It cannot be as vivid, as far-reaching, as powerfully iconic as TV or print. Part of the myth of Pop was the idea, implicit in most *avant-garde* art for as long as there was an *avant-garde*, that painting might yet recover the stature as a dominant medium it had up to the nineteenth century, before the "communications" explosion of the twentieth. People believe what they see in photos, on the movie screen, or perhaps on the TV set, but few would even claim to extract the moral and factual information for the conduct of their lives from looking at works of art. Art is a small thing, though an expensive one, compared to the media. It is a vibration in a museum; it deals with nuances that have no "objective" importance. It is not even a very good religion. But once it gives up its claims to seriousness, it is shot, and its essential role as an arena for free thought and unregimented feeling is lost. The pop sensibility did much to take these claims away, dissolving them in the doctrine that the medium was the message. All that slogan came down to was the idea that it no longer mattered what art said. Manifestly, this was not enough: the human animal is an animal who judges, and even in a culture split as disastrously and in so many ways as ours the problems of choice, taste, and moral responsibility for images still remain. In fact, they get harder. But the rock on which the *avant-garde* as it had once defined itself (the conscience of the Western middle classes) sank was that art no longer controlled that responsibility.

THE FUTURE THAT WAS

The 1970s, a time that evokes little nostalgia in the art world today, went by without leaving a "typical" art behind. Who misses the mild, herbivorous pluralism, the disappointed radical hopes of that not very vivid decade? It was not a time for movements. These, Pop art most of all, belonged to the sixties. Movements would be revived with thunderous *éclat* in the eighties under the sign of post-modernist recycling – neo-Expressionism, *pittura colta*, "Neo-Geo," and so forth. But in 1975 all the isms seemed to be wasms and the only people heard talking about "movements" – wistfully, at that – were dealers. The sixties produced art-world stars with the incontinent frequency of a kid shaking a bag of glitter. The boom market of the eighties would turn this process to parody. But there were no new art stars in the 1970s except gaunt, moralizing Joseph Beuys in Germany.

In the sixties, the vestiges of old *avant-gardist* quarrels were played out through the face-off between "mainstream" and media-derived art – a bout which the latter won. The seventies were more plural; every kind of art from feminist quilts to pastiches of Poussin suddenly found room to coexist and the idea of a "mainstream," beloved of formalist criticism, vanished into the sand. Moreover, the idea of an *avant-garde* collapsed, while the art market was too low to sustain the manic forms of cultural celebrity that the sixties had cradled and the Reagan years, that dishonest decade, would perfect.

The fall of the *avant-garde* – this switch of one of the popular clichés of art criticism into an unword – took a great many people by surprise. For those who still clung to the thought that art had some practical revolutionary use it was as baffling as the fall of the American radical Left after 1970. Nevertheless, social reality and cultural behaviour had stripped its meaning away. The ideal of social renewal by cultural challenge had lasted a hundred years, and its vanishing marked the end of an eagerly sought, if unconsummated, vision of art's relation to life. How total its extinction would turn out to be, however, did not come finally clear until the eighties market took over. For it was the market that turned the *avant-garde* into its commodified cousin, "dynamic obsolescence," as Detroit auto executives used to call it: a new product each year, differently styled to look progressive, run through a net of franchises. The framework for this was

perfected in the 1970s, so that, even if the seventies had done no more than figure out the distribution, sales, and advertising division of what was to become the Late Modernist Art Industry, they would still have been crucial years for art. And they were.

It was in the 1970s that modernism became the official culture of America and Europe. Supported by tax breaks, enshrined in museums, scrutinized by growing armies of academics and graduate students, underwritten by corporations and Government agencies, diffused through the education of rich smart Americans, collected with ever-increasing avidity, it enjoyed by the end of the seventies the strongest backup that living art has ever had from its society. (Seventeenth-century Rome and Pharaonic Egypt may have been exceptions.) Naturally, this did away with the "outsider" status of what used to be the vanguard. The most vivid indication of this was the growth of the American museum.

Since World War II, the Museum has replaced the Church as the main focus of civic pride in American cities. (Meanwhile, American churches were going on TV, and European ones were turning into museums: not one person in five hundred goes to the Brancacci Chapel in Florence to *pray* in front of the Masaccios.) But the religious roots of art experience in the United States stretched much further back. In the mid-nineteenth century, educated Americans tended to view art as a branch of piety. All sorts of paintings, from Raphaels and Guido Renis to the humbler productions of American Luminists, were seen as vehicles of moral instruction. Museum endowment was the new form of tithing. And even when it was not ostensibly pious, art would conquer the provincialism of America, refine its materialism, and take the raw edges off new capital. The ideal of social improvement through art released immense sums into the construction and endowment of museums, as a white mantle of them fell across America. The rich also got Congress to make gifts to these museums tax-deductible, as they were not in England, Germany, or France. Indeed, as happened when the National Gallery in Washington was built with Andrew Mellon's money, the very rich could be forced by the U.S. Government to settle their tax debt and avoid distasteful litigation by endowing a museum.

Thus a formidable system of cultural patronage was set in motion. At the start of America's Museum Age, the 1890s, nearly all European museums were State-run and Government-funded, and would remain so. In America, control remained private, and the aggressiveness of American capitalism got set to compete with the slower-moving cultural bureaucracies of Europe. The sabre-toothed patrons of Edwardian America had amassed monuments of past art housed in Beaux-Arts *palazzi*. But the great change came in 1929, when the Museum of Modern Art was founded in New York.

Up to then, the words "museum" and "modern art" had seemed, to most people, incompatible. "Museums are just a lot of lies," Picasso had said (although his own work was a long tribute to their necessity). "Work for life," Rodchenko had exhorted his Constructivist comrades, "and not for palaces, temples, cemeteries and museums!" Most vividly of all, the Futurists' invective against memory stuck in the public mind: "Turn aside the canals to flood the museums!" No European museum in 1929 was trying to collect modern art. The idea of a battle between old and new — or at least the feeling

that new art needed time to settle and prove itself before it joined the canon the museum represented – was too strongly implanted in the minds of their directors and trustees. To a circle of enlightened collectors in New York, however, this suspension seemed unnecessary, and Alfred Barr, the director they chose for the embryo MOMA, agreed.

Barr was an evangelist, out to present modernism as neither freakish nor subversive but as the culture of his time. MOMA's collection would be ecumenical – although in fact it was heavily weighted towards the achievements of the School of Paris, and in the long run reinforced the Francocentric version of art history that would come under fire in the seventies and eighties. Barr's MOMA would also make no effort to conceal the deep links between modernist and earlier art: connections which the noisier corners of the *avant-garde* had often tried to deny, in order to make themselves seem more radical than they were.

The new pantheon wanted everything and its opposite. Picabia once caricatured Cézanne as a monkey, but Barr wanted the best Cézannes and the best Picabias. There was every difference between van Gogh's pantheism and Gabo's materialism, but both belonged in MOMA. De Chirico and the Surrealists hated one another, but in MOMA's eyes both were cultural facts – although it would be a long time before MOMA grudgingly consented to bow to post-modernist taste and show the pastiches of Renaissance painting de Chirico made in the twenties and thirties.

Thus MOMA tended to defuse the tensions of all moments within the struggles of the vanguards by rendering them historical. Since this became the model for all museum treatment of modern art, by the seventies modernism would tend to look accessible and inevitable, not tense and bristling with problems. And all museums were potentially modern ones; even the Metropolitan in New York felt obliged to woo its audience with a modern-art wing in the eighties, in competition with MOMA – a futile effort, for by then it was far too late to fill it with a major collection.

A vivid symbol of this change was built in the late seventies in Washington: I. M. Pei's design for the East Wing of the National Gallery, which cost rather more than $100 million – only a third the price of a nuclear submarine, to put it one way, but more than twice the gross national product of some African states, to put it another. In its enormous nave, populated by only half a dozen large works by Calder, Miró, David Smith, and Anthony Caro (the main galleries being consigned to the corners), people could stroll about in the institutional ambience of modernism, enjoying it in much the same frame of mind as the bourgeois in Paris sought the ceremony known as "going to the Opéra," a ritual distinct from the enjoyment of music itself. If ever a museum consciously set out to praise its own up-to-dateness, this was it. This idea was taken to an extreme by the Centre Pompidou in Paris, a failure as an exhibition space (since the ductwork plunged its interior into Stygian gloom and its vast floors were hard to subdivide) but a big social attraction. All Paris and its tourists took to Beaubourg as a new Eiffel Tower; they came in thousands each day to ride the escalator to the roof and admire the view from the top; they rode down, mostly without going inside, but were duly put in the cultural statistics as "museum visitors." They were there to bask in the aura of modernism.

By the mid-sixties, the American museum had become the accepted habitat of

240 Carl André *Equivalent VIII* 1978
Mixed media $5 \times 27 \times 90\frac{1}{4}$ ins
Tate Gallery, London

"vanguard" art, and the American university its incubator. Both were so anxious to propagate and explain the new that they became the artist's accomplices or partners, providing a set of permissions and a system of theoretical backup that earlier art had neither had nor, indeed, bothered to ask for. The essential difference between any sculpture from the past and Carl André's *Equivalent VIII*, 1978 (plate 240) – which was ridiculed by the English press when it entered the Tate Gallery but now seems one of the classic objects of its time – is that André's work depends entirely on the museum. A Rodin in a parking lot is still a misplaced Rodin; *Equivalent VIII* in the same lot is just bricks. The museum alone provides the etiquette that identifies it as art, slotting the bricks into the formal debate about contexts which enables them to be seen as part of an art movement called "Minimalism." The paradox of such works was that they staked everything on the institutional context for their effect, while claiming the density and singularity of things in the real world.

Once in a while, a polemically Minimalist work would break out (as it were) into the real world from the museum, causing stress. Such was the case with Richard Serra's *Tilted Arc*, 1981 (plate 241).

Serra, a sculptor of indisputable power and authenticity who worked in threateningly heavy material – huge unadorned steel plates, rolls of lead: blue-collar Minimalism – was commissioned in 1979 by an American Government agency to make a sculpture for a federal office plaza in downtown Manhattan. The result, a shallow curved wall of thick steel plate twice the height of a tall man, slicing 120 feet across the plaza, was by a long shot the most ferociously uncivic sculpture ever placed as a public work in an American city. Though by no means everyone in the offices disliked it, some workers and passers-by felt insulted by its rawness and size, and the arrogant way it cut the (admittedly hideous) plaza in two. They had every right to their feelings: the blame lay with the patron's initial assumption that the public was not to be consulted on matters of public art – medicinal stuff, it seemed to think, like fluoride, though acting on the soul rather than the teeth. *Tilted Arc* showed how wrong this was. It was eventually removed, against stubborn opposition from Serra, who claimed that, because it was "site-specific" (made for a given spot), to shift it would be to destroy it and reduce it to the meaningless array of rusty metal its opponents said it already was. If the fate of *Tilted Arc* proved anything, it was that good art may not necessarily be good *public* art.

Yet the most popular and socially charged public sculpture of the late seventies was a stylistic clone of Serra's work, designed by a young art student named Maya Lin (plate 242): the black V of polished marble walls descending into the ground in Washington, which with elegance and gravity commemorated the Americans killed in Vietnam, whose 57,939 names were incised in the slabs. But here the materials were fine, the mood elegiac, the content fraught with intense emotion, and the artist's ego recessive; not even the addition of a banal bronze figure-group by another artist as a sop to conservative critics could damage its effectiveness as a war memorial.

The case of *Tilted Arc* was exceptional in an America which by the eighties had learned to take anything from artists simply because they *were* artists, and hence privileged. This, too, was largely the result of processes set in train by MOMA. MOMA's values were

241 Richard Serra *Tilted Arc*, Federal Plaza, New York 1981
Cor-ten steel 12 ft × 120 ft × 2½ ins
Courtesy of The Pace Gallery, New York

242 Maya Lin *Vietnam War Memorial*, Washington, D.C.
(photo © Wendy Watriss, Woodfin Camp Associates)

blown through the American education system, from high school upwards – and downwards, too, greatly raising the status of "creativity" and "self-expression" in kindergarten. By the 1970s, the historical study of modern art had expanded to the point where students were scratching for unexploited thesis subjects. By the mid-eighties, twenty-one-year-old art-history majors would be writing papers on twenty-six-year-old graffitists. The modernist ethos was no longer a side issue in art history; it had become an industry, with a hundred links to museum practice, the market, and the activities of living artists. The lag between work and interpretation shrank to near-zero, and the sheer volume of commentary on new and nominally vanguard art expanded beyond anything that could have been imagined in Courbet's time, Cézanne's, or even Jackson Pollock's. For every ounce of fresh thinking, this overload produced a ton of incantatory jargon, art writing in which a fear of missing the bus mingled with the desire to find historical heroes and heroines under every shrub. Being tied into the educational system, institutional modernism produced versions of art history that could easily be taught, stressing a banal narrative of "Progress," "Innovation," and "Movements." This version of modernist priorities was to become as dogmatical and rigid as the pieties of official culture a century before. In 1988, for instance, when the British Council tried to find a New York venue for its Lucian Freud exhibition, no museum there would take it: the work of this great realist was not "modern," still less "post-modern," and did not fit their aesthetic ideology.

Where did this new academy begin? At its origins, the *avant-garde* myth had held the artist to be a precursor; the significant work is the one that prepares the future. The cult of the precursor ended by cluttering the landscape with absurd prophetic claims. The idea of a cultural *avant-garde* was unimaginable before 1800. It was fostered by the rise of liberalism. Where the taste of religious or secular courts determined patronage, "subversive" innovation was not esteemed as a sign of artistic quality. Nor was there a cult of the artist's autonomy: that would come with the Romantics.

Where, in fifteenth-century Florence or seventeenth-century Flanders, did you get your information about the world and how to interpret it? Not from magazines or newspapers, which did not exist; and not from books either, since most Europeans were illiterate and only a fraction of the upper fraction of society could both afford and read a small-edition, bound text. Before the Industrial Revolution, the idea of mass literacy was only an idea, and not always a welcome one. That left two main channels of public discourse: the spoken word (everything from gossip to the pulpit) and visual images – painting and sculpture. Hence the role played by didactic art, from mediaeval glass through the great fresco cycles of the sixteenth century to secular political icons like Jacques-Louis David's *Oath of the Horatii*, in determining public opinion on issues of faith and politics. Under such conditions, images made legends tangible and credible, compelling belief – and so influencing behaviour. That was what public art had always meant to do; and to understand a great public artist like Gianlorenzo Bernini, that megaphone of seventeenth-century papal dogma whose career would be unimaginable today, one must grasp his absolute acceptance of doctrine. There was no angle of refraction, no expressed or implicit friction at all, between his ideas and those of his

patrons.

The *avant-garde* rose in a changed climate of expectation: the triumph of the European middle classes and the spread of capitalist democracy. Against centralized taste, democracy emphasized the salon. Instead of seeing the work of one artist picked as exemplary by king or pontiff, one could go to the salon and find there a veritable Babel of competing images, styles, and messages. The burden of discrimination hung more squarely on the salon visitor than on a churchgoer looking at the parish Last Judgement. The salon encouraged comparison; the commissioned work, belief. The bourgeois audience did not invent the salon but it did create the permissions within which the artistic variety that the salon, by 1820, had come to express could ferment an *avant-garde*. The idea that the *avant-garde* and the bourgeoisie were natural enemies is one of the least useful myths of modernism. "*Hypocrite lecteur, – mon semblable, – mon frère*": Baudelaire's much-quoted line reminds us that the bourgeois, nominal enemy of new art, was its main audience in the 1860s and its only one a century later.

Everyone knows of the scandal and abuse that burst on the Impressionists in the 1870s. But the mockers' children became the public for Monet's and Renoir's work: these light-soaked idylls became their landscape of the mind, an earthly paradise in the here and now. Impressionism was created by the middle class for the middle class, as surely as rococo fans were made by craftsmen for aristocrats. In turn, collectors raised on Impressionism might jeer at the Fauve Matisses in 1905, but their children would not. And so it went, the audience sometimes a generation behind the art but never more, to the point where after the mid-sixties the middle-class audience finally enfolded every aspect of "advanced" art in its embrace, so that the newness of a work of art was one of the conditions of its acceptability.

If the audience for modern art was precipitated from the mixed mass audience of the mid-nineteenth-century salons, the man who did most to provoke it – the first *avant-garde* artist, in the full sense of the word, offering both newness and confrontation – was Gustave Courbet (1819–77), in whom the image of the artist-against-the-system was rounded out. Courbet would accept nothing as a subject that could not be touched, verified as physical fact, in all its weight, density, and embodiment in the world. His refusal to idealize seemed threatening. He was, accordingly, judged either a primitive or a revolutionary, or both. Courbet himself relished this reputation, particularly since it matched his own egotism: "I am Courbetist, that's all," he retorted when asked what school of painting he adhered to. "My painting is the only true one. I am the first and only artist of this century. The others are students and drivellers." No artist, up to then, had ever set himself so firmly against the reigning taste of his day, and none since Goya and David had had a stronger sense of political mission. Everything about him looked threatening, and was so caricatured: his socialist views and left-wing friends like Proudhon, his beefy self, his manifestos of realism, and above all his "coarse," brilliant, unidealistic work. Critics like Alexandre Dumas *fils* attacked him in the sort of language that societies use to punish malefactors, and its wildness seems disproportionate today precisely because, a century ago, painting was held to contain possibilities of disturbance that no one now attributes to it.

Courbet did not invent this social credibility of art for himself; it was his legacy from earlier centuries, in which it had as a matter of course served established power. But although he changed the history of art, his effect on history itself was negligible. The class struggles in France up to Courbet's death in 1877 would have turned out much the same whether *The Stonebreakers* and *Burial at Ornans* had been painted or not. However, our understanding of them would be different. For art does not act directly on politics in the way that *engagés*, from Courbet onwards, hoped it would. All it can do is provide examples and models of dissent. And the "newness" of its language carries no guarantees of its effectiveness, even there.

Nevertheless, as we saw in Chapter 2, the idea of a fusion between radical art and radical politics, of art as a direct means of social subversion and reconstruction, had haunted the *avant-garde* since Courbet's time. On the face of it, it had a kind of logic. By changing the language of art, you affect modes of thought; by changing thought, you change life. The history of the *avant-garde* up to 1930 was suffused with various, ultimately futile calls to revolutionary action and moral renewal, all formed by the hope that painting and sculpture might still be the primary, dominant forms of social speech they had been before the rise of mass media. In uttering them, some of the most brilliant modernist talents condemned themselves to a permanent self-deception about the limits of their own art. Though it hardly alters their aesthetic achievement, it makes the legend of their deeds seem inflated. One is used to reading how the Dadaists in Zurich during World War I struck alarm into the hearts of the Swiss burghers with their antic cabaret turns in the Café Voltaire, their sound-poems and "primitive" masquing; but their real impact on Zurich was negligible in contrast to the significance that (say) the Dada wood-reliefs of Jean Arp have since assumed within the history of art. Even when Dada was politicized after 1918, its actual effect on German politics was nil. In fact, the only *avant-garde* movement in our century that may have affected politics, however slightly, was Futurism, whose ideas and rhetoric (rather than the works of art actually painted by Balla, Severini, or Boccioni) helped supply Mussolini's oratorical framework and set the stage for fascism's cult of armed conflict, speed, phallocracy, and gymnastic authoritarianism. Or was it only that the impact of technology and Nietzsche on the more febrile nationalist-romantic minds of Italy produced similar effusions in art and in politics?

As for the tragic fate of the Russian *avant-garde*, we have already seen how the Constructivists hoped to change their country through art and design, creating not just a style, but a new, "rational" man; and how soon these efforts were snuffed out, after 1929, by Stalin. Artistic *avant-gardes* wither in totalitarian régimes, Left or Right. They are persecuted because, as Ortega y Gasset pointed out long ago, the first effect of *avant-gardism* is to create new élites; the difficult work splits its audience into those who understand it and those who do not. This cleavage does not run along political lines and may not conform to existing layers of power.

The *avant-garde* created these élites by sympathy, the process of mutual recognition – Goethe's "elective affinity." They were gatherings of individuals, not class samples. The art of exception stood to its small audience of exception rather like a sacred text. Its obscurity bound the coterie to the artist, as acolytes to priests. Slowly, a sect crystallized.

But to seek such an audience, to think of it as the right one for *avant-garde* art, was to step away from the ideal of the artist as Public Figure that had been embodied in Courbet's career. Manet and Flaubert never thought themselves "voices of their time" in a political sense. Thus one side of the *avant-garde,* as it developed in the nineteenth century, hated crowds and democracy and stood on its right to develop its discourse without regard for prescriptions about the common good, in what Joyce would call "silence, exile and cunning." Art was above politics and had to be; could one create anything serious out of democratic communion with one's age? Charles Baudelaire thought not: "We have all of us got the republican spirit in our veins, as we have the pox in our bones; we are democratized and syphilized."

Flaubert, Manet, and (above all) Degas also thought not: their realism sought a wintry perfection of nuanced observation, expository, not didactic. It did not aim to show things as they might be but as they actually were. Its model, often invoked by Flaubert, was the objective curiosity of scientific thought, and its aim was to produce a perfectly limpid art in which the world would be mirrored. There is everything in common between the relentless detail in which Emma Bovary's life was built up, and the insatiable, self-delighting curiosity with which Degas viewed the "little rats" of the ballet line working their muscles sore; and both, through their ambition to drown all sentiment in dispassionate analysis, are connected to the "objective," molecular arrays of dabbed light from which Seurat assembled his figures on the speckled lawn of the Grande Jatte. The world is a spectacle which changes itself, but which the artist cannot claim to change. In detachment and irony, art contemplates its disclosure as a language. Its quest for formal perfection, and the sharpening of visual speech, are enough.

From 1880 on, modern art would thus be more gratuitous, ironic, and self-sufficient than ever. It looked esoteric because it was. To see how a Cubist Braque or Picasso from 1911–12 connected to the realities of modern life, with its quick shuttle of multiple viewpoints, its play between solids and transparency, its odd tension between explicit signs (words, numbers, real textures of wallpaper or oilcloth) on the one hand and extreme painterly ambiguity on the other, demanded the kind of sympathetic attention that very few people were prepared to bestow on it. Before 1880, the idea that every work of art contains and talks to its own history, and that this conversation is part of its meaning, was taken more or less for granted as the background to aesthetic experience. With modernism it moved to the foreground, influencing most ideas of what was, and was not, artistically advanced. The more private art became, the more this was so. Advanced art was solitary. It claimed the same rights as the sciences Flaubert took as a literary model – in particular, the right not to be grasped too soon or by too many. This could not have been granted without the intellectual permissions offered by the middle class and a free market. In fact, the American ethos itself dispelled the adversarial role of the *avant-garde.* America embraced change; it was addicted to progress. Just as its business life was suffused with a myth of Utopian innovation (epitomized in the motto of the 1939 New York World's Fair, "Tomorrow's world – Today!"), so its cultural industry came to rely on announcing fresh, unnerving aesthetic changes and telescoping the *frisson* of the Next into the Now. It embraced a businesslike model of novelty and diversity. Nobody *wanted*

an Academy.

Nor did the cultural future look scary, though at the end of the stressed-out, entropic eighties it does. In a former optimistic America, the anguish of the European *avant-garde* – the hostility to the audience that glowers from a Beckmann or even a Picasso – was converted into the idea of advanced art as radical therapy. Hence the opposition between artist and audience nearly vanished. And thus the central hope of the European *avant-garde*, that new art could change society by challenging it, had real difficulty taking root in America. It could only do so as a fiction, supported by tales of cultural martyrdom and transcendence. This sense of simulated tension, basking in the eager smile of an acquiescent public, would lie at the core of much eighties art. Such political art as we have tends to preach mainly to the converted, and in any case no one thinks art can stave off the horrors of the late eighties, from AIDS to crack to the impending greenhouse effect.

Meanwhile, the fetish of stylistic innovation has been deconsecrated, too – though not enough, perhaps, among the cultural bureaucrats of late modernism. We look back on the past and reflect how it has formed the present. But aesthetic value does not rise from the work's apparent ability to predict a future: we do not admire Cézanne because the Cubists drew on him. Value rises from deep in the work itself – from its vitality, its intrinsic qualities, its address to the senses, intellect, and imagination; from the uses it makes of the concrete body of tradition. In art there is no progress, only fluctuations of intensity. Not even the greatest doctor in Bologna in the seventeenth century knew as much about the human body as today's third-year medical student. But nobody alive today can draw as well as Rembrandt or Goya.

Thus, though styles change and names rise like bubbles, the rate of change no longer seems as important – except to the eye of fashion – as it did in 1900, or 1930, or even 1960. But when one speaks of "the end of modernism" (and the idea of a "post-modernist" culture, however ill-defined, has been a commonplace since the mid-seventies), one does not invoke a sudden historical terminus. Histories do not break off clean, like a glass rod; they fray, stretch, and come undone, like rope; and some strands never part. There was no specific year in which the Renaissance ended, but it did end, although culture is still permeated with the remnants of Renaissance thought. So it is with modernism, only more so, because we are that much closer to it. Its reflexes still work, its limbs move, the parts are mostly there, but they no longer seem to function as a live organic whole. The modernist achievement will continue to affect culture for decades to come, because it was so large, so imposing, and so irrefutably convincing. But our relation to its hopes has become nostalgic. The age of the New, like that of Pericles, has entered history. We now face the void of wholly monetarized art, in whose overlit shallows thin voices are heard proclaiming their own emptiness to be (what else?) a "new development."

In the late sixties and early seventies, when so much of the middle-class youth of Europe and America was surging with protest, first against the war in Vietnam and then against racism, sexism, and ecological ruin, it was hard for artists to keep politics out of their

work, whether or not they might privately doubt the public effectiveness of their gestures.

Some did make serious and worthwhile art that reflected their political perceptions. The American artist Neil Jenney (b. 1940) (plate 243) painted views of nature that were iconic details, compressed by their frames. The frames – heavily moulded, in homage to the massive cornices used by nineteenth-century American painters of the heroic view like Bierstadt and Moran – carry the idea of the picture-as-window to the edge of parody. They are also signpainted, with the title of the painting. That the frame is part of the image is emphasized by Jenney's habit of toning its inner edges with white, so that a glow seems to be coming from the picture itself. Inside, one catches a glimpse of broad horizon, a band of achingly pure and silent sky, the trunk of a pine. The frame is a prison for a sign of traditional vastness, the nineteenth-century vision of a pristine America. But look closer and this ideal landscape is cankered, and a sinister cloud spreads upwards from ground zero. Technical perfection evokes a compromised world.

In the tableaux of Edward Kienholz (b. 1927), the imagery of violation, loss, and entrapment could be as palpable as a wall. The solipsism of the figures in *The State Hospital*, 1966 (plate 244), is reinforced by Kienholz's metaphor of the comic-strip balloon, by which the wretched body on the lower bunk is seen to be dreaming only of the identical misery of the patient above. Though the old *avant-garde* claim to change the objective conditions of life through art has gone, the belief that art can regard a wider field than its own processes and still come up with memorable images of it remains in Kienholz and gives special pertinence to the work of, among others, R. B. Kitaj (b. 1932). "It seems to me," Kitaj declared in 1976, "at least as advanced or as radical to attempt a more social art as not to." His idea of a more social art, however, has nothing to do with social realism (plate 245). It is a kind of fragmented history-painting (an effort made, more allusively, by Robert Rauschenberg in the 1960s). Kitaj's enterprise winds back to Eliot's *Waste Land,* being an attempt to see history through the lens of other media – books, photos, enlarged details from movie stills, memories of all sorts of images, from the face of a doomed Jew to the demons tormenting St. Anthony in a Sassetta – combined in a painted montage. It refers obsessively to the chief landscape of Jewish loss, northern Europe in the twenties and thirties, the time of the dictators. When the Mediterranean world appears it is not the sumptuous landscape of pleasure imagined by Matisse and Picasso, but war-torn Catalonia, a red-light district in Smyrna or Piraeus, or the seedy Levantine ambience of Cavafy's Alexandria. Its heroes, whose presences are often invoked by Kitaj's paintings, are the Palinuruses of modernism, the lost helmsmen and "rootless cosmopolitans," wandering Jews and losers of the power struggle: Benjamin, Trotsky, Rosa Luxemburg. Kitaj is fixed on the Diaspora as an emblem of the twentieth century's cultural diffusion and re-centring. Like a literary deconstructionist, denying the possibility of an ultimate meaning for any text, he connects his art to the Jewish scholarly tradition of *midrash* – an accumulated palimpsest of critical interpretation over each line of scripture, producing an "enormous compendium" without an agreed canonical meaning. What generally saves Kitaj's work from the dangers of congestion this poses is his visual flair and his obsessively practised, virtuoso drawing, which runs a gamut of effects from cartooning to sheer lyricism – his are the most erotic nudes in art

243 Neil Jenney *Meltdown Morning* 1975
Oil on panel $25\frac{3}{8} \times 112\frac{1}{2}$ ins
Philadelphia Museum of Art: Purchased, The Samuel S. White, 3rd, and Vera White Collection (by exchange) and funds contributed by the Daniel W. Dietrich Foundation in honour of Mrs. H. Gates Lloyd

244 Edward Kienholz *The State Hospital* 1966
Mixed media construction 96×168 ins
Moderna Museet, Stockholm

245 R. B. Kitaj *Where the Railroad Leaves the Sea* 1964
Oil on canvas 48 × 60 ins
Private Collection, London, Courtesy Marlborough Gallery

today – and comments on a culture of mass reproduction without succumbing to it.

In America in the seventies, art-world politics were influenced by the received ideas of those who, like Herbert Marcuse, argued that *no* act – certainly not the making of images – was apolitical. So almost any art-related gesture, if made in the right lingo, could be claimed as a political act. There was much talk about radical art coalitions and even art "strikes," as though interrupting the art supply would distress the Establishment like a shutdown of oil or airlines. The Minimalist-conceptualist artist Robert Morris in 1970 closed down an exhibition of his boxes and arrays of Styrofoam logs at the Whitney Museum of American Art in New York, in protest against the bombing of Cambodia. If the bombing did not stop, he announced, the show would remain closed. Undeterred by this threat, Richard Nixon and Henry Kissinger did not ground the B-52s. Perhaps the most touching radical gesture of the time was made by a New York artist named Lee Lozano, who announced the enaction of a "piece" in which she would "gradually but determinedly avoid being present at official or public 'uptown' functions or gatherings related to the 'art world' in order to pursue investigation of *total personal and public revolution.*"

In France, however, the vanguard refusenik could go on to become an official State artist. Such was Daniel Buren, who in 1967 announced in a transport of *égalité* that "all art is reactionary" and that the artist, as such, is only a manager of other people's fantasies: "He is 'beautiful' for others, 'talented' for others, 'ingenious' for others, which is a scornful or superior way of considering 'others.'" Buren's solution to the anguish of aesthetic élitism was to exhibit, inside the *Salon de Mai* of 1968, on two hundred billboards all over Paris and on the back of a sandwich-man parading outside the gallery, pieces of green-and-white-striped cloth which looked, to the uninitiated eye, like swatches of identical awning-canvas. "Perhaps the only thing that one can make after having seen a canvas like ours," Buren told an interviewer, "is total revolution." Sure enough, the risings of May 1968 did break out soon afterwards, though one cannot know what role, if any, Buren's striped cloth played in provoking them. Yet by the mid-eighties Buren had become one of the cultural fixtures of the French Left, and Jack Lang gave him the courtyard of the Palais-Royal (one of the richest memory-sites of the early phases of the French Revolution) to impose his stripes on. Buren filled it with stumpy columns of green-and-white marble and half-hidden torrents of chlorinated water making *pipi-*music below – a pointless object, ludicrously out of whack with the Palace and its historical meanings.

Radical artists in the seventies disparaged the art market and the "commodification" of art. The object of their scorn was a seedling, a mere sprout, compared with the invasive monster the art market would become in the 1980s. But Art's economic dependence on Capital caused heartburn. That capitalism was evil in itself and the root cause of all racism, war, and oppression was still a received idea in '68 thinking, among artists, too: period baggage that would not get its long-overdue repacking until the eighties. It chimed with the growing feeling that the aspirations to "heroic" art (the adjective sprouted quotation-marks in the seventies) were somehow phoney, mere sales talk. In this slide-area, one of the few acceptable guides was Marcel Duchamp.

In the late sixties, Duchamp – who within twenty years would be an unconsulted and a nearly forgotten oracle – had risen to the stature, among younger artists, that Picasso had enjoyed in the forties. But there was an important difference. Picasso was the living prototype of the "heroic" modernist, grappling with all the sensations the world could offer, feeding them through his own unabashed emotions – which, in his old age, had lost none of their strength and indeed took on a sardonic sexual ferocity to which there was no parallel anywhere else in twentieth-century painting (plate 246) – and imposing himself on life as freely as Rubens had done. Duchamp, on the other hand, was a poet of entropy. Nobody at the time wanted to grapple with Picasso, but Duchamp opened up a small, distinct area of liberty to which scores of younger artists found themselves admitted. The freedom he offered was fairly gratuitous. It was the dandy's right to perfect a gesture on as small a scale as you wanted. Duchamp invented a category he called "*infra-mince*," "sub-tiny"; it was occupied, for instance, by the difference in weight between a clean shirt and the same shirt worn once. *Infra-mince* was the weight of Duchamp's little phial of Paris air. He had proposed "a transformer to make use of little wasted energies," like a giggle, or the breathing-out of smoke. (Such an instrument would have had its uses in some New York art circles.) In one sense, to bother with such insignificances is pure dandyism, doodling, a way of filling time. But in another, it claims a critical purpose. It says, in effect: art, in the larger frame of things, is small, and one only makes it to think a little more clearly. Nobody, or no one intelligent (in Duchamp's implied view), can presume to change society through art. That was why the German *engagé* Joseph Beuys would presently attack the silence of Duchamp as overrated – though it had not necessarily been more so than the Noise of Beuys.

The cult of *infra-mince* helped set off a general reaction against what had become the standard modernist museum art of America – the big, well-made, opulently coloured "post-painterly" canvas, aimed to give intelligent if sometimes rather diffuse sensuous delight: Frankenthaler, Louis, Noland. In its place was proposed an art so small – indeed, so insignificant – that one would hardly know it was there. Hence the sculpture of artists like Richard Tuttle, whose work consisted of a dun-coloured rag or a piece of bent wire. Tuttle was chosen to represent the U.S.A. at the 1976 Venice Biennale with a piece of unpainted wood a little longer than a pencil and three-quarters of an inch thick. How, after this touching reversal of Roosevelt's injunction to speak softly and carry a big stick, could any visitor possibly complain of American cultural imperialism?

But even reductive gestures like these – beside which Donald Judd's arrays of plain metal boxes or Carl André's much-execrated bricks seem almost Bernini-like in amplitude – were not enough for some artists. In the quest for an inviolable purity it was necessary that the artwork itself should vanish, shake off its contaminating "objecthood," and emerge as Idea. The result was conceptual art, with its lists, propositions, and gnomic ruminations on slight events. Its ancestry went back to Duchamp's *Green Box*, and two of its closer parents were those masters of provocation Yves Klein (1928–62), who once held an exhibition in Paris consisting of an empty gallery, and the Italian Piero Manzoni (1933–63), whose gestures included the publication of an edition of small cans each containing thirty grams of the artist's shit – a comment on the cult of personality in

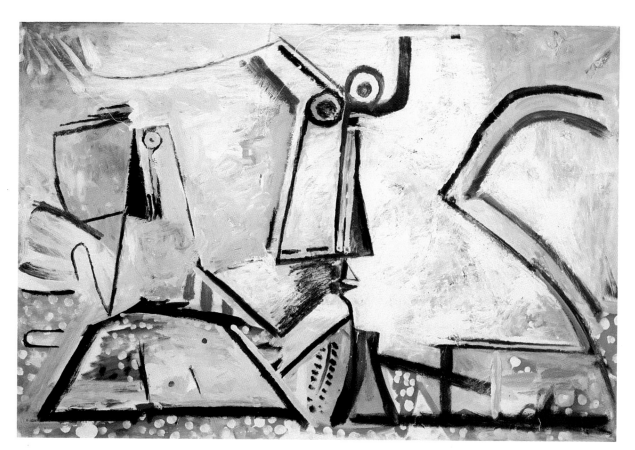

246 Pablo Picasso *Nu Couché et Tête* 1972
Oil on canvas 51¼ × 76¾ ins
Centre George Pompidou (photo B. Hatala)

the Western art market whose succinctness could hardly be surpassed. But most later conceptual art, especially when made in the purlieus of American art schools like Cal Arts – which nurtured much of the art of the eighties – bore no trace of Manzoni's wit or Klein's longing for transcendence. More typical were the inane effusions of the German artist Hanne Darboven, who covered thousands of sheets of paper a year with scribbled numbers, obscure sums, and sentences copied from books.

The obscurity and pointlessness of most conceptual art was made worse by the language in which it came wrapped. "Supposing," began one piece in *Art-Language,* a journal of the seventies, "that one of the quasi-syntactic individuals is a member of the appropriate ontologically provisional set – in a historical way, not just an *a priori* way (i.e., is historical); then a concatenation of the nominal individual and the ontological set in *Theories of Ethics* (according to the 'definition') . . ." One would think such boilerplate would protect an artwork from the caresses of any collector, but one would be wrong. As Lucy Lippard, a leading radical critic of the seventies, mournfully admitted: "Hopes that the conceptual art would be able to avoid the general commercialization, the destructively 'progressive' approach of modernism were for the most part unfounded. . . . Whatever minor revolutions in communication have been achieved by the process of dematerializing the art object, art and artist in a capitalist society remain luxuries."

And yet conceptual art lingers on – partly, no doubt, because, despite the "rigorousness" claimed for it, it was so easy to do. It ensured that no idea, no matter how fribbling or faint, could be altogether ruled out as the *donnée* of a putative work of art. It also enabled ideas about art which were stale, trivial, or both to be recycled in the name of "criticality." The echo-chamber of Duchampian footnotes proved both long and narrow. Among the offerings of the 1989 Whitney Biennial in New York, for instance, was a wall consisting entirely of colour-samples from official buildings in Washington; another wall, covered with blowups of the opacity-designs on "security envelopes," banal interference patterns picked (the artist said) because they looked like the gestural surface of Abstract Expressionism; some framed sheets of fir construction ply whose knot inserts had been copper-leafed to show that they were not *real* knots; and a table packed with ten thousand blue objects like hand grenades, all similar but each a little different, thereby "calling into question" – or was it "ironically asserting"? – the "myth" of "autographic originality."

In the seventies, earthworks and land-art were the opposite extreme from this disembodiment, and although most people knew them only from photos, at least no one could say the works of Michael Heizer, Walter De Maria, James Turrell, and the late Robert Smithson in the U.S., and Richard Long in England, were insubstantial. Too big for the museum, land-art was a literal retreat to the desert, an escape from the horde of casual art-consumers. Turrell's ongoing project involves the partial transformation of the entire, perfect volcanic cone of Roden Crater in Arizona. Smithson's *Spiral Jetty,* 1970 (plate 247), a curl of bulldozed rock along whose top one could walk, was built at the edge of the Great Salt Lake in Utah, projecting a quarter of a mile into the brine and only legible, as a whole spiral, from the air. Today it can no longer be seen, because the lake rose and drowned it. But when one could see it, any visit to the *Spiral Jetty* took on the character of a pilgrimage, because it was so distant and, indeed, so hard to find. One's first

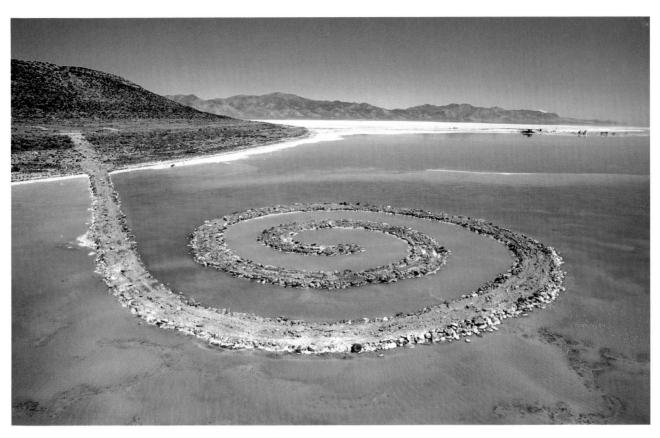

247 Robert Smithson *Spiral Jetty* 1970
(photo Gianfranco Gorgoni/Colorific)

impression was not of a new work of art but of an archaic one – a huge petroglyph imposed on the surface of the lake. Seemingly located outside modernist time, its spiral form held ancient associations, being a meander-maze, the oldest form of the labyrinth. Its museum-defying size was no mere inflation but a necessary element of the work.

Started in 1972, Michael Heizer's *Complex One* stands in a flat desert valley in Nevada, four hours' drive over bad roads from Las Vegas. In form it is a geometrical hill of rammed earth, squared off between two truncated triangles of reinforced concrete, inflected by massive cantilevered concrete beams (plate 248). It is 140 feet long, 110 wide, and $23\frac{1}{2}$ high: a daunting task for one man and a couple of assistants. Seen in isolation on the high desert floor, under the burning blue skin of the sky, with low sagebrush stretching away to the eroded girdling range, *Complex One* is a magnificent spectacle. Even its minatory look, suggesting a bunker, seems proper to the site – the edge of the Nevada nuclear proving-ground.

The Romantics' awe in the face of nature is hard to revive in a culture as estranged from nature as ours but, enfolded in distance and immensity, such works of land-art are saturated in nostalgia for it. The desire to see landscape as the site of transcendental "presence" is particularly clear in Walter De Maria's *Lightning Field,* finished in 1977, in New Mexico, two hundred miles southwest of Albuquerque. Unlike Heizer's architectural mass, De Maria's piece looks mutable, almost evanescent – less a sculpture than a vibration in vast space. It consists of four hundred stainless-steel poles, each needle-tipped, their spikes forming a level plane (like a bed of nails) one mile long and one kilometre wide. Any one can act as a lightning-conductor in the electrical storms that sometimes burst over the desert, but actual strikes on them are rare (plate 249). When the sun is high, the poles seem to vanish. Under the raking light of morning or evening, they become bright shafts. At all times they act as a subtheme to the clouds, rain-squalls, and cataracts of sun.

Between these two extremes of the concept and the earthwork, painting and sculpture did, of course, continue in the 1970s. They were downplayed – these were the years of "painting-is-dead" rhetoric, but that in itself was welcome to serious painters, because it tended to discourage those who did not really want to paint. Its main victim was the idea of abstract art as the culminating mode of painting. By the end of the seventies, one could not have found, anywhere in the world, an artist who thought of it the way Kandinsky or Mondrian once had: as the harbinger of a new heaven and a new earth. Nevertheless, abstract paintings of real distinction continued to be made through the seventies and into the eighties, resisting the pull towards Minimalist self-effacement while continuing to provide models of clear feeling.

In the late seventies and early eighties, it was Frank Stella's fearless panache, linked to the profusion of his output, that most publicly resisted the common idea that abstract painting was played out. From the Fascist lugubriousness of early striped paintings like *Die Fahne Hoch* or *Valle de los Caidos* to the galvanic dance of fake-shadowed solids in the *Cones and Pillars* series of the eighties, Stella wrung more variety from abstract art than anyone else alive. One is apt to think of abstract artists' careers beginning in complexity and ending in reduction with the wisdom of age, like Mondrian's. Stella, so far, has

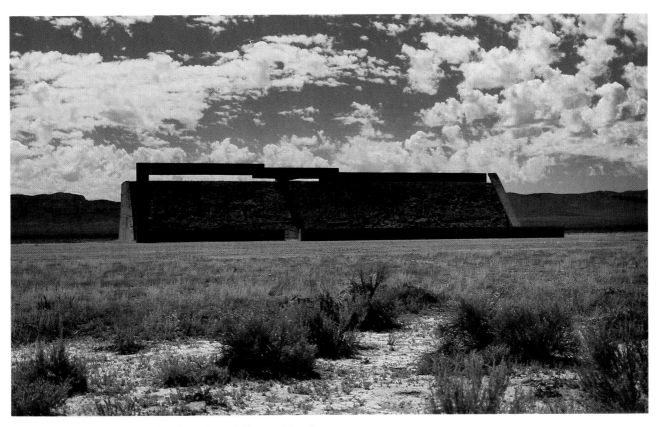

248 Michael Heizer *Complex One, Central Eastern Nevada* 1972
Cement, steel, earth $23\frac{1}{2} \times 110 \times 140$ ft
Collection Virginia Dwan, Michael Heizer
(photo Xavier Fourcade Inc., New York)

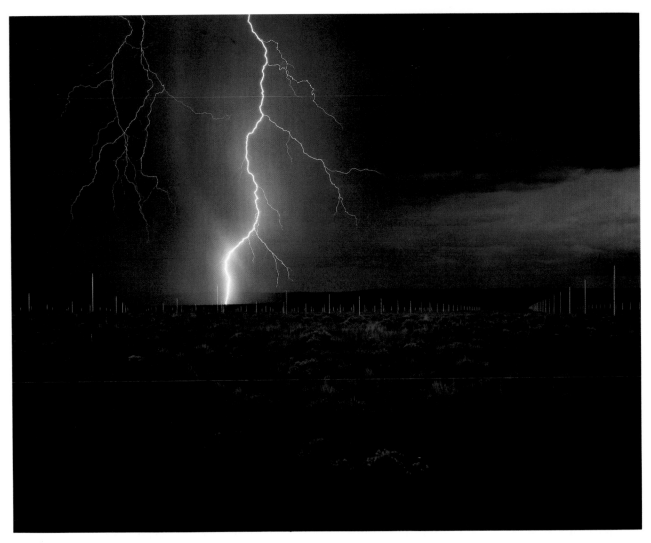

249 Walter De Maria *Lightning Field* 1971–7
Earth sculpture 1 mile × 1 kilometre
Collection Dia Art Foundation (photo John Cliett)

inverted this: he started bare, but complicated his art to the point of apoplexy.

By 1975, he was convinced that abstract painting, for its own survival, would have to learn from Old Masters like Rubens and Caravaggio; it must find "an independent pictorial space to establish its ties with the everyday space of perceived reality." The results were a set of brilliantly coloured oblique reliefs, the "Brazilian" paintings of 1974–5, followed by the "Exotic Birds" in 1976–7. In them Stella now took the Minimalist taste for fabrication (as distinct from hand-making) and used it to carry all that was maximal – hot colour, gestures, and scribbles. This spontaneity was a theatrical fiction. Thinking about Picasso, Stella had come to realize that "It's not the presence of a recognizable figure in Picasso that in itself makes things real, but his ability to project the image and to have it be so physical, so painted." His 3-D paintings, or painted sculptures, descend from Picasso's painted Cubist sculpture, marking the end of its tradition with a barrage of fireworks – a sight both funereal and celebratory. Stella wanted to set forms moving in deep pictorial space and so awaken one's sense of the body. In paintings from the "Indian Birds" series like *Shoubeegi*, 1978 (plate 250), he would replace the solid back plane with a mesh support, so that the agitated, wiggling shapes seemed to hang in the air. Their colour seemed to have gone over the top edge of decorum, especially when heightened with patches of coloured glitter. Not long afterwards, the short-lived vogue for graffiti would release floods of glitz with the same palette, the same eye-grabbing fervour. Both were grounded in a sense of common life, but only Stella made it work aesthetically. He was raiding spray-can art the way Picasso had raided the "primitives" of the Musée de l'Homme.

"When we say a painting works," wrote the English critic Andrew Forge in a memorable passage, "it is as if we are acknowledging that the body is intact, whole, energetic, responsive, alive. This can be said . . . irrespective of whether it is abstract or figurative, stylistically experimental or conservative." And there were certainly other abstract painters of whom it could be said.

One was Bridget Riley (b. 1931). The swelling, wavelike surfaces of her new work had replaced the sharp, unstable arrays of black and white dots she became known for in the sixties – and which had been instantly cannibalized by the fashion industry. But their main content, a sense of slippage or threat to underlying order, remained. What seem, at first, "mere" variations of pattern turn into metaphors of unease, closely tuned uncertainties of reading (plate 251).

In America, even the most cursory sampling of the variety of abstract painting might include Brice Marden (b. 1938), Sean Scully (b. 1945), and Elizabeth Murray (b. 1940). Marden's work was certainly minimal, but not in an abolitionist way: it reflected time he spent in the Aegean. In *Green (Earth)*, 1983–4 (plate 252), an array of long narrow panels is locked together in silent T formations with infills. They suggest the absolute forms of classic architecture, columns and lintels, not presented as diagrams but bathed in a curious stored-up light; their subtle colour is organic, not schematic, and speaks of nature. The surface, much-layered, suggests a history of growth, submergence, and mellowing.

A rowdier artist, a more anarchic maker of shaped and layered canvases, Elizabeth

250 Frank Stella *Shoubeegi (Indian Birds)* 1978
Mixed media on metal relief $94 \times 120 \times 32\frac{1}{2}$ ins
Private Collection, Courtesy Leo Castelli Gallery, New York

251 Bridget Riley *Orphean Elegy I* 1978
Aquatec on linen $55\frac{1}{4} \times 51\frac{1}{4}$ ins
British Council, London

252 Brice Marden *Green (Earth)* 1983–4
Oil on canvas 84 × 109 ins
Courtesy Mary Boone Gallery, New York

Murray also starts in an earlier American vein. The subtle friction of the yellow fingers and pink biomorphic shapes around the central void of *Keyhole,* 1982 (plate 253), has something of the quality of forties De Kooning, sexy and calligraphic at the same time: it is a way of evoking the felt presence of the body as an obsessive subject, but obliquely. And there is a curious discord between the enormous size of Murray's canvases and their domestic emblems – tables and chairs, cups and spoons, an arm, a profile, a breast. Murray is not a "feminist artist" in any ideological sense, but her work emits a sense of womanly experience: forms enfold one another, signalling an imagery of nurture. It is also quite demotic. Her shapes have a cartoony flavour; one of her favourite forms, a swelling lobe pinched at the ends, looks like Popeye's biceps when he is ready to take on the world after the transforming gulp of spinach.

Murray also has a debt to Juan Gris, the quiet master of Analytical Cubism, with his profiles of teacup, *guéridon,* and spoon, their lights and darks fitting together like the notches of a key in the wards of a lock. But Murray's work is coarser, less composed, unstable, and tinged with frank anxiety. However awkwardly, a whole temperament is trying to convey what it is like to be in the world. The effort goes beyond pat categories of abstract and figurative.

Sean Scully's is a fiercer temperament (plate 254). He has stuck to his emphatic stripes now for some twenty years and yet, channelled in this formal motif (which is also a passionately felt *image*), they have become more architectural, a truing and fitting of form with a Doric amplitude to it. Scully's paintings have a bit of the ad hoc quality of his chosen environment – downtown New York, south of Canal Street, with its haphazard, patched, and gridded surfaces of street and wall: a carpenter's geometry but not a cabinetmaker's, still less a Utopian's. The core of his art is the way it is made: not a weightless all-over grid, or a Barnett Newman–style "zip" denoting immeasurable space beyond the canvas edge, but a thick surface of abutments slowly constructed out of an otherwise obsolete technology, paint on cloth, dense with time and labour and useful for nothing except the making of art. Scully's surfaces fairly breathe deliberation and earnestness. Their light and colour relate to the Old Masters: in particular, to Velásquez's silvery greys and ochres over a dark ground. Their *gravitas* is real.

Nevertheless, despite the qualities of such abstract or semi-abstract painting – and the real distinction of some sculpture, such as the work of Joel Shapiro and the precisely inflected, deeply evocative glass-and-steel constructions of Christopher Wilmarth (plate 255), whose premature death at the age of forty-four in 1987 deprived American sculpture of its finest talent since David Smith – the eighties in America, by common consent, belonged to figurative art. That most of the figuration was uncommonly bad seemed, at least for a while, beside the point. And there was a degree of irony here, for in America the turn away from abstraction towards "Bad Painting" – as the clumsy devices of *lumpen*–post-modernism came to be approvingly known – was so often praised by invoking, in a spirit of perverse misunderstanding, a great American painter whose shift from abstract to figurative was not the result of some art-school conversion but a painful moral choice. If one were to pick the outstanding senior American painter of the seventies – whose best work was done in that decade, whose uneasy self-questioning and disturb-

253 Elizabeth Murray *Keyhole* 1982
Oil on 2 canvases $99\frac{1}{2} \times 110\frac{1}{2}$ ins
Collection of Agnes Gund, New York (photo Eeva-Inkeri)

254 Sean Scully *Pale Fire* 1988
Oil on canvas 96 × 147 ins
Collection The Fort Worth Art Museum, Fort Worth, Texas
Courtesy David McKee Gallery, New York
(photo Sheldan Collins)

255 Christopher Wilmarth *Street Leaf (From Mayagüez)* 1978–86
Glass and steel 48 × 72 × 9 ins
Collection of Asher Edelman, Courtesy of Hirschl and Adler
Modern, New York

ing imagery only keep looking deeper ten years after his death – that man would have to be Philip Guston (1913–80).

Every critic has his or her embarrassments, judgements flatly wrong, meanings missed by a country mile. One of this writer's was to somewhat disparage Guston's Ku Klux Klan paintings when they were shown in New York in 1970. Up to then, most people thought they had Guston ticketed and labelled as an Abstract Expressionist with a particular, and very amenable-looking, style: those lyric webs of rose and grey pigment, descending from Mondrian's plus-and-minus abstractions of the sea at Scheveningen, looking like fragments of Monets but with less interior light, which conveyed air and palpitation but nevertheless overtypified him as an abstract painter. Yet it was the prescriptive tone of American abstraction, its presumptuous claim to be the climax and end product of art history, that irked Guston. "I do not see," he had noted in 1958, "why the loss of faith in the known image and symbol in our time should be celebrated as a freedom. It is a loss from which we suffer, and this pathos motivates modern painting and poetry at its heart." It is now easy to see something coming to the surface of his paintings in the 1960s, a solidified form, like a boulder or the back of a head glimpsed in fog (or grey mud) – a thing wanting to be seen. But a figure? Figures belonged to Pop art: they were not the business of high abstraction. Hence the audience's crossed lines and missed connections when Guston's struggling lump became his Ku Kluxers, those squat pointy-headed cartoons of menace riding around with nooses and cigars in their stubby automobiles. Guston had painted such figures in the 1930s and they were resurrected, after the interlude of his abstract work, by his exasperation with the role assigned to art by formalism: "When the middle 60s came along I was feeling split, schizophrenic. The war, what was happening in America, the brutality of the world. What kind of man am I . . . going into frustrated fury about everything – and then going into my studio *to adjust a red to a blue?*"

Incapable of detachment, he was not a Pop artist, and yet his change had something in common with Pop – the desire for an art which was strung between high moral intent (which Pop did not have) and demotic images (which it did). Guston liked comic strips, in particular "Krazy Kat," the work of that graphic genius George Herriman, whose fans also included Joan Miró, Willem de Kooning, and, reportedly, Picasso. But he also adored Piero della Francesca, whose grave measuring of space and weighing of static density – along with some of his actual images, like the scourge in the Urbino *Flagellation* – wind their way into Guston's late work. This, and other affinities with the great tradition (Mantegna, Goya's *Caprichos*, prison scenes, and Black Paintings, or Piranesi's *Carceri* – and, among the moderns, de Chirico), had no more to do with the facile play of post-modernist "appropriation" than his use of comic-strip drawing had to do with Pop irony.

Both served a larger purpose. Guston's modernism, as Dore Ashton has eloquently written, was of a classic and stonily integrated kind. Its domain of imagery was charted by T. S. Eliot – not the later critic, whose bouts of Anglo-Catholic scolding would be sheet-music to American neo-conservatives in the eighties, but the earlier poet of *The Waste Land*, "The Hollow Men," and *Four Quartets*. Guston's paintings in the seventies give form to much the same sense of alienation, post-traumatic emptiness, grim resistant

humour, and lyric glimpses of a saving order that Eliot made visible in the twenties. His landscape of detritus, the scurf and grunge of civilization – "The goat coughs at night in the field overhead . . . rocks, moss, stonecrop, iron, merds" – was Guston's too, and so was his sense of living underneath the monuments, the great signs of a cracked-up culture on the horizon, at the rim of the dried plain, visible but out of touch. To look at a Guston like *The Street,* 1977 (plate 256), is to become aware of these conjunctions. It looks like a war between New York gangs, or bums: the cluster of stamping knobbly legs in their boots opposed by the phalanx of arms, with their trash-can lids. But its arrangement – frieze-like and processional – evokes Roman sarcophagi and, through them, the Hampton Court Mantegnas; the lids turn into classical shields, and the hobnailed boots (each turned to the eye so that one can see the clunky arc of nails) become the shod hooves of Uccello's martial rocking-horses in *The Rout of San Romano.* All this happens quite naturally, by the artist's appeal to a common culture whose preservation was one of the deeper focuses of his anxiety.

After Guston's death, his style, in all its inward-turning subtlety, its mimicry of awkwardness based on a total immersion in *The* culture of painting, was "appropriated" as an emblem by inferior artists. Having breached the formalist wall (whose defenders were fairly somnolent by then, anyway), Guston left a gap through which kitsch expressionism, "clumsy figuration," and "Bad Painting" swarmed, like the bugs in his own paintings. Guston had never been the "Mandarin Posing as a Stumblebum" that a notorious review headline called him, but his "followers" were rarely more than stumblebums posing as mandarins.

By the end of the seventies, the hegemony of American art was done for. European artists were sick of hearing about it, and Americans were unable to sustain it. Wasn't there more to art than the virtuous aridities, the bleeps and buzzes of mild self-consciousness, that had become the menu of American academic modernism? What about myth, memory, fantasy, wit, narrative, faces and figures, and the once-familiar sense of being up against the wall? What about *differences* – the cultural signs that made Catalans unlike Castilians, Berliners unlike Munichers, Neapolitans unlike Venetians, and all of them unlike Americans? Where was the deep Europe that had preceded the last quarter century of postwar reconstruction and still lay under that veneer, below the doings of an internationalized (for which read "Americanized") art world?

Such questions were basic to European art in the late seventies and early eighties, and although the quality of the answers varied greatly, the fact that they were asked at all brought, at first, a feeling of self-possession and relief. Artists set out to recover their own cultural past, including the immediate past of their ancestral modernism. This entailed a rethinking of some priorities engraved on twentieth-century art history by MOMA and its offshoots. Sometimes the sense of the past was deeply internalized in the work, as in Giovanni Anselmo's sculptures, laconic rather than conventionally Minimalist, with their rocks and pigment conveying a highly poetic sense of substance to the territory of dreams once explored by Giorgio de Chirico; or Enzo Cucchi's turgid, apocalyptic

256 Philip Guston *The Street* 1977

Oil on canvas $69 \times 110\frac{3}{4}$ ins
The Metropolitan Museum of Art: Purchase, Lila Acheson
Wallace and Mr. and Mrs. Andrew Saul Gifts, Gift of George
A. Hearn, by exchange, and Arthur Hoppock Hearn Fund, 1983

visions (plate 257), equally invoking the pre-Christian past and the rituals of the modern rural witch, full of farm animals, cemeteries, watchtowers, and huge dreaming heads, which rose from the landscape of his native Ancona. But it could also look like picking over the rejects – for instance, Sandro Chia's pastiches of Italian Futurism, Mussolini-era official art, and "unacceptable" late de Chirico. This revived eclecticism could skate on its own manic energy, as did the cluttered, nervy work of Sigmar Polke (b. 1941), which took for its main stylistic device one of the worst clichés of *lumpen*-modernism – the transparent overlay of images that Francis Picabia had resorted to in the twenties and thirties, but quoted from a wide variety of sources in media, high art, common and élite culture (plate 258). It could also reflect a relatively tranquil connection to the past, as in Ian Hamilton-Findlay's sculpture, in which a transmuted imagery of Arcadia and the classical garden winds together with an acute political sensibility.

The big trans-Atlantic news of the early eighties was German neo-Expressionism. In fact, Expressionism had never quite gone away. It lingered in the seventies behind both land-art (with its implied view of Nature as awesome and sacramental) and body-art (Vito Acconci, Chris Burden, or the Viennese artist Arnulf Rainer).

But the prophet of Expressionist revival was a German, Joseph Beuys (1921–86). Sculptor, maker of happenings, political *Luftmensch*, and fantasist, he became the most influential figure in the European art world and was to no small degree responsible for the eighties upsurge of European confidence in its own art as against New York's. In part, this was due to his magnetic and benevolent character, which, like the Pied Piper's fluting, drew hundreds of young people to the forum provided by an institute he bankrolled, the Free International University in his home city of Düsseldorf. It also sprang from his talent for publicity, which rivalled Andy Warhol's – although Beuys himself lacked Warhol's reamed-out, voyeuristic cynicism. His grey fedora hat and fishing-jacket (which never came off in public) became a trademark as instantly recognizable as Warhol's shades and silver wigs. He was, in fact, the descendant of those "inflation saints" who had once flocked to the Bauhaus in Weimar, but with a genius for self-promotion.

Beuys did not become a professional artist until he was in his forties and had survived a string of crippling depressions; the late conversion of this Luftwaffe pilot and the spiritual anguish that preceded it became an important part of the legend for his fans, who took his role of penitent prophet as seriously as though he were an art-world Luther challenging the American papacy. For them, Beuys's wartime suffering became part of the hagiography of modern art – especially the occasion in 1943 when he crashed in a Ju-87 on the Russian front and was saved by wandering Tartar tribesmen who wrapped his wounded body in felt and fat, thereby planting the germ of Beuys's obsessive interest in these substances as art materials, emblems of healing.

As political artist, Beuys had no orthodox Left ideology. His answer to art's incapacity to directly transform society was to extend the word "artist" to cover everyone – so that art would be any kind of being and doing, rather than specifically *making* – and then designate the whole social fabric, politics and all, as a "Social Sculpture." The Expressionist roots of such fantasies were not hard to see. Art, he declared, "should be a real

257 Enzo Cucchi *Painting of the Precious Fires* 1983
Oil on canvas $117\frac{3}{8} \times 153\frac{1}{2}$ ins
Collection of Gerald S. Elliott, Chicago

258 Sigmar Polke *Paganini* 1982
Dispersion on canvas $78\frac{3}{4} \times 177$ ins
Saatchi Collection, London

means, in daily life, to go in and transform the power fields of the society."

Did it? Hardly. But the best of Beuys's *objects* (not the illusory "Social Sculpture") remain both mysterious and deeply convincing. He was brilliant at using laconic, coarse, gritty, abandoned things to evoke a tragic sense of history. A case in point was his poignant reliquary box for Auschwitz, whose impact came from indirection: no depicted bodies, just things in a glass case, blocks of fat on a battered hot-plate, mouldering sausages, a dry rat's carcase in a pail of straw like a parody of Christ in the manger, a drawing of a child, an engraving of the camp with serried blockhouses. The "artless" quality of Beuys's found objects gave them special conviction.

Many of his larger pieces occupy a middle ground between threat and humour: his swarm of survival sleds (plate 259), each with its blanket, flashlight, and ration of fat, pouring from the back of a Volkswagen bus; or his felt-covered piano, looking like an ill-stuffed grey elephant with two red crosses sewn on its hide. His interest in shamanism and the invocation of animal totems – hare, bee, stag, and the like, scribbled out in countless drawings, moulded in wax, and scratched on slate – has much more to do with the pantheism of earlier twentieth-century northern romantics like Klee or Franz Marc than it does with real anthropology, despite Beuys's hope for an "anthropological" art which could give common human actions the character of ritual. The most memorable image he found to express his belief in the contract between artist-as-shaman and animal-as-totem was his 1965 happening, *How to Explain Pictures to a Dead Hare*, in which he appeared with his head smeared with honey and covered in gold leaf, an iron plate tied to his right foot, muttering inaudibly for three hours to the animal's corpse cradled in his arms.

These mock-rituals, this fiddling with sticks and fat, bones, rust, blood, mud, coarse felt, gold, and dead animals, were meant to embody a state of precivilized consciousness – a familiar modernist theme. But they suggest, as earlier "primitive" quotations did not, that some return to barbarism, or at least tribalism, impends. Hence the popularity of Beuys's art with young romantics; it offered a delicious *frisson* of earth-and-race imagery to people who live in high-rises. In doing so, it helped rehabilitate certain core feelings of German art which had been repressed after the fall of Nazism.

Figural Expressionism had been a German and Austrian invention. It was not simply a twentieth-century art movement, but the end of a vein of imagery that extended from Bavarian folk-carvings and the work of Matthias Grünewald to the Alpine melancholy of Caspar David Friedrich and the ecstatic Nature-worship of Philip Otto Runge. Hitler loathed Expressionism as "Jewish," but some prominent Nazis, led by Albert Speer, had tried to persuade him in the thirties that at least some aspects of Expressionism – its imagery of primordial landscape and rural simplicity, its fondness for peasant motifs and animistic visions of Nature – might serve the Party quite well.

Speer went so far as to propose Emil Nolde, himself a Nazi, as an official artist. Hitler would not hear of this, and so the Expressionists were driven into exile or the camps. Yet this did not mean that German artists, after the war, gladly embraced Expressionism. By then, its "Germanic" qualities, its celebration of the instinctive, the irrational, and the *völkisch*, had become almost as thoroughly contaminated by the fallout from Nazism as

Wagner's music or Schinkel's architecture. Abstract art was now identified with freedom and democracy. It became part of the image of postwar reconstruction: most German artists took to an international style, and wore abstraction the way German architects wore the abstract curtain-wall office-block – as the virtuous uniform of de-Nazification.

Beuys broke this bind. His gift for taking conventionally repellent materials and socially abhorrent memories and converting them, as by a shamanistic act, into oblique visions of history was what touched off the Expressionist revival of the late seventies. He managed to integrate German longings for a mythic past back into modern culture, enabling Germans – for the first time, in the visual arts, since 1933 – to move with an easy conscience amid their inherited Romantic imagery, so fatally contaminated by Hitler.

The result was *heftige Malerei*, "heavy-duty art," a new outpouring from a well thought long-closed. In fact, the "New German Painting" was not all that new; it just took rather a long time establishing itself, especially in America. It went back to the early sixties, most vividly in the work of two young Berlin painters, Eugene Schönebeck (b. 1936) and Georg Baselitz (b. 1938). It acknowledged, in effect, that the fathers – making mild "international" art amid the postwar German rubble – had let this generation down, so that the sons' best hope was to reach back to an older and still painfully sincere form of German self-declaration, Expressionism. Perversely, Baselitz insisted on the "non-objectivity" of his work: "I work exclusively on inventing new ornaments." Nothing could have been less ornamental or abstract than the work he and Schönebeck showed in the early sixties, following on their callow, apocalyptic-sounding *Pandemonium* manifestos – "We want to excavate ourselves, abandon ourselves irrevocably . . . in happy desperation, with inflamed senses, undiligent love, gilded flesh: vulgar Nature, violence. . . . I am on the moon as others are on the balcony," et cetera. Schönebeck's gross homunculi, Baselitz's massive, weakly drawn figures wandering amid piles of rubble, conveyed much of the underside of the postwar "German economic miracle" – a sense of mutilation and inherited defeat, whose arch-symbol was the Berlin Wall. The couple displaying their stigmatized hands to one another in *The Great Friends,* 1965 (plate 260), now look like prophetic emblems of Baselitz's own generation, the bearers of Green eco-politics, Red Army Faction terrorism, and German student revolt in the late sixties.

Schönebeck gave up painting in 1966. Baselitz went on to become a national treasure, issuing repetitive canvases by the vanload from his converted Gothic castle (eight shows a year was not unusual for him), a flood of coarsened product which was, of course, applauded by German critics and cultural bureaucrats as challenging and heroic. (The lingo of *avant-gardism* was brain-dead in English by the eighties, but it survived in other European languages, especially German.) He fell back on one standard device, that of painting his motifs upside-down in order to emphasize their "abstract" qualities while preserving a coarse symbolism of insecurity. Upside-downness has been Baselitz's trademark for fifteen years now. Consequently, his thick, ropy, and nominally impassioned paintings of bathers, bottles, or trees have come to look quite generic; they do not offer a moment's imaginative access to *this* body, *this* vessel, *this* plant; they are merely, as Baselitz himself put it, "motifs," pretexts for visual display. The conflict between Baselitz's thick, bright charades of intense feeling and his stereotyped, voluble output

259 Joseph Beuys *The Pack* 1969
Volkswagen bus with 20 sledges, each carrying felt, fat, and a flashlight
Collection Herbig, Germany

260 Georg Baselitz *The Great Friends* 1965
Oil on canvas 97½×117 ins
Museum Moderner Kunst, Vienna (on loan from Ludwig
Collection, Aachen)

makes much of his work in the eighties hard to take seriously; to compare it to that of an earlier Expressionist master like Beckmann is ludicrous.

But, then, which German neo-Expressionists do compare to their ancestors of sixty years before? Even to pose the question today is to feel a twinge of embarrassment; despite the heat of the eighties market, the backing of the West German Government and a score of corporations, the unstinting praise of critics, and the efforts of museums to enshrine it, most *heftige Malerei* looks hasty, raucous, and woefully inflated. Much neo-Expressionism, oddly enough, now looks like a codicil to Pop art, in which a perpetual *fortissimo* of "expressiveness" – big size, thick paint, contorted figures, staring eyes, haste of facture, and fictive wildness of colour – is quoted cold like any other museum style. There is less authentic feeling in one of A. R. Penck's twenty-foot scrawls of algebraic signs and pseudo-archaic stick-figures than there was in a few square inches of a late Klee. Posterity is unlikely to yearn for the work of Rainer Fetting, Salome, K. H. Hodicke, Helmut Middendorf, and the rest, in all its meretricious haste and blaring awkwardness. Conceivably, out of all the new German painters who emerged at the end of the seventies and were celebrated in the influential shows of the early eighties – *A New Spirit in Painting* at the Royal Academy, *Zeitgeist* in Berlin – the only durable one may be Anselm Kiefer.

Kiefer (b. 1945) was taught by Beuys at the Düsseldorf Academy, and his work still carries Beuys' imprint in its materials – tar and straw, rusty iron and lead. His enormous paintings, whose accumulation of all-over detail shows a considerable debt to Pollock as well as to Beuys, are historical emblems with mystagogic overtones. Their obsessive subject is the fatal collision of German and Jewish history, and this has raised the accusation that Kiefer has played with "fascinating fascism" simply to give his work an unearned moral weight. This is certainly unfair, although – just as certainly – his pictorial rhetoric sometimes does cave in under the load of the history it invokes. A partial list of its referents would include alchemy, the Kabbalah, the Holocaust, the story of Exodus, Napoleon's occupation of Germany, the neo-classical kitsch of Nazism: heavy freight, even for large paintings to carry. What may be Kiefer's most humanly poignant cluster of images was provoked by "Death Fugue," a poem written in a German concentration camp by Paul Celan, which runs in part:

> Death is a master from Germany his eyes are blue
> He strikes you with leaden bullets his aim is true
> a man lives in the house your golden hair Margarete
> he sets his load upon us he grants us a grave in the air
> he plays with the serpents and daydreams death is a master from Germany
> your golden hair Margarete
> your ashen hair Shulamith . . .

Margarete, the blonde personification of Aryan womanhood, and Shulamith, the cremated Jewess who is also the archetypal Beloved of the Song of Solomon, interweave in Kiefer's work in a haunting and oblique way. Neither is seen as a figure – Margarete's

261 Anselm Kiefer *Sulamith* 1983
Oil, emulsion, woodcut, shellac, acrylic, and straw on canvas
$114\frac{1}{4} \times 145\frac{3}{4}$ ins
Saatchi Collection, London
(photo Anthony J. Oliver)

presence is signalled by long wisps of golden straw, while Shulamith's emblem is charred substance and black shadow. Thus with *Sulamith*, 1983: a Piranesian perspective of a squat, fire-blackened crypt, the paint laid inches thick in an effort to convey the ruggedness of its masonry (plate 261). It is taken from a Nazi architect's design for a Wagnerian "Funeral Hall for the Great German Soldiers," built in Berlin in 1939. The Hitlerian monument becomes a Jewish one; at the end of this claustrophobic dungeon-temple is a small fire on a raised altar, the Holocaust itself.

Kiefer's talent is for the motif, the image, and he is not a formally inventive artist. His drawing lacks fluency and clarity, and his colour is monotonous, though the former seems to reinforce the grinding earnestness of his style and the latter certainly contributes to its lugubrious intensity. But his work, for all its magniloquence, carries its messages without the pompous narcissism that afflicts so many of his peers.

Certainly there was no one like Kiefer in New York, whose old role as the imperial centre of late modernism began to show bad signs of wear in the eighties. But these signs were (at least at the beginning of the decade) partly hidden by a frenetic surface of reputation-making, critical hog-calling, and market promotion. Andy Warhol's *work* made its final descent into feeble kitsch, but the messages of his *career* – that the fashion industry was the prime model of culture and that the business of art was business – came down like an avalanche, in the midst of the biggest art-market boom in history.

In the eighties, the profile of the art boom of the sixties reversed itself. Fifteen years before, amid the clamour with which America discovered the culture of youth as an end in itself and sought to identify late adolescence with visionary truth and political morality, art tended to be absorbed in its own processes (Minimalism) or high-mindedly decorative (colour-field). Whatever pigs and Fascists might be denounced from the pulpit of the college barricade, whatever mutations the moral anguish of Vietnam might wreak on verbal discourse, the stained field and the minimal box retained their Apollonian character; and youth per se was generally seen as one more technical problem an artist must deal with on the way to maturity. In the early eighties, the exact opposite held true. Though the American Left was demoralized and in full retreat, the art world came to regard youth per se as a sign of merit – "freshness," "new talent," fodder for a suddenly booming mass market.

A quite different America had emerged from the closet with Ronald Reagan's arrival in the White House. Its atmosphere was one of benign, coarsely ideological opportunism – of Feelgood government by public relations and image-management. America in the eighties embarked upon a politics of hypocrisy and reassurance that meshed perfectly with its culture of celebrity and promotion. Reaganism made extravagance okay – more okay, indeed, than it had been since the Vanderbilts ran up their "cottages" at Newport in the 1890s.

Art was the perfect commodity for this ethos. America (not even counting Europe) now held more than a million millionaires – many of them serious, eight-digit millionaires. Gradually at first, and then with a collective rush of enthusiasm, this army of potential collectors realized that art was the only commodity that you could spend

limitless amounts of money on without looking coarse and ostentatious. Marble baths only meant wealth, but Jasper Johns offered transcendence. The more art you bought, the more of a prince you seemed. Every greenmailer became his own Lorenzo. Hollywood producers who until the eighties had been minding their traditional business, which was to drench the airwaves with glitz and muck, now blossomed forth with private museums. The sabre-toothed realtor might still suppose that Parmigianino was a kind of cheese, but he had learned to pronounce the syllables of Jean Baudrillard's name and to murmur knowledgeably of post-modernist irony. Like caribou migrating across the northern tundra, ruminant herds of art-interested folk cruised the galleries of West Broadway and the East Village, sometimes alone in their limos and sometimes chivvied along in groups by professional art advisors, thoughtfully munching on the new and the interesting. Thus art, for the first time in history, faced mass-market conditions. Every other American, it seemed, had come to believe that the ownership of works of art lent not only social but also a kind of moral distinction: the De Kooning in the living room suggested worth, more dramatically than the Bible in the parlour of an older America. But there were not enough De Koonings (or older art of any kind) to go round.

In 1980, the three most expensive paintings ever sold at public auction were Turner's *Juliet and Her Nurse* ($6.4 million), Velásquez's *Portrait of Juan de Pareja* ($5.4 million), and van Gogh's *The Poet's Garden* ($5.2 million). These prices seemed scandalous and spectacular at the time. Today they would be almost too low to bear reporting. The art market by the end of the eighties had become a bullring of deranged fetishism, in which van Goghs could sell for $35 million to a Japanese insurance company and $53 million to an Australian brewer; where *Yo Picasso,* a small early self-portrait of no special importance, auctioned for some $5 million in the mid-eighties, went in 1989 for $47 million; where even a work by a living artist, Jasper Johns's *False Start,* could and did make $17.7 million on the block. Such prices have already done incalculable damage to the idea of art as a socially shared medium, freely accessible to thought and judgement. In the end, they may destroy it altogether, with very few areas of exemption. The glittering and exorbitant surface of the art market does not conceal an immense sourness: the death of the old belief that great (and not-so-great) works of art are, in some sense, the common property of mankind. Locked in its frame of preposterous "value," the masterpiece becomes an instrument for striking people blind.

It is of course a long drop from these price-levels to those of most contemporary art, but there was (to use a phrase beloved of Reagan-decade economics) a trickle-down effect. The stuff most consumed by the new mass market was newly made, and the market project of post-modernism was to persuade its audience of the ultimate value of the temporarily fresh. (Naturally, every flatulent cliché of the *legenda aurea* of vanguardism was dusted off and recycled.) The faculty that enabled one to shoot from the hip and hit the Future before its prices quintupled was solemnly described by one New York art dealer and collector, Eugene Schwartz – in a term borrowed from the jargon of the stock exchange – as "apperceptive mass." With hundreds, and then thousands, of aspirant collectors diligently flexing their new-found apperceptive masses, the New York art world by the mid-eighties had begun to bear more than a passing likeness to Utrecht at the

height of the tulip mania.

Perhaps its barely dissembled hysteria would not have mattered so much if the new material it enshrined had possessed the solidity of the best American art in the fifties or sixties, but not much of it actually did. (There was a lot of bad American art in those days, too, but at least some of it has been winnowed out by time.)

Yet, despite the hype and hullabaloo, too much of this new art was risk-free, tethered to small experiences and shrunken pictorial ambitions. In fact, its prevalent tone of voice came not so much from within the fine-art traditions as from mass media – especially, television. This was the first generation of American artists to have grown up in front of the Box, glued to the nipple of electronic kitsch since infancy, imbibing its ultrafast change of images, its throwaway cool, its predilection for banal narrative, and its fixation on celebrity. Within twenty years of the birth of Pop, television had produced a common culture from which the first-hand experience of nature was virtually obliterated, except (through the ecology movement) as a subject of political concern. This culture was permeated with a curious and distancing sense of replay. It was image-saturated to a previously unimaginable degree. Herein lay a problem for the American *fin-de-siècle*. When the whole world, including the images of its culture, comes to us ticketed and labelled in advance, the habit of surprise is overtaxed; novelty seeks a faster turnover and a coarser vividness. Art can be overconsumed, and in the eighties it was.

Whole categories came back, but not in their original form, having mutated in an exacerbated awareness of their own history. You could not (it was felt) naïvely "express," but you could quote the language of expression. Thus all art, recycled from the collective memory-bank of reproduction and museum display, seemed to aspire to the condition of Pop art. Movements came back as simulacra of themselves, a process well suited to the Alexandrian phase of modernism, a culture obsessed with recycling and academic quotation. The hot word of the early eighties was "appropriation," which sounded more dynamic than just "quoting" someone else's art and more respectable than merely "plagiarizing" it. Thus Sigmar Polke's appropriations of Picabia's "transparencies" would in turn be appropriated by a younger American artist, David Salle (b. 1952); while the very cultural construct of the artist-as-hero would be appropriated and turned, as by the touch of the alchemist's wand, into leaden cliché by Julian Schnabel, a roundly self-admiring painter who once went so far as to tell a reporter that Duccio, Giotto, and van Gogh were "my peers."

In the eighties, one experienced the full force of a culture of reruns and of the peculiarly dislocating effect it can have on whatever is aesthetically specific. Like television itself, rerun culture tends to erase the sense of being in a given place at a given time. It is both hungry for revivals and tormented by a sense of *déjà-vu* – born of the total availability of all images. In its perfect availability, reproduction tends to overwhelm direct experience of art on the museum wall. Through weightlessness, it promotes discontinuity. Could one construct an oeuvre around inflections of meaninglessness? Like a distracted viewer spinning the TV dial, David Salle certainly tried: his tangles of imagery with no clear narrative line, taken from photographs, movie stills, and fine art, proposed a derisive inertia, a cool indifference, as the hip way of seeing. Scarcely even

competent as a draftsman, Salle nevertheless did tell a truth about the image-glutted conditions of seeing in the mid-eighties, and his work did bear faint signs of social meaning within its emptily eroticized stylishness. This may not have been much, but at least it was better than the diet of pseudo-primitivism and wild-child candy served up at other counters of the post-modernist delicatessen.

Yet there was a core of worthwhile art made by younger New York artists in that overstressed decade. Thus, apart from the abstract and semi-abstract artists mentioned earlier (Scully, Marden, Murray), there was, for instance, the gravely iconic work of Robert Moskowitz (plate 262), and that of Susan Rothenberg (plate 263). Rothenberg came out of Minimal art into figuration in the mid-seventies with, of all things, pictures of horses: equine silhouettes, emblematic not descriptive, embedded in flat space. Their "primitive" look was, in fact, quotation; it was clear from her knowing use of close-valued colour and her pasty, elegantly manipulated pigment that she was already an artist of considerable sophistication. It seemed less certain where she could take this quasi-heraldic imagery. But she clove to the (equally emblematic) human figure, presenting it as a collection of parts, signs, and fragments: an open mouth, a lump of a head, or a set of sequential images of a reaching arm that seemed to stutter across the canvas in a condition of terminal insecurity. The work looked muffled, ineloquent, and infrangibly sincere. It spoke of emotional implosion and survival. There was an intriguing contrast between the toughness of her pictorial means, and the anxiety they suggested. Together, they did not so much portray pathos as embody it.

Yet the presence of a few such artists was not enough to dispel the suspicion that New York was going the way Paris had gone after 1955. The demoralized, wounded, and yet still mesmerizing colossus of Manhattan remained a monumental centre, of course – the Karnak or Babylon of modernism; and as a cultural *bourse*, a place where art was traded, it had reached a point of inflationary power never seen in the world before. But just as, by the eighties, it was evident that for the first time in three hundred years no truly great artist was at work in Paris, so the sense of loss and slippage in Manhattan was deep. Culture was too decentralized now for the imperial model to hold. If New York curators felt graffiti and other trivia were the "significant" art of the next fifteen minutes, why should artists in Chicago, Sydney, or Brussels take that seriously? Why should anyone care about the porcelain inanities of a Jeff Koons, let alone suppose that they posed "issues" that should be responded to?

By demonstrating the bankruptcy of "innovation," the eighties inadvertently changed the old modernist relation between form and feeling. Once the task of modernism had been to find radically new forms, from which new feelings would naturally be born. But Minimalism had been the last art movement of this kind, and after it the idea of formal "innovation" was played out in a welter of low novelty-art. Thus the serious artist needed to go deeper into feeling, even at the risk of looking "conservative." (Museums would lose sight of this in the eighties; on both sides of the Atlantic, they clung to their decaying fictions of the "progressive" with the same obstinacy that had led them, fifty years earlier, to exclude the modern.)

And so the greater share of the effort to recover depth of feeling and obstinate

262 Robert Moskowitz
Thinker 1982

Oil on canvas 108 × 63 ins
The Helman Collection,
New York
Courtesy BlumHelman
Gallery, New York

263 Susan Rothenberg *Up, Down, Around* 1985–7

Oil on canvas 89 × 93 ins
Collection of Gerald S. Elliott, Chicago, Courtesy Sperone
Westwater, New York

individuality for painting was carried, almost unnoticed at first, by artists in England. One of them was Howard Hodgkin (b. 1932), whose work cannot readily be classified as either abstract or figurative, though it is subtly autobiographical.

Hodgkin is distantly related to Roger Fry, and one of his vividest childhood memories was of brightly coloured furniture from the Omega Workshop, echoes of which (along with those of icons and miniatures) survive in his own tablets of painted wood. He grew up in libraries and gardens, and his sense of scale relates to enclosure: the page of a book, the space of Moghul miniatures, with their brilliant colours and complex interior framing. (For Hodgkin a very large painting is three feet square.) The special aura of his work is an intimacy that verges on voyeurism but suppresses anecdote. It arouses curiosity but in the end frustrates it.

The surface does not idealize its own flatness or spread, like colour-field painting. Indeed, it seeks the opposite, a compression: "Infinite riches in a little room." Landscape or interior, every image is an imaginary opening – a scene, framed tight, sometimes like a miniature stage, with planes that suggest flats, wings, and a proscenium. Within it the blobs of colour quiver in their congealed, pasty light. Colour is the penumbra of sensuous association which conjures up a whole cast of half-negated objects: you could illustrate Mallarmé with Hodgkin. His space is constructed purely in terms of colour, a project rare in English painting. He risks using it at extreme saturation, and gives it a singular power to evoke mood; it can be by turns radiantly joyous, sharp, pensive, almost oppressively sumptuous (the light in the reds and cadmium oranges in *Dinner in Palazzo Albrizzi* is helped by an underlay of gold leaf, which also tacitly alludes to the gold mosaics of San Marco), or lavishly atmospheric in its big limpid brushmarks.

Can one speak of a "School of London" in the seventies and eighties? No, if the words mean a common style shared between artists. Yes, if they are only meant to acknowledge the presence of a few singular talents, cross-linked by shared sympathies, defending the value of their differences from the received values of art elsewhere. Plainly, England now has a majority, if not a monopoly, of the best figurative artists in the world: Francis Bacon, David Hockney, R. B. Kitaj, Leon Kossoff, Frank Auerbach, and Lucian Freud, a formidable roster whose last three names meant very little outside England at the start of the eighties.

For most of his career, Frank Auerbach (b. 1931) was seen as a murky Expressionist who made obsessively thick paintings – a marginal figure, rendered more so by his habit of drawing in museums and working from the live model. Actually, he was no more an Expressionist than Giacometti had been.

Born in Berlin but raised from childhood in England, Auerbach studied with David Bomberg (1900–57), the much-underrated former Vorticist. Bomberg held that the sense of touch precedes and is more psychologically profound than the sense of sight. To draw, he insisted, was to create an architecture of touch and weight. He spoke of "the spirit in the mass," and of drawing as "a set of directions" – a belief that left its mark in the weight and emphatic scaffolding of Auerbach's work. Bomberg's teaching set Auerbach against the thin, linear, post-Cubist look of most English art in the early fifties – "I have to begin with a lump in my mind."

264 Howard Hodgkin *Dinner in Palazzo Albrizzi* 1984–8
Oil on wood $46\frac{1}{4} \times 46\frac{1}{4}$ ins
Collection of the Modern Art Museum of Fort Worth,
Museum Purchase, Sid W. Richardson Foundation Endowment Fund

From the outset, he painted the same sitters over and over again, always in the studio, never from memory. Without the model in front of him he could not invent, there being no resistance in what is simply made up. And resistance, in Auerbach's terms, is very much a value. So is newness, which for him has nothing to do with *avant-garde*-ness. Newness is existential, not stylistic. "Real style is not having a program – it's how one behaves in a crisis."

Newness rises from repetition. It is the unfamiliar found in the midst of the most familiar sight: "To have done something both unforeseen and true to a specific fact." Auerbach's work (plate 265) is full of observed facts of posture, gesture, expression, gaze, the configuration of the head in all its parts, the tenseness or slump of a body. The brush does not so much "describe" these as go to inquisitorial lengths in finding kinetic and haptic equivalents for them. A dense structure unfolds as you look. The essential subject of the work, however, is not that structure as a given thing, but rather the process of its discovery. The image stays mobile and open to radical change right up to the last minute. If the "lump in my mind" works, it is because the sense of idiom has somehow been changed by the vehemence of transposing sight into marks. "The struggle with the canvas *expels* style, somehow – one can only tell the brute truth in the middle of a quarrel." The long-term movement in Auerbach's work since the fifties has been from opacity to clarity, from densely piled paint to more immediate rhythms of drawing and a Venetian amplitude of colour – notably in his landscapes of Primrose Hill, which with their dewy freshness, their rush of wind and weather captured in Auerbach's hooking line, bear comparison to Constable.

The meaning of such painting, and of Leon Kossoff's, too, lies beyond mere optical pleasure; it is the result of a very deliberate, highly self-critical effort to seize the immediate and the concrete, to find equivalents for haptic sensation in paint. This seizure and squeezing of reality goes on in Lucian Freud's work, too, but in a colder way. Freud's gaze on the human body is infamous for its supposed detachment. Every burst vein and inch of sagging flesh, each tuft of pubic or armpit hair is set forth, not "clinically," but stripped of narrative and sentiment. The image, in a favourite word of both Freud's and Auerbach's, compels assent by its "rawness." No modern nudes are more densely packed with bodily life. The ability to re-form the naked body in terms of clear, energetic shape while seeming not to lose a pore, not a hair, of its tensely scrutinized presence – as in *Naked Portrait with Reflection,* 1980 (plate 266), with its extraordinary drawing of the woman's breasts and thorax – seems to define Freud's idea of pictorial truth. The body is new every time, and the whole of it is a portrait. Because he wanted the body to carry the expressive force that the face would otherwise pre-empt, "I used to leave the face until last. I wanted the expression to be in the body. The head must be just another limb. So I had to play down expression in the nudes." There was no "formal system" in Freud's shapes – no sphere-cone-cylinder devices for making a reliable little pictorial engine out of that most unreliable, mutable, and fierce of pictorial objects, the human body. The work is full of radical elisions, but these are not so much the result of a liking for certain kinds of distortion as "the result of forced necessity from moment to moment." As a result, no painter since Picasso has made his figuring of the

265 Frank Auerbach *Head of J.Y.M. I* 1981
Oil on board $22\frac{1}{8} \times 20$ ins
Marlborough Fine Art (London) Ltd.

266 Lucian Freud *Naked Portrait with Reflection* 1980

Oil on canvas 90 × 90 ins
Private Collection, Courtesy Odette Gilbert Gallery, London

human body as unsettling an experience for the viewer as Freud's.

The realist impulse was felt elsewhere in the seventies and eighties: in Spain, with the minutely observed yet structurally expansive work of Antonio Lopez Garcia (b. 1936), whose still-lives carried on the seventeenth-century Spanish tradition of the *bodegón*, all stillness and molecular intensity. The most interesting realist in France was an Israeli living in Paris, Avigdor Arikha (b. 1929). Small, low-coloured, and high-keyed, Arikha's paintings imply a loathing of spectacle, of the tyranny of impact. They are single images, enumerations of ordinary objects – a battered pair of black shoes, a pottery jug, or a Manet-like bunch of asparagus tied in blue paper – set down with an odd undercurrent of unease, and imbued with a sense of the difficulty of any kind of description. Trying to stabilize a sight in the midst of an unpredictable frequency of markings, Arikha's work is all concentration and breathes an air of scrupulous improvisation and anxiety: "To paint from life at this point in time," he argues, "demands both the transgression and the inclusion of doubt."

Realist painting also re-emerged in America, though less convincingly than in Europe. Andrew Wyeth's ridiculously overpromoted Helga paintings looked like pious deodorant ads beside Freud. Although the fact that many American artists were now staking their claim to attention on having revived a tradition showed how far the temper of the art world had swung from *avant-gardism*, it was also clear that few of them could meet the standards which that tradition demanded. Their work tended to have a quality of excess declamation, like Alfred Leslie's huge versions of Caravaggio and David; or else they were simply inert tonal figure-painting, ploddingly drawn. A notable exception, who made a virtue of a cold and laboured approach to the studio nude, was Philip Pearlstein (b. 1924). Pearlstein's paintings have nothing seductive about them. The naked bodies are edited and cropped by the canvas edge, like photographic images. The paint surface is tallowy and matter-of-fact; the colour, dry. Yet works like *Female Nude on a Platform Rocker*, 1977–8 (plate 267), have considerable intensity as visual argument. Pearlstein's dispassionate drawing gives the whole mass of the body an analysed presence, and in its perceptible vehemence of thought seems to be beyond mannerism. There was, in fact, something in common between the blunt discourse of Pearlstein's approach and the tough, detached polemic of much American abstract art in the sixties. Both recognizably come from the same culture, where what you see is what you get.

Apart from Wyeth, the most popular figurative artist in America during the 1980s continued to be an Englishman, David Hockney (b. 1937). In the 1970s, the idea of a depictive painting that was both sociable and serious did not strike American artists as altogether worth having, and Hockney's visual elocution – detached, amiable, but sharply discriminating – was more enjoyed in the galleries than emulated in the studios. By the eighties, he looked unique, an act without followers. Perhaps only a foreigner could have come up with such an affectionate image of the blank good life under the California sun as Hockney's *A Bigger Splash*, 1967 (plate 268); its mildly astringent quality sets it at a distance from the fulsome accumulations of fact about suburbia in American Photo-Realist painting, but it is the demonstrated mastery of means that makes it live – the sheer virtuosity with which Hockney could render the white veils of water thrown up by the

267 Philip Pearlstein *Female Nude on a Platform Rocker* 1977–8
Oil on canvas $72\frac{1}{4}\times96$ ins
Brooklyn Museum, New York, J. B. Woodward Fund

body as it is swallowed by the blue, a vanishing-act watched by absences, with all degrees of stylization in perfect balance. No wonder that Hockney, the Cole Porter of figurative painting, should so often and so exaggeratedly have been taken for its Mozart.

America also ritualized the display of emotional wounds, the quest for therapies; and that, as much as anything else, may explain the success of a painter whose work was partly based on realist conventions, Eric Fischl (b. 1951). On a certain level, Fischl's work is pure Hollywood: an art of hand-painted, keyed-up film stills, fragments of psychic plots that tell of the pangs of parental estrangement, adolescent rebellion, and emptiness in the suburbs. Fischl declares his theme to be "the crisis of American identity, the failure of the American dream." With rueful scorn, his narratives fix on the white middle-class world from which he came (plate 269). They are relentlessly adult-hating: a sour, discontinuous serial, packed with tension, farce, and erotic misery. Fischl country is suburban Long Island. It smells of unwashed dog, barbecue lighter fluid, and sperm. It is permeated with voyeurism and resentful tumescence. Fischl's style of painting comes out of thirties realism – mainly Edward Hopper, with a retrospective dash of Winslow Homer, though without the pictorial and formal control of either. Despite its many solecisms of drawing and awkwardnesses of figure-composition, it has much the same emotional appeal to over-shrunk American collectors that pictures of orphans by Sir Luke Fildes did to Victorian philanthropists.

Among Americans, the conditions of art education had not favoured serious figurative painting. Indeed, they were so set against it that they nearly severed its roots. Traditions are not self-sustaining; they can be wrecked in a generation or two if their essential skills are not taught, and late-modernist American art education did just that – naturally, in the name of "creativity." It was a good deal easier to give a graduation passmark for photographing 650 garages in suburban San Diego, or spending a week shut in a gym-locker at UCLA with a urine-bottle and calling one's ordeal "a duration-confinement body-piece," than to insist on even moderately exacting and hence "élitist" tests of technical prowess. Fischl, as a student in California in the early seventies, had to endure "life classes" which consisted merely of the students' rolling naked on the floor and splashing one another with paint. But the full effect of this educational liberalism was not felt until the eighties produced a depictive revival mostly carried out by the worst generation of draftsmen in American history. In part, the collapse of training was due to glut – the overpopulation of art schools, caused by the general delusion that art is therapeutic. Every year in the 1980s, about 35,000 graduate painters, sculptors, potters, and other "art-related professionals" issued from the art schools of America, each clutching a degree. This meant that every two years the American educational system produced as many aspirant creators as there had been *people* in Florence in the last quarter of the fifteenth century. The result was a Fourierist bad dream. Secure in the belief that no one should be discouraged, the American art-training system had in effect created a proletariat of artists by the end of the seventies, a pool of unemployable talent from which trends could be siphoned (and, if need be, abandoned) more or less at will. But the woozy sense of aesthetic democracy it promoted also weakened the ideal of mastery just at the moment that it came under attack from every deconstructionist in

268 David Hockney *A Bigger Splash* 1967
Acrylic on canvas 96 × 96 ins
Private Collection, London

269 Eric Fischl *Bad Boy* 1981
Oil on canvas 66 × 96 ins
Saatchi Collection, London

academe. In this way, the dominance of mass-media imagery – of art which took the effects of mass media as its given field of enquiry – was reinforced, thus driving art down even further towards the status of a footnote. A cloud of uneasy knowingness has settled on American painting and sculpture. Its mark is a helpless scepticism about the very idea of deep engagement between art and life: a fear that to seek authentic feeling is to display naïveté, to abandon one's jealously hoarded "criticality" as an artist.

The contrast between our *fin-de-siècle* and the last seems blinding: from Cézanne and Seurat to Gilbert and George, in just a hundred years. The year 1900 seemed to promise a renewed world, but there can be few who watch the approach of the year 2000 with anything but scepticism and dread. Our ancestors saw expanding cultural horizons, we see shrinking ones. Whatever culture this millennium brings, it will not be an optimistic one. Perhaps (or so one devoutly hopes) artists are waiting in the wings now as they were a century ago, slowly maturing and testing the imaginative visions that will enable them to transcend the stagnant orthodoxies of their time, the endgame rhetoric of deconstructionism, the crust of late-modernist assumptions about the limits of art. An exacerbated sense of irony – necessary condom of the new *fin-de-siècle* – makes us doubt that the sense of virgin territory that beckoned modernism onwards will be waiting for them. But can we really be so sure? It is a curious fact of art history, perhaps only a coincidence but perhaps not, that its entries upon fresh creative cycles after periods of exhaustion so often fall between the years '90 and '30. The essential lineaments of fourteenth-century painting had been fixed by 1337, when Giotto died. The main visual forms of the Florentine Renaissance had been created by Masaccio, Brunelleschi, and Donatello by the time of Masaccio's death in 1428. Between 1590 and 1630, the language of Western art was rewritten by Caravaggio, Rubens, Bernini, Poussin, and the Carracci. A similar "reradicalization" showed itself between 1785 and 1830, with David, Goya, Turner, and Constable. In each case, the first rush of creative ebullience was followed by winding-down, academization, and a sense of stagnancy which fostered doubts about the role, the necessity, and even the survival of art. So, too, with our own century.

BIBLIOGRAPHY
AND INDEX

BIBLIOGRAPHY

I have not tried to list all the sources – articles, taped interviews, books, and films – consulted in preparing *The Shock of the New*. But since this is a book for the general reader, I append a list of books that may well be of interest for further reading. Certainly they have helped me. They do not make up a full bibliography on modern art – a daunting and perhaps impossible task by now – but they seem to me to represent, with a decently close texture, at least some of the critical debate surrounding it.

Ades, Dawn *Dada and Surrealism Reviewed*. London: Arts Council of Great Britain, 1978. New York: Barron, 1978.

Andersen, Troels *Malevich*. Amsterdam: Stedelijk Museum, 1970.

Andersen, Troels (ed.) *Vladimir Tatlin*. Stockholm: Moderna Museet, 1968.

Andersen, Wayne and Klein, Barbara *Gauguin's Paradise Lost*. New York: Viking, 1971.

Apollonio, Umbro (ed.) *Futurist Manifestos*. London: Thames & Hudson, 1973. New York: Viking, 1973.

Arnason, H. H. *History of Modern Art*. London: Thames & Hudson, 1969. New York: Abrams, 1969.

Arnason, H. H. *Robert Motherwell*. New York: Abrams, 1977.

Barr, Alfred H., Jr. *Picasso: Fifty Years of His Art*. New York: MOMA, 1946; revised & enlarged edn, 1974. London: Secker & Warburg, 1975.

Barr, Alfred H., Jr. *Fantastic Art, Dada, Surrealism*. New York: MOMA, 1947.

Barr, Alfred H., Jr. *Matisse, His Art and His Public*. New York: MOMA, 1974.

Battcock, Gregory (ed.) *Idea Art, A Critique*. New York: Dutton, 1973.

Bayer, Herbert, with Gropius, Walter & Ise (eds.) *Bauhaus 1919–1928*. London: Bailey Brothers & Swinfen, 1959. Boston: Branford, 1959.

Berger, John *The Success and Failure of Picasso*. London: Penguin Books, 1965.

Blake, Peter *The Master Builders: Le Corbusier, Mies van der Rohe, Frank Lloyd Wright*. New York: Norton, 1976.

Blake, Peter *Form Follows Fiasco: Why Modern Architecture hasn't Worked*. Boston: Little, Brown, 1977.

Bowlt, John E. (ed.) *Russian Art of the Avant-Garde: Theory and Criticism 1902–1934*. New York: Viking, 1976.

Bradbury, Malcolm and McFarlane, James (eds.) *Modernism 1890–1930*. London: Penguin Books, 1978.

Chipp, Herschel B. (ed.) *Theories of Modern Art*. Berkeley: Univ. of California Press, 1968.

Clark, T. J. *Image of the People: Gustave Courbet and the 1848 Revolution*. London: Thames & Hudson, 1973.

Cohen, Arthur (ed.) *The New Art of Color: The Writings of Robert and Sonia Delaunay*. New York: Viking, 1978.

Conrads, Ulrich (ed.) *Programs and Manifestoes on 20th-Century Architecture*. London: Lund Humphries, 1970. Cambridge, Mass.: MIT Press, 1970.

Le Corbusier *The City of Tomorrow*. London: Architect Press, 1971. Cambridge, Mass.: MIT Press, 1971.

Cowart, Jack, et al. *Henri Matisse, Paper Cut-Outs*. New York & London: Abrams, 1977.

Dube, Wolf-Dieter *The Expressionists*. London: Thames & Hudson, 1972.

Dube, Wolf-Dieter, et al. *Ernst Ludwig Kirchner*. Berlin: Staadtmuseum, 1980.

Dunlop, Ian *The Shock of the New*. London: Weidenfeld & Nicolson, 1972. New York: American Heritage Press, 1972.

Duthuit, Georges *The Fauvist Painters*. New York: Wittenborn, 1950.

Egbert, Donald Drew *Social Radicalism and the Arts*. London: Duckworth, 1972. New York: Knopf, 1970.

Elliott, David *Rodchenko and the Arts of Revolutionary Russia*. New York: Pantheon, 1979.

Farmer, John David *Ensor: Major Pioneer of Modern Art*. New York: Braziller, 1978.

Fermigier, André *Pierre Bonnard*. London: Thames & Hudson, 1970. New York: Abrams, 1969.

Flam, Jack D. (ed.) *Matisse on Art*. London: Phaidon, 1973.

Flint, R. W. (ed.) *F. T. Marinetti: Selected Writings*. New York: Farrar, Straus, 1972.

Forge, Andrew *Robert Rauschenberg*. New York: Abrams, 1972.

Friedman, Martin *George Segal: Sculptures*. Minneapolis, Minn.: Walker Art Center, 1978.

Fussell, Paul *The Great War and Modern Memory*. London & New York: Oxford University Press, 1975.

Gardiner, Stephen *Le Corbusier*. London: Fontana, 1974. New York: Viking, 1974.

Golding, John *Cubism: A History and an Analysis, 1907–14*. London: Faber, 1959. New York: Wittenborn, 1959.

Goldwater, Robert *Primitivism in Modern Painting*. New York & London: Harper & Brothers, 1938.

Graetz, H. R. *The Symbolic Language of Vincent van Gogh*. London: Thames & Hudson, 1963. New York: McGraw-Hill, 1963.

Gray, Camilla *The Great Experiment: Russian Art, 1863–1922*. London: Thames & Hudson, 1962. New York: Abrams, 1962.

Greenberg, Clement *Art and Culture: Critical Essays*. London: Thames &

Hudson, 1973. Boston: Beacon Press, 1961.

Gropius, Walter *The New Architecture and the Bauhaus.* London: Faber, 1955. Cambridge, Mass.: MIT Press, 1965.

Guérin, Daniel (ed.) *Paul Gauguin: The Writings of a Savage.* New York: Viking, 1978.

Haftmann, Werner *The Mind and Work of Paul Klee.* London: Faber, 1967. New York: Praeger, 1954.

Hamilton, George Heard *Painting and Sculpture in Europe, 1880–1940* (Pelican History of Art). London: Penguin Books, 1967.

d'Harnoncourt, Anne and McShine, Kynaston (eds.) *Marcel Duchamp.* London: Thames & Hudson, 1974. New York: MOMA, 1973.

Hemmings, F. W. J. *Culture and Society in France, 1848–1898: Dissidents and Philistines.* London: Batsford, 1971. New York: Scribners, 1972.

Heron, Patrick *The Changing Forms of Art.* London: Routledge, 1955. New York: Macmillan, 1956.

Hess, Thomas B. *Willem de Kooning.* New York: MOMA, 1968.

Hess, Thomas B. *Barnett Newman.* London: Tate Gallery, 1972. New York: MOMA, 1961.

Hitchcock, H. R. *Architecture: Nineteenth and Twentieth Centuries* (Pelican History of Art). London: Penguin Books, 1958.

Hobbs, R. C. and Levin, Gail *Abstract Expressionism: The Formative Years.* New York: Whitney Museum, 1978.

Hodin, J. P. *Edvard Munch.* London: Thames & Hudson, 1972. New York: Praeger, 1972.

Honisch, Dieter, et al. *Trends of the Twenties: Catalogue of the Council of Europe exhibition, Berlin 1977.* Berlin: Reimer, 1977.

Hoog, Michel *Robert Delaunay.* Paris: Flammarion, 1976.

Hulton, Pontus *The Machine as Seen at the End of the Mechanical Age.* New York: MOMA, 1968.

Jean, Marcel, and Meizei, Arpad *History of Surrealist Painting.* London: Weidenfeld & Nicolson, 1960. New York: Grove, 1960.

Kandinsky, Wassily and Marc, Franz (eds.) *The Blaue Reiter Almanac.* Munich: Piper, 1965. London: Thames & Hudson, 1974. New York: Viking, 1974.

Kelder, Diane (ed.) *Stuart Davis.* New York: Praeger, 1971.

Koolhaas, Rem *Delirious New York.* London: Thames & Hudson, 1979. New York: Oxford University Press, 1978.

Kozloff, Max *Jasper Johns.* New York: Abrams, 1968.

Kozloff, Max *Renderings: Critical Essays on a Century of Modern Art.* New York: Simon & Schuster, 1969.

Kramer, Hilton *The Age of the Avant-Garde.* New York: Farrar, Straus, 1973.

Krauss, Rosalind *Passages in Modern Sculpture.* London: Thames & Hudson, 1977. New York: Viking, 1977.

Kudielka, Robert *Bridget Riley: Works, 1959–78.* London: British Council, 1978.

Lane, Barbara Miller *Architecture and Politics in Germany, 1918–1945.* London: Oxford University Press, 1968. Cambridge, Mass.: Harvard University Press, 1968.

Leymarie, Jean *Juan Gris*. Paris: Editions des Musées Nationaux, 1974.

Lippard, Lucy *Pop Art*. London: Thames & Hudson, 1967. New York: Oxford Univ. Press, 1966; Praeger, 1969.

Lippard, Lucy *Six Years: The Dematerialization of the Art Object from 1966 to 1972*. New York: Praeger, 1973.

Meyer, Ursula (comp.) *Conceptual Art*. New York: Dutton, 1972.

Mondrian, Piet *Plastic Art and Pure Plastic Art*. New York: Wittenborn, 1945.

Motherwell, Robert (ed.) *The Dada Painters and Poets: an Anthology*. New York: Wittenborn, 1951.

Nadeau, Maurice *The History of Surrealism*. London: Cape, 1968.

Nochlin, Linda "The Invention of the Avant-Garde: France, 1830–1880", in *Avant-Garde Art*, ed. Thomas B. Hess and John Ashbery. New York: Macmillan, 1968.

Nochlin, Linda *Realism*. London: Penguin Books, 1971.

Novak, Barbara *Nature and Culture: American Landscape and Paintings, 1825–1875*. New York & London: Oxford Univ. Press, 1980.

O'Connor, Francis and Thaw, Eugene *Jackson Pollock: A Catalogue Raisonné of Paintings, Drawings and Other Works*. New Haven, Conn. & London: Yale Univ. Press, 1978.

O'Doherty, Brian (ed.) *Museums in Crisis*. New York: Braziller, 1972.

O'Neill, John P. *Clyfford Still*. New York: Abrams, 1979.

Overy, Paul *Kandinsky: The Language of the Eye*. London: Elek, 1969. New York: Praeger, 1969.

Pehnt, Wolfgang *Expressionist Architecture*. London & New York: Thames & Hudson, 1979.

Poggioli, Renato *The Theory of the Avant-Garde*. New York: Harper, 1971.

Richardson, John *Georges Braque*. London: Penguin Books, 1959.

Richter, Hans *Dada: Art and Anti-Art*. London: Thames & Hudson, 1968. New York: McGraw-Hill, 1966.

Rose, Barbara *Claes Oldenberg: a Catalogue*. New York: MOMA, 1969.

Rose, Barbara *Helen Frankenthaler*. New York: Abrams, 1971.

Rose, Barbara (ed.) *American Art since 1900: a critical history*. Rev. ed. London: Thames & Hudson, 1975. New York: Praeger, 1975.

Rose, Barbara (ed.) *Readings in American Art since 1900: A Documentary Survey*. New York: Praeger, 1968.

Rosenberg, Harold *The De-Definition of Art: Action Art to Pop to Earthworks*. London: Secker & Warburg, 1972. New York: Horizon Press, 1972.

Rosenberg, Harold *Discovering the Present: Three Decades in Art, Culture, and Politics*. Chicago & London: Univ. of Chicago Press, 1973.

Rosenberg, Harold *Art on the Edge: Creators and Situations*. London: Secker & Warburg, 1976. New York: Macmillan, 1975.

Rosenblum, Robert *Cubism and Twentieth-Century Art*. London: Thames & Hudson, 1961. New York: Abrams, 1961.

Rosenblum, Robert *Modern Painting and the Northern Romantic Tradition: Friedrich to Rothko*. London: Thames & Hudson, 1975. New York: Harper & Row, 1975.

Rosenblum, Robert (intr.) *Edvard Munch, Symbols and Images: a Catalog.* Washington, D.C.: National Gallery of Art, 1978.

Rowell, Margit *The Planar Dimension, Europe 1912–1932.* New York: Guggenheim Museum, 1979.

Rubin, William S. *Dada and Surrealist Art.* London: Thames & Hudson, 1969. New York: Abrams, 1968.

Rubin, William S. *Frank Stella.* New York: MOMA, 1970.

Rubin, William S. *André Masson.* New York: MOMA, 1976.

Rubin, William S. *Pablo Picasso: A Retrospective.* New York: MOMA, 1980.

Russell, John *Georges Braque.* London: Phaidon Press, 1959.

Russell, John *The World of Matisse, 1869–1954.* New York & London: Time-Life Books, 1969.

Russell, John, with Gablik, Suzi *Pop Art Redefined.* London: Thames & Hudson, 1969. New York: Praeger, 1969.

Schapiro, Meyer *Modern Art, 19th and 20th Centuries: Selected Papers.* New York: Braziller, 1978.

Scharf, Aaron *Art and Photography.* London: Allen Lane, 1968.

Schneider, Pierre and Preaud, T. *Exposition: Henri Matisse.* Paris: Editions des Musées Nationaux, 1970.

Seitz, William C. *The Art of Assemblage.* New York: MOMA, 1961.

Shattuck, Roger *The Banquet Years: The Origins of the Avant Garde in France, 1885 to World War I.* Rev. ed. London: Cape, 1969. New York: Random House, 1968.

Speer, Albert *Architektur.* Berlin: Propylaen, 1978.

Steinberg, Leo *Jasper Johns.* New York: Wittenborn, 1963.

Steinberg, Leo *Other Criteria: Confrontations with Twentieth-Century Art.* New York & London: Oxford Univ. Press, 1972.

Stuckey, Charles F. *Toulouse-Lautrec: Paintings.* Chicago: Art Institute, 1979.

Szeeman, Harald (ed.) *Le Macchine Celibi/The Bachelor Machines.* Venice: Alfieri, 1975.

Tafuri, Manfredo and Dal Co, Francesco *Modern Architecture.* New York: Abrams, 1978.

Taylor, Joshua C. *Futurism.* New York: MOMA, 1967.

Tisdall, Caroline *Joseph Beuys.* New York & London: Thames & Hudson, 1979.

Waldman, Diane *Kenneth Noland: A Retrospective.* New York: Guggenheim Museum, 1977.

Waldman, Diane *Mark Rothko, 1903–1970.* London: Thames & Hudson, 1978. New York: Abrams, 1978.

Waldman, Diane (intr.) *Roy Lichtenstein.* London: Thames & Hudson, 1971. New York: Abrams, 1971.

Welsh, Robert P. *Piet Mondrian 1872–1944.* Toronto: The Art Gallery, 1966.

Wildenstein, Daniel *Monet's Years at Giverny: Beyond Impressionism.* New York: Metropolitan Museum of Art, 1978.

Willett, John *The New Sobriety, 1917–1933: Art and Politics in the Weimar Period.* London: Thames & Hudson, 1978. New York: Pantheon, 1978.

INDEX

438 / INDEX

A NOTE ABOUT THE TELEVISION SERIES

The BBC eight-part series *The Shock of the New,* which was the origin of this book, is a coproduction with RM Productions, Munich, and Time-Life Films, New York. The production team was as follows:

Series Producer Lorna Pegram; *Series Producer's Assistant* Hazel Wright; *Series Researcher* Robert McNab; *Assistant Researcher* Melda Gillespie; *Producers* Robin Lough, David Richardson and David Cheshire; *Producer's Assistants* Paula Leonard, Anne Lee, Val Mitchell and Nadia Haggar; *Series Cameraman* John McGlashan; *Series Assistant Cameraman* Graham Frake; *Series Sound Recordist* Simon Wilson; *Supervising Film Editor* Jesse Palmer; *Film Editors* Ian Pitch, Martin Crump, Richard Brunskill, Rick Spurway and Sue New; *Rostrum Cameramen* Ivor Richardson and Ken Morse; *Graphics Designer* Sid Sutton; *Composer, Series Title Music* Peter Howell.

A NOTE ABOUT THE AUTHOR

Robert Hughes was born in Australia in 1938 and has lived in Europe and the United States since 1964. Since 1970 he has worked in New York as art critic for *Time* magazine. His books include *The Art of Australia* (1966); *Heaven and Hell in Western Art* (1969); *The Fatal Shore* (1987), winner of both the W. H. Smith Prize and the Duff Cooper Award; a collection of essays on art and artists, *Nothing If Not Critical* (1990); and *Frank Auerbach* (1990). He has twice received the Franklin Jewett Mather Award for Distinguished Criticism from the College Art Association of America.